Thomas Kinkade

Thomas Kinkade

THE ARTIST IN THE MALL

EDITED BY ALEXIS L. BOYLAN

Duke University Press

Durham and London

2011

© 2011 DUKE UNIVERSITY PRESS
All rights reserved. Printed in the United
States of America on acid-free paper ∞
Designed by Amy Ruth Buchanan
Typeset in Bembo by Tseng Information
Systems, Inc.
Library of Congress Cataloging-in-
Publication Data appear on the last
printed page of this book.

Contents

Illustrations

Figures

Acknowledgments

This book has been a long time in the making, and along the way many debts have been accrued on my part. To begin with, I would like to thank the original panel of speakers from a session on Thomas Kinkade at the College Art Association conference in 2004: Monica Kjellman-Chapin, Michael Clapper, Patrick Luber, Chris Pearson, and Andrea Wolk Rager. Their smart and perceptive presentations, followed by the enthusiastic audience response, encouraged my need to expand the conversation. The authors who subsequently joined this project have likewise brought insight and energy, and I appreciate their scholarship and patience with the process. In terms of transitioning this material into its published form, Matthew Marshall, Duke University Press, the outside readers, Mandy Earley, and Ken Wissoker have been instrumental. Ken's patience, steady hand, and good advice were profoundly meaningful. A word of gratitude must also go to the Thomas Kinkade Company, in particular Mary Gerbic, Linda Mariano, Robert C. Murray, and Rosalba Quezada, each of whom helped to ensure that Kinkade's illustrations were included. Two paragraphs in my introductory essay previously appeared in print in "Stop Using Kitsch as a Weapon: Kitsch and Racism," *Rethinking Marxism* 22, no. 1 (2010): 42–55.

Numerous colleagues and friends deserve special notice: Matthew Baigell, Faith Barrett, Emily Bivens, Gina Bloom, Catherine Hollis, Beauvais Lyons, Michael Orr, and Alan Wallach. All read drafts, offered suggestions and encouragement, or simply listened. Additionally, I would like to thank my colleagues and students at Lawrence University, the School of Art, University of Tennessee, and the University of Connecticut for their support. Finally, I want to recognize my family: my parents and their spouses; my brothers, Gabriel and Nicko; and my partner, Micki, and her family. Nothing would get done without your love and good humor. Thank you.

Introduction

ALEXIS L. BOYLAN

When people hear that I am editing a book about Thomas Kinkade, I usually get two reactions. The first, typically from colleagues and students, begins with a look of abject horror. Their eyes widen in shock, and they ask, "The lighthouse guy?" Then, after a second or two, there is the smirk and the knowing nod, "Ah, funny. Can you believe people think that's art? Will you be sending up his audience? Religion? The contemporary art scene? American consumer culture?" Invariably, before I can respond to these questions the speaker has moved on to tell a story about a relative, a coworker, or a neighbor who actually *owns* a Kinkade painting, "Can you imagine?"

The second reaction is more direct. The speaker looks me in the eyes, smiles openly, and says, "Oh my gosh, how wonderful. I love his art."

Many contemporary artists elicit "love them or hate them" responses. In certain circles if the names Damien Hirst or Jeff Koons are mentioned, there is no end to the ways in which people will praise or vilify their work, either applauding the artists as the saviors of art or tossing them out as evidence of an artistic apocalyptic condition. Yet if one were doing a random survey of the general public, most people would probably never have *heard* of Hirst or Koons. Mere recognition, not love or hate, would be the issue.

Kinkade does not suffer from that problem. It has been estimated that a Thomas Kinkade image is present in almost one out of twenty homes in the United States.[1] His primary works—paintings—are technically not paintings at all but rather high-quality prints. These are sold with painted highlights added by the artist himself, or by other artists Kinkade has trained or his corporation has authorized, or simply as unadorned prints. Kinkade's paintings are distributed through his gallery stores in malls across

the country, and his images have been merchandised to sell everything from Bibles and bedsheets to La-Z-Boy chairs.[2] Kinkade sells his works on QVC, in Christian stores, and through an extensive website, and he enjoys a significant secondary market on auction sites such as eBay. Even as his corporation has taken hits in recent years with the "great recession," lawsuits, talk of bankruptcy, and closed gallery stores, Kinkade continues to expand his empire with licensing deals with NASCAR, Disney, and Major League Baseball.[3] His corporation boldly proclaims him to be "the most successful and most collected living artist in U.S. history," and it is hard to challenge that assertion.[4] Love him or hate him, Kinkade and his art are known in the United States in a way Hirst and Koons could not even begin to approach.

For many these facts merely prove that Kinkade is engaged in a different game than Hirst or Koons. Hirst and Koons are "fine" artists, speaking to selected audiences who understand the elixir of materials, pop culture references, and art-historical precedents that result in works of art that puzzle the complexities of capital, irony, individualism, and artistic authority in complicated and intellectually provocative ways (see Jeff Koons, *Pink Panther* [1998; pl. 1]). Their works are created for the homes of a few exclusive patrons but primarily for museum and gallery spaces. The selling of art for these men is facilitated by their agents or gallery owners, whose job it is to worry about the marketing and press so that the artists can focus their energies on the "creative" process.

Many would argue that Kinkade is more of a marketing phenomenon than an artist, not at all in the same league or in the same intellectual or philosophical profession as Hirst and Koons. To these critics Kinkade's work does not stimulate the audience toward complex, ambiguous, or subversive understandings of our world the way that "art" would, and, likewise, the work does little to question his role as an artist or our role as audience. And finally, for those who might still believe in Kantian ideas of the sublime and beautiful in art (art historians mostly, the visual culture scholars sighing deeply at this obsession with taste and beauty), his work fails on that front as well, resorting to cloying color schemes and formulaic landscape tropes that borrow heavily from Hudson River school artists and impressionists but do neither source justice in terms of technique, originality, or innovation.[5] His popularity, it follows, is merely a sign of the commodification of art and the way in which contemporary audiences are easily seduced by kitsch and marketing through the disassociating mecha-

nisms of capitalism. Kinkade's work is thus a nightmare about the future of culture manifested in a poster, sold as a painting, hung in a gold frame, and named "art."

It is with a variation of this narrative in mind that many assume that for an art historian to edit this book, there must be an element of disdain or mocking involved in the approach to Kinkade. Although Kinkade does, indeed, elicit a certain degree of disdain from some of the authors of this collection, a book that engaged only that perspective would be impossibly limited, both in its intellectual and political value. The methodology of art history is often mobilized to disparage Kinkade, but it can also encourage the investigation of the historical and social circumstances that gave rise to him and his career. This is a perfectly respectable approach, and several of the essays in this collection exemplify the crucial value in such a historical methodology. Context matters, and a historical lens takes away some of the power of theoretical paradigms that argue that cultural forces simply manipulate passive human actors and activities. Locating Kinkade with biography and influences reminds readers that accidents or coincidence can be as important as large social and political mechanisms in creating culture. For example, while Kinkade certainly capitalized on the resurgence of evangelical power and the broader cultural turn toward political conservatism in the United States in the 1990s, it was his California upbringing during the 1960s and 1970s that shaped much of his trajectory. Some might argue that a Kinkade-like figure was bound to emerge or that the careers of many other artists and graphic designers mirror his (save the business savvy), but in fact, as several of the following essays argue, Kinkade's rise to prominence was not just a matter of the right person at the right time. The historical analysis offered suggests a knowing artist who engaged with conversations about iconography and the broader art world and created work that did not merely reflect culture but also gave vision and shape to that culture. Thus, as an art historian I find satisfaction in analyzing Kinkade with these methods because he is contextualized and therefore contained in ways that make him less a chimera or a boogeyman hovering around the edges of our view or projected as some omen of the demise of culture broadly. Kinkade is placed in perspective and located within paradigms that remind us that his art, and indeed his vision of himself as a specific kind of artist, are born out of dialogues that have important intellectual and social currency.

Yet, as has become apparent in the past decade with the rise of visual culture studies and academic programs, to limit the discussion of Kinkade to these traditional "art-historical" parameters would be to overemphasize both the artist and the objects in ways that obscure the power of the visual and the power of audiences to use these images to their own ends. Visual culture studies has emerged in part to address, as Mieke Bal argues, art historians' failure to "deal with both the visuality of . . . objects—due to the dogmatic position of 'history'—and the openness of the collection of those objects—due to the established meaning of 'art.'"[6] Instead, we must pay more attention to the act of looking itself. To that end this book also asks readers to consider how Kinkade's images speak to audiences, how audiences use those images, and how the images abandon the artist (and even the audience) and take on a life of their own. Scholars of visual culture typically point to the ways in which visual images activate their own responses and, as W. J. T. Mitchell has so evocatively suggested, the ways in which images activate their own wants and desires.[7] This line of inquiry points to the subversive possibilities inherent in visual culture of circumventing power and reassigning it to a multitude of sources. Indeed, what is perhaps so captivating about Kinkade's works, and what several authors in this collection point out, is that within the images that critics have found stale, stagnant, and confining, viewers have found room for radically different conversations. Kinkade's religious message would be one such example. Kinkade himself speaks directly to his desire to have his art testify to his belief in the salvation of the soul through Christ. Yet numerous viewers purposely tune that message out, look past it or around it, and still connect on deep and meaningful spiritual levels with Kinkade's art. In considering this phenomenon in traditional art-historical terms, viewers who miss the intentions of the artist and the Christian imagery would simply be misreading the images or only appreciating a select aspect of the painting. But discarding assumptions about the authority of the artist and even the object to dictate "rightness" or "wrongness" opens a dialogue about what audiences want and need from visual imagery more broadly. Several authors raise this question to argue that using a Kinkade Visa card or living in a Kinkade-style home evokes wholly different relationships between audience and object. While numerous theorists of consumption have argued why people buy certain kinds of objects for their homes,

theory and practice diverge when we examine what desires are met and *sustained* by audience uses of Kinkade's images.[8]

Thus, from both art history and visual culture perspectives the subject of Thomas Kinkade emerges as a tool to illuminate ideas about the artist, his historical and cultural trajectory in the late twentieth century and beyond, and audience response to and manipulation of his works. And yet the taste issue lingers, lurking around every attempt to clarify, mark with precision, and articulate these points. Art history and visual culture studies, while diverging in numerous ways, seem to agree that it is best to leave aesthetics to others because it muddies the critical water.[9] But taste, loving or hating, as seen from the two sets of comments I typically receive about this Kinkade project, matters. A colleague of mine put the issue quite bluntly: "Do you worry that in writing about Kinkade you are advocating him in some way, making him legitimate?"

The question itself asserts that it is not the millions who have purchased and engaged with Kinkade on an emotional, spiritual, and aesthetic level that can make him "legitimate"; instead, scholars, critics, and museum professionals hold that magic key. On a political level I do not want to agree with that assertion, but as one who writes from within that world, and who has access to write because of my position among those ranks, it would be absurd to imagine that there is not significant power in those institutions. Aesthetics has often been sheared from art-historical inquiry in ways that attempt to affect some sense of objectivity. Yet these divisions are often false and arbitrary, and as a result the questions of beauty, worth, value, and taste do not go away but tend to resurface in tricky and deceptive ways. The line between the contemporary art critic and the contemporary art historian is foggy, and taste, whether acknowledged or implied, is omnipresent. In choosing authors for this collection, I have sought to represent a variety of voices with different tastes, both personal and scholarly, in respect to Kinkade and with different intellectual perspectives as to the problem of taste in determining who in the art world gets recognized and who gets ignored. If Kinkade garners some "legitimacy" from this volume, he is welcome to it, but I would also hope that discussions of his art and his audience open up the far more pressing questions of the place of aesthetics in art history and visual culture. *Beauty* and *value* are understandably treacherous words, and these ideas have historically been the tools by

which those in power have silenced the voices of those on the margins.[10] Yet as Kinkade and his popularity prove, there is a craving for such things. While many academics and artists have sought to move beyond ideas such as "taste" and "beauty," or have theorized that they no longer (or never did) exist or matter, Kinkade has swept in and filled a need for these concrete concepts for millions. We should not respond to this with attempts to edify those terms or reinscribe ideas like "beauty" with their previous authority or meanings. It is worth noting, however, that while we have been look-ing elsewhere, Kinkade has filled the malls, the Internet, and homes with his version of beauty and art. Perhaps the question is not whether this art historian can legitimize Kinkade but whether Kinkade casts doubt on the legitimacy of art scholars in general.

In his discussion of Felix Gonzalez-Torres, Nicolas Bourriaud argues, "The availability of things does not automatically make them commonplace."[11] His comment is in reference to Gonzalez-Torres's sculptures of colorful wrapped candies that are arranged in exhibition spaces. The candies are small and wrapped in shiny paper, and viewers can look at *the* piece and leave it undisturbed or take *a* piece of candy to keep as a memento of the visit or to eat. For the sculptor, and those familiar with his works, the candies often symbolize particular biographical details.[12] The vibrant candies act either as a memorial, evoking the past and a fixed moment of wholeness while speaking simultaneously to the flux of the present mo-ment as the candies, like memories, are taken away, moved, and then re-placed, or as a site of infinite hopefulness with the possibility of renewal and replenishment. For Bourriaud, whose theory of relational aesthetics openly embraces the desire for art to speak to both beauty and the sacred in this contemporary postmodern moment, Gonzalez-Torres symbolizes an "ideal balance" between "visual beauty and modest gestures."[13] Finally, the candies represent the artist's attempt to break apart the monopoly of experience dictated by museum space. The audience can take home or con-sume the piece, thus denying the museum some of the authority of owner-ship.

Now consider Kinkade's *Sweetheart Cottage III: The View from Havencrest Cottage* (1994; pl. 2). The commonplace here, to reference Bourriaud's pas-sage above, is the landscape, as familiar in function and visual dynamics to viewers as the wrapped candies. Like Gonzalez-Torres, Kinkade does

not mask his work's intentions; the landscape is immediately readable and requires no decoding. The colors are soft and alluring, as is the light that emanates from the Cotswold-style cottage. The cabin stands at the edge of a deep precipice from which picturesque mountains emerge triumphantly. The tops of the cliffs are shrouded in a thin pink and blue gauze of fog and clouds, and several birds float lazily through the air. As with the Gonzalez-Torres piece, for the casual or unschooled Kinkade viewer there is one level of interaction in which a landscape is simply a landscape. Yet for "the cognoscenti" this is part of a series of images devoted to Kinkade's wife, to whom he has been married for decades and who is responsible for guiding him back to his Christian faith. This painting, the third in a series of sweetheart cottage pictures, is an homage to their love and, by proxy, to the love of God. Also like Gonzalez-Torres, Kinkade defies the cultural authority of museums and galleries by making this piece infinitely reproducible. It can be purchased in mall stores or on the Internet; it is available in numerous sizes, and as a notepad; or the image can be sent as an e-card to anyone through Kinkade's website.

As I suggested earlier about Hirst and Koons, any comparison of Kinkade and Gonzalez-Torres dissolves around definitions of *art* and *kitsch*. Gonzalez-Torres plays delicately with audiences and tosses colorful, happy, sweet treats before their eyes as a metaphor for the dissolving human body and the temporality of all things (even art). Gravitas is the decisive factor here; Gonzalez-Torres considers memory and death in sophisticated and contradictory ways, whereas Kinkade prefers the realm of pleasure and visual satisfaction. Finally, the ability to literally and freely consume pieces of Gonzalez-Torres's candy spills within the walls of a museum challenges the value-producing function and the institutional authority of the place itself. Kinkade's works are simply for sale. It is this complexity and subversiveness, along with playful uses of the familiar, that make Gonzalez-Torres's work *art*. Kinkade, likewise, tosses colorful, happy, sweet treats before his viewers, but his work is labeled *kitsch*.

Several authors in this collection puzzle over the historical trajectory of this art-kitsch divide and the mechanisms that maintain and defend these terms. A brief discussion of the pertinent issues concerning kitsch, taste, and consumer culture sets the stage for these conversations. As a paradigm, kitsch highlights some of the questions and contradictions that Kinkade reveals about definitions of and desires for art. The concept of kitsch is an

apt vehicle to use in considering theories of consumption and the plea-
sures and anxieties afforded through the range of purchasing possibilities
provided by Kinkade's work. Kitsch also reflects the tensions surround-
ing contemporary religious art, particularly evangelical Christian images.
In the end, while the very notion of kitsch may be flawed, it is useful for
understanding the extent to which Kinkade is implicated in several key dis-
cussions about the very nature of contemporary visual culture.

Clement Greenberg's essay "Avant-Garde and Kitsch," published in
1939, remains the foundational text on the nature of kitsch.[14] Greenberg
begins his essay by questioning how "one and the same civilization pro-
duces simultaneously two such different things as a poem by T. S. Eliot and
a Tin Pan Alley song, or a painting by Braque and a *Saturday Evening Post*
cover" (6). Greenberg's introductory premise, therefore, is constructed on
the notion that T. S. Eliot's poetry and Tin Pan Alley music are fundamen-
tally different. They come from the same place but do not share the same
defining features; they are made of different stuff.

Out of this initial distinction Greenberg forms his construct, which
posits kitsch as standing against the radical social and political possibilities
of the avant-garde. The latter's social value stems from its artistic ability
"to keep culture *moving* in the midst of ideological confusion and violence"
(8). This movement is what maintains the value of culture; it is the be-
ginning and end of all artistic inquiry. Kitsch, according to Greenberg, is
"commercial art and literature" (11), which were born out of the Industrial
Revolution. Urbanized masses (a result of the Industrial Revolution) simul-
taneously lost their taste for their indigenous folk cultures and "discovered
a new capacity for boredom." Out of this need kitsch is born. Greenberg
argues, "Kitsch is mechanical and operates by formulas. Kitsch is vicarious
experience and faked sensations. Kitsch changes according to style, but re-
mains always the same. Kitsch is the epitome of all that is spurious in the
life of our times. Kitsch pretends to demand nothing of its customers ex-
cept their money—not even their time" (12). All the more insidious is the
deceptive nature of kitsch. It has many "different levels" and masks itself as
something more valuable and different from what it is, making it possible
for fascist and totalitarian regimes to use it as a tool for manipulating the
masses. Greenberg understands the draw of this culture. High art is hard,
he argues, and demands concentration, while kitsch is easy, and for those
who labor all day, easy is better.

Greenberg's premise—which divided artistic production into two dia-metrically opposed camps, one on the side of progress, complexity, and so-cial justice, the other defined by boredom, stagnation, and passivity in re-gard to power—was challenged by the advent of pop art in the 1950s. Andy Warhol, for example, took the visual imagery of kitsch that Greenberg so despised, removed it from its context, and repackaged it, thus confusing or disrupting the boundary between the commonplace and art. Warhol's soup cans are the most famous example of this, but he pillaged liberally, from commercial products and celebrity publicity stills to FBI mug shots, for his source material. This mixing of visual imagery of popular culture, commercial culture, and political culture appeared both personal and im-personal, but if one appealed to Warhol to clarify the situation, one was met with an artist who also refused to explain himself. He claimed that his art had no deeper meaning, no ulterior motive, no authority, no agenda beyond itself, and he hinted at no theoretical structure that could support his objects or artistic persona. Similarly disassociating, Warhol's medium, screen printing, with its promise of infinite reproducibility, undermined the notions of originality, authenticity, and aura that Greenberg and others found so crucial, so progressive, about art. As Dick Hebdige argues, "Pop challenged the legitimacy of validated distinctions between arts and the lingering authority of prewar taste formations."[15] In this view kitsch is ren-dered as a radicalizing visual vocabulary with which to speak to modern or postmodern life, liberating the viewer to look with new eyes at all cate-gories of culture.[16] Analyzing the works of second-generation pop artists such as Koons (pl. 1), Sarat Maharaj argues that "no sooner are the kitsch elements [in works by these pop artists] 'mastered and framed' by a self-reflexive, ironic gaze than they elude its grip, doggedly reasserting their 'kitsch quality.' A radical indeterminacy prevails—we never quite find our feet with regard to which element serves and manipulates the other."[17] Pop seems to offer a kind of double-consciousness (to twist W. E. B. Du Bois's term) that allows viewers, and indeed the artist, to position themselves as a part of the "problem" and then also as part of the "solution" through detachment and irony. Meaning and intention are not fixed onto objects alone but instead must also include considerations of context and fram-ing. Pop art would seem to admonish Greenberg—with his obsession over categories of art and kitsch—to calm down, chill out, get cool, and see the joke.

Yet while pop art no doubt expands the category of "art," it is less clear that pop art fundamentally shifts the definitions or shape of materials that continue to be defined as "kitsch." For if kitsch really is no longer a category of any distinction, the choice of pulling visual images from popular culture becomes moot. More important, the marketplace of art objects, regardless of pop's play with multiplicity and materials, maintained an affection for and reliance on the elite trade in art. Warhol's works might have been screen prints, undermining the value of originality, but most now reside in museums and galleries. Or, to put it another way, patrons and museums did not imagine soup cans in a profoundly different way after Warhol and purchase cans instead of screen prints to hang in their homes or institutions. To use a different example, Koons's images might borrow from tabloids and cartoons, but the aesthetic qualities of those original sources have remained quarantined in the world of kitsch. The indeterminacy that kitsch gives to the category of art when it borrows from it is not returned; if anything, kitsch as a category becomes more solid. Kitsch must remain kitsch for pop art's borrowings to have meaning. Thus, regardless of the radical promise that pop might disrupt Greenberg's paradigm, it instead reinvigorates the very binary he theorized.

Perhaps as a response to pop art's engagement with kitsch, numerous scholars have focused less on the role of kitsch in culture than on the nature of kitsch itself in an attempt to define or mark the boundaries of its reach. This search cannot be separated from a central desire to see "art," as Greenberg does, as ultimately important and redemptive to society. Those who look to find the heart of this thing called "kitsch" are actually looking for a way to define *art*. Emblematic here is Milan Kundera's description of kitsch in his novel *The Unbearable Lightness of Being*:

> Kitsch causes two tears to flow in quick succession. The first tear says: how nice to see children running on the grass!
>
> The second tear says: How nice to be moved, together with all mankind, by children running in the grass!
>
> It is the second tear that makes kitsch kitsch.[18]

For Kundera it is the act of feeling oneself moved, not as an individual but as some act of common humanity, that is at the heart of kitsch. It is the thing that moves from a personal, individual state of emotion, with all the complexity, isolation, and contradiction that might entail, to the organ-

ized and performative emotion that claims to speak for some global or human vision that damns the object into kitsch-hood. Kundera distrusts any claims to a shared moment or a unifying narrative, but in his definition of kitsch lies the suggestion that contained within the first tear is something real, something authentic, something that might have been "art." But the second tear—the universal one, the calming one, the tear that makes it not just one tear but a cry—is where art is extinguished and kitsch invades.

It is also in this second tear that Kundera reveals the element of pleasure or satisfaction that he sees at the heart of kitsch. The first tear *enjoys the vision of the children running*; it accepts and is moved by the thing itself. The second tear is about the pleasure not of the thing *but of the act of being moved.* Kitsch is about the feeling, not the real. It has become removed from the authentic (the sight of the children) and is instead about the idea of having a profound emotion ("how nice to be moved"). In this distinction Kundera suggests that pleasure is crucial to kitsch, but it is a false pleasure, born of lazy and self-indulgent fantasies of what an emotional moment feels like. Kitsch is therefore a mimic and one that denies the ability to experience the real by replacing it with a performance and script of what emotion is.[19]

Kundera, like Greenberg, sees kitsch as duping most viewers out of an authentic relationship with the world. But others have suggested that audiences may activate kitsch in more primal and knowing ways. Pleasure and authenticity remain at the core of Celeste Olalquiaga's ruminations on kitsch, yet she does not view it as duplicitous or misguiding. Kitsch denies nothing to the viewer because it never promises to be more than what it is: "Kitsch is nothing if not a suspended memory whose elusiveness is made ever more keen by its extreme iconicity. Despite appearances, kitsch is not an active commodity naively infused with the desire of a wish image, but rather a failed commodity that continually speaks of all it has ceased to be—a virtual image, existing in the impossibility of fully being. Kitsch is a time capsule with a two-way ticket to the realm of myth—the collective or individual land of dreams."[20]

In this view of kitsch it is always a weak or "failed" entity that merely stores, in an incomplete way, the fantasy or memory of what once was the real. Olalquiaga continues: "Kitsch is the attempt to repossess the experience of intensity and immediacy through an object" (291). In other words, kitsch is connected to time and to death, to repossession of the thing that is no longer available—an imitation, to be sure, but not of a malicious sort.

The familiarity and the emotions kitsch elicits are all knowing compromises in a failed attempt to recapture that which has been lost. Kitsch does not represent a fleeing from reality or a denial of the real, and it in no way competes with art or any kind of profound emotional state. For Olalquiaga kitsch is "a spell to which one succumbs willingly, knowing its delicate fabric can disintegrate with the slightest interference. . . . Kitsch drifts between waking and sleeping hours, half dream and half reality, all memory and desire" (97). The deception is not one the viewer is tricked into seeing but one she or he embraces as a fulfillment of need. In Olalquiaga's view kitsch makes the world livable because it mediates the nagging want that hovers at the edges of our lives and allows us to freely engage in memory without a trace of morbidity or regret.

Although these authors diverge in the context of their assessment of the authenticity of kitsch, what is perhaps more interesting is their positions on the audience's sense of control or consciousness in relation to it. Kundera, in using the metaphor of the tear, asserts that the inner self cannot dictate or control the impact of kitsch. One might perhaps keep from crying, but once the first tear has fallen, it is nearly impossible to stop the next one. For Kundera there is no stopping kitsch's impact once viewed because the audience is trapped in the performance and emotion. But Olalquiaga sees agency: we decide to succumb to a spell. For her the control ultimately rests with the viewer who looks to kitsch with desire, knowing that desire cannot be satiated through the object but wanting the object just the same. Kitsch is both the longing for satisfaction and the recognition that it can never be obtained.

This conceptual range concerning kitsch and its authority infuses the way most critics, audiences, and the authors in this collection view the impact of Kinkade. On the one hand, a work like *Sweetheart Cottage III*, viewed through Kundera's notion of kitsch, speaks to the profound and sublime beauty of nature while demanding that it be viewed in that way. Kinkade is not speaking to a specific landscape and denies the viewer the ability to locate this geography with any specificity. Instead, he speaks in broad visual generalizations about landscape and directly to the vocabulary of awe that has historically defined the genre (the bold vista, the bright sky, the lush greens of the grass contrasted with rocky and steep mountain cliffs). For those, like Kundera, who view kitsch as an impediment to the real, Kinkade's art prevents any possible engagement with landscape. In-

stead, the viewer is confined to the space of emoting about the *feeling* of landscape. Kinkade does not paint things; he paints the desire to feel (and also to feel in unison with others).

But if viewed as a spell, as a memory and a fantasy that is not the real thing (with that distance from the real constituting its value), Kinkade's art is kitsch at its most useful. Viewed this way, his imagery serves the needs of his audience, who recognize the painting for what it is and what it does. Kinkade's pastel landscapes—the cottage cuddled into the folds of the land, the emanating of a soft light, and the birds flying gently through the air—are understood as not real, not living, not approachable in any actual sense. The value is instead in the fantasy, the suspension of time, the allowance for memory and fantasy to commingle in the mind of the viewer. In real landscapes winter comes, forests burn, and people get lost; in other words, in real landscapes decay and death exist. Kinkade's images are frozen; they suspend time and disallow decay and death, which soothes the mind if only momentarily. He gives pleasure of the most profound sort, and the audience recognizes its remove from lived experience as the source of that pleasure. As Kinkade himself would argue, "[My art] beckons you into a world that provides an alternative to your nightly news broadcast. . . . People are reminded that it's not all ugliness in this world."[21]

For the viewer, and indeed the reader of this collection, the first crucial issue that one must settle in regard to Kinkade is one's position on kitsch as an aesthetic experience. Various authors in this book will suggest alternative definitions to the ones I have presented and give nuance to critical appraisals of kitsch, but the heart of the issue is questions of authenticity and the truth of experience. For those who see Kinkade as a sham and a charlatan, his art will always represent the pathway to deception, the dead-end street of kitsch that promises the real but delivers nothing but processed fantasies and deferred dreams. In his recent catalogue of the contemporary artist Rudolf Stingel, Francesco Bonami argues that Kinkade "indulges in the mundane to ideologically exploit the banal." For Bonami wonder lies at the heart of true art (or, as he writes in his essay, in "Painting" [with a capital *P*] as opposed to "painting"), and Kinkade "subdues wonder to taste, bad taste." He concludes triumphantly, "Painting can either aim for the picturesque, the cheesy cottage, the plurality of bad taste, the underdeveloped childhood inside the average viewer, or strive to be a great work of art— hence the triumph of resolution, the mono-logical and mature expression

of a single artistic expression."[22] Bonami is not addressing kitsch directly but rather defining the flip side of kitsch: art. Yet the idea of "wonder" here is the same as Kundera's first tear—the thing that stops the mind, that isolates in awe. It is the power of art that Kinkade seems, to his critics, to undermine and mimic.

But again, the words that Bonami uses—*picturesque, cheesy, plurality*, and even the idea of an "underdeveloped childhood"—can be seen as the positive and desirable end of Kinkade's project. For what Bonami views as Kinkade's use of nostalgia, his obvious and overt desire to please the eye with his works, his unrepentant quest to visually satisfy, some would suggest, is exactly what the viewer wants. It is kitsch in the best sense of being the "spell" that Olalquiaga claims we desire. And after all, what exactly is the difference between wonder and a spell?

Greenberg's assessment of the poor aesthetic quality of kitsch is based in a materialist understanding of culture and political economy. As a Marxist, and in response to the rise in fascism and Nazism that he witnessed in the 1930s, Greenberg viewed kitsch as a malevolent force that worked in the aid of the mechanisms of capitalism. Greenberg, along with the cultural theorists of the Frankfurt school, assumed that the masses were relatively powerless against the forces of the dominant class, which maintained its power through the manipulation of popular culture. For Greenberg only the avant-garde could stand in opposition and offer alternatives to this dominant regime, and, even then, only a small segment of the population would ever see through commodification and mass-produced culture to recognize originality and resistance.

Since the historical moment when Greenberg wrote "Avant-Garde and Kitsch," the impact of popular culture in the United States and, indeed, around the world has only increased. Globalization and the Internet are but two factors that have worked to expand the forces by which material goods and imagery circulate at dizzying paces. Yet it is the promise of a radical avant-garde as existing separately and somehow isolated from these trends that seems the most antiquated aspect of Greenberg's theory. The institutionalization of art practices through schools, residencies, corporate sponsorships, and the increasing corporate presence in museums and gallery circles has corrupted the already tenuous fantasy that these worlds could stay apart.

In this way all art—from high to low, kitsch to "Painting"—is engaged

in the world of commodities. The dissolving of this boundary is most acutely argued by Jean Baudrillard in his work on consumption and culture. For Baudrillard consumers do not want commodities because they *need* them but because objects have themselves come to be symbols: "You never consume the object in itself (in its use-value); you are always manipulating objects (in the broadest sense) as signs which distinguish you either by affiliating you with your own group . . . or by marking you off from your own group by reference to a group of high status."[23] Baudrillard is still focused on the problem of production, like Marx and Greenberg, but for him the issue is not the quality or context of an object. The object is merely a referent by which the consumer establishes her or his own set of symbols for decoding. Thus art is no different from any other commodity; it does not exist in a rarified world separate or oppositional to the mainstream. There is no "difference between 'cultural creativity' and 'mass culture'; . . . both play primarily on a code, and on a calculation of market share and amortization."[24] The differences between art and kitsch thus become not inherent but rather symptomatic of notions attached to symbolic value. Class and class aspiration or anxieties create the values that are then placed on all commodities, and art is no different. Kitsch "reaffirms the value of the rare, precious, unique object," Baudrillard contends, but only to the end that both are involved in the logic and organization of consumption.[25]

Pierre Bourdieu's theories about taste have likewise worked to disengage the notion that the objects of consumption have fixed and transhistorical qualities (such as being "art" or "kitsch"). Instead, he argues that taste is a learned quality attached to objects as mechanisms of maintaining class order and identity: "The aesthetic disposition is one dimension of a distant, self-assured relation to the world and to others which presupposes objective assurance and distance. . . . Being the product of the conditionings associated with a particular class of conditions of existence, it unites all those who are product[s] of similar conditions while [it] distinguishes them from all others."[26] The very idea of taste, of one object retaining more or less value in an aesthetic sense than another, is a part of complex systems of codes that are maintained through the language of distinction. Or, as Bourdieu writes, people "distinguish themselves by the distinctions they make."[27] In regard to art, or what one learns and accepts as art, this theory holds. What one believes art to be depends entirely on what class

or group one belongs to, and investments adhere to understanding, within that identity, what is and is not art.

For Baudrillard and Bourdieu class is crucial to the appraisal and understanding of goods and their meanings. While they come at the question of consumer choice from different philosophical and disciplinary models, both illuminate Kinkade's popularity and cultural impact. In detaching, or at least distancing, Kinkade's paintings from notions of inherent artistic value that can be judged in some objective sense, we are able to consider more concretely the activities that surround the object, audiences' relationships to it, and what the object might signify beyond the imagery it represents. In short, what a focus on Kinkade's art as commodity provides is a mechanism to consider how these objects operate, not merely as the producer and distributors dictate but in conversation with audiences as symbols of the ways in which class and class desire are constructed.

This was evident at a Kinkade event in Birmingham, Alabama, hosted by local Kinkade gallery owners. The event was held at the convention center in a multipurpose room. Numerous Kinkade paintings were on display around the perimeter in a manner similar to an auction house's presentation of objects before the start of a sale. About a half-hour into the event, Kinkade himself came to the stage and spoke about his life, his art, the movie about his life, and, finally, his charity work with Points of Light, a group spearheaded by former president George H. W. Bush. Kinkade handed the microphone over to one of the event hosts, and the man announced that he was going to auction off a Kinkade painting that the artist had signed for a local charity. To begin the process, he asked how many in the crowd had been to an art auction before; only about five or six out of the seventy-plus in attendance raised their hands. He smiled at the crowd and said, "Well, now you can tell your friends and family that you have been to a *real* art auction." Then he made a joke about being careful not to itch or sneeze because that might be mistaken for a bid. There were lots of laughs.

To certain communities this entire scene might appear as a huge farce. "Real" art auctions take place in auction houses, and unique objects with some level of pedigree are sold. Typically, the objects are not the sort of thing one could buy anywhere in the country (as you can Kinkade's), on the Internet, or on television. To many at the Kinkade event, however, there was currency in being able to participate in a "real" auction and tell-

ing family and friends about it. Although a certain class of people might not recognize this as an art auction, the people in that room had perhaps found value in this new "real" experience. As Bourdieu might argue, the distinctions made here are class based, not aesthetic. Was this event any less "real" than buying a Jackson Pollock at Sotheby's? How "real" are any of these objects in defining an individual's purpose, meaning, and presence in our culture or even in individuals' own lives?

Kinkade himself often blurs the lines of what exactly his art represents and what it symbolizes. At this Birmingham event he referred to his paintings both as "investments" and as "heirlooms." No doubt Kinkade assumed that the people in that room would already be aesthetically drawn to his work, but he was unafraid to directly address things they might desire beyond the aesthetic experience. These terms, *investments* and *heirlooms*, both suggest some deferred gratification, some pleasure and benefit to be reaped at a later date (perhaps even after the grave). It is this willingness to speak to the various wants that surround his paintings—the joy of ownership, of pride in displaying art, the flourish of sophistication in using art as decoration, the satisfaction in imagining art as an investment, and the obsessive thrill of collecting—that perhaps makes Kinkade such a potent target for vilification as a pied piper of consumerism and product placement. It is also his willingness to sell his work in places previously deemed "off-limits" to serious art collectors, such as the mall, television, the Internet, and even a convention center, that adds to the unease of many with his marketing techniques.[28] I am not the only voice in this collection to suggest that much of the discomfort and animosity hurled at Kinkade results from his overt willingness to speak to art as a class-conscious commodity. Kinkade's products soothe the class anxieties of some and disrupt others, but the specter of class lurks nonetheless.

We are also left with the question of Kinkade's role in the art/class binary. Is he a figure of democratizing purpose? Does he bring art to the masses? Returning briefly to the discussion of pop art is instructive here. Warhol's work suggested the dismantling of hierarchies and an ironic-innocent stance that devalues, or at least reestablishes, the links between the artist, object, craft, authenticity, and value, yet his work also represents a new fissure between the "art world" and the public. Visual vocabularies that shift with context and intention are a bit like passwords, whispered among those in the know to get them into the club but designed to keep

others out. Not surprisingly, this artistic turn was viewed by many as the latest and most austere evidence of the disdain the art elite have for the masses. The joke, some will still contend, is one by the artist on the viewer, and many viewers do not find it funny. Kinkade would concur with that and positions himself as an antidote to that kind of art-world snobbery. Yet his version of art-as-populism is a tricky balancing act, particularly given that his works can sell for several hundred dollars and that his work has made him a very rich man. Who and what is liberated or denied here is foggy; as several authors will suggest, Kinkade profits from these class–art tensions and perhaps even reinvigorates the divide.

Kitsch is also a crucial paradigm for understanding Kinkade as a religious artist. He was raised a Christian but experienced a religious reinvigoration in the 1980s; Kinkade was born again. Although few of his paintings are explicitly religious in nature, he describes his images as "messengers of God's love."[29] In an interview for a Christian magazine in 2000 he says, "I want to use the paintings as tools to expand the kingdom of God."[30] Kinkade's Christian values not only motivate his own life and work but are coded into his artistic production. In this sense his art proselytizes the masses; he wants his images to spread the word of God.

Kinkade is part of a growing social and political movement in the United States among some evangelical Christians, active through groups such as the Moral Majority, Promise Keepers, Focus on the Family, and the Traditional Values Coalition, who advocate a "return" to traditional Christian-based ideas about societal structure and propriety.[31] This movement has also had a significant cultural impact. Films such as Mel Gibson's *The Passion of the Christ* (2004) and Andrew Adamson's *The Chronicles of Narnia: The Lion, the Witch, and the Wardrobe* (2005) were marketed specifically and successfully to Christian groups and organizations, as were books such as the Left Behind series, first published in 1995 by Tim LaHaye and Jerry B. Jenkins and that as of this writing have sold more than fifty million copies.[32] There is clearly money to be made in marketing to Christians, yet few of these projects have achieved critical success beyond the scope of Christian organizations. Kinkade, who has been associated with this growing phenomenon based on his marketing strategies (his company works with Christian bookstores, for example) and his own stated religious beliefs, has likewise suffered from accusations that his work panders to Christian audiences. He has often been collapsed into the larger category of religious art and collec-

tibles that has been popularly understood as kitsch because of its manufactured reproduction, sentimental imagery, didactic function, and ephemeral qualities.[33]

This collapsing of kitsch and religious imagery marked much of the conversation about art and religion in the twentieth century. As the historian Colleen McDannell neatly summarizes, "What in the nineteenth century was considered tasteful and pious, in the twentieth century came to be seen as tacky and religious."[34] Yet audiences have continued to crave religious imagery and objects regardless of the ways in which those images have been critically appraised. As a result, when evaluating religious art, scholars have separated notions of aesthetics and religious value; in other words, when critics consider a religious image, what the object looks like is typically not evaluated vis-à-vis what the image means to various consumers.[35] This critical divide has, not surprisingly, had an impact on the relationship that contemporary artists have to the subject of religion. James Elkins notes, "Contemporary art, I think, is as far from organized religion as Western art has ever been, and that may be its singular achievement—or its cardinal failure, depending on your point of view."[36] For those scholars who have sought some kind of language to bridge the "divide" between art and religion the problem revolves around sentimentality and didacticism. In assessing, for example, the Precious Moments Chapel in Carthage, Missouri, Frank Burch Brown argues, "The problem is not that the art is accessible. It is how it achieves that accessibility, and at what price. . . . These are formulas that trigger a predictably tearful or heartwarming response but that offer no new insight, and in fact tend to trivialize genuine religious feeling, and so to profane what is sacred."[37] For Brown it is important to take into account that people seek an emotional and spiritual experience from religious art and that when that art fails to give "a new insight," it fails *both* as art and religion and is remanded to the world of kitsch.

Kinkade's paintings offer little of the kind of "insight" that Brown speaks of. Kinkade does not produce any images that explicitly reproduce biblical stories. His religious imagery is mainly in the guise of bridges and church steeples, lighthouses, and suggestive beams of light. Jesus is represented in only a handful of images, and, again, Kinkade does not historicize or give them any specific biblical detail. Images such as *The Good Shepherd's Cottage* (2001; fig. 1) locate Jesus in Kinkade's world, herding sheep into a warmly lit home. Here Jesus conveys no biblical message, illustrates

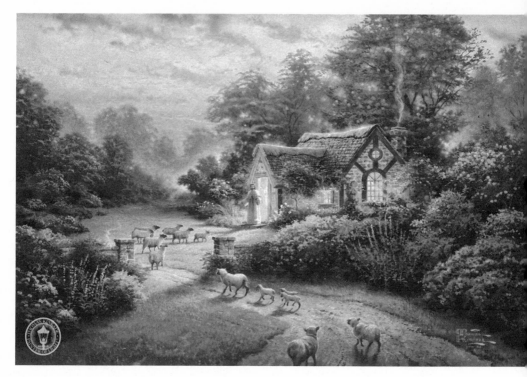

Figure 1. Thomas Kinkade, *The Good Shepherd's Cottage*. © 2001 THOMAS KINKADE.

no scene, provides no moral lesson. He is instead loosely depicted as a kind shepherd in a brightly lit landscape with acquiescent sheep. The religious message is tenuous beyond the notion that Jesus tends to his flock and that the flock gets to live in a comfortable home.

But audiences have clearly responded to Kinkade's brand of religious imagery. The quality of insight it provides is minimal; Kinkade breaks no new ground either in his depiction of Jesus or in his reading of Jesus as a shepherd. Instead, he works to distance the figure of Jesus from any narrow biblical reading and any specific landscape or time period. The cottage looks like a Cotswold-inspired home, but nothing about the landscape anchors it geographically or chronologically. Jesus's clothes and the building he stands near are not from the same period. Kinkade also overtly courts the sentimental, both in his use of soft coloring and fuzzy lighting and in the general message of the piece. Jesus here is not a judge but a kindly shepherd looking to care for his flock. All is warm, calm, and reassuring. Depending on what one wants from a painting, from art, and from spirituality, the image is either a wonderful success or the worst kind of kitsch.

This collection examines the works of Thomas Kinkade from multiple competing, complementary, and, at times, contradictory perspectives. To that end we begin with David Morgan's discussion of Kinkade in relation to previous producers of Protestant imagery. Morgan maps the ways Kinkade both borrows and deviates from religious iconography, which has itself moved historically between didactic and artistic aims. In tying Kinkade to artists as diverse as Currier and Ives and Warner Sallman, Morgan creates a historical framework by which we can see more clearly the various visual associations that Kinkade plays with in his work.

The next two essays confront the contemporary religious conversations and communities that Kinkade engages. Micki McElya begins by arguing that although Kinkade is popularly known as the "Painter of Light™," a more fitting title would be "Painter of the Right." She situates Kinkade's personal history, work, and wide popularity within the history of the rise of the Religious Right in the 1970s and the "culture wars" of the 1980s and 1990s. Using a clever comparison of Andres Serrano's *Immersions (Piss Christ)* (1987) and several of Kinkade's works, McElya interprets Kinkade as an overtly political artist who is engaged deeply with the rhetorics of Republican conservatism. Seth Feman's "God in the Retails: Thomas Kinkade and

Market Piety" approaches the issue of contemporary religious communities through the lens of Kinkade and capitalism. Feman contends that Kinkade's true contribution to art, and indeed theology, is the artist's advocacy of a spirituality that is tied to the activity of consumerism. This "market piety," as Feman terms it, binds Kinkade's artistic persona, his art, and his Christian values to the desires of his audience for a purchasable vision of spirituality. Feman complements his astute arguments concerning contemporary religious culture and capitalism with some fascinating interviews with Kinkade's fans, who reveal complex and surprising relationships to the art they collect.

Karal Ann Marling has built her formidable scholarly reputation by advocating artists and work that others dismiss or disregard. Her contribution here is no exception as she considers Kinkade's collectibles. Using a methodological mélange of art history, visual culture studies, and affection for popular culture, Marling provides an overview of the recent history of the collectibles market and the ways in which Kinkade has successfully blanketed our malls, drugstores, and televisions with a myriad of merchandise. While her tone is often lighthearted, Marling demands that readers consider how they judge the objects in other peoples' homes and the spiritual value of the objects we claim as our own.

If Marling's tone is slightly irreverent, the next essay reasserts the very serious side of considering Kinkade's work. Andrea Wolk Rager explores how Kinkade creates a powerful and persuasive aesthetics of nostalgia within his imagery. Using postmodern and psychoanalytic theory, Wolk Rager contends that through repeated images of nostalgic fantasies, Kinkade's art enacts a landscape of repression that denies consumers the true healing they seek. Numerous critics associate Kinkade with nostalgic impulses, but Wolk Rager pushes past easy or trite assumptions on this subject. Her readings of Kinkade's works assert the value in traditional art historical techniques of close looking while forcing the reader to confront the very definition of nostalgia historically and in this contemporary moment.

The focus of the volume then turns to topics more material—concrete and asphalt to be specific. Christopher E. M. Pearson relates Kinkade's "virtual real estate" to his gated housing complex, The Village at Hiddenbrooke, built near Vallejo, California, in 2002. Referencing the neoconservative New Urbanism movement and contemporary real estate practices,

Pearson argues that Kinkade's painted cottages stand as hyperbolic manifestations of the suburban ideal. By speaking to desires to buy into a controlled social environment based on safety and exclusion, Kinkade's audiences perform their own class anxiety and aspirations. Yet while Kinkade's visual images are manifested physically in the form of houses, the artist also seeks a far more conventional form of institutionalization: a place in a museum. Julia Alderson focuses on Kinkade's opened—and then closed—museum that featured his original paintings. Alderson documents the history of Kinkade's museum and cultural center in its various iterations and considers this endeavor within the context of the changing role of museums in American culture. She argues that there is increasingly little space between the goals of public institutions such as museums and a private corporate entity like Kinkade; both seek a paying audience.

The collection then breaks from traditional scholarly writing and voice with the inclusion of an essay by Jeffrey Vallance. Vallance is most famously known as a conceptual artist who blends elements of performance and installation to explore concepts of spirituality, mortality, and the legitimacy and hypocrisy of the art world. The first work to garner him notoriety was his piece *Blinky the Friendly Hen* (1978), in which Vallance purchased a whole chicken from a supermarket and then buried it in high fashion at the Los Angeles Pet Cemetery. His more recent work has focused on the power and history of reliquaries; Vallance assembles shrines that combine objects of autobiographical value, from an Orange Crush bottle cap to boxer shorts, to speak to both the preciousness of religion and memory and the humor of the egoistic artist. Vallance curated the first major museum exhibition of Kinkade's art and collectibles. This show, Thomas Kinkade: Heaven on Earth, made headlines in 2004, and Vallance recounts here his experiences organizing the show, speaks of his personal friendship with Kinkade, and considers the future of Kinkade as an artist. Vallance professes utter and complete sincerity and asks the reader to trust him and that he writes with no irony and only a little gentle-spirited mischief. Yet, as with his curatorial turn with the Kinkade exhibition, many will read this essay as another of Vallance's performance pieces, where the artist plays the role of the art-world jester, with Kinkade as the spectacle he directs us to laugh at. Readers will have to judge Vallance's tone and intention for themselves, but of interest here, too, is the nature of collaboration between two

contemporary artists. Competition, respect, repulsion, and attraction have long been the energy promised when artists choose to work together, and all of this is in evidence in Vallance's telling of his half of this collaborative experience.

The last two essays deal directly with Kinkade and the language of contemporary artistic production. Monica Kjellman-Chapin argues that Kinkade relies on a calcified and formulaic division between "high art" and low forms of culture, usually tagged with the dismissive and derogatory label "kitsch," in order to imbue his own productions with value, prestige, authenticity, and singularity. The rhetoric he deploys and the associations he mobilizes in his work, exhibition venues, and publications, which Kjellman-Chapin investigates in some detail, function to convince the buying public that his work, despite mass reproduction, is in fact unique. In this way Kinkade maintains his identity as a creative artist and elevates his status to that of a great master painter. Finally, Anna Brzyski takes up Kjellman-Chapin's specific claims about Kinkade's strategies and reads them against the broader project of defining art in the postmodern age. Brzyski argues that the segment of the art market that includes Kinkade will always stand outside the boundaries of "fine art" because of the investments that art professionals—critics, artists, museum and gallery professionals, and academics included—have in defining art narrowly. For Kinkade to be considered outside of the limited scope of the marketplace is, according to Brzyski, impossible without a monumental paradigm shift in concepts about art and art production.

As I stated at the beginning of this introduction, Thomas Kinkade elicits widely varying responses that point to the ways in which we, as a culture and, indeed, as individuals, value or distinguish between the real and the fictive. Kinkade reveals the stakes in considering concepts such as art and kitsch, beauty and surface, style and insight. His work also demands that we consider the degree to which we want those terms and the outcome of this discussion to be dictated by the marketplace. Kinkade's images have permeated American visual culture, and this feat is all the more amazing when we consider that it has happened within the space of two decades. While it is possible to argue, as many have, that this is merely a marketing anomaly and a passing fad, this answer does not truly satisfy the distinct sense that several of the authors discuss in this collection that there is a tan-

gible *desire* for the objects and art that Kinkade creates. Audiences *need* his works, and this need should also be measured against the wave of available visual imagery from which to choose. People seek out his art and bring it into their homes, an intimate act even in a cynical world of crass consumption. What drives this collection is the quest to understand what that desire for Kinkade means about art and what it means about his audiences. This collection also exposes in productive ways the tensions that exist in terms of the methodological approaches in art history, visual culture studies, and cultural studies.

By way of some last words concerning the purpose and goals of this volume, I want to recount a discussion I participated in a few years ago. I had been asked to speak to a class of MFA students about Kinkade; the discussion was lively. Not surprisingly, most of the students damned the artist, calling him a fraud and making derisive comments about his work. But then one student quietly and tentatively spoke up. She said that she grew up in a home full of Kinkade images and that her parents are great fans of his work. Her own art has little in common with his aesthetic, and she said that while her parents have been supportive of her career, after several of her shows they have opined, "Your work is so interesting. Very different. But have you ever thought of painting like Kinkade? His work is so good and you have so much talent. You could try to paint like him." The class laughed, but there was nothing but pain on the face of the student.

This poignant moment reminded me that beyond all of the rhetoric and furor that surround Kinkade, there are people whose lives, relations, and perceptions are shaped profoundly by his art. This student was raised in a home with art and with parents who clearly valued that art. In many ways this is the kind of a household that all art professionals and those dedicated to art education hope for. And the art had, in one sense, served its function as a gateway into creativity for the child that grew up in that house. Yet a disconnect had occurred in this creative interchange. Instead of art being a conduit for connection, it had become a source of isolation and distance. The story is evidence that Kinkade is, in fact, contributing to the shaping of a new generation of artists in ways that are complex and worth considering with seriousness and focus. His words and images, like all important art, leave traces and mark us in deeply personal ways.

Notes

1. This is a frequently quoted figure, although there is no way to definitively verify it. Based on Media Arts Company sales figures and the shear number of licensed Kinkade products, it is a reasonable statistic. Kinkade himself more regularly boasts that his images are in "ten million homes." Interestingly, that is a number he started repeating in 2001, but the figure has not increased in more recent years. For the one-out-of-twenty statistic, see John Leland, "Subdivided and Licensed, There's No Place like Art," *New York Times*, Oct. 4, 2001. In regard to the figure of ten million, see Orlean, "Art for Everybody," 125; and Associated Press, "Often-Scorned but Popular Artist Thomas Kinkade Gets First Museum Exhibit," April 3, 2004, www.grandcentralartcenter.com/press_2004_4_3.php (accessed May 10, 2010).

2. I will be referring to Kinkade's works as paintings since that is the way he refers to them, and that is the way his audience refers to them—it is typical that contemporary artists define the nature of their work, and critics and scholars follow suit.

3. In regard to issues of bankruptcy, see Kim Christensen, "Thomas Kinkade Firm Seeks Bankruptcy Protection," *Los Angeles Times*, June 3, 2010, http:// articles.latimes.com/2010/jun/03/business/la-fi-kinkade-20100603.

4. Press release, The Thomas Kinkade Company, Oct. 11, 2004, www.mediaarts .com/press/index.shtml (accessed Nov. 20, 2004).

5. Immanuel Kant's paradigm about the power and essential qualities of the sublime and the beautiful root much of art historical conversations about taste. He writes, "The sublime moves, the beautiful charms" (Kant, *Observations on the Feeling of the Beautiful and the Sublime*, 47).

6. Bal, "Visual Essentialism and the Object of Visual Culture," 5. Discussions about the divide between art history and visual culture are ongoing, but for a good summary see "Responses to Mieke Bal's 'Visual Essentialism and the Object of Visual Culture.'" See also "Visual Culture Questionnaire"; Rogoff, "Studying Visual Culture"; Mitchell, "Showing Seeing"; Alphen, "'What History, Whose History, History to What Purpose?'"; and Corbet, "Visual Culture and the History of Art."

7. See Mitchell, *What Do Pictures Want?*, esp. 28–36.

8. See Baudrillard, *Simulations*.

9. For more on this issue, with particular emphasis on beauty and cultural studies, see Shumway, "Cultural Studies and Questions of Pleasure and Value."

10. There are numerous examples of this argument, particularly in art criticism that deals with feminism and postcolonial theory. One of the most accessible and illuminating remains Berger, *Ways of Seeing*.

11. Bourriaud, *Relational Aesthetics*, 58.

12. For more on this piece and Gonzalez-Torres's works, see Dietmar Elger's two-volume catalogue raisonné *Felix Gonzalez-Torres*.

13. Bourriaud, *Relational Aesthetics*, 58.

14. This and the following paragraph derive from Boylan, "Stop Using Kitsch as a Weapon," 44–45.

15. Hebdige, "In Poor Taste," 78.

16. There has been much written about the radicalism of pop art and its place as a marker of the divide between modernism and postmodernism. For a good summary of this debate and issues of the radicalizing and racial possibilities of pop art, see Kobena Mercer's introduction to *Pop Art and Vernacular Culture*; see also Kulka, *Kitsch and Art*.

17. Maharaj, "Pop Art's Pharmacies," 337.

18. Kundera, *The Unbearable Lightness of Being*, 252.

19. It is worth noting, however, that Kundera acknowledges that everyone falls for kitsch in certain moments and that what saves one is the knowing of kitsch and its power. Then it is, as he writes, that kitsch is reduced to yet another "human weakness" (Kundera, *The Unbearable Lightness of Being*, 256).

20. Olalquiaga, *The Artificial Kingdom*, 28.

21. Quoted in Olalquiaga, *The Artificial Kingdom*, 97.

22. Bonami, "Paintings of Painting for Paintings," 14, 15, 19.

23. Baudrillard, *The Consumer Society*, 61.

24. Ibid., 102. Baudrillard goes on to argue that art "no longer stands opposed, as *works* and as semantic substance—as *open* significations—to other *finite* objects. They have become finite objects themselves and are part of the package, the constellation of accessories by which the 'socio-cultural' standing of the average citizen is determined" (107).

25. Ibid., 111.

26. Bourdieu, "The Aesthetic Sense as the Sense of Distinction," 205.

27. Bourdieu, *Distinction*, 6. For more on Bourdieu, art, and taste, see Greenfell and Hardy, *Art Rules*.

28. It is worth noting that museums, those rarified temples of culture, have also begun to aggressively court consumers in malls and on the Internet. See Ritzer, *Enchanting a Disenchanted World*, 25.

29. Ibid. In terms of religious imagery in Kinkade's work, he has published one image of Jesus Christ, *The Prince of Peace* (1999) (see p. 44), and one image that features a Christlike figure emerging from a Cotswold-style cottage beckoning sheep to him, *The Good Shepherd's Cottage* (2001) (see p. 20). More typical are his images of churches nestled in scenic woods by a brook. See, e.g., *The Aspen Chapel* (2001), *Streams of Living Water* (2000), and *Mountain Chapel* (1998).

30. Balmer, "The Kinkade Crusade," 50.

31. Numerous books track the changing landscape of religion and politics in

the past decades. See, e.g., Watson, *The Christian Coalition*; and Gutterman, *Prophetic Politics*.

32. For more on Christian culture, see Balmer, *Mine Eyes Have Seen the Glory*; and Kintz, *Between Jesus and the Market*.

33. The artist Betty Spackman explores this genre of art in her book *A Profound Weakness*.

34. McDannell, *Material Christianity*, 164.

35. For a good analysis of these strategies, see Brown, *Good Taste, Bad Taste, and Christian Taste*, 128–37.

36. Elkins, *On the Strange Place of Religion in Contemporary Art*, 15.

37. Brown, *Good Taste, Bad Taste, and Christian Taste*, 144.

Thomas Kinkade and the History
of Protestant Visual Culture in America

DAVID MORGAN

Geography is an unavoidable element in any definition of nationhood. While the actual borders of a nation may be unstable, offering occasions for cultural and even military conflict, citizens commonly imagine their collective identity by seeing its material expression in the features of a terrain. Landscape is more than physical dimensions—it is the boundary of a larger self. If king, language, or a religious polity such as "Christendom" served as the pivot around which peoples orbited in eras before modernity, the modern nation-state relies on forms of collective imagination, among which landscape—in painting, song, and story, as well as national parks and roadside scenery—serves as the enduring deposit of national destiny.[1] Landscape roots imagination in time and place and provides the meeting point of past and present, divine and mortal. It is among the most pervasive and most powerful forms of national mythology and imagined community, since landscape combines the mundane and the dramatic in a single range of common experience. For many Americans mountains, oceans, and forests bear the imprint and intent of divinity, while farms and landownership secure the material base for individuality, citizenship, and liberty. To be sure, the same may be said of other peoples for whom land and geography define national, ethnic, or religious identity. Americans exercise no monopoly on the cultural magic of a naturalized ethos. It is a common human myth, all the more so when its enchantment tailors a landscape to the peculiar lineaments of a people. This is the power of a national imaginary.

The popular regard for the art of Thomas Kinkade is not difficult to understand when considered in the context of the devotion of Americans to their national landscape. Kinkade offers American consumers pic-

tures that intermingle piety with national pride by envisioning landscapes that are both glorious and inviting, magnificent and intimate, evidence of blessing from above and a history of goodness here below that vouch for the possibility of reclaiming what remains a divinely insured national trust. Although the appeal of Kinkade's work among his admirers depends on his keen insight into popular taste and his ambitious marketing, there is a long history of mass-produced and mass-marketed lithography in the United States that constitutes a historical framework for understanding the production, distribution, and reception of his work. Here I will survey that history by examining the religious subjects of lithography from Currier and Ives to Warner Sallman, including the marketing and reception of their images and focusing on the enduring importance of landscape as a subject matter that continues to inspire a special fondness in Americans generally and devout Americans in particular.

Nineteenth-Century Lithography: Piety and the American Home

Other than photography, the visual industry in the nineteenth century most closely associated with the home was the print trade—engravings and lithographs. These inexpensive forms of image making were available to almost all Americans, across racial, economic, and regional lines. Certainly the most well known, but by no means the only, firm responsible for providing affordable prints for parlor and workplace was Currier and Ives. Nathaniel Currier set up shop in New York in 1834. Around 1840 he began including religious imagery in his stock, especially geared to Catholic immigrants, whose use for devotional imagery of saints was answered by hundreds of editions of lithographs with captions in French, Spanish, German, and Italian.[2] Currier issued many versions of the stations of the cross, as well as other biblical subjects.

In the mid-1840s Currier began to offer images aimed at Protestant consumers, including many different scenes of families reading the scriptures in the parlor and memorial imagery set at graveside in country cemeteries, with looming neo-Gothic churches in the background. It is a common misconception that Protestants historically have been averse to imagery. Although Protestants have often avoided placing images in church sanctuaries, they have, in fact, long made avid use of illustrations in instructional manuals and illustrated tracts and Bibles, as well as in print imagery de-

signed for display in the home. Decorative imagery imbued with religious or moralizing features, including landscape, was displayed in the parlor, which was the most formal space within the American home. Both subjects of reading the scriptures and mourning at graveside offered Protestants pious imagery suitable for domestic display. Scripture reading was a common practice in the parlor, and the funerary imagery answered to the national movement to replace city graveyards with pastoral cemeteries conceived as idyllic rural gardens. Currier left blank spaces on the urns or gravestones in the prints in which customers wrote the personal details of their deceased loved ones. This personalization of the mass-produced artifact was enhanced by the hand-tinting of prints that Currier and Ives used. Even when the mechanical process of chromolithography allowed prints to be uniformly tinted, Currier and Ives continued to prefer coloration by hand. One reason may be that no two prints were ever exactly alike, giving customers the sense of a unique work to frame and display.

These mass-produced but personalized prints were placed on mantels, pianos, organs, bookshelves, and parlor walls. A print like *Home to Thanksgiving* (1867) celebrated the rural homestead, in particular, as the cherished location of domestic values, the origin of American identity, and the womb of family tradition (see fig. 1). Such imagery was designed by Currier and Ives for display in the home, especially the parlor. Parlors were the middle- and working-class home's single public space, the site for presenting the family to visitors, and therefore the home's most suitable location for the display of images. Parlors commonly included bureaus, bookshelves, and organs that served for the presentation of photographs, prints, and mementos for the delectation of visitors and family members. (It is a practice that persists to the present day. Living rooms, the latter-day parlor, are a favorite destination for Kinkade's prints.) Moreover, the home was the place for the spiritual formation of children. Displaying religious imagery on the walls of the home not only engaged in moral instruction but more subtly influenced thought, feeling, and behavior. According to Catherine Beecher and her sister, Harriet Beecher Stowe, who authored *The American Woman's Home*, a popular guide to homemaking, tasteful chromolithographs and engravings that hung in the home exerted salutary effects on children.[3]

Religious prints issued by Currier and Ives (James M. Ives joined the firm in 1852 and became a full partner in 1856) and their competitors ex-

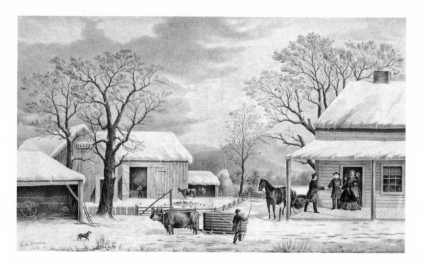

Figure 1. George H. Durrie, *Home to Thanksgiving* (1867), lithograph published by Currier and Ives. COURTESY OF THE LIBRARY OF CONGRESS.

panded the visual expression of religious belief within and outside of the home. Evangelical Protestantism had always been committed to proselytism, so images that served this end posed little problem for most Protestants. In fact, on many occasions lithography firms produced religious prints to be used by organizations such as the American Tract Society, Sabbath schools, and the American Sunday School Union (ASSU) as premiums for subscribers or as rewards for Sunday school attendance. An example is *The Happy Family* (ca. 1850; fig. 2), issued at midcentury by Augustus Kollner Lithography, for circulation by the ASSU, which was founded in 1826 in Philadelphia. The image is designed as if to announce in direct visual terms what constitutes a happy family. Emerging from a rustic and sturdy country home, the well-dressed family assembles itself to walk the short distance to worship at the rural church, whose plain steeple rises in a clearing of picturesque foliage. The family evinces a decidedly gendered structure: the women in the center are flanked by males, who mirror one another in gesture, headgear, and the signature Protestant accoutrement—a thick volume of scripture tucked underneath the arm. The female interior of the family, tellingly enclosed by the masculine walls of father and son, consists of mother and daughters, typically cloaked and bonneted and occupied with the tender duty of the elder looking after the younger. The happy

family is thus the family piously engaged in replicating moral values in the pastoral setting of American country life. The population shift from rural to urban began during the antebellum period. In 1790, when the first U.S. census was taken, only 3 percent of the nation's inhabitants lived in cities with a population of more than eight thousand people. By 1860, 36 percent of Americans living in the Northeast resided in urban centers, as did 30 percent of those living in the West.[4] The percentages increased dramatically after the Civil War, but the psychological impact of urbanization was already well under way during the first half of the century.[5]

Protestant clergy and moralists never tired of pitting the purity of rural life against the immoral distractions and enervating assault on vitality posed by living in the nation's cities. The appeal of nostalgic imagery like *Home to Thanksgiving* may have been the desire to secure the roots of family in the countryside — even if only in the imagination — in a time when offspring were leaving the family farm in increasing numbers. Attractive as town and city were to aspiring young Americans — offering employment in industry, finance, and commerce, and various forms of entertainment

Figure 2. Augustus Kollner, *The Happy Family* (ca. 1850), hand-tinted lithograph, for the American Sunday School Union. COURTESY OF THE LIBRARY COMPANY OF PHILADELPHIA.

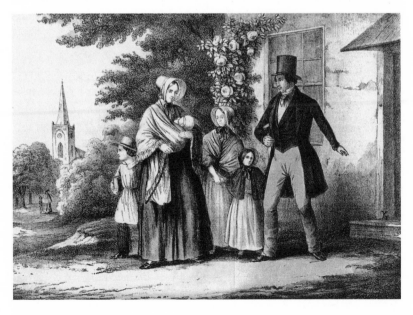

that were not available in rural life—many urban Americans with rural backgrounds were unwilling to sever ties to the countryside. Currier and Ives provided images for use in the home that were hugely popular in part because they mitigated the break with the farm, nurtured family ties, and helped Americans imagine their national unity as grounded in the rural ethos that they ritually remembered on holidays such as Thanksgiving and Christmas.

The cultural work of these images was not anti-urban escapism; rather, they provided a way of having both worlds—city life in fact and rural values in imagination and child rearing. If such imagery hailed the good life of the country, it was in large part because most Americans still lived in villages and on farms in 1860.[6] But the pattern of migration to cities was already firmly established. Although some Protestant moralists denounced city life outright, most believed the better strategy was to reform inhabitants of the large cities. This was the agenda of countless temperance, antiprostitution, and orphan societies founded by Protestant associations during the antebellum era. Protestant activists wanted rural values to dominate big-town life in a rapidly industrializing nation whose labor force was being expanded each year by hundreds of thousands of immigrants. A substantial number of immigrants arriving in the United States between 1840 and 1920 were non-Protestant—Catholic, Greek Orthodox, Jewish, and a number of Asian religions—and most settled in cities.[7] Tract, mission, temperance, and Sunday school societies seized on mass-produced images in their urban campaigns of moral reform, assimilation, and evangelization, disseminating images like *The Happy Family* to promote Protestantism among non-Protestants and renewal among those raised in or converted to the faith. Modeling piety on the ideal arrangements of country life sought to reinforce the moral authority of the home, which was considered a microcosm of society. Moreover, by focusing on scenes from modern everyday life rather than using biblical subjects, organizations like the American Sunday School Union sought to situate piety squarely in the daily and domestic lives of Americans. This is a lesson that Protestant imagemakers in the twentieth century and the twenty-first would not forget.

One of the most ambitious programs for national conversion that was deeply invested in mass-produced imagery in the nineteenth century was the Sunday school movement. Although it first attained regional stature in 1824, when the American Sunday School Union was established in Phila-

Figure 3. *The Great Commission*, May 12, 1901, lithograph on card stock, Providence Lithograph Company. COURTESY OF SANDY BREWER.

delphia, the Sunday school movement organized itself into a national and international association in the 1870s. Leaders of the International Sunday School Association worked with a number of printing firms to provide weekly illustrated lessons for Sunday schools. Among these firms was the Providence Lithography Company. By 1880 Providence Litho was producing large lithographic posters for use in the Sabbath classroom.[8] Beginning in 1889, the images were also issued as Bible lesson cards (fig. 3) the size of baseball cards, which students received in class and took home with them. Printed in several colors, the cards were issued on heavy stock and included on one side the lesson and on the other an image that illustrated the biblical text for that Sunday. The cards were each dated for use in a curriculum called the Uniform Lesson System, which organized a systematic reading of the Bible for all age groups and was used around the world

by a large variety of Protestants. Providence Litho shipped its illustrated lesson posters and cards to Australia, New Zealand, British South Africa, Canada, Britain, and Germany. Business was successful. In 1911 Providence Litho sold 6,512,000 lesson cards.[9] As can be seen in this example, issued in 1901, the subject is Jesus's Great Commission, when he sent his followers out to evangelize the nations (Matthew 28:19–20). But once again, rather than merely illustrating a Bible verse, the card encouraged American Sunday school children to imagine the scene in their own day, unfolding on the plains among Native Americans. The flat landscape appears as impassive and pliable as the calmly seated Indians, who listen to the homily of a preacher standing before the scene as if it were a panoramic screen rolled by him as he gestures mechanically.

The legibility of the imagery was key for the task of teaching children. "As has been repeatedly pointed out to us by the editors," the art director at Providence Litho told the artist Arthur Becher in 1932, who was at work on a lesson illustration, "we must be very careful to have the story so completely and clearly told that for small children the picture can stand without explanatory text."[10] In addition to the editorial board, children knew what they wanted. The artists they most frequently relied on were Heinrich Hofmann (1824–1902), Bernhard Plockhorst (1825–1907), and Harold Copping (1863–1932). Hofmann and Plockhorst were nineteenth-century German artists trained in the academic tradition of narrative historical tableaux and shaped by the solemn piety of the Nazarene school.[11] Copping was a British artist whose imagery was used by the Religious Tract Society and the London Missionary Society. His most beloved images were moments from the life of Jesus and images that corresponded to devotional hymns. Hofmann is perhaps most remembered for his paintings of Christ at prayer in Gethsemane, Christ as a boy teaching in the temple, and Christ and the rich young man. Plockhorst's most widely reproduced pictures were Christ blessing the children, the Good Shepherd, Guardian Angel, and Christ's entry into Jerusalem. Plockhorst's imagery circulated so widely among Sunday school materials and devotional posters that his painting of Christ as the Good Shepherd could still be used as the basis for a tile mural on a Lutheran church exterior in Virginia as late as 1970 (fig. 4). Providence Litho negotiated repeatedly over the course of decades to secure copyright permission to reproduce drawings and paintings by these artists. By using the images, the firm contributed to shaping

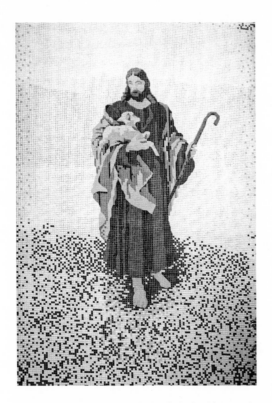

Figure 4. Baird Terrazzo, *The Good Shepherd* (ca. 1970), terrazzo
tile mural, Good Shepherd Lutheran Church, Roanoke, Virginia,
based on Bernhard Plockhorst, *The Good Shepherd* (ca. 1889), oil
on canvas, location unknown. PHOTO BY DAVID MORGAN.

the iconographical core of Protestant visual piety. Artists who were sub-
sequently employed by the company were not sought out to innovate but
to recycle this cherished set of subjects and imagery set forth by Hofmann,
Plockhorst, and Copping. Artists were encouraged to emulate the expres-
sion, conception, and even particular aspects of the images sent to them as
models. They were also directed to use particular colors and tonalities be-
cause of their appeal to children and their mechanical reproducibility. In
1934 an artist was coached "to keep in mind that for successful reproduc-
tion and appeal to children the following points are virtues: bright, cheery
color, keyed fairly high; lively contrast of hue and value; full value scale
to offset halftone shrinkage; simple mass pattern to allow extreme reduc-
tion."[12] The combination of these elements—clarity of theme and rela-

tion to biblical text, preferred subject matter, color and tonal appeal, and the exigencies of reproduction—yielded a popular aesthetic that stressed legibility, visual cogency, and upbeat emotional appeal. As the art director counseled an artist: "We must keep it in mind to lean over backwards in not offending any 'church-goers' and also avoid causing nightmares among 6 to 8 year old children."[13]

The images that dominated the American Protestant imagination from the antebellum period to the early twentieth century are striking for the ways in which they focused attention on the present. Far more often than illustrating the biblical past, religious-image-makers produced an iconography that aimed at situating believers in the present world, where they were tasked with evangelism, moral purity, and encouraging moral reform among fellow citizens. Most important as the locale for imagining national purpose and the practice of daily piety was the landscape. If Americans increasingly lived in or near large cities as the nineteenth century came to a close, they still sought to envision their nation as a rural dominion whose center of gravity was the small world of country church, Sunday school, and pious home.

Mass-Produced Visual Piety:
Devotional Iconography in the Twentieth Century

Providence Lithography Company's commercial packaging of the popular iconography of Hofmann and Plockhorst and the land of the Bible as it appeared in Copping's work exerted an enormous influence in shaping the Protestant imagination in the twentieth century. Images of biblical figures, places, and events were imbued with sacred text, which ensured their legibility and their appeal to children. The imagery allowed children to envision a fond place where Jesus performed every act recorded in the New Testament. The pageantry of dress, speech, miracle, and dramatic action that became familiar in film epics such as Cecil B. DeMille's *The Ten Commandments* (1923, 1956) or in the countless versions of the life of Jesus were first worked out in the visual vocabulary of Providence Litho's images and paradigmatic use of Hofmann, Plockhorst, and Copping. The lesson was not lost on commercial competitors. One of the firm's customers during the 1930s and 1940s was the Gospel Trumpet Company, headquartered in Anderson, Indiana. As late at 1949, Gospel Trumpet was still trying to

Figure 5. Warner Sallman, *The Head of Christ* (1940), oil on canvas. © 1941 WARNER PRESS, INC., ANDERSON, INDIANA. USED WITH PERMISSION.

secure copyright on Hofmann's imagery for use in its church publications (Church of God).[14] In part as a way of filling the Hofmann gap, in 1941 two employees at the firm, Anthony Kriebel and Fred Bates, began marketing lithographic prints of paintings by a freelance religious artist and commercial illustrator named Warner Sallman. At the end of the previous year Sallman had painted what would become the most widely recognized image of Jesus in midcentury and since, simply known as *The Head of Christ* (fig. 5). Kriebel and Bates worked out an agreement with Gospel Trumpet (also known as Warner Press) to market the imagery that Sallman began steadily producing under arrangement with the two men. Like the relation of artists with Providence Litho, Sallman operated as an illustrator of the ideas

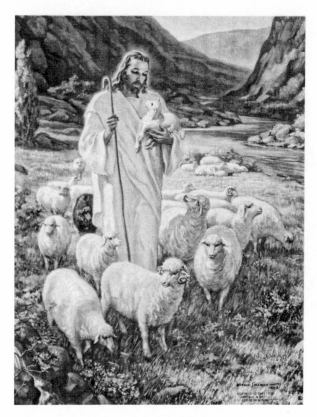

Figure 6. Warner Sallman, *The Lord Is My Shepherd* (1943),
oil on canvas. © WARNER PRESS, INC., ANDERSON, INDIANA.
ALL RIGHTS RESERVED. USED WITH PERMISSION.

and orders placed with him by Kriebel and Bates, and eventually Warner
Press. A committee was formed at the company to articulate directions to
the artist and to review his work as he sent it to the company. Kriebel and
Bates proceeded to diversify the product line under the clear identity of
Sallman's imagery. As one of his biographical essays indicates, "Due to the
enthusiastic acceptance of the facial features of Sallman's 'Head of Christ' a
demand grew for more pictures by Sallman showing Christ in various set-
tings."[15] His publishers instructed him to maintain the recognizability of
The Head of Christ in more pictures such as *Christ in Gethsemane* (1941), *Christ
at Heart's Door* (1942), and *The Lord Is My Shepherd* (1943) (fig. 6). Kriebel and
Bates also steadily expanded the line of Sallman products to include illus-

trated Bibles and instruction books, lamps, clocks, plaques, mottoes, stationery, pins, buttons, pencils, and calendars.

As commercial products, Sallman's mass-produced lithographic images literally bear the imprint of the marketplace. This is evident in the artist's painting the mark of copyright on the very surface of the finished works: "Copyright [date of image] Kriebel & Bates." But almost from the beginning of his work for Kriebel and Bates, Sallman was presented as something more than the commercial artist he had been up to the 1940s. As his religious imagery settled into a secure niche in the market of Sunday school and illustrated devotional books, the publishers found that they could also sell the images as stand-alone portraits; that is, as devotional works of *art*. Providence Litho expressly refused to do this, claiming the trade in single images was prohibitive. Their market was limited to printed goods such as religious curricula, illustrated books, magazines, and calendars. Kriebel and Bates learned rather quickly, however, that Sallman's pictures appealed as individual prints and could be marketed to rival the much more familiar work of Hofmann so widely distributed by Providence Litho and other publishers in the first half of the century. In 1943 a Chicago journalist visiting the Cathedral of St. John the Divine in New York City noted that images of Christ on sale there included Sallman's *The Head of Christ*. Although "the famous work by Hofmann is the most popular . . . the one by far most sought after is that by a Chicago commercial artist and religious lay reader, Warner Sallman." Seeing reproductions of *The Head of Christ* at the cathedral and "that it was accepted by cathedral visitors from the world over—most of them religious-minded and of discriminating taste," the journalist wrote, "I realized that it must have merit of unusually high order."[16]

The comment marks a point of transition—from commercial illustration to sacred art. In dozens of publications that followed during the next two decades, until the artist's death in 1968, his images were portrayed as "religious masterpieces" and "devotional art." Sallman appears to have participated in developing this packaging of himself in numerous articles based on interviews with him. He himself developed a narrative about his career, which he rehearsed at hundreds of "chalk talks" in churches and YMCAs, where he recreated in chalk or pastel one of his four or five best-known paintings. In his autobiographical comments he characterized his work as part of a "ministry of Christian art." In 1947 Kriebel and Bates

issued a pamphlet by this title, written by a friend of Sallman's, who lauded the artist as "known and loved the world over for his outstanding contribution to the field of religious art," claiming that his artistic achievements had placed him "among the eminent painters of religious art."[17] A 1950 trade catalogue of the Gospel Trumpet Company presented Sallman's "masterpieces" in "walnut-veneer picture panels" and promoted them as "gifts of elegance, richness, and good taste."[18]

In fact, Sallman never exhibited his work in competitive art exhibitions or worked with an art dealer or fine art gallery, and he certainly does not appear to have understood himself as a fine artist dedicated to building a body of work to be regarded primarily for its aesthetic value and artistic originality. Although his publishers and sympathetic writers in the religious press depicted him as an "artist," it was not as a fine art producer whose livelihood depended on juried exhibitions, museum shows, or gallery sales. It was instead his personal piety that was always stressed in the press and promotional literature. He was "a consecrated artist" whose imagery could not be distinguished from his faith since that was its real source.[19] Sallman traveled to churches, YMCAs, and Christian youth camps to recreate his major images in chalk as he provided a personal religious testimony. His art was part of a Christian ministry, and he never sought to detach it from that purpose. Accordingly, even though he later conceded that he had been influenced by another work of art, Leon Lhermitte's 1892 oil painting *The Friend of the Humble* (Museum of Fine Arts, Boston), when he made his well-known portrait of Jesus, that detail was not included in his chalk talks, where he reinvented the picture's origin. At the chalk talks he told the story that the charcoal drawing prototype came to him in a vision late one night as a revelation from God. Sallman related that he quickly sketched the mental image and worked it up into a finished drawing, which was published and became the basis for his oil painting in 1940 (see fig. 5, p. 39). In other words, the image originated not as an artistic conception or derivation but as a sacred epiphany.

This origin certainly fit the category of religious or sacred art most plausibly, and it proved to be an effective marketing strategy for Sallman. He and his publishers were able to present framed reproductions of his paintings as suitable for display in the home, and therefore as devotional art, precisely because they reflected Sallman's Christian commitment and experience. He served as a conduit for the image more than as its artistic

originator. The testimony of the picture's origin helped authenticate the imagery as "Christian art." The framed tableaux were promoted as suitable for the Christian parlor, bedroom, or living room because of their pious maker's interpretation of biblical subjects, which was conducive to promoting Christianity in the home and workplace, imparting devout sentiments, and even shaping behavior. If some Protestants had misgivings about "art" in the Christian worship space, and if lower- and middle-class Americans lacked a tradition of spending money on art, the categories of "sacred art" and "consecrated artist" opened up the possibility of displaying the imagery as stand-alone artistic panels priced for affordability, which made the imagery ideal for the inexpensive gift market. The designation "sacred art" also helped the publishers package the imagery for adult use. They used Sallman's pictures for children's publications in Sunday school and devotional literature in ways directly parallel to Providence Litho's Bible lesson cards. But by affixing the status of "art" to the imagery in promotional literature and church press articles, it could be readily presented for independent display in the home or workplace.

Kinkade and the American Imagination

All of this bears on the phenomenon of Thomas Kinkade, whose commercial success likely surpasses any of his predecessors in the market of "sacred art" but remains indebted in some sense to the entire tradition of mass-produced lithographic imagery of religious subjects, from Currier and Ives to Sallman. First, like them, Kinkade has relied on the mass medium of lithography to make his images affordable to a broad national audience. Second, he has specialized in a particular domain of the commercial marketplace, keying his identity as an image-maker to a specialty niche that he has built and continued to dominate by diversifying a core concept. Though he has readily adapted the concept to a variety of products, like Sallman he has maintained an unmistakable look or visual signature, which has been the key to continued patronage. Customers recognize the style of his work and purchase its many commercial transmogrifications—books, calendars, statuary, jewelry, and collectibles. But Kinkade has been able to move up-market, presenting his work in lucrative "limited editions," as collectible commodities, and as investments that have increased their value over time. He has done so by achieving, at least in the eyes of his admirers,

Figure 7. Thomas Kinkade, *The Prince of Peace.*
© 1999 THOMAS KINKADE.

the stature of fine artist, something Sallman never did, though, as we have seen, he was considered a "Christian artist" and his work was cherished as "religious art." Like Sallman, who experienced an evangelical revival of faith and attributed *The Head of Christ* to direct divine inspiration, Kinkade is a born-again Protestant who reported seeing the face of Jesus in a vision in 1980, which he painted as *The Prince of Peace* (published in 1999; fig. 7).[20] As with Sallman's portrayal, Jesus appears meek, eyes closed, brow furrowed, the quiet victim of scorn to which he passively submits.

But Sallman never enjoyed the commercial success that Kinkade has continued to command. By installing his work in commercial gallery spaces in malls around the country, Kinkade has framed his work in a setting that

middle-class consumers, who might otherwise avoid art galleries out of intimidation or for lack of sufficient resources, feel comfortable patronizing. They are able to balance their desire to decorate (match the color of décor or use wall imagery to accent an interior color scheme) with their interest in art whose subject and style speaks to them. Whereas Sallman traveled about to perform chalk talks, recreating his most beloved imagery for the sake of evangelical testimony, but also using personal appearances to imbue his mass-produced imagery with the aura of the "Christian artist," Kinkade hit on the far more lucrative practice of training assistants to highlight prints, which bestows on mass-produced prints the authorial marks of a hand-painted original. As noted earlier, the practice of hand-painting lithographic prints prevailed in the studio of Nathaniel Currier and other litho producers before the advent of chromolithography. Currier and Ives employed a workshop of women who hand-painted their lithographs, especially large format imagery for sale at a higher price to customers who sought an upscale product for domestic or public display. But if customers of Currier and Ives appreciated the hand-tinting, they did not do so because it was the mark of the individual artist. Most prints were unsigned. Kinkade's highlighted prints appeal because the added paint enhances the scintillating effect that is the trademark of "The Painter of Light." Viewers perhaps want to see their Kinkade come alive.

Kinkade has found a significantly larger market than Sallman did by eluding the constraints of a "ministry" of art given to illustrating scripture or portraying Jesus as a devotional figure. By avoiding strongly explicit religious subject matter, Kinkade has been able to present his landscape painting as art in its own right. Yet he has secured the patronage of Christian viewers who are very fond of Kinkade's infusion of his landscapes with pious references and an aura of providential majesty, which appeals to American pride and to the religious mythos of divinely sanctioned national purpose. His landscapes recall the long-standing American preference for a rural ethos as the desirable basis for national identity. When Kinkade does paint urban scenes, as he often does, they are rarely set in the current day. He envisions instead the nostalgic New York or San Francisco of yesteryear. But it is his landscape paintings for which the artist is most popular. His ability to link piety and landscape is one of the most attractive features of his art for Christians. His approach is to embed Christian symbols and allegories in the landscape so that they are identifiable for those

who wish to see them but unobtrusive for those who do not. "The natural world," he has commented, "is rich with allegories of profound spiritual truth."[21] Kinkade pulls these allegories from the Bible and from the history of religious verse and song. He finds them in the "garden of prayer," in the "bridge of faith," in a rocky "stairway to paradise," in the "dawning of a new day," and in the "power and majesty" of a waterfall. Each of these names the subject of a landscape in which the artist matched a principal feature to a religious sentiment.[22] The list goes on. One example will suffice to determine the importance of the approach for Kinkade.

Rock of Salvation (2001; pl. 3) is a coastal scene that pairs Kinkade's favorite motif, the country cottage with gabled, slate-shingled roof and stone walls, with a rocky shore and a sturdy lighthouse rising into a sunset sky. The same theme is treated in Beacon of Hope (1994), A Light in the Storm (1995), and Clearing Storms (1997), each of which the artist regards as "an allegory of faith," "a symbolic scene charged with a joyous message."[23] In every case Kinkade silhouettes a coupled home and lighthouse against a cloudy or stormy sky, which opens up into the distance, terminating in a low horizon. In spite of the apparent instability posed by storm, the house, lighthouse, and horizon provide a reassuring visual stability, an unyielding center of gravity that is invariably accented by windows glowing uniformly with a fire whose warmth vies successfully with the darker tones of sky and water without. Kinkade places the lighthouse and home on the left, at midlevel, and the horizon in the lower third of the picture field. A pathway of one sort or another invariably leads the viewer's eye from the foreground to the home, providing easy access to the structure, anchored in stone, at or near the horizon. The eye is directed to the privileged spot, parking effortlessly at the visual target, returning there faithfully after scanning the spaces about it. Kinkade consistently accents the home and lighthouse with conspicuously luminous windows. If viewers find the lighthouse pictures welcoming, it is surely because they leave no doubt as to the outcome of life's storms: the durable lighthouse is steady and unshakable. Faith always prevails. The cozy stone houses perched on the rocky edge of the sea are soothing metaphors of a snug human soul nestled beside the emblem of faith, the lighthouse, which radiates the promise of safe haven. Rather than serving mariners as navigational points of reference, Kinkade's lighthouses are beacons of home, picturesque signage of

security, of comforting reliability. He is able to invest in landscape the tender reassurance that Sallman provided his viewers in *The Lord Is My Shepherd* (see fig. 6, p. 40), which was an evocation of the words of the Twenty-third Psalm ("The Lord is my shepherd, I shall not want; he makes me lie down in green pastures"). Likewise, Kinkade's pictures evoke scriptural imagery. For biblically literate Protestants the imagery is redolent of favorite Bible passages, such as when Jesus refers to himself as the "light of the world" (John 8:12) or when he states that the wise man builds his home on rock rather than sand because it will not be harmed by stormy wind or flood (Matthew 7:24).

The lighthouse pictures share with most of Kinkade's landscapes a predilection for compositional stability. Nearly every picture exhibits a number of three key devices: symmetrical massing, a firm sense of figure and ground relations achieved in tonality and contour and accented by color, and a central entry point that leads to an unmistakable center of interest, whose task is to envision the human presence in the landscape. Kinkade offers a firmly structured progression for the eye, never wishing for the viewer to be surprised or become lost. The eye begins at the bottom of the image and works its way step by step to the center of interest, guided by the balanced distribution of masses to either side that lead into the distance and then back to the center of interest, which is typically a cottage or house, a bridge, a waterfall, a mountain, gate, road, or street. The serial engagement in pictorial composition bears the formal structure of storytelling — there is a beginning, middle, and end, whose clear articulation and ordering of parts ensure that one is never lost in the telling. There are principal characters, but none of these is an actual, historical individual. The task is not portraiture but formulaic narration. The characters all operate as players whose roles are prescribed by the genre of narration — fairy tale, folk tale, limerick, joke, or parable. The story is about the rehearsal of its familiar formal devices. It is not meant to innovate or depart from the formula because its social and psychological usefulness lies essentially in its familiarity. Everyone can gather round and enjoy it as a social event and repeat it. One expects stereotypes and clichés, conventional devices that are a common stock of knowledge.

Kinkade provides this pictorial continuity in a way that Sallman did when he modified but did not fundamentally change the iconographical

motifs he inherited from countless religious painters. Kinkade looks to Currier and Ives, to Norman Rockwell, and even possibly to Sallman in one instance for motifs in subject matter and style. His *Home for the Holidays* (1991; fig. 8), revisits Currier and Ives's beloved lithograph of the same theme (see fig. 1, p. 32). A sleigh-bound family arrives at the sturdy home of country folk, presumably the enduring, well-illuminated family home of scattered generations. The figures in the foreground are silhouetted by an effulgent light shining from the windows of the house that appears to be ablaze within. If Currier and Ives portrayed the rural roots of an increasingly urbanizing nation, Kinkade imagines a place that never existed. As he himself notes of the image, it is "an example of memory and imagination blending together to create an idyllic vision."[24] Certainly Currier and Ives were indulging in nostalgia, but not by promoting an anachronism. Kinkade does not paint a memory, as Currier and Ives may have, but envisions one, fantasizes a memory. His images of holidays and family homes are cherished as nostalgic reversals of rifts and developments in American society that have long perplexed Americans for the menace that modern allurements pose to an ideology that equates moral purity with a preindustrial age. As Kinkade commented of the reprise of a favorite theme, a nostalgic painting of Christmas: "I'm inviting you to a Christmas party unlike any you've ever attended—because it takes place a hundred years ago! In my paintings I love turning back the clock to a simpler era. That's what my *Victorian Christmas II* is all about: it brings my favorite holiday and a glorious historical period alive on canvas."[25] For many Americans Kinkade's pictures fondly envision a kinder, simpler, purer nation, one grounded in village life; home life purged of strife; a landscape splendidly devoid of industry, metropolis, racial diversity, secularity, poverty, or economic alienation. "Christmas" has come to mean this ideal American world, a fond, largely concocted memory of a nation of plenty. The image arrests the urbanization of America and fixes its center of gravity in a fantasized past that morphs urban America into something it is not in a way that parallels nineteenth-century landscape imagery that transformed the national terrain into an icon of divine providence.

Although religious imagery is usually embedded and allegorized in his landscapes, Kinkade has on a few occasions produced more explicitly religious pictures. The one in which the specter of Sallman appears is *The Good Shepherd's Cottage* (2001; Boylan fig. 1, p. 20). A heavily mantled Christ

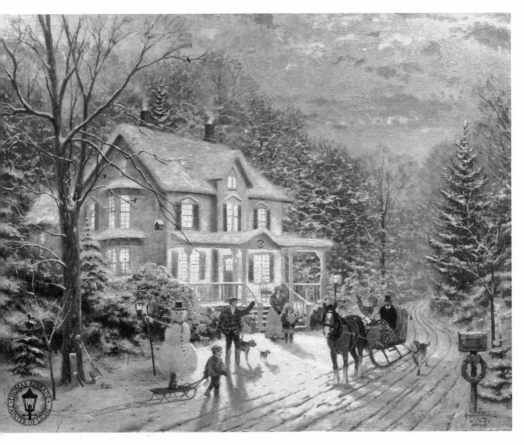

Figure 8. Thomas Kinkade, *Home for the Holidays*. © 1991 THOMAS KINKADE.

figure, redolent of the Victorian paintings that inspired Sallman, stands at the incandescent door of a stone cottage, with arms parted to welcome a winding line of lambs, which make their way faithfully toward the shepherd. The theme subverts the normal motif in Plockhorst's and Sallman's images (see figs. 4 and 6), in which a shepherd leads his flock in pasture or meadow to water or protects them from predators; sheep are typically led and not left to wander on their own. But Kinkade bends the logic of the pastoral metaphor to fit his very successful iconographical repertoire. The miniature cottage is his symbol of the human soul, the abode of the heart, the nostalgic site of pure living, the rural refuge in fantasized, snug memory. Where else would Jesus stand? The lambs are stand-ins for people, Kinkade's viewers, who seek out his pictures as havens and escapes. Jesus resides in the warm feelings one has for a childhood that never existed but should have. Instead of a crook to direct the flock and protect it when threatened by attack, this Shepherd offers a cozily lit cottage sequestered in gardens and crepuscular calm.

The illogic of Kinkade's transposition persists: are the lambs supposed to enter the cottage? Where will they stay? No fold is visible. The path leads them and us to the welcoming gesture that dominates a good deal of nineteenth-century devotional art—the standing figure of Christ, arms wide, welcoming the faithful.[26] The devout are meant to come into this little heaven of concocted memory while Kinkade plants a doll-like Jesus at the threshold of one of his cottages, suggesting that the home is Christ's bosom, a kind of maternal abode that recalls a long American history of "feminized Christianity" in which Jesus and Mother freely intermingled.[27]

But Kinkade knows what he is doing. He has updated the motif, shifting the setting from the pastoral valley of the Twenty-third Psalm to the country cottage, the set piece of Kinkade's vision of Cotswold picturesque. If the older piety visible in Sallman centered on the intimate embrace in which the Savior held the lamb (see fig. 6), in Kinkade's iconography the dream of security rests in a nostalgic vision of bucolic home ownership. The soul rests easiest not in the tender arms of the Savior but in the solid embrace of a country home. Kinkade's cottages, which he has painted in large numbers, mean more than the quaintly sited soul at rest in idyllic nature. They are the fantasized American home, fervent versions of the American Dream—the seaside or forest getaways where troubles vanish—no cell phones, no home repairs, no mortgage, just the ease of retreat from

the bothersome press of reality. As Christopher E. M. Pearson notes in his essay in this collection, there is not even a road to travel from the home to the outside world. The cottages are, in fact, pictorial counterparts to the several planned communities in Texas and California in which residents live in homes and neighborhoods sprung to life from Kinkade's pictures. The living rooms of these homes are destined to display the artist's visions of the domestic ideal, just as Currier and Ives manufactured lithographs of scripture reading in the home for mid-twentieth-century Victorian parlors. The fanciful, daydream cottages of his prints suggest that salvation involves some material return.

These pictures, it seems clear, are finally about those who own and display them. And that should be no surprise. Art and taste are powerfully engaged in constructing and maintaining the worlds in which their fond viewers reside. In an unsteady world of financial risk the best haven from the insecurities of the marketplace is the one locked up in the unassailable realm of yesteryear. But Kinkade's art-commodities allow their owners to have it both ways. They get nostalgia in the salutary form of an investment appreciating on the living room wall. The rise of Kinkade's art during the 1990s coincided with the boom of the American economy, during which time enormous amounts of personal wealth were invested in fine art. The record-breaking prices fetched by art on auction in that decade may have found a less prestigious but no less lucrative counterpart in the market for Kinkade's pictures. If the American home was sacralized by images of domestic Bible reading and mourning in the nineteenth century and by Sallman's pictures of Jesus in the twentieth, many pious homeowners today look to the more material security provided by Kinkade's collectible imagery. By investing in a commodity with resale value, Christians hang their vision of America on a promise that gives "redemption" a cheerful double meaning.

Notes

1. See Anderson, *Imagined Communities*.

2. See Morgan, *Protestants and Pictures*, 179–83. Among the best studies of the firm remains Peters, *Currier and Ives, Printmakers to the American People*. A more recent study is Le Beau, *Currier and Ives*.

3. Beecher and Stowe, *The American Woman's Home*, 93. On domestic Chris-

tianity in nineteenth-century America, see McDannell, *The Christian Home in Victorian America, 1840–1900*.

4. Klein, *A Population History of the United States*, 91, 136.

5. The symbolic capital accorded rural life over the city pervades antebellum Protestant literature. See, e.g., Everts, "The Social Position and Influence of Cities." Elsewhere I have examined this theme in antebellum religious illustrations (see Morgan, *Protestants and Pictures*, 51–63). On the importance of rural imagery for nineteenth-century American artists and patrons, generally, see Burns, *Pastoral Inventions*; and Truettner and Stein, *Picturing Old New England*, 15–41.

6. The U.S. Bureau of the Census for 1860 showed that 29 percent of Americans lived in cities with more than eight thousand inhabitants (Klein, *A Population History of the United States*, 136).

7. In 1890, for example, there were slightly more than nine million Roman Catholics reported in the U.S. Census, which equaled the combined number of members of the major American Protestant denominations of the nineteenth century: 2.2 million Southern Baptists, 1.6 million Presbyterians, 1.4 million Congregationalists, and 6.2 million Methodists. See Newman and Halvorson, *Atlas of American Religion*, 49. The great majority of Catholics in the United States in 1890 were immigrants or children of immigrants. The 1850 Federal Census counted 1.2 million Catholics in the nation (ibid., 69). For demographic information on Jewish and Asian populations in the United States from 1870 to 1930, see Gaustad and Barlow, *New Historical Atlas of Religion in America*, 210, 259.

8. An instructive source for the history of the firm is an unpublished and anonymous typescript entitled "History of the Providence Lithograph Company," dated Sept. 26, 1954, in the collection of the Rhode Island Historical Society (hereafter RIHS).

9. Ibid., 72.

10. Mr. Nelson, art director of Providence Litho, to Arthur Becher, Aug. 8, 1932, Providence Lithography Company Records, Mss 1028, box 3, folder 28, American Artists 1, RIHS.

11. The Nazarenes were a group of pious German painters led by Friedrich Overbeck and Franz Pforr, who founded the Brotherhood of St. Luke in 1809 while art students in Vienna. They later moved to Rome, where they occupied an abandoned monastery and pursued a figurative art of Christian subject matter that emulated the religious tableaux of Raphael and Dürer among others in the attempt to purge modern art of its secularity. Some painters among the group returned to prominent teaching posts in Germany and Austria, where they trained new generations of artists, who continued to paint highly didactic religious pictures that became favorites among British and American Protestants. Heinrich Hofmann and Bernard Plockhorst represent a later nineteenth-

century chapter of the Nazarene legacy. See also Grewe, *Painting the Sacred in the Age of Romanticism*.

12. Nelson to Becher, March 2, 1934, Providence Lithography Company Records, Mss 1028, box 3, folder 28, American Artists 1, RIHS.

13. Phillips Booth, art director of Providence Litho, to John Clymer, June 27, 1940, Providence Lithography Company Records, Mss 1028, box 3, folder 29, American Artists 2, RIHS.

14. See correspondence of April 8, 1949, Providence Lithography Company Records, Mss 1028, box 2, folder 7, Gospel Trumpet Company, 1948–49, RIHS.

15. Peterson, *The Ministry of Christian Art*, 7. For further discussion of religious marketing of Sallman's images and others related to his work, see McDannell, "Marketing Jesus."

16. William F. M'Dermott, "A Visit to a Cathedral," *Chicago Daily News*, Feb. 6, 1943.

17. Peterson, *The Ministry of Christian Art*, 7.

18. *Home and Church Supplies*, cat. no. 51 (Anderson, Ind.: Gospel Trumpet, 1950), 136.

19. Stafford, "A Consecrated Artist."

20. Kinkade's autobiographical account, posted at his website with *The Prince of Peace* (http://www.thomaskinkade.com), briefly describes the revelation: "How true this was for me in 1980 when, as an art student, I came to have a personal relationship with Christ. Just a few weeks later, awash in my new-found faith, I found myself sitting in an art class, my mind wandering. As I went through the motions, my eyes on the disinterested model posing for the class, I was suddenly struck with a powerful vision."

21. Kinkade, *The Thomas Kinkade Story*, 130.

22. Each of the following is reproduced in Kinkade, *The Thomas Kinkade Story*: *The Garden of Prayer* (1998); *Bridge of Faith* (1997); *Stairway to Paradise* (1998); *A New Day Dawning* (1997); and *The Power and the Majesty* (1994).

23. Ibid., 112, 150.

24. Ibid., 72.

25. Ibid., 96.

26. The motif is evident in religious iconography, from Bertel Thorvaldsen's marble sculpture of the resurrected Christ, entitled *Christus* (1821), to one of Sallman's paintings of the same subject, produced in 1946, called *His Presence*, in which Jesus appears in dazzling light, facing the viewer with arms spread.

27. For a visual history of Jesus and Mother in popular Protestantism in the United States, see Morgan, *The Sacred Gaze*, 191–219.

Painter of the Right:
Thomas Kinkade's Political Art

MICKI McELYA

A young boy delivers newspapers on his bicycle in an idyllic suburban community populated by prosperous-looking white people going about their morning routines as a male voice intones, "It's Morning Again in America." A slogan for Ronald Reagan's reelection campaign in 1984, this phrase opened the popular television spot that included, along with the boy on his bike, adults headed to work in a range of American suburban, rural, and city locales and a young couple getting married. The ad hummed with hushed reverence as the narrator suggested to American voters that after four years of the "Reagan Revolution" a new day had dawned, and it was time to embrace the Republican rewards of prosperity, security, and strengthened families and communities. The overall effect was similar to the sentimental coffee commercials so prevalent in the 1980s that likewise traded in images of quiet, industrious mornings and inviting domesticity.[1] In 2000, another presidential election year, Thomas Kinkade released *Hometown Morning* (pl. 4), the sixth and last painting in his Hometown Memories series (1995–2000). In it another young man delivers papers from his bike. He is chased playfully by a dog and watched by Norman Rockwell, who drives past him in a 1930s-era car. The linking of these two paperboys, and the fantastical visions of the American morning they inhabit, is suggestive of the political underpinnings of Kinkade's work.

The paperboy of *Hometown Morning* is also significant in his relation to Kinkade's oft-cited biography. As his fans know, after his freshman year of high school a thirteen-year-old Kinkade carried papers for the *Sacramento Bee* in Placerville, California, a small mountain community outside the city. Cast as much more than a teen's part-time job in popular narratives

of Kinkade's life, this paper route paid for his art supplies and provided additional income to aid his divorced mother in her struggle to support the family financially. Perhaps most important, it was while working this route that young Thom first caught sight of Nanette, the girl he would date through high school and eventually marry.[2]

Whether self-portrait or homage, that paperboy is entrenched in the story of Kinkade's marriage and "family values," not unlike the focus on normative families that fueled Reagan's 1984 commercial. And like Reagan's advertisement, Kinkade's painting carries an overtly political message. Painted in the year that would see the conclusion of Bill Clinton's second term and his inevitable exit from the White House (under the cloud of the impeachment scandal) and the mobilization of the Right to end eight years of Democratic control of the executive branch, Kinkade's nostalgic American dreamscape was forward looking. It would be, he suggested, morning in America once again. Puddled remnants of a cleansing rain make the streets glisten and reflect rich pools of light in Kinkade's painting, which depicts the community reemerging, clean, energized, and happy to start a new day.

Although Kinkade is popularly known as the "Painter of Light," a far more fitting title would be "Painter of the Right." I make this claim after considering the artist's biography, iconography, and wide popularity within the history of the rise of the Religious Right and the "culture wars" of the 1980s and 1990s. Locating Kinkade's work and marketing along this historical trajectory explains his impact and phenomenal success as outgrowths of the new Protestant evangelical culture that coalesced in the 1970s and became increasingly tied to the Republican Party. This pairing, shaped by the cold war and backlash against the new social movements and counterculture of the 1960s, was especially prominent in Southern California, where Kinkade moved as a young man to attend art school. Orange County and other areas surrounding Los Angeles were microcosms of post–Second World War politics of containment and white suburban affluence. Those sprawling communities of ranch homes linked by new highways and sustained by public and private funds coming from the military installations that dotted the area and from the rapid expansion of defense industries were the source of a new kind of grassroots conservative organizing. Driven by anticommunist fervor, these activists, termed "suburban warriors" by the historian Lisa McGirr, worked for a strong mili-

tary, capitalism unfettered by regulation, and "traditional" families as the sources of American character and dominance. This New Right moved around the edges of the Republican Party and national politics until Barry Goldwater's 1964 campaign for the presidency. Conservatives' success in securing the nomination for their candidate proved more important than his landslide defeat and signaled new powers within the party. A former New Deal Democrat turned anticommunist voice of the Right, Ronald Reagan emerged as a political star in his efforts for the Goldwater campaign and rode that popularity to the governor's office of California in 1966. At the same time, the nation—and Southern California in particular—was witnessing a radical transformation in Protestant religious culture marked by the growth of large nondenominational churches, television and radio broadcast networks, and other faith-based businesses. Although never synonymous with the New Right, these congregations and customers were often either themselves conservative activists or politically sympathetic to the pro-faith and pro-family moral rhetoric of New Right anticommunism and free-market radicalism. During the 1970s the more conservative wing of the Republican Party came to rely increasingly on the mobilization of Christian voters, who in turn came to see the party itself as their best means for protecting "traditional values" and promoting their social agendas. The two movements converged on such issues as abortion, gay rights, the Equal Rights Amendment, and prayer in schools and became institutionally linked as an identifiable "Religious Right" in 1979 when Jerry Falwell joined several New Right strategists to found a faith-based political organization called Moral Majority. This alignment proved enormously significant in the 1980 elections, which saw the involvement of nearly two million new voters who mostly identified themselves as evangelical Christians and mostly voted for Reagan, despite the fact that Jimmy Carter was a devout Southern Baptist and self-proclaimed evangelical. After helping to propel Reagan into the White House and electing a new slate of conservative senators and representatives in 1980, the Religious Right continued to grow, becoming the central facet of national political life and communities of faith that it is today.[3]

Kinkade's spirituality, politics, artistic production, and entrepreneurship were nurtured in the same environments and institutions that sustained the development of the Religious Right. Like thousands of other Californians in the late 1970s, he found himself drawn to the new therapeutic evangeli-

calism, where he was also surrounded by the moral politics of the Right. When he declared himself the Painter of Light in 1989, Kinkade translated this religious and political confluence into his work and marketing. Since then, his art, message, and persona have resonated with conservatives who understand themselves to be locked in an epic cultural battle for the soul and future of the nation. At the same time, his political art has been widely popular because it is rarely marketed as such overtly. For much of the 1990s Kinkade was not explicit about his political affiliations; he rarely endorsed causes or candidates, and any donations he may have made to local and national campaigns were not widely publicized. Today the artist's partisanship is more pronounced. For instance, he was a regular in George W. Bush's White House and an honorary committee member of the Presidential Prayer Team, a group that encourages daily prayer for the president, his cabinet, and the military. Kinkade's political views and their connections to his faith have always been clear in his rhetorical choices in interviews and marketing materials and the iconographic vocabularies of his work. He has promoted his paintings as universally American and as widely emblematic of an essential national character and wholesomeness. A recent promotional brochure describes Kinkade as a "painter-communicator" bringing hope and tranquility to the millions who enjoy his images. "Each one of his art treasures creates a quiet messenger that affirms the basic values of family and home, faith in God, and the luminous beauty of nature."[4]

Although his art is often understood both by fans and critics to speak a generic and benign message of uplift and self-congratulatory nationalism, Kinkade's images operate as potent and penetrating conservative propaganda. His vision of nostalgic nationalism bathed in God's light is widely representative of the suburban, racial, sexual, and economic politics of the Right. His images reflect longing for a mythic American past of simpler times and intimate communities free from the anxieties of alienation, diversity, and economic or social inequality, while at the same time promoting whiteness, normative heterosexuality, Christianity, middle-class aspirations, and free-market radicalism as the core of "American values." He affirms his audiences' accumulative desires, prejudices, and fears through reassuring locales and blessed light. Kinkade says, "For many millions, my art provides an escape from the pressures of everyday life and a gentle affirmation of such foundational values as home, family, faith, and simpler ways of living."[5] This element of escape or retreat through consumption is

evident in the response of one buyer of a hand-highlighted print from the Hometown Memories series: "It's like a picture of some tightly knit neighborhood where everything is well and everyone is friendly to each other. It's nice!"[6] In her contribution to this collection Andrea Wolk Rager argues that the expressly therapeutic function of Kinkade's nostalgia is characteristic of both postmodern responses to dislocation and the insidious commodification of daily life in the United States. Kinkade's is a deeply reactionary vision of the past and present that rejects the social movements, liberal and radical discourses of rights and citizenship, and cultural upheavals of the 1960s and celebrates conservative ascendancy in the 1980s. In this sense, "painter-communicator" is an apt description of his place in contemporary political culture. He does not merely illustrate the nostalgic fantasies of the Religious Right; he proselytizes them in malls around the country and increasingly around the world.

The Lord as Art Agent

In the Hometown Memories series Kinkade offers a vision of his childhood and small-town life that is at once expressly imaginative in its nostalgia and historical pastiche while claiming to be realistic in its expression of core truths and values. Kinkade's childhood memories as he depicts them in his paintings are full of iconographic references to the 1930s and earlier, especially in clothing styles, vehicles, and historical figures. Kinkade similarly reaches past his own birth in 1958 and his 1960s childhood in his cityscapes, village scenes, and large collection of Christmas paintings. In an essay on holiday images, memory, and imagination for *American Artist*, he writes,

> Although I grew up in a classic American small town, the era of my childhood was not the era of the Model T or horse-drawn sleighs. . . . Yet in my earnest enjoyment of such subjects, perhaps a greater truth is at play. . . . We all conjure up images of what was or what will be. When I am interviewed, journalists often assume I am a much older man whose painting subjects stem directly from childhood experiences. Collectors, too, often seem convinced my paintings are a direct expression of my life. I'm often asked, "Did your hometown really look like that?"[7]

Beyond his obvious and lucrative appeals to popular holiday imagery, such as Currier and Ives–inspired sleighs or historical Coca-Cola print ads, Kinkade's persistent reimagining of his own and America's collective past in the 1930s, 1940s, and early 1950s — as always happening prior to the 1960s — isolates both visions from the social and cultural upheavals and political transformations of that period. This is a world unmarked by the civil rights movement, feminism, gay liberation, or the Vietnam War, suggesting instead the mythical, simpler youths and "Good War" of the "Greatest Generation."[8]

Kinkade anchors his critiques of modern life and what he calls "modernism" in art to the moment when he had to leave that idyllic place — his childhood and Placerville — to attend college at the University of California, Berkeley, in 1976. He has described his time there as unsettling on many levels. Frustrated by what he believed were distractions from his development as an artist by the school's liberal arts focus and alienated from the artistic values and influences of his professors and peers in studio classes, Kinkade was especially unmoored and repelled by his new surroundings in the Bay Area of the 1970s. "Talk about culture shock!" he writes, explaining his decision to leave Berkeley. "You couldn't imagine two places more completely opposite than Placerville and Berkeley. . . . Having grown up in a small town — which was a lot like a Norman Rockwell painting — the anything-goes environment of Berkeley made me hunger for more structure in my environment."[9] In 1978 Kinkade headed to Southern California in search of that structure at the Art Center, Pasadena. His skepticism of the teaching and artistic philosophies and aspirations of his instructors and fellow students persisted there; Kinkade would ultimately count the school as the second he left without completing a degree.

In addition to shaping his work and further clarifying the kind of painter he did not wish to become, Kinkade's move south had a profound impact on him as an individual and as an artist because it put him in close proximity to the area's burgeoning evangelical culture and grassroots conservative organizing. Raised in the Church of the Nazarene, Kinkade had drifted from his faith by the time he left for college. But feeling alone and consumed by self-doubt, he later found solace in the youth-oriented, nondenominational Protestant evangelicalism that had become so prevalent in Southern California. Describing his Christian rebirth to a reporter for

the *Toronto Star* more than twenty years later, Kinkade explained, "I first went at 18 to . . . Berkeley, which is not exactly a conservative Christian centre. I left and was then living in a bombed-out ghetto in Pasadena. . . . I kept wondering, 'Can I ever be an artist? Am I just fooling myself?' I was 20 years old and I was in despair, a great despair." Perhaps because of his upbringing or, he jokingly told the reporter, because he was trying to get closer to his date, Kinkade went to a revival and was transformed. "I wanted to get out of this despair and went to a revival meeting—probably because I had the hots for the girl who invited me—and as I stood up at the altar something changed in me. I knew I could trust God. I asked the Lord to be my art agent."[10]

While Kinkade tells this story as one of personal religious journey, he was in fact part of a much larger transformation within Protestant Christianity in the 1970s. The revival that led to Kinkade's rebirth, which he has also described as "an old-fashioned tent crusade," was a hallmark feature of its host, Calvary Chapel of Costa Mesa.[11] In stark contrast to its folksy, diminutive-sounding name, Calvary Chapel describes itself today as "one of the ten largest Protestant churches in the United States" and reports its membership at more than 20,000, with another 1,337 national and international affiliate churches ministering under the Calvary Chapel name.[12] Founded by Pastor Chuck Smith with twenty-five members in 1965, by the time Kinkade came into contact with the ministry almost fifteen years later, it boasted a membership of several thousand and commanded millions of dollars in resources, including a lucrative contemporary Christian music business. This incredible growth stemmed from the counterculture-inflected "Jesus Movement" that emerged in Southern California in the late 1960s. These young evangelicals rejected religious institutions as morally compromised and corrupting of the spirit and of personal relationships with Jesus. Their influences were the fashions, drugs, and music of the counterculture, earning them the name "Jesus freaks" from the media. Chuck Smith seemed an unlikely leader of such a flock and admitted that he was initially disgusted by the "hippies." A former Pentecostal minister who had felt limited by denominationalism, Smith was (and is) socially and politically conservative with an apocalyptic anticommunist vision that included warning in the early 1970s of an impending "one world order" and global government under the anti-Christ's leadership. Encouraged

by his college-aged daughter to see past his first impressions, however, Smith began proselytizing to the surfers, hippies, and Jesus people along the beaches of Orange County. He rented houses for converted kids to live in communally as they studied the Bible and stopped using drugs. He held enormous mass baptisms in the ocean at Corona del Mar and invited Christian folk singers and rock groups to play at his services, which, by that time, were heavily populated by young people. Smith's ability to bring "wayward" counterculture youth to Jesus attracted equally large numbers of middle-class adults who shared his politics and appreciated the message and vigor of Calvary Chapel. They brought with them their commitments to conservative political organizing and a fervent belief that traditional faith, family, and American values were under siege by the likes of feminism, gay liberation, obscenity in the popular culture, and the intrusive liberalism of the federal government, particularly the Supreme Court.[13]

The combination of cultural influences and social and political conservatism that came together at Calvary Chapel is characteristic of the evangelical transformations of the late 1960s and 1970s. The political and cultural mix of Southern California produced several of these new churches, including the televangelist Robert Schuller's Crystal Cathedral in Garden Grove. Schuller's ministry, which began at a drive-in theater in 1958, had eight thousand members in traditional Sunday services and reached another three million through his weekly *Hour of Power* television broadcast by 1978. Two years later, the Crystal Cathedral opened the ninety-foot doors of its current soaring glass and steel home, designed by Philip Johnson and John Burgee.[14] The religious scholar Donald Miller has termed the institutions that emerged in this period "new paradigm churches" and argues that Calvary Chapel was a pioneer among them. *Megachurch* is the more common term today, descriptive of their enormous congregations, campuses, and wealth, as well as their all-encompassing missions, from daily religious services to gyms, theaters, competitive sports leagues, schools, and counseling. While they champion "traditional values," these churches are anything but traditional, a fact, Miller argues, that stems from the ways they "and their members have responded to the therapeutic, individualistic, and anti-establishment themes of the counterculture."[15] All of these elements have found expression in the work of Thomas Kinkade, from individualism and therapeutic rhetorics to the artist's positioning of

himself as a populist maverick battling a traditional museum culture and the contemporary art world.

Calvary Chapel was also a leader in developing Christian businesses and the faith-based marketplace on which Kinkade has relied for much of his sales. The church's tax-exempt religious products and music company, Maranatha, was a forerunner in publishing and recording contemporary Christian music. It was also an inspiration for other religious entrepreneurs in and outside of the Calvary Chapel community in the 1970s, including one member's Christian shopping center, Maranatha Village, and several service sector businesses that identified themselves as Christian-owned and operated by using the Maranatha name.[16] Much more than means for profit or proselytizing, these businesses were concrete expressions of the new evangelical individualism that understood wealth and accumulation as powerful expressions of one's faith and as one of the many benefits of accepting Christ. In a description of Robert Schuller's message that applies to Calvary Chapel as well, Lisa McGirr argues, "in contrast to the old evangelism that had centered on damnation and sin, [Schuller] emphasized self-help. This worldly message talked of discontent rather than sin—turning toward and accepting Christ was the first step toward self-fulfillment. After accepting Christ . . . one must pursue success in personal and mundane ways."[17] Meshing easily with the stark anticommunism and free-market radicalism of the New Right, this message affirmed consumption and the profit motive as both patriotic and pious.

Although nearly ten years passed before Kinkade came to see the marketing of his work as ministry, his entrepreneurship, like his spirituality and conservatism, was shaped in profound and enduring ways by his rebirth in this particular place and moment. His desire to create spaces of retreat and spiritual renewal for his collectors, to make God's grace and relationship to the saved pictorially manifest, is a direct expression of the therapeutic and individualistic cultures of the new evangelicalism. This is also true of the expense associated with collecting Kinkade's art and his own financial success. While the extensive merchandising of his work makes it accessible in some way to most, limited-edition and hand-highlighted prints are very costly. Potential buyers are encouraged to see altruism and spiritual fulfillment in their individual consumption and accumulation, a point Seth Feman expands on in his contribution to this volume. In a broad sense this

religious worldview has shaped the political commitments of the Christian Right and tied it more closely to the Republican Party on issues such as taxes, affirmative action, corporate regulation, and welfare reform. It makes any governmental action or policy that can be framed as limiting the individual's "right" to become wealthy a simultaneous intrusion on fundamental Christian values. Wealth itself becomes spiritually meaningful in this context, a fact made clear in Kinkade's success.

This assertion of the equivalency of material wealth and status aspiration with piety and salvation is perhaps most obviously represented by two recent images in which Kinkade imagines heaven: *Living Waters: Golfer's Paradise, Hole One* (2005) and *Lakeside Manor* (2006). In the first a stone path cuts through lush flowers, giving way to a manicured green bisected by a stream. A sign and two golden orbs indicate the tee-off point, while two sand traps and the flag marking the second hole appear in the distance. "Like many people of faith, I have often contemplated the glories of heaven," Kinkade writes of his celestial golf course, continuing that it "might be a perfected form of our earthly dwelling—almost like a renewed Garden of Eden for us to enjoy."[18] Intended as the first in a series entitled Mansions in Paradise and released a year later, *Lakeside Manor* depicts a remarkably literal reading of John 14:2: "In my Father's house are many mansions." Kinkade explains, "In His intriguing account of the promise of Paradise, Jesus proclaimed that each of us will find a welcoming home amidst its 'many mansions.' In my new *Mansions in Paradise* series, I turn my artist's eye away from the humble cottages of village and town and toward more majestic dwellings. My goal in this series is to create mansions truly worthy of a paradise, whether earthly or heavenly."[19] Painted in the tradition of an English country estate, nestled in trees and wildflowers, and fronted by a meandering brook rather than the lake of its name, the manor mostly resembles the houses designed for the first Kinkade-inspired "Masterpiece Homes" planned community in northern Idaho on the shores of Lake Coeur D'Alene, which had just broken ground a month before the picture's release. It was joined that summer by plans for another Masterpiece Homes development in Columbia, Missouri, "The Gates at Old Hawthorne," to be built around a championship private golf course.[20] With profound synergistic acuity Kinkade drenches potential Masterpiece Homes buyers in God's grace, provides art to hang on the walls of their

earthly paradise, and encourages those who may never find themselves living in such a home to dream of the afterlife as an exclusive country club to which they already belong.

Restoring Dignity to the Arts

Kinkade marks 1989 as a turning point in his career. This coincides with the moment when the culture wars came to focus on the contemporary art world and federal funding for the arts, a political development resulting from Religious Right activism. After the relative successes and growth of the movement during the Reagan years, 1988 was a difficult time for the leadership of the Christian Right. The year witnessed several scandals concerning sex and finances among prominent televangelists such as Oral Roberts, Jim and Tammy Faye Bakker, Jerry Falwell, and Jimmy Swaggart. Consistently topping the headlines, these most visible figures of the movement, at best, were reduced to the status of national jokes and, at worst, brought significant damage to the moral authority and political power of religious conservatives nationally. Combined with what Sara Diamond has called his own "knack for creating bad press," Pat Robertson, the Christian Broadcast Network founder and *700 Club* host, saw his attempt to secure the Republican nomination to run as Reagan's successor derailed in part by his inevitable association with troubled fellow televangelists.[21] In the aftermath of scandal and political turmoil Falwell formally disbanded Moral Majority, by then renamed the Liberty Federation, in 1989. Looking into this void and building on the networks of his failed presidential bid, Pat Robertson joined forces with Ralph Reed, a young but seasoned Republican activist in Georgia, to create the Christian Coalition. Calling for a return to grassroots organizing and renewed focus on the local politics of school boards, city government, and state legislatures, the Christian Coalition went to work setting up state chapters and mobilizing conservative activists around domestic issues such as abortion, sex education in public schools, homosexuality and the AIDS crisis, and "obscenity" and perceived anti-Christian bias in the popular culture. Their first mass mailing seeking new membership, which was sent to the list of contributors to Robertson's campaign, capitalized on one of the most heated issues of the preceding months and denounced the National Endowment for the Arts (NEA) for supporting the work of Andres Serrano and Robert Mapplethorpe. The

letter urged people to join them in fighting the federal government's pro-
motion of obscenity, homosexuality, and anti-Christian sentiment.[22] This
political environment created Kinkade as we understand him—for good or
for bad—today. The decade began for the artist with religious rebirth and
ended with the birth of Thomas Kinkade, Painter of Light.

Driven to action by months of public pressure from the American
Family Association, a Mississippi-based religious organization that had
come to prominence organizing national protests of Martin Scorsese's film
The Last Temptation of Christ (1988), socially conservative and mostly Re-
publican members of Congress took aim at the NEA and several artists who
had received federal funds directly or indirectly in the late 1980s. Most of
those artists singled out for question and demonization were gay or lesbian,
explicitly feminist, nonwhite, or some combination of these categories.
Furthermore, their work tended to grapple with their bodies and identi-
ties, history, and contemporary political environments. Revisiting her in-
fluential article of the time, "The War on Culture," Carole Vance remarked:
"Sex panics are politics by other means, and the recent campaigns against
and through sexual imagery achieved significant and disturbing results.
Long-standing efforts to defund and reduce the scope of the NEA, largely
unsuccessful during the Reagan presidency when framed in terms of cost-
cutting and anti-elitism, achieved real success in the 1990s through the
strategy of 'add sex and stir.'"[23]

These were indeed "significant and disturbing results," as contempo-
rary politics continue to be shaped by the success of this strategy. Re-
cent examples range from Clinton's impeachment to the antigay marriage
propositions placed on the ballots of several states in the 2004 and 2008
presidential elections, which helped to mobilize self-proclaimed and then
media-anointed "moral values" voters. Appeals to "family values" and
homophobia have proven consistently effective both in their abilities to
turn out voters on the Religious Right and in keeping Republican Party
agendas tied closely to these constituencies.

Focus on NEA funding heated up in the summer of 1989 when Alfonse
D'Amato (R-NY) denounced Serrano's photograph *Immersions (Piss Christ)*
(1987; pl. 6) while tearing a copy to pieces on the senate floor. He declared
it a "so-called piece of art" that was "deplorable," "trash," and a "despicable
display of vulgarity." Most egregious, he argued, American tax payers had
unwittingly paid for it because Serrano had been (indirectly) supported by

an NEA grant. Several members of Congress, including Senator Jesse Helms (R-NC), joined D'Amato in sending a letter to the acting head of the NEA denouncing its support of Serrano and a Mapplethorpe retrospective. With the NEA budget up for renewal, Republican members of the House joined the fray and threatened to cut resources dramatically, gathering support by circulating the catalogue from *Robert Mapplethorpe: The Perfect Moment*, which was then set to open at the Corcoran Gallery of Art in Washington. Succumbing to political pressure and the public scrutiny generated by Congress, the Corcoran cancelled the retrospective. Struggles over the future and parameters of NEA funding would continue into the 1990s in several high-profile cases, including the following year's grand jury indictment and ultimate acquittal of the Cincinnati Contemporary Art Center's director on misdemeanor obscenity charges for hanging the Mapplethorpe retrospective and the new NEA director's unilateral rejection of four solo performance art fellowships to Karen Finley, John Fleck, Holly Hughes, and Tim Miller, who became known as "The NEA Four." Later that year Congress reauthorized the NEA for another three years in a compromise bill that nonetheless required grant recipients to hold to "general standards of decency and respect," construed by critics as a loyalty oath not to make "obscene" art.[24]

It was in the context of these consuming public debates about contemporary art and the funding role of the state, driven by right-wing charges of rampant anti-Christian sentiment among left-leaning cultural elites and society's perverse decline, that Thomas Kinkade realized his artistic calling as the "Painter of Light." Between 1984 and 1989 Kinkade had produced his work under the "brush name" Robert Girrard, but in the midst of the controversies raging around Serrano's *Piss Christ* and Mapplethorpe's frank photographic explorations of sexual identity, Kinkade saw the light, literally, and returned to working under his given name. In *The Thomas Kinkade Story* his authorized biographer explains: "Light became important to Kinkade's artistic vision, not only as an expression of visual contrast and luminous color but also as a tool to suggest spiritual values within a painting. 'I began to see something consistent was happening in my paintings,' says Kinkade. 'Every scene I envisioned was constructed to enhance a sense of radiant light. . . . It was a moment of deep revelation to me—I suddenly knew I wanted to attempt to use light in new and exciting ways in my work. That vision hasn't changed to this day.'"[25] Kinkade's description of

his artistic realization as a "revelation" suggests that God set and then re-
vealed this path for him. The artist frames himself as a messenger in a mo-
ment of profound artistic upheaval.

With the incorporation the following year of the Media Arts Group,
the company that marketed and distributed his images and licensed mer-
chandise (that now operates under the name of The Thomas Kinkade
Company), the artist set out to spread his vision to consumers and to cre-
ate collectors. Kinkade quite literally heeded the call of Helms, who had
attempted to stave off charges of censorship in his quest to prohibit the
NEA from funding any art (he) deemed "indecent" and "offensive" by cele-
brating the marketplace as the ultimate arbiter of artistic value. If art was
"good" and reflected mainstream tastes and national values, he reasoned,
the public would support the artist by buying his or her work or by pay-
ing to see it. The senator argued, "No artist has a preemptive claim on the
tax dollars of the American people; time for them, as President Reagan
used to say, 'to go out and test the magic of the marketplace.'"[26] Through
the alchemy of the faith-based marketplace Kinkade positioned himself
as the antidote to the appalling and elitist contemporary art world that
was constituted in public-funding controversies. He translated the Reli-
gious Right's fusion of partisan politics, Protestant evangelism, and radi-
cal free-market capitalism into his own iconographic product — the Light.
The very political configurations that had driven Kinkade's artistic rebirth
shaped his customers and fueled his newfound popularity and significant
sales. By 1992 he had opened his first three Signature Galleries in Cali-
fornia. Given the painter's ideological associations with social conserva-
tism and the Republican Party, it is fitting that the next gallery he opened
and the first outside of his home state was in Kennebunkport, Maine,
the resort community made famous as the first President Bush's family
retreat.[27]

While timing and the heated political environments of the culture wars
had much to do with this success, Kinkade showed a keen understand-
ing of consumers' simultaneous desire to believe they could be part of the
elite community of art collectors and their wish for the status and satisfac-
tion that knowledge of fine art carried. Around this time Kinkade began
his highly publicized practices of hiding the letter N in all of his works
to honor his wife, of naming pictorial elements after his daughters and
friends, and of embedding other codes one would recognize as being con-

nected to him intimately if she or he was familiar with the painter's biography. In a charged political environment that made consistent recourse to the obfuscating nature of contemporary art and dwelled on sneering elitism, Kinkade offered his collectors a way to bridge this divide without succumbing to the "perverse" values of that world. He worked in straightforward images and motifs, such as faith, family, and landscape, but also made buyers aware that coded images and special messages were there to be discovered by the truly knowledgeable Kinkade collector. This latter quality of the work he substituted for interpretation, creating a kind of populist connoisseurship among collectors, appealing to insiderism while remaining widely accessible. This tactic has been enhanced by the creation of the Thomas Kinkade Collectors' Society, which for a yearly fee of fifty dollars includes the gift of a small print for enrolling, a membership card, lapel pin, quarterly newsletter, access to an online community, and the opportunity to join the "family of thousands of collectors worldwide and be the first to know of exclusive product opportunities, inside information, new releases, Thom's activities, and much, much more!"[28]

Kinkade is very clear about his political motives and their resonance with his audience. Looking back on the decade that made him "America's most collected living artist," he has spoken of himself as a cultural warrior fighting "the corrosive effects of Modernism" through his message of Light. "I see a campaign for culture shaping up around me," he explained to Randall Balmer in 2000. "Art is the cultural battle at play right now. . . . I'm on a crusade to turn the tide in the arts, to restore dignity to the arts and, by extension, to the culture." Balmer notes that in addition to *South Park* and "gangsta rap," Kinkade believes that modernism has led "to what he calls the 'fecal school' of art, or 'bodily function' art, a reference to the work of Robert Mapplethorpe and to a controversial 1999 exhibition at the Brooklyn Museum of Art, which featured a depiction of the Blessed Virgin surrounded by elephant dung."[29] This last image Balmer describes is a common misrepresentation of Chris Ofili's *The Holy Virgin Mary* (1996), which is not "surrounded" by elephant feces but rests on a dung base and depicts an exposed left breast composed of a single dung sphere. Like bookends on the decade's controversies over contemporary interpretations of Christian iconography, the 1989 congressional denunciation of Serrano's *Piss Christ* and the 1999 attacks on Ofili's work by the Religious Right and Catholic conservatives, and the Republican politicians who relied on both, mark for

Kinkade two points in an ongoing artistic decline defined by bodily func-
tions and base desires, by piss and shit rather than spirit and soul.

Although not referenced explicitly in Balmer's article, Serrano's *Piss
Christ* arguably had the most profound effect on Kinkade's iconography, his
1989 artistic awakening, and his current persona. The controversial photo-
graph also points suggestively to recent controversies surrounding Kin-
kade's business troubles and litigation. Aesthetically, Kinkade shares with
Serrano a reliance on the manipulation of light effects and the use of light
as symbolic of God's presence and the individual's potential for salvation.
Serrano's title belies pointedly the profound and affecting beauty of the
play of light on the crucifix and surrounding effervescence. This central
luminosity is compounded by the increasing darkness radiating from the
Christ figure, moving from bright yellows and oranges to deeper ambers
and browns at the far corners of the image. The recognition that one is
looking at the crucifix—an icon and intimate tool for prayer—submerged
in urine undermines the light's symbolism, calling into question a series
of interconnected relationships between spirit and body, institutionalized
religion and individual faith, church and state, sexuality and sin, life and
death, and illness and vitality. *Piss Christ* compels audiences to confront
limitations and rejection, whereas Kinkade composes his images "to en-
hance a sense of radiant light" and to affirm, not question or examine criti-
cally, "the basic values of family and home, faith in God, and the luminous
beauty of nature."

More recently, Kinkade and Serrano have been linked not only by
their images of light but by the very act of urination. It was commonly
known that the urine represented in *Piss Christ* was the artist's own. The
outrage of conservative members of Congress, pundits, and organizers on
the Religious Right was shaped in part by their assumption that the work
was aggressively anti-Christian, tantamount to Serrano pissing not only
on Christ's image but on all followers of Christian faiths. In March 2006
the *Los Angeles Times* published an expose of Kinkade's "dark side," as it had
been alleged in testimony connected to the lawsuits of several former Sig-
nature Gallery owners. The bankrupt owners argued that they were driven
out of business and into financial ruin by the Media Arts Group itself and
that Kinkade manipulated shared faith and a sense of Christian mission to
their demise and his own profit.[30] A number of former employees, gallery
owners, and associates also testified in arbitration to several very public

incidents of Kinkade's bad behavior, including public drunkenness, strip-club and bar hopping, public urination, lewd conduct, and at least one case of probable sexual harassment. Characterized by the *L.A. Times* and other news outlets that picked up the story as astoundingly bizarre was the art-ist's admitted penchant for urinating in public, or, as one witness called it in deposition, "ritual territory marking." Kinkade's "territory" was said to have included an elevator in a Las Vegas hotel and a figure of Winnie the Pooh in another hotel in Disneyland. In an interview with the *Times* a former vice president for the Media Arts Group, Terry Sheppard, "re-counted a trip to Orange County in the late 1990s for the artist's appear-ance on the 'Hour of Power' television show at the Crystal Cathedral in Garden Grove. On the eve of the broadcast, Sheppard said, he and Kinkade returned to the Disneyland Hotel after a night of heavy drinking. As they walked to their rooms, according to Sheppard and another person who was there, Kinkade veered toward a nearby figure of a Disney character. 'Thom wanders over to Winnie the Pooh and decides to "mark his territory,"' Sheppard told The Times," adding that Kinkade said, "There's one for you, Walt," as he splashed the decorative figure.[31] Jeffrey Vallance suggests an ir-reverent reading of this incident later in this collection, but those involved in the lawsuit found nothing humorous in the act. For collectors and em-ployees with profound investments in Kinkade's faith and conservative values, it is hard to know what part of this story was more disturbing, the fact that Kinkade followed an appearance on the popular television show helmed by the televangelist and megachurch pastor Robert Schuller with a night of excessive drinking or that he then urinated on Winnie the Pooh in a dismissive, if not overtly aggressive, act against Walt Disney. The tim-ing of the story could not have been worse for Kinkade, considering the significant publicity that surrounded his creation of a special-edition anni-versary print for Disneyland's fiftieth year in 2005, a fact that contributed to its prominence in arbitration and the press.[32]

For critics and litigants the incident brought into focus Kinkade's poten-tial hypocrisy, suggesting that his trademark Light was superficial and his mission only profits. This compels a reconsideration of his earlier com-plaint that contemporary art has been based on a "lie" that "art is about the artist."[33] By this Kinkade meant that artists on the one hand were unneces-sarily oblique in their messages, self-indulgent, and contemptuous of their publics, while he on the other hand set out to engage directly, to uplift,

and to affirm his audiences, not alienate them. In the process Kinkade has made his art all about his own history, his rags-to-riches story, his faith, his family, and his own force of personality—he has made it all about the artist. He created himself as the Painter of Light to counter directly the perverse figures and nonnormative behaviors that many saw in the art world of the 1980s and 1990s revealed to them by right-wing politicians and Religious Right organizations. The extent of the damage to this construct in the face of revelations of Kinkade's own sexual desires outside of his marriage, his alcohol consumption and rowdiness, or his public urination and apparent disdain for an American icon remains to be seen. Not unlike the televangelists mired in scandal in the late 1980s, Kinkade attempted to shut out the snickers of his detractors and the bad publicity to appeal directly to his collectors for their forgiveness and continued support in a personally trying time. He admitted some degree of human failing and claimed to be back on the path of righteousness, to be standing once again in the light.

Kinkade's Homeland Security

Disneyland 50th Anniversary (2005) is compositionally reminiscent of a much earlier Kinkade painting that celebrated American democracy, *Flags Over the Capital* [sic] (1991; fig. 1). The image depicts a capitol building that is almost identical to the U.S. Capitol but is removed from the urban environment of Washington, nestled in trees, and surrounded by or draped with more than fifty American flags. Unlike Disneyland's iconic castle, the capitol building is not in the center of the image but sits suggestively to the right. Kinkade's signature glow burns from each window. Similar to the Disney image, but distinct from the largest body of Kinkade's work, this painting teems with people—citizens—gazing at and walking around the building. Immediately striking in his depiction of the citizenry is its remarkable whiteness.[34] Not only is Kinkade's civic image almost uniformly white, but all of the figures are mostly paired in heterosexual couples of different generations or in family groups.

For many years *Flags Over the Capital* remained one of Kinkade's most overtly patriotic images. This all changed ten years later, however, in the wake of September 11, 2001. Dating the period from his 2000 invitation to paint an image for the national Christmas tree lighting, which he titled *The Lights of Liberty* (2000), Kinkade's biography refers to this most recent stage

Figure 1. Thomas Kinkade, *Flags Over the Capital.* © 1991 THOMAS KINKADE.

in his career as "The Light of Freedom." This is also the name of a 2001 painting he produced to honor those who died and acted to save others on 9/11, several prints of which were donated to raise money or given to firehouses in New York City. In the foreground of the image a large American flag waves from a pole topped by a gold eagle, caressed by gleaming light and soft clouds. Describing this aspect of the painting, Kinkade says, "The billowy clouds in the heavens remind us that despite our challenges, God surely has shed His grace on this land."[35] In the background lie the scarred Lower Manhattan skyline and the Statue of Liberty, which is positioned to look out at the viewer. This piece was followed two years later by *America's Pride* (2003), which depicts the same flag and pole against a slightly brighter but very similar sky in the foreground of another image of the Capitol and Washington Monument. Given that this painting is the first of a new series entitled Flags over America, the focus on the Capitol makes a subtle reference to his earlier painting while it aims for greater realism and removes all human figures.

Kinkade's new focus on "freedom" is not merely an appeal to the post-9/11 swell in patriotism and growth in the market for flag-draped images and items, nor is it a simple expression of his own love of country. Rather, it again links the artist to the rhetorics of the Right seeking to equate "freedom" with the PATRIOT Act, the War on Terror, and freewheeling global capitalism. This connection is revealed, for instance, in his second image created to celebrate the national Christmas tree, *Symbols of Freedom* (2004; fig. 2), and his explanation of its iconography.

> Like Norman Rockwell's famed "Four Freedoms," my *Symbols of Freedom* celebrates foundational American values. The Department of Agriculture tower at the left symbolizes the Freedom from Want. The national Christmas tree expresses the pageantry of the holidays, its glowing lights affirming the hope that burns in every heart through our individual Freedom of Religion. The severe obelisk of the Washington Monument represents for me the founding of our republic which provided Freedom from Fear by placing government on the side of the people. Finally, the cupola of the Jefferson memorial symbolizes our founding father's steadfast commitment to Free Speech. Illuminating these powerful symbols and touching the modest crowd is the glorious light of God's golden sunset.[36]

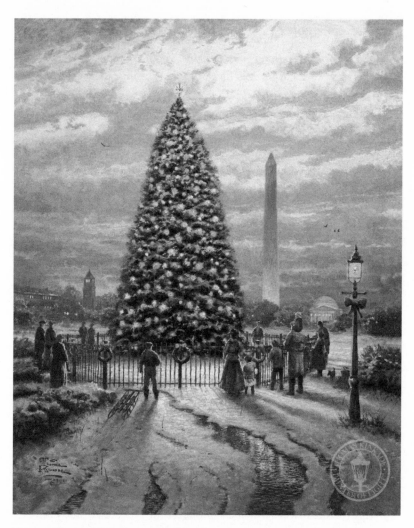

Figure 2. Thomas Kinkade, *Symbols of Freedom.* © 2004 THOMAS KINKADE.

Figure 3. Norman Rockwell, *Four Freedoms* (1943). COURTESY OF THE
LIBRARY OF CONGRESS.

Franklin D. Roosevelt had outlined these four freedoms in his State of the Union Address of January 1941 to frame the expansion of American military assistance to Britain before the attack on Pearl Harbor brought the United States into the Second World War officially. Rockwell produced four hugely popular paintings in 1943 (fig. 3) illustrating the freedoms that circulated widely; these paintings were used to sell war bonds and were reprinted in the millions.[37] Although he finds inspiration in Rockwell's representations, Kinkade's own wartime image is a radical departure from his hero's sentiments. Where Rockwell focused on individual Americans and private scenes, such as the iconic family Thanksgiving image depicting *Freedom from Want*, Kinkade offers federal offices and centralized authority like the Department of Agriculture. Kinkade's *Freedom from Fear* and *Freedom of Speech* are symbolized by two national monuments to two Founding Father presidents: George Washington and Thomas Jefferson. He gives us the "government on the side of the people" as opposed to Rockwell's everyman who stands to speak his own opinion at a town meeting, indicating very different estimations of where the power of democracy rests. Similarly, Rockwell's worried but tender and protective parents are replaced by a representation of the original Founding Father, cementing further the association of democracy with the power of the executive office (a power the George W. Bush administration was in the process of expanding significantly). Finally, where Rockwell suggests a multiplicity of faiths and Americans in the only racially diverse image of his four, *Freedom of Religion* for Kinkade is symbolized by a Christmas tree, equating national identity with Christianity and religious freedom with a war on Islamic terrorism. Once again, Kinkade's nostalgic reliance on Norman Rockwell and persistent references to the "Good War" are revealed to be in the service of very contemporary political aims.

This was not the first time Kinkade considered Rockwell's images of freedom in the aftermath of 9/11. Just before the first anniversary of the attacks, he released a print entitled *Hometown Pride* (2002; fig. 4), which referenced the ubiquity of American flags in neighborhoods around the country and recalled his construct of the small town from his Hometown Memories series. "In *Hometown Pride*, I'm trying to evoke the very essence of the American dream—the peace and precious freedoms that continue to be our birthright. In his celebrated Four Freedoms paintings, Norman

Figure 4. Thomas Kinkade, *Hometown Pride.* © 2002 THOMAS KINKADE.

Rockwell recognizes Freedom from Fear as one of the cardinal protections Americans enjoy. That is the spirit—the message if you will—of this proud painting."[38] Where Kinkade's earlier "Hometown" images had been full of people, including his childhood self delivering papers on his bike, the streets of this American dreamscape are notably empty. More reminiscent of Rockwell's own focus on home and family than the centralized federal authority imagery of two years later, Kinkade offers a vision of safety in suburban affluence and privatization. The less-expensive "inspirational print" version of *Hometown Pride* carries "United We Stand" as its inscription. Kinkade seeks to pull his audience into his vision, the unseen "we" who coalesce through this depiction of citizenship and national community in flying a flag while staying behind closed doors. With this representation of "homeland security," or of locating security only within the home, Kinkade was at the forefront of a different kind of right-wing nostalgia for 1950s America that emerged in the post-9/11 build-up to war through cold war–inflected rhetorics of domestic containment and ever-increasing threat levels.[39] With the same political sense, speedy response,

and market savvy he showed in the 1980s, Thomas Kinkade embraced these particular versions of patriotism and "freedom" as key components of his Light trademark.

As I conclude this essay, writing at the close of the 2008 presidential campaign and the last days of the George W. Bush administration that Kinkade once seemed to herald in his *Hometown Morning* canvas, it is hard to say what paths the Painter of the Right will take in the coming years. His trademark Light seems to have dimmed as we confront the toll in human lives and human rights of an endless War on Terror, ongoing wars in Iraq and Afghanistan, the devastation of the American housing markets, global recession, and financial turmoil—whither "The Gates of Coeur d'Alene?" This electoral cycle has witnessed the continued centrality of self-identified evangelical "values voters" but also the fracturing and potential realignments of what had once seemed a solid Religious Right. What is clear, however, is that we have not heard the last of Thomas Kinkade. The "painter-communicator's" work, message, and business plan are adapting and will continue to morph not only to fit this new political and economic terrain but to shape and plow through it.

Notes

1. The commercial is collected in the American Museum of the Moving Image online exhibit "The Living Room Candidate: Presidential Campaign Commercials, 1952–2004," www.livingroomcandidate.org/commercials/1984 (accessed June 15, 2010). On the impact of this campaign ad and slogan, see Troy, *Morning in America*, 161–63.

2. Kinkade, *The Thomas Kinkade Story*, 149. It has been suggested that this is a self-portrait; see Kreiter, "Thomas Kinkade's American Dream," 38.

3. On the history of the rise of the New Right in Southern California, see McGirr, *Suburban Warriors*. On the historical development of linkages between the New Right and Christians and the development of the Religious Right in the United States generally, see Diamond, *Not by Politics Alone*; Martin, *With God on Our Side*; and McGirr, *Suburban Warriors*, 217–61. For the figure of two million new voters in the 1980 presidential elections, see Diamond, *Not by Politics Alone*, 69.

4. "Thomas Kinkade—Painter of Light," brochure available at the Thomas Kinkade Riverchase Gallery in the Riverchase Galleria, Birmingham, Alabama, summer 2006.

5. Kinkade, "Reflections," 19.

6. Quoted in Orlean, "Art for Everybody," 126.

7. Kinkade, "Holiday Inspirations," 16.

8. Daniel Marcus examines this tendency toward "conservative uses of nostalgia" in the political culture from the 1970s to the present in his *Happy Days and Wonder Years*.

9. Kinkade and Reed, *Thomas Kinkade*, 12.

10. Peter Goddard, "The Creator of This Painting Is One of the World's Most Successful Living Artists: What's He Doing Right?," *Toronto Star*, Nov. 1, 2003.

11. Rick Barnett describes Kinkade's rebirth "during an old-fashioned tent crusade in Southern California" in Kinkade, *The Thomas Kinkade Story*, 24. Randall Balmer identifies Calvary Chapel as its host in Balmer, "The Kinkade Crusade," 49. There are varying accounts of Kinkade's rebirth narrative circulating in the popular press and authorized biographies. Note, for example, the description Seth Feman recounts in his contribution to this collection.

12. See www.calvarychapel.com (accessed Oct. 25, 2008).

13. On the history of Calvary Chapel, see Balmer, *Mine Eyes Have Seen the Glory*, 12–30; McGirr, *Suburban Warriors*, 243–49; and Miller, *Reinventing American Protestantism*.

14. On Robert Schuller's Crystal Cathedral, see McGirr, *Suburban Warriors*, 249–54.

15. Miller, *Reinventing American Protestantism*, 21.

16. McGirr, *Suburban Warriors*, 248–49.

17. Ibid., 251.

18. Thomas Kinkade, *Living Waters: Golfer's Paradise, Hole One* brochure (July 2005), www.thomaskinkade.com (search: living waters) (accessed April 30, 2010).

19. Thomas Kinkade, *Lakeside Manor* brochure (May 2006), www.thomas kinkade.com (search: lakeside manor) (accessed June 15, 2010).

20. Press release, Thomas Kinkade Company, "New Housing Community in Columbia, MO Features Thomas Kinkade Homes," Aug, 14, 2006, www .thomaskinkadecompany.com (search: "News" tab, then chronology of press releases).

21. Diamond, *Not by Politics Alone*, 74.

22. On the dissolution of Moral Majority and the founding of the Christian Coalition, see Diamond, *Not by Politics Alone*, 72–80. On the Christian Coalition's first mass mailing protesting the NEA, see Martin, *With God on Our Side*, 303.

23. Vance, "The War on Culture," 221.

24. On this history, see Free Expression Policy Project, *Free Expression in Arts Funding*, 6–13; Hughes and Elovich, "Homophobia at the NEA," 233–34; and Vance, "The War on Culture."

25. Kinkade, *The Thomas Kinkade Story*, 51.

26. Quoted in Hyde, "The Children of John Adams," 253.

27. Kinkade, *The Thomas Kinkade Story*, 52.

28. Thomas Kinkade Collectors' Society Member Benefits, www.thomas kinkade.com (accessed Oct. 25, 2008).

29. Balmer, "The Kinkade Crusade," 53. Andrea Fraser examines the over-determined focus on the dung in Chris Ofili's work throughout the controversy sparked by the Brooklyn Museum of Art's September 1999 show Sensation: Young British Artists from the Saatchi Collection; see Fraser, "A 'Sensation' Chronicle," 132–34.

30. Kim Christensen, "Dark Portrait of a 'Painter of Light,'" *Los Angeles Times*, March 5, 2006; Bob Eyelko, "Artist's Firm on Hook for $2.1 Million," *San Francisco Chronicle*, June 18, 2009.

31. Kim Christensen, "Dark Portrait of a 'Painter of Light,'" *Los Angeles Times*, March 5, 2006.

32. It is interesting that this reported incident appears to have had no effect on Kinkade's relationship with the Disney Corporation; he continues to produce images utilizing Disney's characters.

33. Balmer, "The Kinkade Crusade," 53.

34. In the extreme lower, right-hand foreground of the painting stands one figure in green of indeterminate gender who appears to be a person of color. Notably this figure is almost always cropped out of the image for its extensive merchandizing on items such as commemorative plates and teddy bears. There are also two African American servicemen to the left of the image, one in the color guard (also usually cropped out) and another in an army uniform. Closer to the center of the image, this soldier is usually the only obvious nonwhite person in merchandised reproductions.

35. See www.thomaskinkade.com (search: light of freedom) (accessed April 30, 2010).

36. See www.thomaskinkade.com (search: symbols of freedom) (accessed April 30, 2010).

37. On FDR's Four Freedoms speech and Rockwell's images, see Foner, *The Story of American Freedom*, 219–27.

38. See www.thomaskinkade.com (search: hometown pride) (accessed April 30, 2010).

39. For discussion of the ways in which cold war metaphors and ideologies have shaped popular, governmental, and military responses to 9/11, see May, "Echoes of the Cold War."

God in the Retails:
Thomas Kinkade and Market Piety

SETH FEMAN

Although Thomas Kinkade has given various accounts of his religious re-
birth, he describes one event in particular as the moment "the light came
on."[1] In 1980, while sketching a nude model in art class, the sorrowful face
of Jesus materialized before Kinkade's eyes.[2] Though partially veiled in
shadow and crowned in thorns, a heavenly light surging with God's re-
demptive power shone across Christ's face, lifting the figure from earthly
pain into the warmth of heaven. According to Kinkade, this vision cast off
his youthful despondence and turned him into a believer.

After that particular vision faded, the revelation continued for Kinkade,
who found himself blessed with the ability to perceive the presence of God
as a ubiquitous ethereal light. Believing it his divine charge to share this
miraculous insight with others, Kinkade enhanced the role of light in his
art. Abandoning his earlier depictions of brooding landscapes and portraits
of the destitute, Kinkade adopted this radiance as the central theme of his
new bucolic landscapes and garden scenes.[3] As Kinkade explains it, his art
experienced its own religious conversion: "When I got saved, my art got
saved"; "The Painter of Light" was born.[4]

Kinkade was visited by a second revelation a few years after his con-
version. On completing *Placerville, 1916* (1985) as a fundraiser for his home-
town's new library, Kinkade decided to present copies of the image to the
two hundred donors who had commissioned the work. Wanting to fabri-
cate the most precise replicas possible, he perfected a printing process in
which he transferred a digital image of the painting onto a plastic substrate
and then affixed the printout onto canvas.[5] Producing convincing facsimi-
les, Kinkade immediately realized that mass production could widen the

scope of his nascent ministry, helping him "to share the hope and love of God" with a much larger audience.[6] As he understood it, "[God] gave me a way to create multiple forms of art that looked like the original, but weren't just a poster." God had given Kinkade the gift of mass reproduction.[7]

While God's gift advanced His mission, it also made Kinkade's work profitable.[8] By 1998 his proselytizing mission had become a modern market phenomenon. Having trademarked his born-again nickname and traded shares of Media Arts Group, Inc. (MAGI), his company, on the NYSE, his proselytizing business broke $120 million in annual sales. Kinkade's art empire had experienced the miracles of the market.[9]

Because Kinkade views each of these events, his personal conversion *as well as* his corporate ascension, as a series of divine interventions in his life, they come together to form the basis of his piety, a faith he shares with millions of collectors. In his public statements, captions, and books, and reflected in collectors' comments, Kinkade fuses elements of Christian orthodoxy and capitalist ideology into a single faith, what I call *market piety*, a veritable theology that believes free-market consumerism to be numinous.[10] To distill this piety, it helps to distinguish between Kinkade's faith and the beliefs held by his cultural antecedents who have similarly marketed Christianity.

To rationalize their religious faith with their market commitments, Kinkade's predecessors have tended to defend their enjoyment of economic abundance by proclaiming (often self-consciously) their dedication to authentic faith. Yet by spurning doubts about the sincerity of their faith, figures as diverse as Henry Ward Beecher, Bruce Barton, and Jim and Tammy Faye Bakker did more than justify their market involvement; by apprehending God's work in the market, they have developed a vibrant theological tradition in which attaining wealth substantiates divine favor. Indeed, Joel Osteen, the senior pastor of Lakewood Church in Houston, may be the most popular mouthpiece of the Prosperity Gospel to date, but his theology that sees economic success as evidence of sainthood dates back at least to seventeenth-century Puritans, among others.[11]

Kinkade is certainly heir to this tradition. Because the Christian beliefs developed by his imagery and biography always function as commodities within a strategic corporate system, he synthesizes evangelism with a capitalist common sense in ways comparable to those of his predecessors.

Yet Kinkade does not simply insist that God works through an otherwise profane market, thereby sacralizing it. Indeed, since commerce and Christianity have never been separate or contradictory for Kinkade, since he sees no categorical distinction between the two, he finds little need to harmonize them or to justify their collusion. Nor does Kinkade simply rely on evangelical-capitalist synchronicity to suggest that economic involvement and churchgoing could be a similar sort of devotion. Rather, what makes Kinkade stand out from other religious figures who have put their faith in the market is this: by mobilizing ideas about art to make evident his religious faith, Kinkade turns consumerism into the primary expression of devotion. Instead of simply bringing God to bear on the market or suggesting the market can perform godly work, both of which his predecessors have done, Kinkade uses concepts of art to sanctify consumerism, wholesale.[12]

Put simply, Kinkade's art and artifacts warrant attention not simply because they market Christianity but because of the particular ways they make consumerism religious. Using a broad concept of art to classify both religious practice and consumption, Kinkade brings them together, not simply evading but nullifying the tensions between spirit and material that his Protestantism might summon. The effect of this is profound. By making art consumption the principal ritual of his hybrid faith, Kinkade manufactures a theology of commodity exchange. Moreover, through Kinkade the consumption of art becomes a religiously meaningful way to transcend the difficulties of modern life (which ironically includes consumerism), making his hybrid market piety into an inconspicuous yet pervasive cultural identity for many of his collectors. Furthermore, since his faith is realized as a material practice, even those consumers and critics who resist the religious meaning Kinkade prescribes for his art tend to extol consumerism within the religious parameters he sets out for the market generally, thus acquiescing to his faith. Since to consume art is to practice this faith, shopping makes seeing into believing.

After his conversion Kinkade developed his relationship with God through daily prayer. He realized quickly that God intended for him to do more than simply share his vision of light; Kinkade came to understand that God wanted him to use art as a "direct frontline ministry."[13] Kinkade believed God, as his "art agent," directed him to reach out to the hearts of the un-

churched and convert them to the Christian faith.[14] Recognizing Judgment Day's imminence, he began working with particular urgency on his holy errand, hoping to expose as many as possible to Christianity through his art and save their souls.[15]

The Christian content in Kinkade's work can best be seen in typical images such as *Sweetheart Cottage III* (1994; pl. 2). As Kinkade asserts, the panorama's imposing scale and natural beauty represent God's masterful power and grandness. To substantiate this claim, Kinkade insists that nineteenth-century artists like Thomas Cole and Frederic Church are his forebears.[16] Those artists composed commanding landscapes that revealed God variously through nature's power, its beauty, and allegorical symbologies. Motivated by a sense of moral urgency in a moment of rapid industrialization and nation building, they often created and popularized their art in hopes that it would promote decency and benevolence.[17] Similarly concerned with maintaining morals in a modernizing age, Kinkade patterns his landscapes and symbolic systems after theirs. In particular, Kinkade draws on the vivifying light used in nineteenth-century landscapes, replicating it in his own work as a metaphor for God's salvific omnipresence. While the warm sun burning off the fog that blankets the valley in *Havencrest Cottage* taps into the religious meaning of light developed by earlier artists, it also builds a visual vocabulary to explain the personal awakening that lifted Kinkade out of his dark days and into a Christian life.[18]

Unlike his antecedents, however, who often painted nearly unoccupied landscapes, Kinkade includes the cottage in the foreground, which dominates the scene. Painted against the hazy backdrop with rich colors from a bolder palette and with a more solid hand, the prominent house commands the viewer's attention and its familiar domestic form stands out against the sublimity of the transcendental panorama. Lights radiating from within the home emit an almost palpable brilliance, enhanced by Kinkade's use of a nearly neon hue that pours through heart-shaped windows, encircling the cottage in an otherworldly halo. By contrasting the atmospheric, earthly luster of the distance, which already suggests God's salvific power, with an even more radiant glow inside the home, Kinkade extends his metaphor to fit his particular theological beliefs. Domesticating the divine illumination makes visible his modern-day, evangelical emphasis on personalizing piety and privatizing one's relationship with God.[19]

Similarly, Kinkade's works often prominently feature transitory motifs

like inviting bridges, open doors, swung-wide gates, and flower-lined passages that draw the viewer toward a luminescent destination. In inviting the viewer to enter the work with such details, Kinkade hopes that the uplifting experience of transitioning into the work and then approaching the light will replicate the stirring experience of his religious conversion—the sole requirement for salvation according to most evangelical theology. Yet, because Kinkade depicts familiar, naturalistic scenes instead of complex theological concepts (after all, roads, stairs, and glowing lights are not necessarily perceived as religious), the purely visual prompts compel the viewer to enact this inconspicuously religious journey without recognizing the relevant theology. Although many Christians appreciate the doctrinal basis of these metaphors, Kinkade designs his works to be experienced in a broad, generalized cultural context so that the simple act of beholding the images allows all viewers to experience the sensation of conversion, no matter what their religious affiliations.[20]

To assure these conversional metaphors are not lost on the uninitiated, Kinkade paints a second narrative into his images that merges evangelism with the quasi-religious therapeutic tradition, helping to direct viewers ever closer to his Christian message. Composed of a series of emblems that refer to Kinkade's personal biography (like his wife's initials or the dates of his daughters' births), his life story acts as an allegorical model, uplifting viewers by leading them through his example of pristine moral propriety and Christian conviction.[21] Each of his numerous books recounts his biography, from the detailed coverage in his *The Thomas Kinkade Story: A Twenty-Year Chronology of the Artist* (2003) to abbreviated versions in bestselling coffee-table collections like *Thomas Kinkade: Paintings of Radiant Light* (1995). News coverage and countless fan and reseller websites also recall details about his conversion, marriage, and his children's lives. In addition, gallery attendants in his stores and his company's staff are often required to memorize his biography and to repeat it when meeting with clients.[22]

Most significant, product descriptions and artist's statements that accompany each image, along with catalogues, promotional materials, and sales pamphlets, actively associate the anecdotes and memorable moments they contain with the painted emblems, giving them concrete meaning. Connecting his biography to the images, they prompt viewers to interact with the works while participating in Kinkade's religious journey. For example, the text that accompanies *Sweetheart Cottage III* states:

Nanette and I have been planning a trip to the Austrian Alps for months. I've wandered the verdant, flowering Alpine valleys in my mind, even climbed the soaring, snowcapped peaks (very likely the only way I'll do that). And this delightful vista expressed the best that I've "seen" on my imaginary ramblings.

Havencrest Cottage is poised on a hillside midway between the towering, sun dappled mountains, and the Alpine meadow, festive with blue Lupine. The jutting rock is the perfect perch for viewing the vast sweep of God's grandeur.

A rainbow symbolizes promises kept; my profound hope that the real trip will live up to my lovely anticipations.[23]

Given the series title, Sweetheart Cottage, and that he mentions his wife at the outset, Kinkade encourages the viewer to seek out emblems that refer to Nanette, like the red heart on the door painted with an N, the N etched into the chimney, and the one formed by crossing twigs behind the house. By implanting these referential details into the landscape so that they must be searched out, he does more than simply express his nuptial dedication; he suggests that his family values are what God has intended. As he indicates, "God's grandeur" is best viewed from the "jutting rock," which upon examination is as much the home's bedrock as it is a natural outcropping. The N incised in its side, as if by weather and time, mixes metaphors, linking marriage's holy union with the earth's genesis. Indeed, by ending the passage with a reference to rainbows as promissory symbols, Kinkade conjures up Genesis 9:12–17, in which, as part of their reconciliation after the Flood, God commands Noah to be "fruitful and multiply" and creates a rainbow to bless their covenant. As in the Bible, Kinkade's rainbow suggests his lifestyle takes up these biblical and familial commitments.

To suture the Christian basis to these familial symbols, Kinkade sometimes intersperses more specific Christian emblems as well. In addition to the titles of his works, often biblical allusions like *The Power and the Majesty*, *The Hour of Prayer*, and *The Mountains Declare His Glory*, he signs some images with a stylized fish that symbolizes Jesus and "John 3:16," evangelicals' most cherished verse, which highlights the significance of conversion.[24] He also offers "Inspirational Editions" that pair his images with framed scripture verses that function as captions.[25]

While one might assume that the religious biographical content would

dissuade non-Christians, viewers generally accept these details less as en-forced doctrine and more as evidence of Kinkade's good moral stand-ing—a personal expression that simply demonstrates his commitment to "values." As one collector put it, "Religion is not that important to us. . . . But it's nice to see [Kinkade] comes from a religious perspective and talks about family."[26] Another confirmed: "It means a lot to know not only that the artist is a fellow Christian, but to see the symbolism in his paintings as well as value he places in family [by] putting his family in certain paint-ings and hiding their initials."[27] Nonetheless, by mixing symbols meant to evangelize with those that refer to his biography, Kinkade's life story acts as a moralizing parable that is indivisible from his Christian faith. While insisting that his biography is a series of miracles ordained by God, the symbols Kinkade typically uses to describe his life, like the other visual metaphors in his works, do not appear conspicuously religious, nor do they necessarily resemble traditional iconography (only one of Kinkade's works prominently features a cross, and two depict Jesus). Instead, like his rain-bow, they appeal to an audience of any creed by using symbols anyone might find in daily life, even while they carry religious meaning.[28]

Despite the works' nonreligious appearance, in using these emblems and associating them with biographical texts that provide their religious sig-nificance, Kinkade follows, and then notably updates, a long tradition of Protestant popular art meant to be at once commonly appealing and reli-giously edifying. Like seventeenth-century emblem books that made an amusement of pairing illustrated symbols with metaphorically enriched, Scripture-based explanations, Kinkade invites viewers to search out the symbols from his life for fun. For example, about *Falbrooke Thatch* (1993) Kinkade playfully writes, "I've hidden hearts throughout the painting. The more hearts you can find, the more romantic you are."[29] Since romance for Kinkade is expressly related to the maintenance of a holy marital union, his version of the seventeenth-century "emblem book game" similarly teaches a religious-based moral lesson.[30] At the same time, fashioning his theology as a more commonly accessible diversion makes his religious outlook more widely replicable.

Kinkade's Life Values Collection, for example, builds directly on the pre-cedent set by Thomas Cole's religious series Voyage of Life (1842) by simi-larly presenting a four-part, metaphorical journey through life's waters. Harkening to Cole's four stages of life, Kinkade displays four "foundational

values of the good life [that] interweave in a seamless whole . . . the moral order of God's universe like an exquisite tapestry." As Kinkade explains, the first stage, *Perseverance* (2000), an image of a schooner tossed about in rough waters, but with glowing light and calm waters in the distance, "considers life as a voyage through stormy seas, a test of faith and a demonstration of God's sustaining love." *Courage* (2004; pl. 5), the second stage, which depicts the boat approaching a sun-basked lighthouse in the foreground from the dark and dreary sea, "expands on the metaphor of a sea voyage, bringing us to the moment of divine inspiration, when God graces us with courage beyond the merely human, the resolve we need to overcome any obstacle."[31]

Yet instead of inviting viewers to experience the religious lesson by following an angelic allegorical figure, as did Cole, Kinkade amends the tradition by offering himself and his own model life as a more familiar, worldlier archetype: "'Perseverance' is inspired by a real moment of doubt and determination. Sailing in a friend's schooner far out beyond Monterey Bay, we found ourselves swallowed in a fog bank, unable to see the shore. I wondered whether, if a storm broke out, we would have the courage and faith to make our way to shore? The storm does strike in 'Perseverance'; thunder crashes, sails billow, waves toss the fragile boat."[32] Then, in *Courage*, Kinkade transforms from the painter into the leader while allowing the viewer to become the voyager. Directing the traveler out of the storm, a metaphor for dark days, sadness, and loss, and into the light that represents God's divine care, he makes his own religious epiphany into a more common experience: "I make full use of a vocabulary of personal artistic symbols to convey this message: God rewards our perseverance with His gift of courage. Our lone sailor has come within sight of a lighthouse; the beacon of divine love will guide him to shore. . . . I painted *Courage* at a time when I was especially grateful for God's hand of deliverance in my life. May it remind you that courage is, truly, a gift from the Almighty."[33] By switching among roles—"*I* painted," "*my* life," "may it remind *you*," "*our* perseverance," "*our* lone sailor"—Kinkade communicates and connects with the viewer, folding his religious life and the viewer's personal life together. All the while, he makes the bourgeois fantasy of leisure, of boating in a schooner along the northern California coast, into a profound experience of faith, steering the more commonly idealized trajectory of upward mobility toward a religious epiphany.

This, it should be clear, represents a notable break from the artistic tradition Kinkade claims as his. While Cole, Church, and other landscape artists of their era often painted nature as sublime, which represented God's dominance over humans and their civilization, Kinkade inverts this relationship completely. Instead of focusing on feeble humans before a great and terrible God, Kinkade highlights humans and their built environment as the way to access "God's grandeur." As I have suggested, this may be partly theological, an expression of Kinkade's evangelical commitment to personal conversion. At the same time, it always represents that faith as a worldly one. If Kinkade paints a path to salvation, the vessel is laden with middle-class commodities—a manicured garden, a country home, a schooner, and, always, his works of art.

Kinkade clarifies this worldly faith most explicitly by developing his artistic persona in his bestselling inspirational book, *Lightposts for Living: The Art of Choosing a Joyful Life* (1999).[34] Much like Norman Vincent Peale's *The Power of Positive Thinking* (1952), or more recent self-help literature like Rick Warren's *The Purpose Driven Life* (2002) and Rhonda Byrne's *The Secret* (2006), Kinkade uses his seemingly nondenominational, inspirational text to coach readers through their daily lives. Yet where Peale's therapeutic "Guideposts" recounted the uplifting experiences of celebrities and ordinary people, Kinkade's "Lightposts" offer as examples anecdotes from his personal experience. Using his artistic process as a metaphor for how to lead a simple yet spiritually attentive life, he motivates readers to move from the book's reprinted images to their daily experience by impersonating his creative authority. "Your life is really part of an unfolding plan," he says, "a charted voyage, an exquisitely executed work of art. Every circumstance in your life, every event that occurs is moving you a little closer to your final destination. Every response you make adds another brushstroke to the final picture."[35] As promotional materials suggest, by teaching his readers to "thoughtfully apply creative intention to the real-world challenges of family, worship and faith, fitness, conflict, and relationships," he invites them to follow his artistic outlook in their own daily lives. Not only does associating his allegorical life with Christianity turn these "everyday tasks into a meaningful expression of God's goodness," but by characterizing the broadly spiritual, self-help tradition in artistic terms, Kinkade uses notions of art to merge religion and lifestyle until they are virtually indistinguishable.[36]

Interviews confirm Kinkade's success in using art to synthesize religion and daily life among his viewers. By calling attention to his biography in marketing materials and public statements, his fans often seek out the emblems he paints in, forming them into a coherent allegorical narrative that, in the process, coaxes them into an empathetic relationship with the artist and the religious morality he presents. Then, using his exemplary life as a benchmark to reassess and realign their own lifestyles, viewers take on his values and moral routines along with their semiveiled Christian meaning, following his religious journey as if it were their own. While the images do not necessarily inspire all viewers to spontaneously accept Jesus as their savior, Kinkade defines these commonly idealized values by the Christian context he develops around them. Accepting them on Kinkade's terms is a willing acceptance of a Christian identity.

One collector, for example, explained that she sent Kinkade postcards and greeting cards to friends "to let them show how the light of the Lord is shining out of me," in the same way it shines out of Kinkade.[37] Another made the point more vividly by recounting her fantasies of going to Kinkade's hometown and hunting for the cottages he paints, literally retracing his steps. Most of all, she wished to work in one of his galleries, not only to be around the art more often but because that was as close to Kinkade's religiously artistic life as she, a nonartist, could get.[38] A third interviewee revealed that she had actually sought out the places Kinkade lived and painted. To further replicate his lifestyle, she had even changed her career so she, too, could "share the glow inside my [own] heart," duplicating Kinkade's revelation. At her new job, counseling survivors of domestic violence, she gave out Kinkade's images, hoping to "bring a sense of nature and Spirit" to other women. Although there is no way to know how her clients reacted to the images, it seems likely that some of the women would have shared the solace and encouragement she found through the images. Her interview also indicates the incontrovertible practices that enliven Kinkade's images. By adopting Kinkade's Christian revelation personally and then reproducing it in this more general artistic language of uplift ("nature and spirit"), she highlights the process by which Kinkade's Christian beliefs, transformed through the material distribution of artworks, are made more commonly accessible.[39]

As this last interview helps to demonstrate, the lifestyle Kinkade promotes is far more complex than one that is solely and traditionally Christian.

While Kinkade substitutes his life story for religious allegories, updating the religious emblem tradition, inverting the meaning of nineteenth-century landscape paintings, and making his work enticing to a variety of modern consumers, including nonevangelicals, his biography provides a specifically domestic and upwardly mobile model championed by an alluring celebrity. Instead of simply teaching biblical lessons or leading viewers through a declaration of faith per se, Kinkade's artistic leadership and divinely sanctioned prosperity offer a worldly path by which viewers can experience and share in his religiously meaningful lifestyle. Kinkade may naturalize a religious landscape by making his persona a character within the image, but he also channels sentimental longings for material wealth to inspire religious lifestyles by moving beyond the frame. That is, shifting the focus from what his art represents to what art does as a cultural commodity, Kinkade emerges from his work as a persuasive cultural spokesman and lifestyle pundit, tapping into the notion of the artist as an expressive romantic to persuasively articulate his market piety.[40]

To foster this transition, Kinkade publicly describes his works in opposition to the brutal modernity he sees in the world, making his images shine ever brighter against it.[41] Crafting these antagonisms, he says, "My work reflects a slower pace in the midst of a frenzied world. . . . My work is an icon of hope, an antidote to CNN."[42] Yet when Kinkade positions his art within the culture wars, debates about morality, and what he characterizes as a cultural crisis, he accentuates this polarity by making it appear apocalyptic. Calling his work a "campaign for culture," he argues, "Art is the hot button in the cultural battle at play right now. . . . The disintegration of the culture starts with the artist."[43] Or again, "You have to expect spiritual warfare whenever you stand up for righteousness or call attention to basic values. It's just a matter of light battling darkness."[44] With prophetic flair he goes as far as allying the art world with violence, claiming that "bad" art is a gateway to pathological behavior: "On one side there's Jackson Pollock, and way over on the other side there's the Columbine shooting. And I know there's a connection between them. I don't know how, but I know it's there."[45] To prevent violence, he offers not only his moralizing images but also the good life he insists they promote.

This dichotomization, to be clear, does not split between spiritual and material realms, religious and commercial ones, nor even conservative and liberal perspectives per se (although Micki McElya would dis-

agree). Rather, Kinkade manufactures a divide between "good" art on the one hand and violence-inducing antiart on the other by using a rhetorical strategy to associate his art with religious faith and other art with heathenism. But while Kinkade casts this division by literally fashioning the culture wars as a religious crusade, another tactic materializes; he not only gives eschatological import to the tension between art and antiart, but he introduces the market as the way to perceive this distinction. Whereas few like modernism, he tells us, countless people purchase his art, proving its cultural relevance: "My art is relevant because it's relevant to ten million people. That makes me the most relevant artist in this culture. . . . Look at someone like Robert Rauschenberg. What's his Q rating? How many people have his art?"[46]

In this way Kinkade creates a logic in which the commercial success of his art maintains his art's religious value. Precisely by embracing his market success, rather than abnegating it, Kinkade effectively opposes his "good" art to antiart, thereby developing art as a category in which commercial and religious ideals combine and his market piety is revealed. To develop this logic, Kinkade calls himself a "populist artist," insisting that the public's fiscal devotion to him and his products demonstrates that he has been authorized to represent its will. "If my work became unpopular tomorrow," he explains, "I'd receive that message. And because I'm a servant of art, I'd say to our culture, 'Culture, how can I reflect who this nation is and what it needs?' And then I'd go deliver it."[47] By labeling consumers as his constituents and linking the market with democracy, Kinkade equates popular consumption with popular consent, turning the logic of market populism into a profound proselytizing tool.[48] As he suggests, since his faith openly defines his persona, his selection as a popular leader, evidenced by market success, substantiates the existence of a national pious audience. For him, proof of a common piety is in the payout; the "kingdom of God" becomes the entire market.

When Kinkade infuses populism with Christian terminology, he does so quite plainly: "I represent the forefront of an entirely new trend, a populist movement that takes images people understand and creates an iconography for our era."[49] Yet while Kinkade contends that his iconography popularizes his faithful worldview, his commercial strategies tend to focus less on the moralizing ideals he paints into the works than on the material exchange of his art. He insists, for example, "Anyone from any cul-

ture can celebrate the joy of walking through a fragrant garden, the peacefulness of a stream, a cozy cottage with glowing windows that beckon us to enter and sit beside the fire . . . universal images that represent the inner longings of all people . . . what I call the lifestyle of light."[50] But Kinkade makes this iconography realizable and commonly compelling as the "lifestyle of light" specifically by connecting it to everyday consumer culture, as he did in *Courage* with his schooner. In *Lightposts for Living* Kinkade develops the meaning of materialism further, defining the "lifestyle of light" not by the imagery he paints but as "a quality of living that, ideally at least, is unhindered by dark forces of negativity, overstress, and despair. . . . [It is] the golden light of fortunate circumstances . . . a great job, a happy family, a life of adventure."[51] More than the dreamy life in his paintings, these seemingly attainable ideals are the same sensations offered by middle-class consumerism; the sense of upward mobility, familial cohesion, and leisure-based freedoms can be obtained, he suggests, through art-object consumption.[52]

Consumption thus becomes a doctrine of salvation. Indeed, by binding faith to materialist lifestyles, Kinkade makes his market piety attractive, perhaps even second nature, to many consumers. As the collectors I interviewed confirmed, although many get pleasure from imagining themselves walking into Kinkade's fantastical images and living the moralizing lifestyle he promotes, they are under no illusions about his scenes' attainability, at least in this life. Rather than the otherworldly home and garden ideal depicted in his paintings, Kinkade makes the "lifestyle of light" appealing to them by offering material consumption of art, inflected with religious significance, as the solution to the tensions he has called forth. As one fan put it, as commodities the art gave her "a healthy glowing feeling each time I look at them . . . [because] they were all gifts from my husband and given with such love and thoughtfulness." As she recounted, her husband remembered her joy while shopping at a gallery and had saved up to make the purchase. No matter how lushly painted, the content of the images paled in comparison to this material symbol of their love. Though the images offered respite from daily life, the objects were more fulfilling to her as conspicuous signs of wealth, family, and leisure; the material perfection of daily life.[53]

Another woman clarified this point: She said, "I love to sit and stare at his work and imagine myself within the scenes he paints," but she gets

true "peace and solace" from the size of her collection. They cover "all four walls. I also have a pillow, mugs, figurines, water globes, calendars, etc. My family buys me Kinkade items all the time and I am bursting at the seams with them."[54] One woman went even further in describing the way Kinkade's images compelled her to save and spend, not just on his works but on other commodities as well. "I had to make payments over six months in order to own it, but it was so very worth it," she explained. "By gazing on the picture I created a vision of the little house near a brook that I'd like to own. I found that home and owned it for four and a half years."[55] For her Kinkade's creations offered respite from the world, not by quieting the consumerist desires that can make modern life challenging but, in fact, by promoting consumerism as a way to achieve inner peace.

In these ways Kinkade proselytizes his hybrid market piety by offering his images as a subterfuge for market interests. Yet, rather than merely using religiously moralizing imagery to move merchandise, selling God so to speak, Kinkade sells a consumerist ethos that is always indivisibly religious because it is also always artistic. Going beyond the religious content of the images, the symbols, familial emblems, and autobiographical parables, Kinkade's works *as commodities* tap into the uplifting sensations of consumerism and economic mobility. Through him as a symbol of artistic expressiveness, the transcendent experience of everyday capitalism—the elation of shopping, spending, and owning—becomes a conversion experience. Yet unlike typical evangelical conversions that wholly alter viewers' subjectivities, his images do their biblical work by functioning as common commodities, albeit commodities intoned by Kinkade's artistic context. Indeed, rather than bringing heaven to earth, Kinkade's art reifies it, transmuting paradise into property. As one interviewee tellingly described her favorite Kinkade work, "I think heaven is that universal and welcoming. . . . It looks like a place of devotion, but it doesn't look anything [like what] I would immediately describe as 'Christian' or any other faith." However, what makes the images so popular, she went on to say, is that "they are just products. . . . It's just consumerism."[56]

Skeptics suspicious of Kinkade's sincerity in harmonizing the market and religion through art often balk at the idea that "just consumerism" could have devotional significance. Yet, as the interviews I undertook suggested, there is little conflict for most consumers. In fact, for some collectors the sensation of consumerism helps them to express and experience

their faith. Kinkade has facilitated such a piety by resolutely defending his beliefs since Media Arts' founding, rationalizing his market piety in the process. Insisting his multimillion-dollar earnings are "blessings" God has given him, Kinkade argues that profiteering is part of a divine plan, that sales document the spread of God's message. "The drive is not material. The drive is not commercial success," he claims. "The drive is utilizing whatever talent you have to bless others. . . . I want to use the paintings as tools to expand the kingdom of God."[57]

To refute his staunchest critics, he asserts, "I don't have a company, I have a cause," yet it would be counterintuitive for Kinkade to disavow his economic success.[58] According to the market populist logic he uses to naturalize his piety, there is nothing particularly contemptible about being corporate; rather, for him profit is praiseworthy. Tapping into market populism not only justifies Kinkade's profiteering by making it seem democratic but also situates his company, Media Arts, within similar late-1990s corporations that used that logic to make free-market capitalism a matter of faith. *Forbes* magazine affirmed the connection between Media Arts and the rest of the Internet economy when it honored the company on its list of top-two-hundred small companies, along with a host of dot-com ventures. Jubilant with free-market praise, the report explained that, like its Silicon Valley allies, "Media Arts sells not so much products as image, and sentiment."[59] By using art to make consumerism and religion simultaneous lifestyles, *Forbes* suggested, Media Arts acted like other New Economy start-ups that creatively sold Americans on the Internet lifestyle by offering consumerism as the path to utopia.[60]

As typified by Media Arts, Internet companies in the 1990s demonstrated unprecedented devotion to laissez-faire markets, often using God as their metaphor. By exalting the materialist values of money and product to the immaterial level of liberal individualist lifestyles, companies gave market participation spiritual magnitude, characterizing the entire economic climate as a sort of awakening. Not only did they present consumerism as an uplifting personal makeover (the stuff of Kinkadian religious conversion), but they also declared that consumerism would function much like evangelistic self-determinism.[61] With such latent theological meaning creating a commonplace market piety of the broader economy, Media Arts simply made the religious connotation explicit. Indeed, while Kinkade's conversion and the religious imagery he paints may be one way

faith characterizes his art, Media Arts' association with the New Economy and its market populist logic may have been as generative in asserting the brand's religiosity.

When one art-marketing consultant called Media Arts "the dot-com of the art scene," it was not just guilt by analogy, however. Since going public the company had assembled itself like any other venture capital-backed Internet company structurally, geographically, and through personnel affiliations.[62] Most important, this meant transitioning, as one company vice president put it, "from image-based equity to a style-based brand."[63] By stepping up its production of art-related goods, focusing less on items that replicated Kinkade's paintings, and instead licensing out the brand to a variety of nonrepresentational goods like carpets, wallpaper, and house paints, the company flourished.[64] At the same time, the ease of shifting from image to object sales affirmed what interviews revealed; while the content of Kinkade's images offers pleasurable fantasies and sets up a religious framework, it is the act of consumerism that offers spiritual uplift. Although it seems to be contradictory, by shifting from image-based to object-based sales, Media Arts deliberately marketed the immaterial sensations of lifestyle by highlighting the pleasures of object consumption, always enhancing this by couching consumerism and the objects in artistic terms. Instead of selling mere commodities, ephemera with limited use value, Media Arts mystified material worth in terms of art and religion, exalting the sensations of consumerism with impressions of relationships, identities, and moralizing emotions.[65]

To ensure that a twenty-dollar screensaver, or even the less representational "Sweetheart Cottage" daisy bouquet, would carry as much religious meaning as *Havencrest Cottage*, Media Arts recast its licensing empire as "a multi-dimensional lifestyle brand."[66] As Kinkade blithely explained it, distilling his Christian-based moralizing lifestyle into the salable essence of a brand name, "The conversion of the Thomas Kinkade image into a fully-integrated lifestyle brand, with towels bearing the brand 'Thomas Kinkade,' . . . will suggest the home values you see in the prints."[67] Although this also hinted at a suggestive division between Kinkade the person and Kinkade the trademark, Media Arts could now methodically synthesize a new Kinkade persona that better secured the artist's Christian beliefs to the commodity enterprise.[68] Solely through a brand name, Media Arts set out to save souls.

By 2002, after Media Arts shared in the economic downturns that notoriously plagued the Internet economy, Ron Ford, the company's CEO, smoothly assured investors of Media Arts' recovery strategy. He explained that the company had been so enchanted with spreading Kinkade's message that it had allowed poor business maneuvers to pull Media Arts from its message-based course into bad investments, weak markets, and nonviable ventures.[69] To pull out of its slump, the company would return to its foundational elements, not only by trimming back extraneous risks, such as an unsuccessful Internet product, but by concentrating on Kinkade wholeheartedly in order to return to its commitment to God. As Ford explained, "The company was distracted . . . from its message, which is to share God's light everywhere. . . . We're back to basics and very focused on the Kinkade brand." Instead of sharing God's light by accentuating the religious meaning in Kinkade's paintings per se, the company planned to reaffirm its faith by increasing its "focus on the Kinkade brand." Yet in saying this, Ford did not disavow art. Rather, he affirmed that art was the essence of the Kinkade message, the brand, and that only by concentrating on art would the company be able to do the work of salvation. According to Ford, selling the name brand would spread God's message; the company's return to God would be a turn toward better business.[70]

The apotheosis of Kinkade's sacralization of shopping appeared on the market that year with the release of his "Painter of Light" credit card.[71] The branded Visa card depicts Kinkade's *Spring Gate*, an image portraying a dirt path winding around a bend, past a brick wall, and toward a glowing destination—each a part of Kinkade's conversional repertoire. No matter how irreducible such conversional metaphors of ministry may seem, an overlaying Visa imprint, eagle hologram, and MBNA logo assert the card's economic function. Yet these symbols of the economy do not diminish the card's religiosity; as part of a constellation of trademarks they enhance it, synthesizing because they are foregrounded by Kinkade's art. Counterpoised atop the painting, the Painter of Light trademark logo and Kinkade's fish-topped signature balance the icons of credit lines with trademarks of Kinkade's Christian beliefs, fusing common capitalist culture and the ineffable experience of faith through art, charging them as a simultaneous gesture.

So prevalent is this market piety that even those who have not bought into Ford's appraisal of the company's Christian recommitment tend to

show unwavering dedication to the faith, even if they doubt Kinkade's sincerity. For example, in 2006, when a group of former gallery owners accused Kinkade and Media Arts of defrauding them, the proceedings were replete with references to religion. Norman Yatooma, an attorney representing six class-action suits against Media Arts, explained to reporters: "Dealers were induced to become dealers by way of Kinkade's persona. He holds himself out as a Christian. It's not just a business, it's a ministry. An opportunity to take part in God's work."[72] The majority ruling in favor of one suit's claimants reiterated this point: "[The company] created a certain religious environment designed to instill a special relationship of trust surrounding the investment. Media Arts, through its agents . . . held itself out to be acting on a higher plain [sic] and . . . [used] terms such as 'partner,' 'trust,' 'Christian' and 'God' and many other direct and also oblique references to a higher calling." With such a high level of trust, the ruling continued, the gallery owners understandably "saw no reason to seek legal counsel" regarding their arrangement with Media Arts, even though they sought legal advice in all their other business dealings.[73]

In other words, what ultimately made "good faith" go bad was not Media Arts' unsavory business dealings, only some of which were found to be fraudulent—specifically Kinkade's undercutting side deals but not the raw deal of a franchise system in which the operators assumed nearly all the risk. Rather, the ruling suggests that the language of God had been a misrepresentation of Kinkade's business but not necessarily his art. The claimants were defrauded because, as reports indicated, they had sought "to share God's light with the Painter of Light" without recognizing that business might not have been as godly as Kinkade's imagery.[74] While the arbitration association condemned Media Arts for not making its business meet the godly expectations set by the art, it upheld the possibility that religion *could be* a valid element of business practice in better hands. Despite its accusation that the art's message and business practice did not pair up, the ruling stated that "overt religiosity [in business] was not unreasonable." Indeed, even while reprimanding Kinkade, the commentary was peppered with the religious language Kinkade brought to the market in the first place, allowing it to move fluidly between the business notion of "a covenant of good faith" and the good faith of the Good Book.[75] Though unconvinced of Media Arts' connection to the divine light in Kinkade's imagery, it suggested that the market could, perhaps in more honest hands,

be as glorious as Kinkade's landscapes purported to be. Falling in line with the free-market common sense of the time, the ruling sanctioned market piety as a valid and coherent belief system.

In other words, efforts to determine if the "covenant of good faith" did correlate to the Good Book did not broach the question of whether it should, and thus merely helps to reveal what was truly at stake.[76] Kinkade's language had so powerfully formulated and manipulated public discourse that his market piety seemed natural, rather than anathema, to the free market. One reporter made this point most clearly by cynically recounting that "in the 13 minutes he granted for an interview, Mr. Kinkade used the word 'family' 17 times." However flip this observation may be, it demonstrates that even while deriding the connection between "Kinkade" and "family values," the terms have become so nearly synonymous that such criticisms simply reiterate the relationship. By rhetorically structuring and limiting the ways people can conceive of Kinkade and the market by which he is experienced, his market piety becomes nearly insurmountable.[77]

Notes

1. Another report (the one cited in Micki McElya's essay herein) claims he converted while on a date at a tent revival. The one described here appears in the catalogue to Kinkade's 2004 gallery show (see Vallance, *Thomas Kinkade*, 9) and is repeated in Jeffrey Vallance's contribution to this collection. For another alternative, see Peter Goddard, "The Creator of This Painting Is One of the World's Most Successful Living Artists: What's He Doing Right?" *Toronto Star*, Nov. 1, 2003.

2. The artist captured this miraculous revelation from God in a painting he would later publish as *The Prince of Peace* (1999; see Morgan fig. 7).

3. See Wooding, "'Simpler Times' with 'The Painter of Light'"; and Christina Waters, "Selling the Painter of Light," *AlterNet*, Oct. 16, 2001, www.alternet.org/story/11730 (accessed June 23, 2010).

4. Laura Sheahen, "'When I Got Saved, My Art Got Saved,'" *Beliefnet*, April 30, 2002, www.beliefnet.com/story/105/story_10518.html (accessed June 23, 2010); and Orlean, "Art for Everybody," 124.

5. See Raffety, "Thomas Kinkade"; and "Interview with Herbert D. Montgomery."

6. Homer, "Thomas Kinkade," 2; and Sam Whiting, "Let There Be Light: Sentimental Painter Thomas Kinkade Has a New Book for 'Joyful' Living," *San Francisco Chronicle*, May 26, 1999.

7. Marco R. della Cava, "Thomas Kinkade: Profit of Light," *USA Today*,

March 12, 2002; and Orlean, "Art for Everybody," 124. Like descriptions of Kinkade's conversion, there are other versions of his printing discovery. See, e.g., Kinkade and Reed, *Thomas Kinkade*.

8. Raffety, "Thomas Kinkade"; Sam Whiting, "Let There Be Light: Sentimental Painter Thomas Kinkade Has a New Book for 'Joyful' Living," *San Francisco Chronicle*, May 26, 1999; Christina Waters, "Doubting Thomas," *San Jose Metro*, Sept. 6–12, 2001; and John Leland, "Subdivided and Licensed, There's No Place like Art," *New York Times*, Oct. 4, 2001.

9. Balmer, "The Kinkade Crusade," 49; Smith and Baker, "Sunny Side Up," 200; and Orlean, "Art for Everybody," 124.

10. In 2001 I collected interviews at dozens of galleries and bookstores in the eastern United States, and in 2004 I gathered thirty-eight write-in testimonials solicited through ads in *Sojourners*, *Christianity Today*, and *Christian Century*. These interviews are identified in subsequent notes by a number. See http://chnm .gmu.edu/tools/surveys/form/303.

11. Many scholars have done work on the interaction between religion and the market in the United States, often highlighting the ways faith has been rationalized with the "secular" market. At times, this rationale seems to operate under an inherited pretense that the market is indeed profane or that religion is somehow a different, more sacred, order of experience than daily experiences such as market exchange. While perceiving this division, and overcoming it, seems to be true for many of the cases they analyze, Kinkade suggests that the market is, in fact, a religious realm, making his faith in the market syncretistic, not a matter of Christian belief sacralizing the market or of the market being used as a profane tool to proselytize. Colleen McDannell's historiographical work helps explain why scholarship often reinscribes sacred-profane divisions; Bruce Forbes's and Jeffrey Mahan's collection classifies the basic relationship typically perceived between religion and popular culture. See McDannell, *Material Christianity*, esp. 1–66; and Forbes and Mahan, *Religion and Popular Culture in America*. Also see Moore, *Selling God*; Schmidt, *Consumer Rites*, esp. 262; Morgan, *Protestants and Pictures*, esp. 341; Frykholm, *Rapture Culture*; and Giggie and Winston, *Faith in the Market*.

12. I thank David Morgan for challenging me to rethink Kinkade's relationship to some of these antecedents. Morgan's book *Protestants and Pictures* demonstrates impressively how art and notions about art and aesthetic value mediated between the commercial realm of mass production and religious concerns. As I argue here, in taking up this trend, Kinkade pushes further into the market than his antecedents, to the point that Christian faith becomes subsumed by a general faith in the market, which is characterized by, but not limited to, Christianity.

13. Jasper, "A Beacon in the Night," 15.

14. Smith and Baker, "Sunny Side Up," 200; Patti Davis, "Rich Man, Poor Man," *Los Angeles Times*, July 26, 2000; and Kinkade, "Putting God into Words."

15. On completing each image, Kinkade gathers his family and prays for God's approval, asking that the work be used as a ministry. Balmer, "The Kinkade Crusade," 50, 53; Wooding, "'Simpler Times' with 'The Painter of Light.'"; Pamela Yip, "Thomas Kinkade's Paintings Dazzle Christian Collectors," *Knight Ridder/Tribune News Service*, Jan. 24, 2001; Wakefield, "Saving Souls through Painting," 42; Kreiter, "Thomas Kinkade's American Dream," 66; and Michael J. Paquette, "Popular Artist Dips His Brush in Divine Inspiration," *Washington Post*, Feb. 21, 1998.

16. Hunter Drohojowska-Philp, "Painted into a Corner?" *Los Angeles Times*, April 4, 2004; Kinkade, "Maximalism"; and Kinkade and Reed, *Thomas Kinkade*, 11–12.

17. Miller, *American Iconology*; Miller, *The Empire of the Eye*; Truettner and Wallach, *Thomas Cole*; and Wallach, "The *Voyage of Life* as Popular Art."

18. Jasper, "A Beacon in the Night," 15; and Kinkade, "Maximalism," 20.

19. Balmer, "The Kinkade Crusade," 55. For a critique of this detail, see Wolfe, *Intruding Upon the Timeless*, 147.

20. Kinkade does this intentionally (see Jasper, "A Beacon in the Night," 15). As he says, "The power of the written word is being weakened and that should not be a scary thing for the Christian Church because ultimately, God's Word, though it is a written word, is only of power when it is enlivened by the Holy Spirit in the hearts of men. . . . It's very interesting how powerful these paintings have become in people's lives. . . . God would touch people through these paintings . . . people would have physical healings in front of the paintings and . . . they had had a salvation experience and had come to know Jesus" (Wooding, "'Simpler Times' with 'The Painter of Light'").

21. Jasper, "A Beacon in the Night," 15; and Wooding, "'Simpler Times' with 'The Painter of Light.'"

22. Tessa DeCarlo, "Landscapes by the Carload: Art or Kitsch?" *New York Times*, Nov. 7, 1999; and Orlean, "Art for Everybody," 124.

23. See www.christcenteredmall.com/stores/art/kinkade/sweetheart-cot tage-3.htm.

24. For Kinkade on John 3:16, see Pamela Yip, "Thomas Kinkade's Paintings Dazzle Christian Collectors," *Knight Ridder/Tribune News Service*, Jan. 24, 2001; and Christina Waters, "Selling the Painter of Light," *AlterNet*, Oct. 16, 2001, www.alternet.org/story/11730 (accessed June 23, 2010). Some viewers also envision subliminal religious symbols like crosses. See www.thomaskinkadedestin .com/trivia.htm (accessed Oct. 12, 2006).

25. "Thomas Kinkade Inspirational Prints Illustrate the Eight Daily Readings

for National Bible Week, 2000," *National Bible Association*, www.nationalbible
.org/nbw/00/wokinkade01.htm (accessed Oct. 12, 2006).

26. Quoted in John Leland, "Subdivided and Licensed, There's No Place like
Art," *New York Times*, Oct. 4, 2001.

27. Interview no. 4, April 4, 2004.

28. See Homer, "Thomas Kinkade," 2.

29. See www.christcenteredmall.com/stores/art/kinkade/sweetheart-cot
tage-2.htm (accessed June 23, 2010).

30. Fan sites attest to the way viewers play these games; see www.artonthe
web.com/kinkade-trivia.htm; and www.thomaskinkadedestin.com/trivia.htm
(accessed Oct. 12, 2006). For an example of a seventeenth-century emblem book
see Quarles, *Emblems, Divine and Moral* (1635). On the emblem book lineage from
Quarles to Cole, see Wallach, "The *Voyage of Life* as Popular Art." Also see Bruyn,
"Toward a Scriptural Reading of Seventeenth-Century Dutch Landscape Paint-
ings," 100.

31. *Art of the South* (Feb. 2004), www.artofthesouth.com/Thomas_Kinkade/
Courage.php (accessed June 23, 2010); and Christ Centered Mall, www.christ
centeredmall.com/stores/art/kinkade/perseverance.htm (accessed June 23,
2010). Also see Wooding, "'Simpler Times' with 'The Painter of Light.'"

32. Christ Centered Mall, www.christcenteredmall.com/stores/art/kinkade/
perseverance.htm (accessed June 23, 2010).

33. *Art of the South* (Feb. 2004), www.artofthesouth.com/Thomas_Kinkade/
Courage.php (accessed June 23, 2010).

34. Kinkade and Buchanan, *Lightposts for Living*. Similarly his one-a-day calen-
dars pair images with daily "Lightposts." Also see Guttmann, "Thomas Kinkade's
Artistic Values," 2.

35. Kinkade and Buchanan, *Lightposts for Living*, 217. Kinkade pairs artistry
itself with Christianity:

> Art is a faith profession. You take a white piece of canvas and create some-
> thing that wasn't there before. Involved in that process is faith. You'll reach
> roadblocks and stumbling blocks, points where you falter—when you
> need to just be at peace and know that God will work all things together
> for good for those who love Him. So I do that process daily. I pray when
> I come up against a difficult time in a painting and I say, "OK, Lord, you're
> just going to have to do a miracle here because I don't know what to do."
> Inevitably I feel God's comfort and His presence. I would say, commit your
> talents to the Lord, whether it's painting, singing, writing, or running a
> business." (Jasper, "A Beacon in the Night," 15)

36. See Kinkade and Procter, *The Art of Creative Living*. T. J. Jackson Lears
has argued that the "therapeutic ethos" of "self-realization" replaced the salvific

Protestant work ethic. Instead of treating them distinctly, Kinkade merges the two, offering a therapeutic ethos that promotes self-realization *as* religious. See Lears, "From Salvation to Self-Realization."

37. Interview no. 18, Aug. 8, 2004.

38. Interview no. 4, April 4, 2004.

39. Interview no. 9, April 4, 2004.

40. Kinkade, "Maximalism," 20.

41. Wolfe, *Intruding Upon the Timeless*, 145–46. Mary Midgley helps illuminate the constructedness of the world Kinkade paints and implies. As she says, sentimentality is developed by "misrepresenting the world in order to indulge our feelings," or rather, it is a kind of dishonesty perceived through an object-based representation of reality. The problem of sentimentality is not so much its saccharine distortion of reality but its evoking of brutality as a more pervasive standard (see Midgley, "Brutality and Sentimentality").

42. Christina Waters, "Doubting Thomas," *San Jose Metro*, Sept. 6–12, 2001; Peter Whittle, "Thomas Kinkade: Let There Be Light," *Financial Times*, June 10, 2003; Kreiter, "Thomas Kinkade's American Dream," 66–68; and Pamela Yip, "Thomas Kinkade's Paintings Dazzle Christian Collectors," *Knight Ridder / Tribune News Service*, Jan. 24, 2001.

43. Balmer, "The Kinkade Crusade," 53.

44. Jasper, "A Beacon in the Night," 15–17. Honing in on his moral righteousness, he has even suggested his own divine status: "If the critics want to attack, let them attack. I must, as Christ himself said, be about my Father's work" (quoted in Marco R. della Cava, "Thomas Kinkade: Profit of Light," *USA Today*, March 12, 2002).

45. Christina Waters, "Selling the Painter of Light," *AlterNet*, Oct. 16, 2001, www .alternet.org/story/11730 (accessed June 23, 2010); and Hunter Drohojowska-Philp, "Painted into a Corner?" *Los Angeles Times*, April 4, 2004.

46. Quoted in Orlean, "Art for Everybody," 124. Indeed, "relevance" is a trope that appears again and again in Kinkade's interviews. Also see Hunter Drohojowska-Philp, "Painted into a Corner?" *Los Angeles Times*, April 4, 2004; and Peter Whittle, "Thomas Kinkade: Let There Be Light," *Financial Times*, June 10, 2003.

47. Marco R. della Cava, "Thomas Kinkade: Profit of Light," *USA Today*, March 12, 2002.

48. On market populism, see Frank, *One Market Under God*.

49. Tessa DeCarlo, "Landscapes by the Carload: Art or Kitsch?" *New York Times*, Nov. 7, 1999. On Kinkade's populism, see Hunter Drohojowska-Philp, "Painted into a Corner?" *Los Angeles Times*, April 4, 2004; and Harvey, "Skipping Formalities," 18.

50. Homer, "Thomas Kinkade," 2. Also see Wooding, "'Simpler Times' with

'The Painter of Light.'" It is important to note that Kinkade makes his Christianity more or less explicit depending on his audience. For example, while talking to a syndicate he says, "I like to keep my theology and my politics very private because people of all faiths, backgrounds and political beliefs embrace these paintings. My primary calling has been to go beyond the borders of established Christianity into the different masses, into the people who may not be able to be reached by a televangelist" (Pamela Yip, "Thomas Kinkade's Paintings Dazzle Christian Collectors," *Knight Ridder / Tribune News Service*, Jan. 24, 2001). But for the *New American* he says, "My work is a direct frontline ministry. It goes into people's homes and hearts who are unchurched. Many of the people who love my work have never heard the Gospel, and God can use me and these paintings to reach them" (Jasper, "A Beacon in the Night," 15). The message, however, is effectively the same in both; he seeks to unify all viewers through the shared experience of religious uplift.

51. Kinkade and Buchanan, *Lightposts for Living*, 2. Kinkade also explains the common attainment of his lightposts in Lori Tobias, "Seeing the Light: Thomas Kinkade Talks about His Spiritually Inspired Art," *Rocky Mountain News*, April 11, 1999.

52. On the overlap of dominant cultural ideals such as individualism, private property, economic ascendancy, and nuclear family cohesion with a religious value system, see Demerath, "Cultural Victory and Organizational Defeat in the Paradoxical Decline of Liberal Protestantism"; Moore, *Selling God*; Finke and Stark, *The Churching of America, 1776-1990*; and Eduardo Porter, "Give Them Some of That Free-Market Religion," *New York Times*, Nov. 21, 2004.

53. Interview no. 10, April 4, 2004.

54. Interview no. 3, April 4, 2004.

55. Interview no. 9, April 4, 2004.

56. Interview no. 28, Nov. 11, 2004.

57. Balmer, "The Kinkade Crusade," 51–52; and David Lazarus, "Dark Days for 'Painter of Light,'" *San Francisco Chronicle*, March 3, 2002.

58. John Storey and Laura Kleinhenz, "God Is in the Detail," *Independent on Sunday* (London), Feb. 24, 2002.

59. McCormack, "Making People Feel Good about Themselves," 222. CEOs echoed this sentiment as well. Ron Ford, for example, said, "We're not in the art business. We're in the hope and inspiration business" (Marco R. della Cava, "Thomas Kinkade: Profit of Light," *USA Today*, March 12, 2002); see also Frank, *One Market under God*.

60. See Frank, *One Market Under God*.

61. See Kintz, *Between Jesus and the Market*; Frank, *One Market Under God*; Kelly, *Out of Control*, 1–2, 468–72, and chap. 24, "The Nine Laws of God"; Gilder, *The*

Spirit of Enterprise, 258; Edwards, "The Basilica Chip," s140; and Wriston, *The Twilight of Sovereignty*.

62. Calvin Goodman, quoted in David Lazarus, "Warehouse Full, Galleries Empty at Kinkade," SFGate.com, Jan. 27, 2002, http://articles.sfgate.com/2002-01-27 (accessed June 23, 2010). Indeed, Media Arts' corporate directory reads like a Who's Who of Silicon Valley elites. For example, when hired as Media Arts' EVP and CFO in 2001, Herbert D. Montgomery had been an executive at technology and service sector companies such as Cotelligent and Guy F. Atkinson Company. Most recently he had served as the CFO of Standard Media International, Inc., the publisher of the *Industry Standard Magazine*—generally regarded as an insider's guide to dot-com investing and culture. Likewise, Kenneth Raasch had been the president of Trustec Financial Group, Inc., before forming Lightpost Publishing with Kinkade and, while working with Kinkade, served as the president and majority shareholder of First Med Corp, Inc. After leaving Media Arts in 2000, Raasch formed an Internet company affiliated with Hewlett-Packard called Onvantage, Inc., that sold software and offered content management services. Interestingly, Raasch is also reported to be a director of the Council for National Policy, a secretive (once stripped of its nonprofit status for hiding information) conservative Christian lobby group founded by Tim LaHaye of *Left Behind* fame. See Susan Edstrom, "Proxy Statement for Annual Meeting of Stockholders," *Media Arts Group Inc. Central Index* (SEC file no. 000–24294, film no. 96600438, Sept. 10, 1996, www.sec.gov/archives/edgar/data/924645/0000891618-96-001422.txt [accessed May 10, 2010]); "Creative Brands to License Thomas Kincaid," *Home Accents Today*, Jan. 28, 2002, www.homeaccentstoday.com/NewsAnalysis012802.asp (accessed Oct. 12, 2006); and Onvantage press release, "Onvantage Provides Turnkey Private-Label Microportal Solution to Enable HP to Offer Internet Access to Its Employee Purchase Program Customers," Dec. 13, 2000, www.investorville.com/ubb/Forum10/HTML/000003.html (accessed Oct. 12, 2006).

63. "Westinghouse to Offer Thomas Kinkade Lighting Products," PR *Newswire*, March 16, 2004. One executive, Kenneth Raasch, also spoke of Kinkade as a brand and a person but added that faith had become the brand: "We created a brand—a faith and family brand—around a *painter*. The Kinkade brand stands for faith as a foundation for life. He creates a world, and that world makes people feel a certain way. So we saw it as a great opportunity to create products around those worlds—collectible products, books, calendars, home décor items—furniture likely to be found in Thomas Kinkade's world" (Christina Waters, "Doubting Thomas," *San Jose Metro*, Sept. 6–12, 2001).

64. "Art (Industry Annual Report)," *License!* 6, no. 9 (Oct. 2003): 22; Molaro, "Light Ideas"; "Westinghouse Lighting Corp.," 76; and "Evolution of Thomas

Kinkade Brand Continues at Licensing 2004 International Show," *Business Wire*, June 2, 2004.

65. The use of Kinkade galleries to house singles events illustrates this change toward lifestyle marketing. See Tanya Enberg, "Mixing Up the Dating Scene," *24 Hours* (Toronto), March 3, 2004.

66. "Westinghouse to Offer Thomas Kinkade Lighting Products," PR *Newswire*, March 16, 2004; and King, "Suburban Legend."

67. Peter Goddard, "The Creator of This Painting Is One of the World's Most Successful Living Artists: What's He Doing Right?" *Toronto Star*, Nov. 1, 2003; Christina Cheddar Berk, "Kinkade May Be Next Lifestyle Brand," *Wall Street Journal*, July 2, 2003; and Molaro, "Light Ideas."

68. Derdak, "Media Arts Group, Inc."; Orlean, "Art for Everybody," 124; Harvey, "Skipping Formalities," 16; and Christina Cheddar Berk, "Kinkade May Be Next Lifestyle Brand," *Wall Street Journal*, July 2, 2003. In 2002 Kinkade's company hired a former senior vice president from Martha Stewart's Living Omnimedia to help define a unique palette as an aesthetic prompt for brand identity (see Guttmann, "Thomas Kinkade's Artistic Values"); Thomaselli, "Kinkade to Light Up More Than a Canvas," 4; and Brenda L. Moore, "'Painter of Light' Sketches New Role: Self-Help Guru," *Wall Street Journal*, March 24, 1999.

69. Silberman, "A Changing Light," 50, 52; see also "Thomas Kinkade in Deal to Take Company Private," HFN: *Weekly Newspaper for the Home Furnishing Network*, Nov. 17, 2003, 26.

70. Silberman, "A Changing Light," 50, 52; see also "Thomas Kinkade Artwork to Be Featured at CBA Expo in Indianapolis," *Business Wire*, Jan. 27, 2004.

71. "Kinkade Print to Benefit Charity, New Kinkade Credit Card Released," 16.

72. Matt King, "Dark Days for Painter," *Gilroy Dispatch*, March 7, 2006.

73. *Karen Hazelwood and Jeff Spinello v. Media Arts Group*, no. 74 114 Y 01360 03 SAT, p. 10 (American Arbitration Association, Feb. 23, 2006).

74. Cathy Jett, "Virginia Kinkade Dealers Prevail in Arbitration," *Fredericksburg Free Lance Star*, Sept. 21, 2006.

75. *Karen Hazelwood and Jeff Spinello v. Media Arts Group*, 8.

76. Ibid.

77. John Leland, "Subdivided and Licensed, There's No Place like Art," *New York Times*, Oct. 4, 2001.

Brand-Name Living from the Painter of Light

KARAL ANN MARLING

They are hard to avoid, these pleasant, slightly fuzzy pictures of light-houses perched on rocky shores above the surf. Never mind that the skies are aglow with sunshine; the lights in the beacons still flash their message to the eternal sea. "Be part of the hope-filled, life-affirming message of Thomas Kinkade, America's most collected artist," says the detachable flap on the remittance envelopes of no fewer than three of my credit card bills this month. Send only $9.95 for shipping and handling, and one of these four lighthouse lithographs can be yours: *A Light in the Storm*, *Beacon of Hope*, *The Light of Peace*, or *Clearing Storms*. This debtor could clearly use a stiff dose of hope or peace.

The titles telegraph the fact that a Kinkade lighthouse is meant to be something more than a lighthouse. What is trickier to notice is the very small print at the bottom of the ad stating that the pretty pictures in their mats and gilded frames will *not* arrive at my door looking quite so nice unless I am willing to fork over a few more bucks. The framing costs another $9.95, billable to the credit card in question. But the result will be worth the added expense: "All images © 2006, Thomas Kinkade, The Thomas Kinkade Company, Morgan Hill, CA. Satisfaction guaranteed. You must be 100% delighted or your money back!"[1] Few retail establishments these days promise utter delight, let alone hope and peace. As I wrote out my checks—printed with Kinkade's "Serenity" pattern, a little arched bridge spanning a babbling brook (available with or without a Bible verse)—I thanked heaven there was enough left in the account to pay the bills and observed for the umpteenth time that the Painter of Light is clearly some-one special.[2]

When critics mention Thomas Kinkade, it is generally to denigrate him for having the cheap sentimentality of a kitschmeister or a merchant's sensibility offensive to those who like to pretend that art and commerce are separate spheres altogether. But it is one thing to buy a Picasso at auction in New York, with all the attendant hoopla, and quite another to wallow in "collectibles," including checks, pictures sold through credit-card companies, resin figurines based on old Norman Rockwell magazine covers, and the kinds of dust-catchers collected by little old ladies who also collect cats. Robert Rosenblum, the distinguished New York art historian and curator who usually found something interesting about any kind of art, viewed Kinkade as vapid and repetitive. "He doesn't look like an artist who's worth considering, except in terms of supply and demand," Rosenblum told the *New York Times* in 1999. "Of course," he added, "a lot of people would have probably said the same things about Rockwell 20 or 30 years ago."[3]

Indeed, Norman Rockwell is the name most frequently cited in discussions of Kinkade, in large part because the latter has so often cited the former as his inspiration. Rockwell, says Kinkade, was one of the great "icon-makers" of the twentieth century, an artist disdained by the establishment but beloved of the masses. Kinkade owns the oil painting for Rockwell's *Saturday Evening Post* cover of October 20, 1934, picturing a young fellow perched on a weathervane looking off toward an ocean concealed by the angle of vision, a ship's mast, and (surprise!) a lighthouse in the distance.[4] One of Kinkade's fondest memories is of his visit to Arlington, Vermont, where he worked for two weeks in the former studio of his fellow populist.[5] The Kinkade family's trip to Vermont took on the character of a quasi-religious pilgrimage: "It was my dream to paint where Rockwell painted, with the memories of all those pictures in the air."[6] Thereafter, little vignettes of Rockwell—the skinny guy with the pipe—turned up regularly in Kinkade urban and Victorian scenes.[7]

Until the late 1990s, when a major reexamination of his work began, Norman Rockwell's name was synonymous with what *not* to paint, namely, "nostalgic images of idealized everyday American life" or "middle-class America as it wanted to see itself."[8] But Rockwellian nostalgia, in fact, has very little to do with Kinkade's several styles or his preferred subject matter. Rockwell, for one thing, was a figural painter; his typical *Post* covers are close-ups of one or several persons, shown from head to toe, and often

from the rear. Furthermore, except for a modest number of costume pieces fashionable in the 1920s and 1930s and his Dickensian Christmas scenes (later translated into very collectible Hallmark cards), his images are not particularly nostalgic in character. By and large, Rockwell took people as he found them—in their celluloid collars, their housedresses, and their uniforms; it is only with the passage of time that the latest in ladies' sleepwear, circa 1948, looks like an exercise in nostalgia. Rockwell's pictures also repay close examination. While it was the duty of a cover illustrator to entice readers whose view of a magazine on a newsstand was fleeting at best, Rockwell rewarded the buyer by making every last detail of the image tell a story, from the hole in the sole of a shoe to the decorations on top of a ratty old hat. The result was a rich narrative sensibility and a participatory engagement between reader and picture.

Thomas Kinkade, I think, understands the power of that engagement, although the stylistic character of his work owes very little to Rockwell. While he has painted a series of cityscapes (some set in the past), the images that most often find their way into the collectibles market—and onto calendars, mouse pads, coffee mugs, and the flaps of remittance envelopes—are furry, almost cuddly landscapes, blurred at the edges by stippled overpainting. The Kinkade style is the antithesis of the surreal clarity of Rockwell. Thus, the connection between Kinkade and Rockwell is not so much artistic as it is philosophical. To be an illustrator, as Rockwell was, was to be a commercial artist, planning and executing canvases for mechanical reproduction. The "originals," such as the Rockwell owned by Kinkade, were leftovers, the detritus of a commercial process. As a result many of Rockwell's oils have disappeared. The real product was the ad, the cover, the clipped-out magazine picture in a scrapbook—the reproduction. The Rockwell fan can collect old *Saturday Evening Post* covers at a flea market (if she is lucky), or an entirely different range of products, the third- or fourth-class relics, that simply reproduce the reproductions.

Rockwell has often been called "the most-collected" and the "most-reproduced" American artist.[9] The works collected were made to be "collectibles," for the most part: Brown and Bigelow Boy Scout calendars, cards, plates, plaques, figurines, and, most recently, Disney characters substituting for Rockwell's on a wide range of merchandise. They are meant to be inexpensive and reminiscent, of primary value only to the collector. Many of the original Rockwell oils went on tour from 1999 to 2002 in a

major exhibition, with stops in Chicago, Washington, and the Guggen-
heim Museum in New York City.[10] The show stirred up the usual contro-
versy over art vs. commerce, schlock and escapism vs. the avant-garde, and
all the rest. What was never clarified was the fact that the paintings were
made specifically for the purpose of making what the art world calls "mul-
tiples." There was not *a* Rockwell of any given subject—but a template for
many Rockwells. Nor did Rockwell, his editors, or his publishers make any
claims that the multiples were originals.

In various permutations and combinations the practice of making mul-
tiples is not uncommon. Theorists from Walter Benjamin to André Mal-
raux have explored the ramifications of the modern "museum without
walls" created by new means of mechanical reproduction.[11] American art-
ists have taken to the concept with a vengeance. Arnold Friberg, for ex-
ample, best known for colorful, red-coated Mounties bringing justice to
the Canadian frontier, painted hundreds of such works over an almost
forty-year period as magazine ads for a Minnesota paper company. That
firm, in turn, seized on the popularity of the Fribergs with its clients, offer-
ing reproductions of the ads on memo pads and calendars, which eventu-
ally spawned T-shirts, coasters, and reproductions "suitable for framing."[12]
Similarly, Terry Redlin, a kind of rusticated version of Kinkade with a
particular affinity for old pickup trucks, keeps his paintings in the Redlin
Art Center in Watertown, South Dakota, but sells the images on annual
Christmas plates, highball glasses, light-up gas stations in miniature, furni-
ture, and denim shirts with discreet Redlin prints on the breast pockets.[13]
But Kinkade's foray into the realm of consumer multiples was far more
daring, deliberate, carefully strategized—and wildly successful.

By the time Kinkade blipped on the national radar screen in 2001, in a
New Yorker profile by Susan Orlean, he was a millionaire several times over.
By his own reckoning he was "one of the wealthiest artists in the world."[14]
Several hundred Kinkade shopping mall galleries, decorated in a fashion-
able, nature's-wonderland dark green, were up and running and selling
genuine Kinkade art. The run-of-the-Olde-Mill Kinkade came with the
painter's auto-pen signature in the bottom right-hand corner. Pricier were
those "highlighted" (with added tiny globs of paint on the surface to give
the illusion of an original oil) by a certified assistant, a touring master high-
lighter, or the master himself. Sometimes, the buyer was allowed to do the
highlighting under the guidance of gallery personnel. Orlean and others

Figure 1. Thomas Kinkade Springtime Splendor Teacup and Saucer by the Bradford Exchange Ltd. Everett's Cottage. © 1998 THOMAS KINKADE.

contended that this was a scam on a grand scale, that the naive folk who bought "art" in malls thought they were buying something valuable, original, and one-of-a-kind, instead of a fifteen-hundred-dollar lithograph bonded to brushstroke-textured canvas. What was touted as heirloom "artwork" was essentially a fake, Orlean argued, because it was mass-produced in a California plant where crews of by-the-hour Hispanic workers soaked manufactured reproductions of Kinkade paintings in water, peeled off the backing, and then affixed them to canvas.

But no matter. Five thousand other retail outlets were selling Kinkade-licensed tchotchkes, running the gamut from La-Z-Boy recliners to puzzles and teacups (fig. 1). China, jewelry, and a series of novels were yet to come. Kinkade explained his success as a by-product of a conversion experience and a decision to leave the wicked city, both of which seem to have taken hold of him in 1984, when he moved back to Placerville from Los Angeles. His paintings of Placerville and Alaskan towns, "the kind of traditional paintings" he was doing, sold well even out of the trunk of his

car. "But I also knew I couldn't keep up with the demand," Kinkade later wrote. "There must be a way of providing artworks for people without having to paint every single one. I began to understand why illustrators such as Norman Rockwell wanted their work to go onto the covers of such magazines as *Saturday Evening Post* rather than into galleries, but as Rockwell said, 'The *Saturday Evening Post* is a gallery that goes into millions of people's homes.'"[15] So Kinkade founded his own art-publishing business, and the rags-to-riches saga began.

As the kitchen-table enterprise evolved into Lightpost Publishing, the Media Arts Group, Inc., and finally, in the aftermath of the dot-com recession, the privately held Thomas Kinkade Company, Kinkade began to credit his success to divine intervention: "He [God] basically gave me ideas. And one of the foundational ideas he gave me was a way to create multiple forms of art that looked like the original, but weren't just a poster."[16] Beginning in the mid-1980s, in a sharp break with his earlier subject matter, which was a kind of hard-edged naturalism based on streetscapes of unpicturesque sites like Placerville, he began to specialize in made-up cottages, gardens, lighthouses, and gazebos. The treatment was distinctive and, to some onlookers, scary. Joan Didion described cottages "of such insistent coziness as to seem actually sinister, suggestive of a trap designed to attract Hansel and Gretel. Every window was lit, to lurid effect, as if the interior of the structure might be on fire."[17] To the less skeptical observer, however, images such as *Evening at Merritt's Cottage* (1990) were tranquil, pastel, dreamy—and defiantly Christian, aglow with the light of the Spirit. And now, even if it was generated by a writing machine, Kinkade's signature became an integral iconographic component of his pictures: "Thomas Kinkade," sometimes a date, a Christian bumper-sticker fish, a © symbol, and a shorthand reference to a Bible verse, often John 3:16.[18]

Thom himself—as he is known to his admirers—had embarked on a kind of nondenominational art ministry. A painter with a big idea became the Painter of Light (see John 8:12)—light from lighthouses and lightposts, of course, but more often from a kind of hyperbolic firelight emanating from every window on every floor of a series of cottages somewhere in Neverland, far from everyone and everything, nestled in the embrace of a curiously haptic natural setting. Kinkade has often alluded to his stint as a Hollywood animator. In fact, he and his friend James Gurney had worked in the early 1980s for Ralph Bakshi, the visionary filmmaker, churning out

more than a thousand production backgrounds for *Fire and Ice* (1983), a cult classic released by Twentieth Century–Fox. The art director on the film was Frank Frazetta, the cocreator and a brilliant fantasy painter. Gurney, who went on to author the famous Dinotopia books, is generally credited with being the lead background animator, but regardless of the order of precedence, this was the moment at which Kinkade's cottage phase began, with what he calls "highly imaginative images . . . fantasy castles, mountains, and celestial landscapes."[19]

Indeed, the closest visual and emotional analog to one of Kinkade's idyllic cottages is the home of the little men in Walt Disney's animated classic *Snow White and the Seven Dwarfs* (1937). Designed by Albert Hurter in an Anglo-Germanic style derived from illustrated editions of the Brothers Grimm, the cottage was everything Kinkade's little houses would someday aspire to be. It was slightly curved in profile, like clouds or soft bosoms, overgrown with flowers and foliage, miniaturized and strangely welcoming, like a magical dollhouse that just might accommodate grownups.[20] Disney's employees, when *Snow White* was finished, presented the boss with a playhouse-size version of the cottage for his backyard, which was, without doubt, an inspiration for the later Disneyland park with its array of highly detailed, smaller-than-real, and virtually irresistible fantasy buildings.[21] The playhouse, or the film still, is also the most likely point of origin for the trademark Kinkade cottage. And since the 1920s, when Walt Disney licensed a school tablet bearing a picture of Mickey Mouse, Disney's corporation has been the world's leader in merchandizing copyrighted images drawn from its films, characters, and theme parks.

As a model for the kind of enterprise Kinkade dimly envisioned in 1984, there was none better. In 2001 Kinkade made the link between himself and Disney explicit in a television interview. "Walt Disney wasn't satisfied with just making a movie. He said, 'I wanna invite people to step into that world,' and he built Disneyland. . . . We view my work and my cultural identity, in a way, as heir to the Walt Disney kind of tradition."[22] It was only a matter of time before Kinkade became part of the Disney collectibles juggernaut. In 2004 Kinkade was invited to Disneyland to produce a limited edition print of the centerpiece Sleeping Beauty Castle, done from an oil sketch executed on the spot, in honor of the park's fiftieth anniversary. The press release on his special appearance at Disneyland to sign "Artist Proof" editions in the fall of 2005 came from the Kinkade Company.

The original painting, it stated, "depicts the excitement and nostalgia of family trips to Disneyland."[23]

The Disney name is no guarantee of popularity in the art world or in the rarified towers of academe, however. There cuteness, sweetness, fairy-tale castles, and the term *Disneyfication* signify a lack of genuine and timeless significance deemed crucial to "high" art. But the more obvious reason for a general distaste for Kinkade among critics and media commentators is the artist's insistence that the buildings in his pictures convey some sort of diffuse moral lesson—that they are not wholly secular moneymakers on a par with Disney's Sleeping Beauty Castle in Anaheim, California. Since the presidential election of 2000 (if not before), public assertions of faith in the polarized atmosphere of American partisan politics have come to identify someone as from a "red" state: a rock-ribbed Republican, or a member of the Religious Right. Nor does it help Kinkade's reputation among liberal-leaning art professionals that the self-described "devout Christian" (his four daughters all have "Christian" for a middle name) was a member of Bush's Presidential Prayer Team and urged his powerful friend to set up a "special council for the fine arts" in order to give to all Americans "a window on the world beyond poverty and despair."[24] One of Kinkade's business partners put the firm's philosophy this way: "We created a brand—a faith and family brand—around a *painter*. The Kinkade brand stands for faith as a foundation for life. He creates a world, and that world makes people feel a certain way. So we saw it as a great opportunity to create products around those worlds—collectible products, books, calendars, home decor items—furniture likely to be found in Thomas Kinkade's world."[25] "We're not in the art business," says another associate. "We're in the hope and inspiration business."[26]

One of the secrets of selling branded merchandise by the tens of millions of units is to create such a "world," an interlocking system of intimate, self-referential imagery and iconography. Disney's success is predicated on taking one product—an animated film—and spinning it off into figurines, clothing, books, and sheet-and-pillow-case sets for toddlers. Kinkade's Christianized signature panel accomplishes the same feat, as do the barely hidden Kinkadeisms in many of his works. Welcome to Kinkadedom! The letter *N* (for Nanette, his wife) appears over and over again, and the names or initials of his daughters—Merritt, Chandler, Winsor, and Everett—and numerical sequences alluding to events in the family's life

are often added into the mix. More than a copy of the theatrical cartoonist Abe Hirschfeld's distinctive *Nina*s, these details are a kind of acid test of the viewer's true-blue Thomism. Only initiates, the serious fans who name their babies after the Kinkade kids, haunt the galleries, buy the commemorative plates from the Bradford Exchange and the three-dimensional table-top cottages from the Franklin Mint, and read the more than forty books bearing Kinkade's name can fully grasp the meaning of the clues (pl. 7). There is nothing quite like it, except perhaps the Elvis phenomenon. True believers (many of whom prefer the late star's gospel music to his rock 'n' roll) collect obscure personal facts about "The King" along with the branded paraphernalia sold at the row of gift shops across the street from Graceland.[27] The difference is that Elvis Presley did not hide or reveal clues to the deeper meaning of life inside every miniature Graceland or jigsaw puzzle on the market.

Searching out the arcane possibilities for every Kinkade symbol becomes a kind of wicked parody of the methodology used by elite academic art historians in the interpretation of Renaissance masterpieces—a point Monica Kjellman-Chapin expands on in her contribution to this collection. And Thom Kinkade, since an early stint at Berkeley, has had little use for their kind. More than that, however, the numbers and the initials on the gallery prints and the products based on them essentially guide the viewer away from the not-quite-real picture toward the artist himself, the Great and Powerful Oz behind the factory full of reproductions. There is a quasi-Platonic quality to Kinkade's concealment of the original work of art behind a flutter of enticing copies. The copies, in their sheer numbers, call ironic attention to Kinkade as a conservative, middle-class Christian with a yen for proselytizing through the sheer multitudes of his copies. He is not a Picasso, an Andy Warhol, or a Jackson Pollock. His art, for better or worse, is little more than a vehicle for a message unpalatable to those who believe in art for art's sake.

Behind the curtain (Irish lace, I think) lurks the philosophic Kinkade, the author, coauthor, and inspiration for a shelf's-worth of handsome books decorated with vignettes from his images and enlivened by snatches of autobiography—all collectibles in their own right. One of the most surprising of these productions is *Lightposts for Living: The Art of Choosing a Joyful Life* (1999). In the first place this is a very odd sort of book for an artist to write, since the topic is not painting. Instead, *Lightposts for Living* is a self-

help book for troubled souls in search of some deeper, spiritual dimension behind Kinkade's trademark light. To bring the light into one's soul, the Painter of Light counsels, the reader should lead a simpler, more contemplative life devoted to family, home, and the values attached thereto. "I have given much thought to the specific qualities that make life good and the visual attributes that evoke a joyful way of living," he says by way of introduction.[28] Hence the fire-lit cottages, the lampposts, and the lighthouses aglow in the twilight, all of which beckon the restless, troubled soul into a place of serenity, protection, and love everlasting. Like a Pentecostal preacher, Kinkade uses visual symbols—experiential, visceral means—to embody the feeling of the presence of God.[29]

Although doubters may scoff at the notion of a millionaire calling on his followers to take up a life of simplicity, to escape their troubles via a cobblestone path leading toward the cutest cottage imaginable, Kinkade aspires to rouse such feelings in his audience. One of the most interesting of Kinkade's many commercial ventures is a series of novels set in the make-believe New England village of Cape Light. "Inspired by the artistic vision" of the master, the ghostwritten stories feature a wide range of standard, blameless small-town figures who could have come from an old Andy Hardy movie: a mayor with a secret, the editor of the local newspaper, the waitress, a shopkeeper, a cop, the minister, some newcomers, and a sharp-tongued old lady. In a forced bit of dialogue in Cape Light (2002) between the cranky elder and a young guest, fresh out of college, the latter argues that art is about "an artist's personal vision. . . . I don't think real artists consciously set out to edify or educate. . . . If they do it on purpose, it's not really art." That is, as her elder is quick to point out, "a very modern notion," the essence of modern art, beginning in the nineteenth century.[30] Or, more directly, what Thomas Kinkade despises about the art of his own time. "My mission as an artist," he writes, is to do just what the student labels nonart, "to create little glimpses of a world that is tranquil, peaceful, and full of the beauty of God's creation."[31] "My personal calling," he says elsewhere, "is to create paintings and books that reach out and bless the lives of others."[32]

Hard-pressed to find virtue in miniature houses sold by a so-called Painter of Light on the QVC home-shopping channel, art critics call Kinkade's little world sentimental, mawkish, "art lite." But what is the art in his faith-infused artlessness? What, precisely, is a typical Kinkade cottage

scene actually like? It is not in any sense of the word a "realistic" or straight-forward, photographic rendering of a place—even an imaginary one. Per-spective provides the strongest clue to Kinkade's intentions. Most of the facades of his cottages are slightly skewed toward the picture plane; their perky little fronts turn toward the viewer, in anticipation, as if they really were faces anxiously awaiting the homecoming of a loved one from a long journey. Paths point to the glowing windows and the inviting doorways. Flowers nod their heads in the same direction. "Come home! Come home! You who are weary come ho-o-ome," cry the lyrics of the old hymn.[33] Thomas Kinkade lights the way.

In addition, the deliberate clumsiness of the perspective gives Kinkade's "house" images a homemade look, akin to kettle-fresh strawberry pre-serves presented in a Ball jar, still warm from the kitchen. Further, the vari-ous surface additions—the final touches added by Kinkade and his touring army of highlighters—give the images the texture and awkward prettiness of an embroidered pillowcase strewn with French knots and lazy-daisies. Underlying the unquestionably skillful evocations of the fleeting moments of sunrise and sunset, these faux-awkward details put the onlooker at ease. If they suggest a handmade quality at odds with the factory origins of Kin-kade's multiples they also charm with their very homeliness. Surely these are artifacts that *belong* in one's home, alongside Grandma's hand-crocheted afghans, the palms Dad braided after last spring's Palm Sunday service at church, and Mom's collections: the Hummel figurines, the Fenton glass baskets, the dolls by Marie Osmond, and the Christmas villages by Depart-ment 56. Along with the family photos, these are the things that truly make a house a home.

Even before Kinkade appeared on the scene, the house had taken on an almost fetishistic status in American mythology. There were the White House, Graceland, Mount Vernon, the single-family suburban home, and house-shaped collectibles fashioned after them. But the late-twentieth-century mania for collectible ceramic, light-up houses and stores ready to be assembled into make-believe villages under the family Christmas tree began in 1976 when a group of friends met for Christmas dinner in Still-water, Minnesota, a quiet little town on the St. Croix River near Minne-apolis that summoned up childhood memories and family traditions. As luck would have it, they were all in the nascent giftware business begun by a Minnesota greenhouse and floral operation. Department 56, the spin-off

company that now makes the village components, described the epochal Stillwater visit in a 1998 promotional statement that now serves as the official history of an ever-growing product line: "An idea occurred that night to re-create the charming little village and the feeling it inspired, scaling it down so that it could exist for everyone, everywhere."[34] By the early 1980s, the industry was in full swing. Target, Coca-Cola, Precious Moments (Enesco), and others competed to supply villages that resembled New England, the Southwest, midwestern Main Streets, the mythical hideaway of Santa at the North Pole — and lighthouses for the summer trade. It seems more than likely that Kinkade borrowed his own ur-cottages from the Christmas house fad. Like the Painter of Light, the makers of the Department 56 villages made no bones about their desire to spread peace and quiet reverie through their products. Hardcore collectors of the houses, much like collectors of Kinkade prints, speak of coming home after a hard day at work and feeling spiritually refreshed by imagining themselves part of the calm, unchanging warmth of the Lilliputian world beneath the Christmas tree.[35]

Kinkade has done his share of Christmas pictures, including *St. Nicholas Circle* (1993; fig. 2), an uncharacteristically long view down on a village at twilight, nestled in a snowy valley. It most strongly resembles a suburban cul-de-sac or a ceramic village put together out of several sets of houses: Victorian, Tudor, Colonial. The time frame is a long-ago of horses and sleds and tiny steam trains in the distance, but the sensibility is curiously modern, with signposts pointing to other, similar subdivisions nearby, including "Victorian Corners," "Lamplight Lane," and "Reindeer Ridge." By 1998 Kinkade was himself in the village business in a big way. His "First-Ever Illuminated Victorian Cottage," powered by a pair of AA batteries, was made of resin, stood only 3.75 inches tall, and was mounted on a cherry-wood base. Billed as a Kinkade sculpture, it was correspondingly pricey, at $54.90, including shipping and handling. A talking house version, much larger, contained a recording of Kinkade reading "'Twas the Night before Christmas" synchronized to a mechanism that illuminated various rooms as the verse dictated. It sold for only $134.95, and each one was hand-numbered. Florists touted a Kinkade cottage surmounting a clump of boughs and pine cones and impaled on a cherry-red candle. The ad read "Santa and Rudolph. Hearth and Home. Teleflora and Kinkade."[36]

The logical outcome was "The Village at Hiddenbrooke," a real-life,

Figure 2. Thomas Kinkade, *St. Nicholas Circle*. © 1993 THOMAS KINKADE.

gated "Thomas Kinkade Community," opened in 2001 on former ranch-
land thirty-five miles outside San Francisco. The streets were narrow, the
driveways mock-cobblestone. There were no stores, schools, churches, or
businesses. The houses, Tudor-Victorian-cottagey with picket fences and
little stone pillars, started at $425,000. On opening day the crowd of two
thousand potential buyers saw model homes filled with Kinkade collec-
tibles, from teddy bears and toy trucks to furniture and pictures. Although,
according to the developer, Hiddenbrooke was "the first community based
on the work of a single artist," Kinkade did not have a hand in the design
process (although he did approve the marketing plans). That's not how
licensing works, he told the assembled press. "It's taking the paintings as a
starting point and then creating another world of the imagination. We've
got a series of novels being written based on my paintings. That's kind of
like the tail wagging the dog. You start out with the cover of the book, then
you write a story to go around it."[37] But in the sales copy Kinkade, or his
associates, speak of a "vision of simpler times," of "garden-style landscaping
with meandering pathways and . . . secret places," and "cottage-style homes
. . . filled with warmth and personality." Hiddenbrooke sounds eerily like
St. Nicholas Circle crossed with the Disney-themed town of Celebration, in
central Florida. Whether buyers of Kinkade-branded homes will live hap-
pily ever after in a virtual picture frame has yet to be determined, but the
expansion of his inventory of collectibles from paintings of houses to pic-
tures of houses to statues of houses to full-scale houses is audacious in the
extreme. There have been "modern" and Mission-style cul-de-sacs built in
the past and ordinary subdivisions awkwardly named after the developer's
wife. Here, however, Thomas Kinkade, with his houses full of other Kin-
kade merchandise, has done them all one better.

Martha Stewart's life-style brand has established itself in Macy's,
K-Mart, high-end furniture stores, and her own several magazines. Yet
her towels and blankets are about towels and blankets, albeit in certifiable,
good middle-class taste. Kinkade's blankets are not. They point backward,
toward their point of origin, toward Kinkade and his value system. Then
they look forward, toward the urge to make things match, to finish a set,
and all the other consumer impulses that have driven collectors of art, both
high and low. An almost-contemporary case in point is the Ty Beanie Baby
craze of the 1990s. Some participants in that bout of buying madness may
have loved the pert rosiness of "Pink," the flamingo issued in 1995. They

may have teared up over the mawkish sadness of the droopy little "Princess" bear (in imperial purple with a white rose embroidered on its plump tummy), issued to commemorate the 1997 death of Lady Diana. But the frenzy that greeted vendors of the "Princess" suggests, on the contrary, that many collectors bought them in quantity planning to bury them in the attics in dustproof plastic containers alongside the old baseball cards, the Lionel train sets, the Hula Hoops, and all the other detritus of the past sure to be worth a fortune someday. Nostalgia makes people keep things or, just as often, buy substitutes for things they once had. Anticipation of a thriving secondary market keeps the sales cycle going.

And while, as the economy slows, Kinkade prints may begin to clog eBay, disappointing those who hoped to make a killing, most of his fans had something else in mind, I believe. They were not cheated by getting a print instead of a hand-painted work of art. On the contrary, they got exactly what they wanted. What they purchased at the gallery with the green decor was a picture, a collectible, a fancier version of the calendar or the umbrella available at the same place at a much lower price. But it was a collectible loaded with meaning. Kinkade prints thumb their conceptual noses at the uppity ways of the Madison Avenue gallery. They make it plain that religion is a suitable subject for serious consideration; that it is OK to imagine, to escape for a moment, to see the possibilities of a better life in a glowing window; that it is OK to cry, to regret, to hope—and all because of a picture.[38] You can buy one on the Internet or just about anywhere else— an American holy card for our times, a lighthouse for the errant spirit.

Notes

1. See return envelopes for MBNA, Chase, and American Express cards for July 2006.

2. Checks Unlimited (or www.ChecksUnlimited.com) sells the Kinkade checks along with various Disney, Warner Brothers, "Garfield," and Harley-Davidson trademarked designs, about equally divided between the pious and the humorous.

3. Quoted in Tessa DeCarlo, "Landscapes by the Carload: Art or Kitsch?" *New York Times*, Nov. 7, 1999. See also a summary of recent criticism in Clapper, "Thomas Kinkade's Romantic Landscape," 78.

4. The cover painting is titled *The Lure of the Sea*. See Stolz and Stolz, *Norman Rockwell and the "Saturday Evening Post*," 126.

5. On Rockwell and Kinkade see Marco R. della Cava, "Thomas Kinkade: Profit of Light," *USA Today*, March 12, 2002.

6. Kinkade and Reed, *Thomas Kinkade*, 20–21. See also Kinkade with Buchanan, *Simpler Times*, 94.

7. There is a "Rockwell" in the left foreground of Kinkade's *Walking to Church on a Rainy Sunday Evening*, in his Victorian Christmas I series reproduced in *A Holiday Gathering*, and in many other Kinkade images. In compositions that include figures, he is also fond of inserting himself, his wife, Nanette, and his four daughters into the action.

8. Alexandra Novina, "A Swell of Sentiment," www.tfaoi.com/aa/5aa/5aa192d .htm (accessed May 11, 2010).

9. See Jeremy Rose, "Calendar Note," *Los Angeles Times*, July 12, 2006. Rose cites a rumor that Kinkade had recently sold, or almost sold, a painting to Melissa French Gates (Mrs. Bill Gates). Originals, according to Rose, sell for $135,000 and up. But the sale of "originals" in his own galleries is, if true, a recent wrinkle in the Kinkade story.

10. Hennessey and Knutson, *Norman Rockwell*.

11. See Malraux, *Museum without Walls*; and Benjamin, "The Work of Art in the Age of Mechanical Reproduction."

12. Marling, *Looking North*, 17.

13. See info@redlinart.com. LeRoy Neiman, the late Patrick Nagel, and Peter Max are among many artists whose works are known almost exclusively in the form of color lithographs and collectibles.

14. Orlean, "Art for Everybody," 125.

15. Kinkade and Reed, *Thomas Kinkade*, 17.

16. Marco R. della Cava, "Thomas Kinkade: Profit of Light," *USA Today*, March 12, 2002.

17. Didion, *Where I Was From*, 73. The mystery writer Laura Lippman also alludes to what she calls "fairy tale houses . . . in those strangely popular mall paintings, the ones from the man who claimed he was the painter of light" (Lippman, *Every Secret Thing*, 367).

18. "For God so loved the world, that he gave his only begotten Son, that whosoever believeth in him should not perish, but have everlasting life." I am quoting the King James Version of the Bible here. Kinkade prefers this version, according to the notations in several of his picture books. But he is prepared to quote anybody who has spoken in defense of the home, memory, and tradition, from Garrison Keillor and Louisa May Alcott to Marcel Proust.

19. Quoted in Doherty, *The Artist in Nature*, 19.

20. For Hurter and his role in the film see Krause and Witkowski, *Walt Disney's "Snow White and the Seven Dwarfs,"* 26–27.

21. See Marling, *Designing Disney's Theme Parks*, 39.

22. Quoted in *Sixty Minutes* transcript (July 4, 2004). The broadcast first aired in 2001.

23. Press release (Sept. 1, 2005), "Thomas Kinkade's Newest Painting, 'Disneyland 50th Anniversary,' To Be Released at Disneyland Event on September 10, 2005."

24. Here's What's Left, Dec. 28, 2004, http://hereswhatsleft.typepad.com/home/2004/12/index.html (accessed July 13, 2006); and Christina Waters, "Doubting Thomas," *San Jose Metro*, Sept. 6–12, 2001.

25. Christina Waters, "Doubting Thomas," *San Jose Metro*, Sept. 6–12, 2001.

26. Marco R. della Cava, "Thomas Kinkade: Profit of Light," *USA Today*, March 12, 2002.

27. Marling, *Graceland*, 5.

28. Kinkade and Buchanan, *Lightposts for Living*, vii.

29. Pamela Miller, "Faith Embodied," *Minneapolis Star Tribune*, July 22, 2006.

30. Kinkade and Spencer, *Cape Light*, 220.

31. Kinkade and Reed, *Thomas Kinkade*, 11.

32. Kinkade with Buchanan, *Simpler Times*, 17.

33. "Softly and Tenderly" has been recorded by Johnny Cash, *Precious Memories* (1975), Priority/CBS Records, PCT 33087.

34. *1998 Village Brochure* (Eden Prairie, Minn.: Department 56, 1998), 1.

35. Marling, *Merry Christmas*, 63–74, 318–20.

36. See also Kinkade's Christmas gift book *I'll Be Home for Christmas*, compiled by Anne Christian Buchanan. Ads for the tiny house, sold by mail by "Hawthorne Village," appeared in many magazines, including *USA Weekend*, Jan. 1–3, 1999. The larger house came from Hammacher Schlemmer, via www.skymall.com. Teleflora advertised Christmas arrangements with Kinkade details for several years: see *USA Weekend*, Dec. 16–18, 2005.

37. John Leland, "Artist's New Housing Development Is Pretty as a Picture," *Minneapolis Star Tribune*, Oct. 7, 2001.

38. See Tuan, *Escapism*, ix–xii. See also Marling, "Escapism?"

Purchasing Paradise:
Nostalgic Longing and the Painter of Light

ANDREA WOLK RAGER

Nothing nowadays sells so well as the past.
—David Lowenthal, "Nostalgia Tells It like It Wasn't"

To understand the appeal of Thomas Kinkade's imagery, you must allow yourself to be immersed within the anodyne dreamscape of his world. Imagine occupying the place of so many Kinkade customers, comfortably ensconced in an overstuffed armchair, safely nestled within the domestic-like space of a Thomas Kinkade Signature Gallery. Tucked away in a quiet alcove, you gaze up at a large, heavily varnished and gilt-framed lithographic canvas titled *Hometown Memories I: Walking to Church on a Rainy Sunday Evening* (1995; pl. 8). The scene gently greets your eye, drawing you forward until you are gliding along the wide, slightly curving, shimmering road. You are ushered toward the white church steeple, which floats beaconlike in the distance between the gray arc of the street and the sky. Your path through this world has been preordained, but you are also free to gaze from side to side as you follow your mental journey through a world of almost hypnotic stasis, where life has become so simple and slow-paced that it has ceased to move at all. The spring rain glistens on the blooming dogwood trees and manicured rose gardens, while the family pets poke their friendly muzzles out into the air. On either side of this tidy residential street are quaint family homes, each well-kept and self-contained, glowing with the warmth from within. The occupants of these domestic bastions file out onto the sidewalks, each huddled under their protective umbrellas, dry and anonymous as they are called to worship by the distant

church bells. Just ahead is the unmistakable form of a mother and daughter, comforting in their unimpeachable insularity, a harmony in blue and pink. The only signs of the hustle and bustle of modern life are the gleaming classic cars, almost toylike in their presence. On the left is a familiar figure, with his smoking pipe and trusty beagle. It is a vision of none other than Norman Rockwell, reinforcing the illusion that you have stepped into the kinder, gentler world of mid-twentieth-century America.

As the title implies, *Hometown Memories I: Walking to Church on a Rainy Sunday Evening* is meant to be familiar and reassuring, evocative of a cherished moment in your past—a memory of home. With its mixture of vagueness and detail, the image beguiles the mind into believing there is a truth to the fantasy and that this really is what home looked like. It is a visual enactment of a myth of the American past, a past that you sense belongs to you as a birthright, when there was no threatening technology, no pollution or global warming, no unemployment, no violence or social tensions. But there is also no real substance in this Kinkadian arcadia, no rooted sense of place. Instead, there is only the bittersweet pang of nostalgia for somewhere and sometime that was somehow better or simpler than the present. With that nostalgia comes the promise that this painting can help you escape, if only for a few moments, from the fractured and displaced reality of contemporary America into this vision of the security of childhood (and national) innocence. *Hometown Memories I: Walking to Church on a Rainy Sunday Evening* does not make demands of its viewer; instead, it lures you, almost imperceptibly, into a world where memory, placid and pleasant, has been supplied for you. The warm glow, the feeling of comfortably enclosing space, and the sense of welcoming solace complete the process of soporific pacification. This is the world of Thomas Kinkade, and, whether you find it reassuring or deeply troubling, there can be no doubt that it provides a striking insight into the desires of turn-of-the-millennium America.

Beginning in the early 1990s, such images witnessed a widespread surge of popularity that would endure for well over a decade. It is my contention that this pervasive "Kinkade phenomenon" succeeded largely by tapping into a latent but powerful psychological need in the postmodern American consumer. Here I will explore the most significant source of Kinkade's appeal, namely, the visual embodiment of nostalgic desire that serves as the foundation of his imagery. I will demonstrate how Kinkade manipulates

both a psychological and sociological nostalgic response through an aesthetic of repetition. Recurring throughout Kinkade's serial imagery is a set of easily identified and interpreted motifs and symbols that foster a reassuring sense of recognition, familiarity, and honesty for the viewer. The most important of these repeated motifs is the mother-child pairing, evocative of the unitary reality of the womb. Through a maternal aesthetic, Kinkade invokes a world before the Fall, before the fracturing of the childhood psyche. Finally, expanding on the arguments made by Micki McElya in this collection, I will demonstrate how Kinkade's imagery also taps into a prevalent nostalgic undercurrent in contemporary neoconservative ideology that posits a utopian American past as a mandate for our national future.

The majority of viewers, regardless of their opinion on the relative merit or appeal of Kinkade's art, will readily recognize that his imagery provokes a sense of nostalgia that seemingly wells up unbidden from the subconscious. Yet even for those who acknowledge that this nostalgic response is a pleasurable sensation, and one of the primary appeals of Kinkade's lithographs and various licensed merchandise, it is exceedingly difficult to articulate exactly why these sensations emerge.[1] I contend that this feeling of nostalgic longing stems from a precisely and purposefully formulated aesthetic within Kinkade's imagery. The question then becomes, how exactly does nostalgia function on a visual level and how has Kinkade succeeded in manipulating these visual cues to elicit the desired response within his viewers? To understand the powerful allure and commercial success enjoyed by Kinkade during the millennial decades, we must first consider recent attempts to theorize the phenomenon of nostalgia itself.

Since the 1970s, scholarly interest in the prevalence of nostalgia in the postmodern era has dramatically increased across a range of academic disciplines, particularly within the fields of psychology and sociology, as well as in the broadly defined area of contemporary cultural studies.[2] Much of this scholarship foregrounds the need to complicate the typical denigration or dismissal of nostalgia, positing instead that there exists a wealth of nuanced possibilities latent within the nostalgic response.[3] As the nostalgia theorist David Lowenthal once observed, "A taste so widespread may be a necessity."[4] In other words, the mere fact of the ubiquity of nostalgia, for better or worse, renders this phenomenon and its apparent cultural significance worthy of careful study.

Plate 1. Jeff Koons, *Pink Panther* (1988), porcelain,
41 × 20½ × 19 in. (104.1 × 52.1 × 48.3 cm).

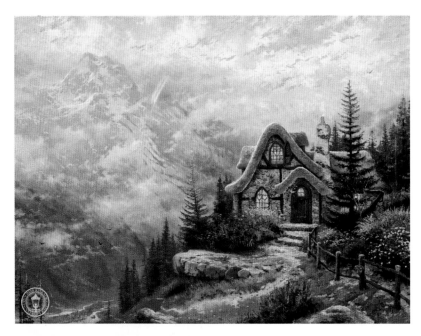

Plate 2. Thomas Kinkade, *Sweetheart Cottage III: The View from Havencrest Cottage.*
© 1994 THOMAS KINKADE.

Plate 3. Thomas Kinkade, *Rock of Salvation.* © 2001 THOMAS KINKADE.

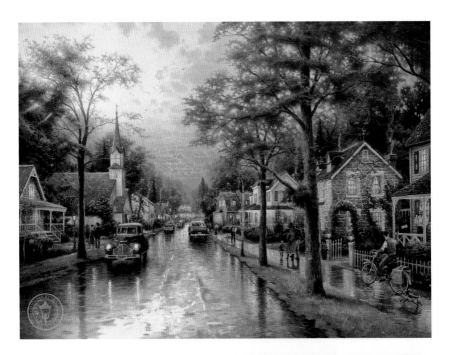

Plate 4. Thomas Kinkade, *Hometown Morning.* © 2000 THOMAS KINKADE.

Plate 5. Thomas Kinkade, *Courage.* © 2004 THOMAS KINKADE.

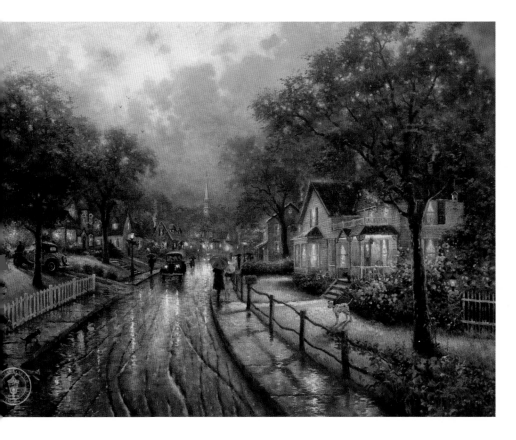

Plate 8. Thomas Kinkade, *Hometown Memories I: Walking to Church on a Rainy Sunday Evening*. © 1995 THOMAS KINKADE.

(opposite, above) Plate 6. Andres Serrano, *Immersions (Piss Christ)* (1987).
© ANDRES SERRANO. COURTESY OF THE ARTIST AND YVON LAMBERT PARIS, NEW YORK.

(opposite, below) Plate 7. Thomas Kinkade *Holiday Memories* music box by the Bradford Exchange Ltd. Village Christmas.
© 1997 THOMAS KINKADE.

Plate 9. Thomas Kinkade, *Main Street Matinee*. © 1995 THOMAS KINKADE.

Plate 10. Thomas Kinkade, *Paris: City of Lights*. © 1993 THOMAS KINKADE.

Plate 11. Overall installation at the Main Gallery, Thomas Kinkade: Heaven on Earth (2004), installation view, dimensions variable, California State University, Fullerton, Main Gallery and CSUF Grand Central Art Center, Santa Ana, Calif. COURTESY OF MICHAEL MCGEE.

Plate 12. Thomas Kinkade and Jeffrey Vallance in Kinkade's studio with *Study for Disneyland Sleeping Beauty Castle* for the Magic Kingdom's 50th anniversary (2004). COURTESY OF GREG ESCALANTE.

Plate 13. Thomas Kinkade, *Seaside Village*. © 2000 THOMAS KINKADE.

The term *nostalgia* dates back to the seventeenth century, when it was coined by medical student Johannes Hofer from the Greek words *nostos* (return home) and *algia* (pain).[5] Hofer was attempting to diagnose an extreme case of homesickness that manifested itself both medically and psychologically. Thus, "nostalgia" was initially viewed as a medical condition of debilitating and potentially fatal homesickness. When the condition was subsequently discredited in the late nineteenth century and dismissed from medical terminology, the contemporary definition of nostalgia as a melancholic but pleasurable emotional state began to emerge in Western discourse. It was also at this time that nostalgia gained temporal associations. Participating in the romantic mythologizing of the past, nostalgia became not just a longing for an absent place but also for a lost epoch.[6] According to Lowenthal, over the next century nostalgia became "an increasingly pervasive ailment," endemic to a society that must "live in an alien present."[7] It should be noted, however, that there appears to be an overarching lack of clarity in tracing the development and shifting manifestations of nostalgia from the nineteenth century to the present. The emerging field of inquiry into the history and nature of nostalgia is still somewhat disparate, and its status as an interdisciplinary phenomenon has only compounded the confusion. At this point I must admit my own stake in this project. As a scholar of nineteenth-century art, I believe that nostalgia has undergone a marked alteration between its modern and postmodern iterations, and much current scholarship does not adequately reflect the nuances contained within this trajectory of development. Part of my intention in undertaking this study, therefore, is to establish how Kinkade's opiated nostalgic vision is of an entirely different nature from the confrontational and provocative nostalgia employed by a number of nineteenth-century artists. That said, let us now examine three of the most prominent theorizations of *postmodern* nostalgia that have emerged in recent years before ultimately exploring how Kinkade exploits each in turn.

The first thread of nostalgia theory originates within the field of sociology and was pioneered with the publication of Fred Davis's *Yearning for Yesterday* in 1979. According to Davis nostalgia had become a distinct form of consciousness, a realm of experience separate from the lived reality of daily life. Only from this removed state of consciousness is the subject able to process conceptions of self and identity.[8] Davis's successors, such as the sociologist Janelle L. Wilson, further argue that nostalgia functions

as a tool for achieving a sense of coherent identity and embeddedness in response to the fractured psyche created by the stresses of the postmodern era.[9] For these theorists nostalgia is not just a pleasant diversion but a potent means of rooting the self among the increasing gaps between sign and signifier. Thus, the nostalgic response fostered by imagery of a fictive, sentimental past (such as that encountered within Kinkade's lithographs) fulfills an essential need of the psyche when confronted with the fundamental rupture of meaning in contemporary American society. For those most afflicted by this disjuncture, nostalgia becomes a very necessary means of achieving self-preservation and the grounding of identity.[10]

A second prominent strain within nostalgia scholarship emerges from the field of psychoanalytic discourse. These theorists argue that nostalgia is a manifestation of the feelings of loss and alienation resulting from the schism between self and other that occurs at birth. As a consequence of this fundamental loss of connection, we each yearn in some capacity to return to the security and gratification of the womb. For example, Julia Kristeva contends that the condition of melancholia, very similar to nostalgia, is predicated on the fulfillment and subsequent rupture of the mother-child bond, fostering an insatiable desire for an irretrievably lost experience (both in a physical and temporal sense).[11] Mario Jacoby makes a similar argument but goes on to explore how this universal human nostalgia manifests itself in the longing for a mythological or prehistoric "paradise."[12] While paradise may take many forms according to cultural needs, Jacoby and other scholars argue that, ultimately, this yearning for a perfect place in humanity's past stems from the rupture of the unitary reality of the womb and the childhood solipsistic connection with the mother. The unitary reality was one where the self was unchallenged and intact, and the universal longing to return to this sense of wholeness is manifested in a utopian projection on the past.[13]

By bringing these two definitions of nostalgia from within the social sciences together, we can define the contemporary nostalgic impulse as a potent psychological tool for achieving a coherent sense of identity, whether against the chaos of postmodern disembeddedness or the universal longing for the unitary reality of the womb. To this behavioral definition must be added the third prominent strain of nostalgia theory, epitomized by the work of Fredric Jameson. In describing what he terms the "nostalgia film," Jameson approaches a definition of the broader cultural

trend of the "nostalgia mode": "Cultural production has been driven back inside the mind, within the monadic subject: it can no longer look directly out of its eyes at the real world. . . . We seem condemned to seek the historical past through our own pop images and stereotypes about the past, which itself remains forever out of reach."[14]

Much like Jean Baudrillard and his theory of the simulacrum, Jameson contends that contemporary culture appears no longer capable of producing genuine "aesthetic representations of our own current experience."[15] Moreover, late capitalist culture suffers from a widespread case of historical amnesia, thereby forcing individuals to rely on a stereotyped style that stands in for history, a tendency that he calls "historicism." Jameson suggests that there are indeed two distinct phases or modes of nostalgia. "Genuine nostalgia" is "the passionate longing of the exile in time, the alienation of contemporaries bereft of older historical plenitudes." By contrast, "postmodern nostalgia" is the transformation of history into "a consumable set of images" through the substitution of style, fashion, and "a kind of generational periodization of a stereotypical kind" for memory.[16] Drawing on Jameson to complete our working definition of nostalgia, we can add that the phenomenon also manifests itself as a style consisting largely of generational stereotypes that replace a nuanced relationship to history or personal past.

One final observation remains to be made on the nature and limitations of contemporary nostalgia theory. By surveying the various interconnected threads of postmodern nostalgia, we have reached a somewhat comprehensive notion of the term. However, the question still remains, what does nostalgia *look* like? While nostalgia is often cited within studies of the visual arts, a consistent definition of the formal components of nostalgia has not yet been firmly established.[17] Apart from the generalized identification of nostalgia as a consumable pastiche of historical stereotypes and styles, typified by the work of Jameson, attempts to articulate an aesthetic of nostalgia have been sparse. Much like Justice Potter Stewart's infamous assertion on the identification of pornography, it is too often assumed that we simply know nostalgia when we see it. Unfortunately, it is not within the scope of this essay to determine a comprehensive description of the development of the nostalgia aesthetic from the nineteenth century to the present. Instead, it is my goal to attempt to convey, through a close analysis of Kinkade's formal and iconographical choices, how an

aesthetics of nostalgia might be envisioned, with the hopes that future studies will take up this theme. With this aim in mind the precarious positioning of Kinkade's imagery between an art historical, painterly tradition and the culture of mass consumer commodities may offer a particular advantage for bridging the emerging scholarship on nostalgia across academic disciplines.

Given the dearth of aesthetic formulations of nostalgia, it might be useful, before returning to a close reading of Kinkade's imagery, to briefly explore a closely related concept: kitsch. Laced as the word is with elitist class bias and hierarchical aesthetic judgments, the concept of kitsch is highly problematic.[18] Nevertheless, the term, which remains strongly entrenched in both scholarly and popular discourse, seems to have something of a symbiotic relationship to nostalgia. Responding to similar cultural impulses, studies of kitsch may provide useful clues to approaching nostalgia as a visual formulation. Celeste Olalquiaga argues for the ties between these two concepts by formulating what she terms "nostalgic kitsch."[19] Attempting to provide an overview of kitsch in the nineteenth century, Olalquiaga similarly encountered the need to distinguish between what she found to be two prominent and opposing strains, "melancholic kitsch" and "nostalgic kitsch." The division between these modes stems from their respective relationships to memory. Melancholic kitsch utilizes allegory to invoke the ephemeral nature of life and to preserve memory. Nostalgic kitsch, in contrast, obliterates memory by transforming it into a fetishized cultural fossil, an empty symbol that encourages stasis rather than growth. The image with which I began this essay, *Hometown Memories I*, seems a particularly apt example of Olalquiaga's description of nostalgic kitsch as "a dead-end street."[20]

To this notion of an aesthetic predicated on stasis and fossilized memory should be added another trope of kitsch, identified by the sociologist Sam Binkley. In an essay that posits kitsch as a distinct visual strategy, Binkley suggests a connection between nostalgic longing and the use of "repetition, imitation and emulation."[21] Rather than being derivative or conventionalized, Binkley argues for such imagery as possessing an aesthetic of faithfulness. In other words, kitsch revels in repetition, in the quotidian rhythms of daily life, and in sentimentality as a means of achieving embeddedness amidst the ontological uncertainty of postmodern life. Such imagery thus offers us the illusion of a "repaired existential cocoon" through the re-

assurance of repetition. Binkley further cements this tie between nostalgia and kitsch by arguing that the former is the dominant impulse behind the latter, stating that this repetitive aesthetic operates primarily out of an idealized past, "a simpler time."[22]

Having thus formulated the parameters of a nostalgic nexus, encompassing theoretical approaches to nostalgia, as well as strategies for its visualization, let us now return to the imagery and aesthetics of Thomas Kinkade with this methodology in mind. Again, it is my assertion that Kinkade owes his commercial success predominantly to his discovery of a means of effectively visualizing nostalgic longing in a manner that assuages the conflicted psyche of many turn-of-the-millennium Americans. The first and most prominent nostalgic element apparent in Kinkade's imagery is his employment of the kitsch strategy identified by Binkley, repetition. Kinkade produces an aesthetic of repetitiveness both through the limited lithographic genres he creates and through the motifs that recur across these scenes. Kinkade's commercial imagery is generally issued in strictly defined series with thematic similarities, such as the Hometown Memories or Christmas Cottage collections. These images are also more loosely grouped into scene types from which Kinkade rarely deviates, namely rural or woodsy cottages, quaint neighborhood or small-town streets, famous cityscapes, lighthouses, bridges, gardens, churches, gazebos, and stairways. This predictability of genre constructs a sense of stability for the viewer; one can rely on Kinkade to produce a new image of a thatched cottage surrounded by a verdant and sun-dappled garden on a regular basis. Kinkade has even created images that revisit previous scenes. For example, *Blessings of Christmas* (2003) offers a slightly different view of the same cottage from *Home Is Where the Heart Is II* (1996).[23] The persistence of these scene types and the overarching series matrix creates the illusion of a complete world, with repetition and reliability forging a sense of truthfulness and familiarity for the viewer. Seriality reassures the viewer, while the limited-edition issuing of these images ensures that they have the illusion of individuality and exclusivity. Kinkade's imagery gives the semblance of consumer choice, but the purchasing of his prints is actually a performance of conformity to the Kinkadian world.

Kinkade further reinforces the repetitiveness of his imagery with a set of motifs that appear time and again in his work, regardless of genre or series. These motifs include pastel sunsets, white-steepled churches, smoking

chimneys, glowing lampposts and windows, wooden boats, pathways and gates, insular family units, friendly dogs, soaring eagles, abundant blooming flora, blossoming pink dogwood trees, and the omnipresent "light" effects that are Kinkade's hallmark. Nearly every Kinkade image contains these motifs, and viewers are encouraged to identify them through advertising copy and corporate-sponsored monographs. One such instance occurs in the catalogue for a recent exhibition of Kinkade's work, which lists not only the motifs but also the corresponding symbolism attached to them within his world.[24] In a strictly defined hermetic system, birds and eagles represent peace and freedom, boats suggest adventure, clouds are reminders of those who have passed away, and the ubiquitous "light" emanating from every image symbolizes the glow of family values.[25] Kinkade thus offers a pre-articulated experience of meaning, a vision of an unfractured realm of signification. These continually reiterated characteristics of the Kinkadian world prompt recognition, acceptance, and identification on the part of the viewer. Kinkade's use of repetition thus helps to combat the alienation of postmodernity described by Davis and his successors through the presentation of a world in which meaning is fixed, where a bird will always symbolize American freedom and a lamppost will, without fail, light the way toward family and morality. This repetition does not demonstrate a lack of creativity on the part of Kinkade (or his viewers) but instead functions as a calculated device for fostering a sense of coherence and connection. Kinkade encourages nostalgic longing at the same moment that he allays it.

In addition to these recurrent motifs and genres, Kinkade includes another level of repetition that encourages personal identification between himself and the viewer by placing what he calls "love notes" or "hidden messages" to his wife, children, and even his own boyhood within his images. This can include depicting his wife's initials carved into the trunk of a tree, naming one of his cottage scenes after a daughter, or even placing a self-portrait into a crowd on a city street. For example, Kinkade, his wife, and a baby (presumably a depiction of one of his daughters as an infant) can be seen strolling down the sidewalk of *Main Street Matinee* (1995; pl. 9), itself a glorified rendition of the artist's actual hometown. These personal motifs amplify the feeling of familiarity and sentimental remembrance, tied as they are to the myth of the artist and apparent only to those who have an intimate knowledge of his life and work (of course, the market-

ing for his images is replete with the details of his biography, making this familiarity easy to achieve). Indeed, in purchasing a Kinkade lithograph, one is quite literally purchasing a bit of the artist himself. Each limited-edition Kinkade print is mechanically signed with special ink that contains the artist's DNA. The ritualistic qualities of the purchase of a Kinkade image thus attain a near communion-like status.[26]

These personal motifs encourage thoughts of family and childhood, with such insular units as Kinkade with his wife and daughter in *Main Street Matinee* frequently repeated. Again and again we find the recurrent and almost unsettling image of a mother and child, isolated and contained, amongst other occupants of a scene. This mother-child unit is always set apart from the other figures, often huddled together in the middle of a crowded street, under umbrellas, with features obscured or with their backs turned toward the viewer. A notable example of this occurs in *New York snow on Seventh Avenue, 1932* (1989; fig. 1), one of Kinkade's urban images. Located just below and to the side of the off-center vanishing point, and highlighted with daubs of red and pink, a small mother and daughter pair can be seen walking toward the viewer in the middle of the busy street. These small figures serve as the anchor for the entire scene, as the viewer's eye is brought back to rest on them again and again. Their faces are obscured, little more than blurred patches of creamy color, but rather than alarming the viewer in their blankness, this serves to give the mother and daughter a certain interiority. It is as if they are so complete, so secure that they do not need the world around them. Alternatively, the vacant features also allow them to function as a screen for projecting the self. This tiny pair presents the viewer with a safe haven in the urban atmosphere, a small sanctuary of infantile connection and unity.

Similar pairings to that in *New York snow on Seventh Avenue, 1932* occur so often that their psychological import cannot be denied. Kinkade, himself the child of a broken home, may be haunted by a nostalgic vision of the unitary reality made manifest. His own nostalgic desire for home and a mythic recreation of the past centers on these figures, content and contained in their detachment from the world. Given the popularity of Kinkade's imagery, the wholeness of this mother-child unit, by extension, fulfills a wider nostalgic need in the American psyche. This evocative pairing lies at the very foundation of Kinkade's work, providing the primary source of identification for the viewer who wishes to (re)envision the secu-

Figure 1. Thomas Kinkade, *New York snow on Seventh Avenue, 1932.*

rity of childhood. The psychoanalytic theory of nostalgia as a longing for reunification with the maternal body as a means of repairing the fractured psyche is thus quite literally embodied within Kinkade's imagery.

Nostalgic longing as a desire to return to the unitary reality of the maternal bond also explains the "womblike" aesthetic found within Kinkade's imagery. As Randall Balmer notes, Kinkade's "paintings provide shelter, a kind of enwombing. The space Kinkade portrays is female space, characterized by interiority. There is nothing angular in his paintings; the lines are soft and rounded and inviting. . . . The art of Thomas Kinkade offers an oasis, a retreat from the assaults of modern life, a vision of a more perfect world. Who wouldn't like to catch a glimpse of that world from time to time, to picture life before the Fall?"[27]

Balmer not only notes the "feminine space" within Kinkade's work but also ties this to a prelapsarian vision, a common trope of nostalgic longing. Kinkade's enwombing vision of childhood, of literal and metaphorical gardens, of protection, wonder, and abundance, is in keeping with Jacoby's unitary reality. It is no coincidence that Kinkade's imagery is marked by soft, fuzzy edges and an abundance of pinks. His cottages, churches, and stairways are nestled in fecund, enclosing gardens. These are soft spaces of nurturing, Edenic in their psychoanalytic import. When Kinkade does not depict the mother-child pair directly, nostalgia for the womb itself is invoked instead. His spaces are often wet and warm, slick with spring rain and soft with diffused light. The images are dominated by curving lines and framing devices that seem to close in around a protected center. One is given the sense of being cushioned and cradled and lulled. These images present a world in which the viewer can feel pacified and pampered, where the literal demands of life become remote from the figurative embrace of maternal reverie.

These elements of the Kinkadian world—the faithful repetition of genre and motif, the reassurance of symbolic continuity, the warm womb-like glow, and the embodiment of the maternal bond in the recurrence of mother-child pairings—are perhaps enough to explain how a nostalgic response could be produced within a viewer on a subconscious level. These aspects of Kinkade's aesthetic are not quite sufficient, however, to account for the immense popularity of his imagery during the millennial decades and its widely acknowledged nostalgic appeal. The final facet required to

secure the perfection of Kinkade's visualization of nostalgia is the incorporation of stereotypical images of the past, a key part of the nostalgia phenomenon as theorized by Jameson. More specifically, Kinkade has accessed the concept of a mythic 1950s America in his imagery, thereby exploiting broader trends in consumer culture and neoconservative politics.

With the rise of the nostalgia phenomenon in the 1970s and the maturation of the baby-boomer generation, "the Fifties" came to serve as the primary locus of nostalgic longing through the proliferation of stylistic tropes. This mythologized and stereotypical envisioning of the Fifties served to foster the illusion of a fixed American identity amid the uprootedness, disembeddedness, and multiculturalism of the postmodern era. Disregarding the historical realities of segregation, McCarthyism, and gender inequality, the romanticized idea of the Fifties became so entrenched that even those who personally experienced the shortcomings of the period still desired a return to the symbolic essence of the era.[28] More of a spiritual location of childhood innocence than an actual historical moment, the Fifties have come to stand in for the broader paradigm of a utopian American and personal past.[29] It must be noted that while Kinkade's imagery is replete with mementos specifically related to the Fifties, from classic cars to the ubiquitous presence of Norman Rockwell, his overall amalgamation of stereotypical generational details that can span anywhere from the early nineteenth century to the mid-twentieth is in keeping with the trend. The myth of the Fifties has monopolized our cultural nostalgic longing to the extent that any aspect of historicized small-town Americana can be considered part of the era.

Micki McElya has described Kinkade as the painter of the "Religious Right" and has elaborated on his ties to Christian evangelicalism and the neoconservative political movement.[30] Additionally, McElya suggests that at the center of Kinkade's propagandistic function as "Painter of the Right" is a nostalgic longing for a mythic American past located in the cultural stereotype of the Fifties. The political scientist Mary Caputi corroborates this link between nostalgia for the Fifties and political and religious conservatism: "Neoconservatism would be the road home to a safety and an innocence, an Eden, that had long been the mythical substrate of America. This movement's mission was thus to reconnect us to a past that would then be projected onto the future, to return us to an innocence that would become the innocence of our future."[31]

Ann Burlein has also commented on this manipulation of nostalgia by the Religious Right, describing how the neoconservative political action group Focus on the Family employed family photography and photo albums representing the Fifties as tools for promoting its agenda of "empowering people personally in ways that disempower them politically."[32] She argues that by promoting the myth of the Fifties through a proliferation of media images that belie the struggles of the period and present only an Edenic fictionalization of the past, the group "provides a way for people to exclude, evade, and efface difference while professing concern and compassionate inclusion."[33] Kinkade's nostalgic imagery conforms to this same trend. Those viewers who turn to the historicized "memories" of Kinkade's imagery seeking fulfillment and redemption through nostalgic longing encounter instead an ideology of disempowerment and exclusion.

To consider this last aspect of nostalgic longing, let us return to a close examination of *Hometown Memories I: Walking to Church on a Rainy Sunday Evening* (pl. 8). Although it is not the most famous, widely reproduced, or collected image in Kinkade's oeuvre, it is perhaps the quintessential work of the Painter of Light™, epitomizing the nostalgic appeal of his unique aesthetic. Once again, here are the family pets, the distant white church steeple, the dusky atmosphere of a rainy evening softened by the warm glow emanating from the windows and lampposts, the overabundant flora of a fecund spring, the white picket fences, the quaint gingerbread homes, and that small mother and daughter pair, walking off into the distance. Taken as a whole, these details are meant to trigger a memory of childhood and security, a moment when the viewer was free from wants, needs, and demands. Indeed, *Hometown Memories I* is part of the series that Kinkade himself terms "Memories," thus cuing viewers to identify with the image by recalling either their own personal past or the media generated images that have come to stand in for true recollection. The viewer is promised familiarity and accessibility, while the recognition of the oft-repeated motifs of Kinkade's world reinforce the perceived verity of the scene. Kinkade writes of the image, "These are the places where families thrive, children grow-up, and memories are made."[34]

The subtitle, however, *Walking to Church on a Rainy Sunday Evening*, indicates that there is another undercurrent at work, narrowing the supposed universality of Kinkade's childhood vision. If Kinkade has indeed created an image of a postmodern paradise, it is an exclusively Christian paradise.

Moreover, it is a racially white and wealthy paradise, free from the taint of poverty and the social strain of a minority presence. In scouring Kinkade's images, it soon becomes clear that the prominent figures in his images are all demonstrably white (in many of his crowd scenes there are figures whose faces are blurred or indistinguishable enough to cause doubt as to their race or ethnicity).[35] Whiteness is thus the norm, and images such as *Hometown Memories I* achieve their nostalgic appeal as much through what has been excluded as what is present. Apart from this performance of cultural and racial purification, Kinkade has also rid his world of commercialism and consumerism. There are no shopping plazas, no signs of industry or technology (apart from the toylike antique cars). This is a neighborhood where many people can walk to work and to church, past the friendly, glowing homes of fellow members of the community. Steeped as Kinkade's art is in commercialization and mechanization, the image he sells is one that denies that world. Tidy and unhurried, Kinkade's *Hometown* achieves a restrained sense of stasis consistent with Olalquiaga's cultural fossilization, the hallmark of nostalgic kitsch. Despite the flocks of antique cars or the scattering of sidewalk pedestrians that line the streets, there is a resounding absence of life and movement. This image, then, performs an erasure of the past, replacing it with a static realm of privilege, whiteness, and the warmth and sanctity of the Christian family.[36] In Kinkade's hometown each orderly house glows with the light of family values from within but remains isolated from the broader community around. These families are bound together but are encouraged to turn inward to the glow of home rather than outward to the concerns of the world. The normative whiteness, affluence, and Christianity of Kinkade's pristine world may not be objectionable in itself, but replacing individual, actual memories of home with this fictionalization facilitates a desire for exclusion and erasure.

Fred Davis, in observing the many forms of nostalgic experience that could be found in the culture around him, argued that nostalgia had achieved a distinct "aesthetic modality," a certain combination of artistic signs that not only evoke nostalgic responses but "by some obscure mimetic isomorphism comes . . . to serve as a substitute for the feeling or mood it aims to arouse."[37] In a unique and compelling way the imagery of Thomas Kinkade weaves together the dominant threads of contemporary nostalgia: the human yearning for the unitary reality of the womb, the postmodern desire to re-embed the fractured psyche, and the stereotypical

relationship to history and memory that has come to define the amnesiac consumer culture of America. Through repetition of genres and motifs, through a consistent and coherent system of signification, through an embodiment of the maternal bond, and through the rendering of an exclusionary myth of the American past, Kinkade's work succeeds at achieving Davis's "aesthetic modality" by synthesizing these multiple manifestations of nostalgic desire in a way that millions of Americans have found compulsively appealing.[38] Yet rather than heal the viewer's fractured sense of self, Kinkade's imagery serves only as an opiate, offering only a momentary prolonging of the nostalgic reverie. Kinkade manipulates those who are most psychically vulnerable, those compelled to turn to his world to combat feelings of uprootedness, a loss of origins, a loss of meaning, a loss of the essential human connection; but rather than offer a means of recovery, his imagery merely provides a momentary "fix" that leaves the viewer needing more. Perhaps this helps to explain why some consumers obsessively collect the imagery of Kinkade on merchandise ranging from lithographic prints to Christmas ornaments. While many are understandably repelled by Kinkade's unabashed exploitation of the often involuntary, visceral nostalgic impulse, others become addicted to the temporary solace of retreating into a world of shared displacement. These viewers find in Kinkade's imagery a fictional place but a place where those who have no real home can find the simulacrum of meaning and belonging that they so desperately crave.

Notes

1. The pervasiveness of this nostalgic response can be found throughout both Kinkade's own advertisements and the reactions of viewers. For example, during a live telecast on QVC Kinkade described his image *Hometown Memories I* by saying that "back then life went a little simpler. . . . [It's] about as nostalgic as it gets!" (April 15, 2003). Another example can be found in a website advertisement for a Thomas Kinkade line of Nelson Bibles, which states, "He is more than a painter. . . . He is a creator of worlds that call us to escape to a simpler time . . . that inspire an inner sense of home, family, warmth, goodness and simplicity that people are naturally drawn to." While the term *nostalgia* is not employed directly, the response described is undoubtedly nostalgic (www.nelsonbibles .com/bibles/dept.asp?dept_id=200 [accessed April 2003]). In a review for the exhibition Thomas Kinkade: Heaven on Earth, curated by Jeffrey Vallance, Peter

Clothier writes, "His pictures ooze with nostalgia for a bygone Hallmark card past that never was" (http://artscenecal.com/ArticlesFile/Archive/Articles2004/Articles0504/TKinkadeA.html [accessed July 13, 2006]). Even those who profess to disdain Kinkade's work cannot deny the nostalgic quality of his images. In an online posting titled, "The I hate Thomas Kinkade club," a woman named Anna writes, "It's the paintings that I hated . . . those paintings with their sugary nostalgia, or worse, this weird kind of fantasy nostalgia mixed with patriotism" (http://littleredboat.co.uk/?p=2306 [accessed April 2, 2006]). See also Kinkade, *Thomas Kinkade*, 112–13. It is interesting that many of the direct references to nostalgia come from less formal sources. In published articles and books many seem hesitant to apply the term directly to Kinkade. However, in "ephemera" such as advertisements, websites, and blogs the term is everywhere.

2. See Grainge, "Nostalgia and Style in Retro America," 27; and Rice, *Through the Lens of the City*, 7–9.

3. Grainge, "Nostalgia and Style in Retro America," 32–33; Rice, *Through the Lens of the City*, 12; see also Tannock, "Nostalgia Critique."

4. David Lowenthal, "Past Time, Present Place," 5.

5. For more on the history of nostalgia, see Ritivoi, *Yesterday's Self*, 15–29; Wilson, *Nostalgia*, 21–23; Lowenthal, "Nostalgia Tells It like It Wasn't," 18–21; and Davis, *Yearning for Yesterday*, 1–7.

6. Wilson, *Nostalgia*, 23.

7. Lowenthal, "Past Time, Present Place," 2.

8. Davis, *Yearning for Yesterday*, 74–76.

9. Wilson, *Nostalgia*, 34–36, 61–62.

10. Wilson writes, "If, according to postmodernism, people feel uncentered in a world so uncertain, then nostalgia may give people a sense of control over their own destiny" (*Nostalgia*, 80). See also Chase and Shaw, "The Dimensions of Nostalgia," 15.

11. See Kristeva, *Black Sun*. See also Caputi, *A Kinder, Gentler America*, 27–33. For a more clinical psychological approach to this manifestation of nostalgia as a failure to "mourn" the loss of the mother bond, see Bassin, "Maternal Subjectivity in the Culture of Nostalgia."

12. Jacoby, *Longing for Paradise*, 4.

13. Ibid., 9. For other references to the utopian or prelapsarian nature of nostalgia, see Tannock, "Nostalgia Critique," 454, 459. See also Olalquiaga, *The Artificial Kingdom*, 293.

14. Jameson, *The Cultural Turn*, 10.

15. Ibid., 9.

16. Ibid., 129.

17. For three examples of studies within the visual arts that engage meaningfully with the concept of nostalgia, see Paul Grainge's "Nostalgia and Style in

Retro America," where Grainge discusses nostalgia as a niche marketing strategy in emerging media such as cable television and the video and music industries; see also Mark Rice's *Through the Lens of the City*, where Rice proposes that nostalgia for the 1930s served as a motivating force behind the national photographic surveys of the 1970s; finally, see Alan Wallach's "The Norman Rockwell Museum and the Representation of Social Conflict," an examination of Norman Rockwell's reliance on the cultural nostalgia for small-town America, itself a nostalgic product of an earlier time, as well as the importance of nostalgia to the architecture and design of the Norman Rockwell Museum in Stockbridge, Massachusetts.

18. See Alexis L. Boylan's introduction to this volume, as well as Anna Brzyski's essay herein for alternative constructions of the concept of kitsch. Much like nostalgia, kitsch is too often used as a means of easily dismissing potentially illuminating cultural trends like the work of Kinkade. Indeed, it can be argued that Kinkade's art and industry conforms almost perfectly to Clement Greenberg's definition of kitsch as the "ersatz culture" of the masses: "Kitsch is mechanical and operates by formulas. Kitsch is vicarious experience and faked sensations. . . . Kitsch is the epitome of all that is spurious in the life of our times. Kitsch pretends to demand nothing of its customers except their money" (Greenberg, "Avant-Garde and Kitsch," 12). It is even tempting to speculate that perhaps Kinkade, who studied art at the University of California, Berkeley, purposely set out to create the apotheosis of Greenberg's kitsch. The question of whether Kinkade's success could have been based largely on his intentional opposition to the avant-garde is a potentially provocative subject.

19. See Olalquiaga, *The Artificial Kingdom*, 122, 291–98.

20. Ibid., 293.

21. Binkley, "Kitsch as a Repetitive System," 131.

22. Ibid., 149, 145. In her analysis of the motivation behind remakes of 1950s-era films, Vera Dika concurs with Binkley that nostalgia is predicated on repetition. Dika, in turn, invokes Freud's theory of the repetition compulsion, a psychological neurosis that develops out of the repression of past trauma by symbolically revisiting the events until the mind has recovered. Dika goes on to argue, however, that the use of repetition in facilitating nostalgia functions as a form of denial and does not therefore allow for recovery. See Dika, *Recycled Culture in Contemporary Art and Film*, 206–7.

23. *Home Is Where the Heart Is II* is itself a sequel, to *Home Is Where the Heart Is* (1992). Thus, *Blessings of Christmas* not only depicts the same cottage as other Kinkade images, but it also is a part of the Blessings of the Seasons Collection. This interconnection increases the collectible value of these images, while also forging the illusion of a fully realized world of cottages and scenes.

24. Vallance, *Thomas Kinkade*, 32. While Vallance is the author of this listing of

symbols and their meanings, it is clear that Kinkade participated and advised in both the exhibition and the catalogue. I assume, therefore, that this list of one-to-one correlations was ultimately generated by Kinkade himself.

25. Ibid., 32.

26. This argument is pursued to different religious and market ends by Seth Feman in his essay in this collection.

27. Balmer, "The Kinkade Crusade," 55.

28. For more on this phenomenon, see Wilson, *Nostalgia*, 63–104.

29. See Burlein, "Focusing on the Family," 321; see also Caputi, *A Kinder, Gentler America*, esp. 2, 6–10, 18, 46, 98–100.

30. See McElya's essay herein.

31. Caputi, *A Kinder, Gentler America*, 2.

32. Burlein, "Focusing on the Family," 314.

33. Ibid., 320.

34. Kinkade and Reed, *Thomas Kinkade*, 134.

35. For more on the normative whiteness of Kinkade's imagery, see McElya's essay herein.

36. Kinkade himself has proclaimed, implicitly, his allegiance to these neo-conservative ideals: "For many millions, my art provides an escape from the pressures of contemporary life and a gentle affirmation of such foundational values as home, family, faith, and simpler ways of living" (Vallance, *Thomas Kinkade*, 19).

37. Davis, *Yearning for Yesterday*, 73.

38. At the beginning of this essay I observed that regardless of where a viewer stands on the spectrum of response to Kinkade's imagery, from vehement repulsion to near obsessive attraction, the nostalgic appeal is almost universally recognized. Those who react negatively to nostalgia in general (and Kinkade in particular) may more readily recognize the primal nature of this appeal and its capacity for manipulation. To put it another way, such viewers perhaps sense that they are being "duped" by the nostalgic appeal and react against it. However, it would seem that many viewers, particularly those who have been rendered psychologically vulnerable, find a particular solace in the nostalgic appeal (and by extension the imagery of Kinkade). Given the pervasiveness of nostalgia in contemporary culture, such viewers are clearly not alone, and the legitimacy of their psychological desire for cohesion deserves to be acknowledged. For one example of how nostalgia can function as psychological coping strategy from a clinical perspective, see Bassin, "Maternal Subjectivity in the Culture of Nostalgia."

Repetition, Exclusion, and the Urbanism of Nostalgia:
The Architecture of Thomas Kinkade

CHRISTOPHER E. M. PEARSON

The paintings of Thomas Kinkade, who is advertised as "America's most collected living artist," consist in large part of representations of architecture. His most characteristic motif—as exemplified by *A New Day Dawning* (1997)—is an isolated cottage in a rural or wilderness setting. Here a small thatched-roof house, evidently sourced from the depths of the English countryside, has inexplicably been relocated to a rocky seashore. The latter might be taken as a depiction of the coastline of Kinkade's native California if not for the rising sun's appearance over the water. As if to anchor the cottage more firmly to this precarious site, it is embedded in lush stands of vegetation, rendered in improbable hues of fuchsia, pink, purple, and blue. For the self-styled "Painter of Light™," however, such standardized décor serves only as a necessary vehicle for the introduction of the real subject of visual (and symbolic) interest, which in this case turns out to involve two competing effects of radiant illumination: the emergent beams of sunlight and the quintessentially Kinkadian blaze of amber light (disconcertingly suggestive, as Joan Didion and others have noticed, of a serious domestic conflagration in progress within) that filters through the cottage windows. Kinkade and his proponents like to point out that his imagery derives from Romantic landscape traditions, and Caspar David Friedrich, J. M. W. Turner, the Hudson River school, and the American Luminists are duly cited as influences. Yet Kinkade's cottages are more than simple incidents in the landscape: they are the focus and fulcrum of his pictures—Seth Feman's comparison between Kinkade and Thomas Cole elsewhere in this volume also speaks to this point. In this respect, at least, Kinkade might also be seen to join a long line of painters known primarily for their

depictions of real or imagined buildings, and here one might even be jus-
tified in invoking the precedents of Saenredam, Canaletto, Guardi, and
Piranesi, as well as such latter-day *vedutisti* as Charles Meryon, Giorgio di
Chirico, Edward Hopper, and Richard Estes. Like his precursors, Kinkade
visually proposes that the existential, emotional, and spiritual ramifications
of the human-made environment can be just as significant as those of the
natural world.

In attempting to locate Kinkade within a matrix of artistic precedent, it
may be more to the point to suggest that his oeuvre has most in common
with that of Andy Warhol, an artist whom Kinkade has reportedly pro-
fessed to admire.[1] This can be asserted because Kinkade's images are simi-
larly mass-produced in a "factory" (represented by the Media Arts Group
of Morgan Hill, California), are self-consciously branded through the use
of a distinctive and consistent visual style, and share a central conceit of
the seemingly indefatigable repetition of images of consumer desire. The
latter, in the case of Kinkade, entails the dream of living in a natural set-
ting whose value is measured by its distance from contemporary urban
reality. Of interest here, however, is not just the intensive commodifica-
tion of Kinkade's cottage paintings but of the *subjects* of those paintings,
for they have now aroused consumerist impulses to such a degree as to de-
mand physical manifestation as functional dwellings. This first occurred in
2002, when the developer Taylor Woodrow opened "The Village at Hid-
denbrooke," a housing estate in Northern California that was marketed as
having been inspired by Kinkade's pictures.

The continuing popular success of both the painted and inhabitable
architectures of Thomas Kinkade confirms his undoubted appeal to large
sectors of the American public. By his own count, his images are on dis-
play in no less than ten million homes in the United States. Thus, in light
of the artist's unexpectedly close engagement with architectural concerns,
one wonders whether Kinkade's artistic goals and methods, though avow-
edly escapist in intention, might have any strategic or ideological affinity
with current practices in American real estate, domestic architecture, or
urban planning. In proposing this initial assessment of Kinkade's archi-
tectural project, I would therefore include in the discussion the principles
of the Neotraditional (though not necessarily neoconservative) town
planning movement known as the New Urbanism. This relatively recent
development in urban praxis is in some sense a misnomer, for it advo-

cates—not without a certain nostalgia—a return to traditional models of neighborhood design, particularly those of the early twentieth century. As articulated in the writings of its most famous theorists and practitioners, notably Andres Duany and Elizabeth Plater-Zyberk,[2] New Urbanist planning ideally aims to offer diversity of housing and usage, walkability, narrow and tree-lined streets, identifiable civic buildings and public spaces, a sense of community, and architectural design that respects local context and regional traditions. Many of these criteria might seem to indicate that the New Urbanism has much in common with Kinkadian imagery. I will argue, however, that the artist's paintings ultimately embody an ideology that is largely antithetical to New Urbanist theory and practice and are, in fact, complicit in disseminating an all too prevalent urbanistic ideal of simulation and theming in which concepts of history and community are evoked and marketed only in order to mask their absence in the built environment.

One of Thomas Kinkade's more frequently cited explanatory glosses, part of the publicity sent to commercial galleries that feature his work, states that each of his paintings represents "a quiet messenger in the home, affirming the basic values of family and home, faith in God, and the luminous beauty of nature." These three themes—the house as a symbol of the nuclear family, the immanent presence of the divine in Christian spirituality, and the visual desirability of the natural world—are typically represented in his pictures by (respectively) a small domestic building, dramatic effects of cloud and sunlight, and an expansive landscape setting of forests, mountains, and coastlines. While this tripartite formula remains constant, it leaves much scope for architectural variation, and Kinkade's cottages make use of diverse historical forms and typologies. We can generalize, however, that most of his buildings tend to be small, of asymmetrical plan, and built of uncoursed stone, with tiled or thatched roofs, functional chimneys, and small-paned windows. *Sweetheart Cottage III* (1994; pl. 2) illustrates the type in its most compact form, here set precariously on a subalpine crag. In one sense these constructions are pure fantasy, as underlined by their toylike proportions, shaky grasp of practical masonry technique, and often implausible settings on the immediate margins of large bodies of water or in remote mountain locations. More cogently, this characterization can be supported by reference to the acknowledged debt that Kinkade's work owes to earlier fantasy art, notably Gustaf Tenggren's

background settings for Walt Disney's animated film *Pinocchio* (1940), as well as to the expected roster of American illustrators like Howard Pyle and Maxfield Parrish.[3]

The patently unreal character of Kinkade's painted architecture may indeed seem self-evident. On the one hand, he makes no claim to architectural or regional authenticity for his images, and his publicity refers positively to his penchant for idealizing or "romanticizing" his subjects. On the other, Kinkade also notes that his cottages tend to be modeled loosely on domestic building traditions of England. Having sought inspiration in touristic villages like Bourton-on-the-Water, Kinkade cites the Lake District and Cotswolds cottage vernacular as particular points of reference. The series Lamplight Lane (1993–96) and Cobblestone Lane (1996–98) are perhaps the clearest examples of this influence. While Kinkade's work has achieved only modest success in Britain, it is perhaps surprising that such localized subject matter has proved to be so popular with his North American audience, who would be unlikely (one imagines) to know of such buildings at first or even second hand. Perhaps the relative unfamiliarity of his source material—the English term *twee* having little resonance on this side of the Atlantic—may constitute part of the escapist appeal of his cottage scenes.[4] It is true that a few characteristically North American domestic-building types, more plausibly a part of his purchasers' actual environment, also appear in his work. These would include log cabins, timber-framed Victorians with wooden siding and gingerbread trim, and even bed-and-breakfast inns. His *Village Inn* (1993), featuring a small cross-gabled cottage with white clapboard siding and an extensive porch, might well be taken as a relatively straightforward illustration of such a business. As an underresearched architectural typology, B&Bs may in fact be the closest realizations of Kinkade's vision and ideology in the American built environment, appearing as isolated relics of an apparently gentler past whose internal arrangements, usually characterized by an indiscriminate clutter of nostalgic bric-a-brac, can play host to suburbanite fantasies of Victorian-era elegance and privilege.

To return to the paintings themselves, it might be worth emphasizing that the distaste felt by many intellectuals and social activists when faced with Kinkade's art stems only in part from the specious and otherwise objectionable visual and technical clichés that so demonstrably make up the bulk of his artistic vocabulary.[5] Many have pointed instead to his subject

matter, and in this connection our attention is drawn less often to those elements that Kinkade so insistently presents as positive and desirable than to those he so complacently represses—that is, the harsh and largely urban realities of contemporary America. To rectify such exclusions, at least one contemporary artist, Jos Sances of Berkeley, has felt motivated to produce simulated Kinkade paintings with marginalized groups such as the homeless pointedly reinserted into the scene.[6]

Yet the escapism of Kinkade's work (his publicity refers frankly to his imagery as "a place of refuge") clearly constitutes a large part of its attraction for his audience. In this respect I would like to identify two major strategies that Kinkade offers his buying public: these we might term *projection* and *control*. Projection concerns the way Kinkade's customers tend to use their purchase: interviews with collectors have confirmed that many see their Kinkade picture as a focus for private meditation.[7] By concentrating on particular details in order to project themselves into a given scene, they create first-person narratives of what it would be like to experience the sights and sounds of a sublime nature, to walk down a country road, to dwell in an attractive cottage. Kinkade famously courts this projection through ritualized staging at the point of sale: the dimming of gallery lights for the viewing of the paintings effects the exclusion of an immediate reality (the shopping mall) in favor of a private escape into a vividly realized fantasy realm, a strategy discussed in Monica Kjellman-Chapin's essay in this collection. Within the canvas this goal is also abetted by the frequent inclusion of such stock motifs as driveways, gates, doors, lighted windows, and evocative and half-screened vistas, which induce both an urge to explore as well as a desire to hide away from the world. The notable lack of visible inhabitants in the majority of Kinkade's pictures allows viewers to locate themselves in an implied position of ownership with respect to the cottage and its landscape setting. Kinkade is in this sense marketing virtual real estate.

The artist at the same time caters to a desire for absolute control on the part of his purchasers. While the often incoherent or improbable relationship between buildings and landscape in Kinkade's paintings witnesses a conflicted (or perhaps gluttonous) desire to experience *simultaneously* both the grandeur of unspoiled nature and the sheltering intimacy of a small home, the crucial point is that both are made the object of a purely private enjoyment. Thus the frequent appearance of large gateways in his

pictures signals an invitation to enter a privileged space, an emphatically bounded piece of private property, while promising the exclusion of undesirable elements. As Wendy Katz has noted, this desire for control is particularly noticeable in the case of Kinkade's collectibles,[8] where purchasers can physically manipulate the elements of miniaturized villages to shape an authentically Kinkadian environment according to personal preference. His architectural project in this case moves beyond the delineation of surrogate buildings into the realm of fictive urbanism. Consciously or unconsciously, these strategies for projection and control evidently answer a need among Kinkade's collectors, one that clearly derives from perceived inadequacies in the actual realm of the American built environment, and it is here—rather than in the world of art—that we need to look for the sources of his popularity.

In proposing a means of escape in both time and space, do Kinkade's cottages speak to an authentic desire for self-isolation or self-sufficiency, perhaps the last vestiges of the ideals of Thomas Jefferson and Henry David Thoreau, on the part of his American purchasers? There are several paradoxes here. While catering to an urge to flee the real or inferred threats of an urban environment, Kinkade's secluded dwellings in fact represent in idealized form the actual circumstances of many suburbanites, who in an apparent effort to find community and communion with nature choose to live in clearly demarcated single-family houses situated many miles from work or traditional civic centers. We might also note the almost complete absence of automobiles in the cottage paintings, thus concealing the only practical means of reaching such out-of-the-way locations—a strategy unmistakably intended to remove any potentially disturbing reference to the place where most of his customers actually spend much of their time as commuters, that is, in their cars or SUVs.

A further irony can be discerned in Kinkade's concerted efforts to imbue his cottages with an air of permanency: their old-world appearance, massive stone construction, and dense plantings of mature vegetation are intended to root them firmly to a particular place and to suggest long-term occupancy. Yet current real estate lore holds that North Americans move house, on average, every four to six years, a situation that has been the norm for several decades. By choice or by necessity the new house will tend to be one that has been recently built, thus inhibiting any real sense of the domestic space as a site of tradition or ancestral pride. Tied to

the whims of a globalized capitalist economy, middle-class Americans—Kinkade's targeted market segment—are essentially rootless. Yet hopeful fantasies about the stability of the family unit and its symbolic manifestation as a permanent homestead anchored to a particular site persist, and they are catered to (some might say exploited) by the American real estate, development, and homebuilding industries. A glance through recent sales literature put out by these sectors reveals that the fabrication of such stylistic categories as "Country," "Victorian," "European," "Farmhouse," and "Craftsman" is held to be of marketing value in lending new houses a cachet of tradition and historical pedigree. Of course, such theming is not a recent development; it might even be said that the history of American domestic architecture since the mid-eighteenth century has been predicated largely on the provision of appropriate historicizing and associational cues for the middle-class home, with legitimating stylistic references drawn variously from ancient Greece, the Middle Ages, the Italian Renaissance, and Palladio.[9] The more commercial application of historicism for the purposes of the home-building and real estate industries might more profitably be traced back to the 1920s.[10] Today, as Duany and Plater-Zyberk have pointed out, contemporary developers are fully aware of the public's aversion to terms like *cookie cutter* and can spend as much as 20 percent of their construction budget on the application of historicizing or decorative elements.[11] While in one sense responding to an evident yearning for individuality and variety, American houses since the Second World War have typically witnessed an ever-slackening commitment to the evocation of a convincing historicism, a trend that the postmodernist praxis of the recent past—ostentatiously resurrecting historical forms only to reposition them as ironic pastiche—failed to halt in any substantial way. If anything, postmodernism has only served to render more cynical and gratuitous the historicizing impulse, which is now manifested largely in the form of cladding or veneers, ornamental trim, and a proliferation of gables, bay windows, prefab columns, and so forth.

By using token signifiers to lend a superficial variety to the homogeneous products of rationalized construction, this kind of scenographic differentiation, almost purely semiotic rather than substantial, may give home buyers the impression that they are purchasing a piece of architecture with integrity, character, and historical resonance. Inevitably, however, such well-established marketing techniques favor emotionally laden

factors of image and connotation over considerations of a more practical sort (utility, commodity, durability, sustainability). Equally, marketers of tracts of such houses tend to emphasize larger associations of neighborhood and connection to the natural environment while making little effort to manifest any of these ideas on the ground; hence the adage that new housing developments tend to be named for those natural features they have destroyed and supplanted. For the developer, homebuilder, realtor, and purchaser the basic unit of sale is still the individual house, and this atomized idea of "home"—a private commodity rather than a community—clearly finds an echo in Kinkade's images of secluded cottages, which in this light appear as mythologized archetypes of the single-family house, floating free of any form of societal interaction.

This interpretation would nevertheless seem somewhat at odds with a second thematic strain within Kinkade's work: his pictures of idealized small-town life. Represented by the series Hometown Memories, as well as several one-off works, these are among the most autobiographical of Kinkade's productions. *Carmel, Sunset on Ocean Avenue* (1999), depicting the California town not far from the artist's present-day residence in the south Bay Area, is typical. Ostensibly positioning the viewer behind the windshield of a car, Kinkade shows crowds of cyclists, automobiles, and well-dressed pedestrians sharing the rain-slicked main thoroughfare. Specific buildings and landmarks, most notably the mission-style bell to the left and the distant Pacific at the end of the street, are recognizably part of the actual geography of Carmel, though the general atmosphere of the painting, with its oddly subaqueous light intended to evoke the ambience of a retreating rain squall, again seems idealized, if not unreal. At far right, Kinkade self-reflexively portrays himself at the easel in the act of capturing the scene (rather damply, one imagines) *en plein air*. Occasionally in Kinkade's oeuvre we even find views of larger American cities, like San Francisco or New York, that evidence a promiscuous variety of buildings, automobiles, and accessories from various historical periods, though passers-by, strangely enough, are always in modern-day dress. As Andrea Wolk Rager points out elsewhere in this volume, the evident strategy is to present the past as a smorgasbord of pleasurable signifiers that can be recalled and recombined at will in order to generate the required mood of unfocused nostalgia.

Such eclectic synchronicity again reminds us not only of the postmod-

ern collage of temporal and stylistic references prevalent in much commercial architecture of the 1980s and 1990s but also of the vision of the ideal American town that has more recently been evoked by the New Urbanist school of planning.[12] New Urbanism, espousing an approach generally known as Traditional Neighborhood Design, first attracted an American following in the late 1980s. Now an influential movement, its aims are broad and potentially radical, envisioning a sea change not only in the fields of architecture, city planning, and real estate development but in the personal values and lifestyles of citizens. Essentially, the New Urbanism can be seen as a reaction to suburban sprawl, for it advocates a return to the more compact, mixed-use model typical of American towns in the early years of the twentieth century. The modern movement, as epitomized by the urbanistic theory of Le Corbusier, is held to account for the promulgation of inflexible gridiron plans, strict zoning laws, and separation of urban functions. This, in turn, is seen to have led to the destruction of older neighborhoods and the rise of a new urban pattern characterized by pedestrian-unfriendly suburbs, strip-mall and big-box retail developments, and a concomitant fragmentation of economic and ethnic groups. Though far from being accepted as a dominant paradigm, the New Urbanism is now being taken seriously by civic governments and developers, and hundreds of projects making use of New Urbanist principles, comprising both new (greenfield) developments and urban renewal (infill or brownfield) initiatives, are currently underway in the United States. In an effort to compromise with existing power structures and market demand, many of these make only limited use of New Urbanist ideas, appropriating the look and terminology of the movement to produce hybrid developments that masquerade as Neotraditional neighborhoods while remaining largely conventional in concept. One of the earliest and most well-known New Urbanist experiments is the resort town of Seaside, Florida, masterplanned by Duany and Plater-Zyberk in the early 1980s, though it was later eclipsed by the controversy generated by Disney's five-thousand-acre town of Celebration in the same state, which opened in 1996.[13]

Politically, the New Urbanism may seem somewhat ambiguous. While the movement is unapologetically conservative in character, its intellectual origins are to be found in the humanistic and even socialistic critiques of Jane Jacobs and Lewis Mumford in the United States.[14] Its more recent exponents would also cite the more radically reactionary (anti-

capitalist, antitechnological) polemics of Rob Krier and Leon Krier and other European "New Classical" architects, who have found a prominent ally and spokesman in Britain's Prince Charles.[15] Generally representing a backward-looking stream of postmodern praxis (what Hal Foster once identified as a "postmodernism of reaction" rather than a "postmodernism of resistance"), this approach finds its most succinct expression in a seminal document known as the Charter for the New Urbanism, signed in 1996 by a coalition of professionals, architects, academics, and other self-styled "Neotraditionalists."[16] Based in Chicago, the Congress for the New Urbanism continues to attract new members and to disseminate the principles of Neotraditional town planning.

The New Urbanist discourse would at first seem to have much in common with Kinkade's hometown evocations, notably a validation of tradition, the desire for community and belonging, and an explicitly antimodernist agenda. The Charter advocates, among other things, "the restoration of existing urban centers and towns within coherent metropolitan regions, the reconfiguration of sprawling suburbs into communities of real neighborhoods and diverse districts, the conservation of natural environments, and the preservation of our built legacy," adding that "communities should be designed for the pedestrian and transit as well as the car; cities and towns should be shaped by physically defined and universally accessible public spaces and community institutions; urban places should be framed by architecture and landscape design that celebrate local history, climate, ecology and building practice."[17] All of these goals again evince a nostalgia for better days, before the hegemony of the automobile, and find an echo in Kinkade's insistent urge to promulgate his own particular vision of the American past, which is similarly characterized by small and friendly communities, livable and vibrant city centers, pedestrian-scaled streets, and respect for historical tradition and the natural world.

It is questionable how far Thomas Kinkade's target demographic is coextensive with the administrators, developers, and investors who take an interest in New Urbanist thinking. Yet the overriding desire to return to the past can be traced in both enterprises, and Kinkade's paintings of hometown scenes might even be seen to provide a vivid dramatization of several New Urbanist criteria put into practice. But by positioning this desire within an escapist recapitulation of an imagined history, Kinkade's pictures present themselves not as viable proposals for the revitalization of

neighborhoods but only as a confused and often inarticulate form of nostalgia—tacitly acknowledging the regrettable absence of community in the present while holding out no prospects for its realization in the future. Conversely, the same might be said of those many new housing projects that pay only lip service to New Urbanist principles, essentially subverting the whole raison d'être of the movement by appropriating only its most obvious stylistic motifs while neglecting the institutional and systemic reforms that a more thoroughgoing ideological commitment would necessarily demand.

In considering Kinkade's urbanistic vision, the artist's own California background is of some relevance. Born in Sacramento, Kinkade grew up in the old Sierra gold-mining town of Placerville. He would later claim to have had an impoverished and largely unhappy childhood there: the family lived in trailer parks and low-rent apartments, his parents divorced when he was six, he felt provincial. He has candidly observed: "I was embarrassed by our home, because it was so shabby. And among my friends, I was the only kid from a broken home. So I guess maybe God became the father I never knew."[18] It is thus tempting to see Kinkade's paintings as an ongoing project to rectify the deficiencies of his childhood, endlessly reiterating themes of home, community, belonging, and the implied but ubiquitous presence of a God/father figure. Methodically, even obsessively, Kinkade has transformed the places he has known in his life—Placerville, Sacramento, San Francisco, Carmel, Los Gatos, and even (latterly) New York and Paris—into sanitized fairylands of light, color, and white middle-class prosperity. But whether this personal narrative is simply another part of Kinkade's marketing strategy, an affective anecdote told to sentimentally-minded customers as part of the sales process, is not clear. We might note that the New Urbanists are similarly concerned to repair the shortcomings of the immediate past through a rejuvenation of the built environment, though their means are necessarily practical and public rather than merely pictorial and private.

Yet in the case of Kinkade the distinction between painting and reality becomes notably blurred when we consider the housing tract known as the Village at Hiddenbrooke, which advertises itself as having been inspired by the artist's cottage paintings. Begun in 1999 and constructed around a golf course designed by Arnold Palmer, Hiddenbrooke is a still-incomplete development of around twelve hundred houses in the foothills near Vallejo,

California. The Kinkade-affiliated phase of this development, "The Village at Hiddenbrooke," was launched in the spring of 2002 by prominent "upscale" developers Taylor Woodrow and is only one example of an estimated 80 percent of new housing projects in America that are gated.[19] Like the Village, such developments are typically situated far from traditional downtowns and maintain a controlled social environment through a combination of prohibitive pricing, high security fences, and monitored access points. Many also enforce strict building and maintenance codes to ensure a reliably genteel ambience for inhabitants. The Village at Hiddenbrooke consists of 101 "cottage-style homes" whose sizes range from medium to large (sixteen hundred to twenty-six hundred square feet), with prices originally set between $367,000 and $419,000.[20] (After a few years, resale values proved to be slightly higher.) The four different house models are named after Kinkade's daughters: the Winsor, the Merritt, the Everett, and the Chandler. Unsurprisingly, the show models featured Kinkade paintings hung prominently over their fireplaces. About half of the projected houses had been sold within a few months, and all were purchased by 2003. A visit to the Village reveals little out of the ordinary in comparison to similar gated developments across North America. The houses are superficially varied but run-of-the-mill, the new gardens and landscaping still somewhat raw (see figs. 1 and 2). Basic civic amenities, apart from the golf club and its restaurant, are nonexistent. Instead, Taylor Woodrow's advertising brochures chose to highlight such features as customized landscaping, white picket fences, flowerbeds, "period" lampposts, a fountain, and a small gazebo, as well as rustic street names like Stepping Stone Court and Rose Arbor Way, which reference titles of Kinkade's paintings. The protection and maintenance of this environment is promised by the Village's tall metal perimeter fence and electronic security gate, as well as a code regulating what residents can do with their homes. My conversations with the present inhabitants of the Village turned up few complaints: people knew what they were buying into.[21] The spacious and well-appointed nature of the homes, the friendliness of the neighbors, and the proximity of nature and the golf course were frequently cited as positive aspects of the development.

But are we justified in seeing the Village—located not far from the town where Kinkade was born—as a realization of the artist's cottage and hometown fantasies in terms of actual architecture and urbanism? The short

Figure 1. A street at the Village at Hiddenbrooke, near Vallejo, California, 2001.
PHOTO BY CHRIS PEARSON.

Figure 2. A home at the Village at Hiddenbrooke, near Vallejo, California, 2001.
PHOTO BY CHRIS PEARSON.

answer is no: the licensing of Kinkade's name to this housing tract was, on the admission of the developer, "a marketing gimmick" that entailed minimal effort to replicate the buildings seen in his paintings.[22] Such an undertaking was seen as too expensive and unnecessary. A generalized emulation of some of the external features of Victorian domestic architecture (gables, porches, bay windows), as well as a few desultory applications of simulated half-timbering and stonework, mark the Village's only tangible steps in this direction. In fact, Kinkade's actual participation seems largely to have been limited to advising the architectural firm of William Hezmalhalch that the houses should evoke a sense of "calm, not chaos, peace not pressure" and reflect "simpler times."[23] And while Kinkade was present to give an address on the Village's official opening day, he has since refused to make any public comment on the development.

Kinkade's tract is certainly not the first housing development to be themed, and as an architecture frankly appealing to nostalgia for a simpler but essentially fictive past, the Village has clear affinities with long-standing traditions of the ersatz vernacular. In a longer historical perspective, we can trace the growing popularity of this conceit from eighteenth-century theories of the picturesque, as manifested in painting in Thomas Gainsborough's sentimentalized if sympathetic portrayals of cottages and peasant life, and in built form at Richard Mique's artificial dairy and village for Marie Antoinette at Versailles (1783) and the quaintly thatched and half-timbered cottages of John Nash's Blaise Hamlet near Bristol (1810).[24] Through the nineteenth century, bourgeois aspirations toward upper-class styles—Second Empire Classicism, for example—tended to prevail in domestic architecture. But the alarming spread of the Industrial Revolution and the consequent growth of cities ensured that pattern books of detached middle-class housing by A. J. Davis, A. J. Downing, and others, which propagated the desirability of simulated rusticity as a means of escape, met with much success. Later in the century, the rise of the garden city and garden suburb, whose village-like ambience attempted to combine the health and fresh air of the countryside with the employment and cultural lures of the traditional urban center, represented the apotheosis of this trend both in England and America.

In closer proximity to Kinkade's Village both chronologically and geographically are such themed California cities as Santa Barbara (Spanish Colonial), Solvang (Danish), and—most pertinently—Carmel. This last

town, founded in 1904 as a rustic artist's colony, has wielded its rigidly en-
forced civic bylaws to maintain a charming if patently artificial cityscape
of cottage-style houses, intimate landscaping, and small and picturesquely
varied boutiques. As in many other themed cities and villages throughout
North America, the initial character of the community was established by
specific historical and ethnic circumstances of settlement, though in the
postwar years these came to be promoted in somewhat caricatured form by
the local business community in order to brand the town as a unique and
attractive destination. One might even say that the American paradigms
for such theming were set by the Walt Disney Corporation, again in Cali-
fornia. "Main Street USA," the two-thirds-scale realization of an imagi-
nary American small town that provides the main ingress to Disneyland,
was crucial in demonstrating that such nostalgia could profitably be mani-
fested in built form. And in bringing such strategies back to the world of
saleable real estate, Disney was again instrumental: its custom-built town
of Celebration in Florida has attempted to go beyond mere theming to
create a functioning and livable vision of idealized small-town America.[25]
Initially criticized for the imposition of heavy-handed rules and a coercive
style of management, the planners of Celebration nevertheless worked to
ensure a certain level of economic diversity within the community, while
its Neotraditional civic center and neighborhoods would seem to func-
tion smoothly and unremarkably.[26] By comparison with such flagship New
Urbanist projects, the Village at Hiddenbrooke necessarily appears unam-
bitious and undertheorized, with no real effort taken to establish a sense of
community by the provision of a civic center or other amenities; its under-
lying motivations—nostalgia, control, safety—are nevertheless compa-
rable.

As dramatized for a larger public by such films as *The Truman Show* (1998),
which was filmed at Seaside, such New Urbanist–influenced developments
continue to attract criticism for an allegedly false or stage-set quality. The
most prominent of such commentators has been the veteran architecture
critic Ada Louise Huxtable, whose polemic *The Unreal America* has attacked
themed commercial and housing developments with unprecedented di-
rectness:

> Today's themed creations are not, and never will be, real places; they
> are not meant to be. They are made for the moment, instant environ-

ments intended to serve only as temporary, substitute events, conceived and carried out as places to visit in which novelty, experience, and entertainment are sold for immediate profit and a short period of time. They are based on proven, family-oriented entertainment formulas. To embrace their limited and exclusionary objectives is to forfeit the larger needs of place and society. To imitate their poverty of reference is to lose all we know about the past.[27]

This study is not the place to consider the merits and viability of the New Urbanism as such, and the larger ontological debate as to whether any newly built and deliberately planned community can in fact claim any authentically traditional qualities, the sense of organic inevitability that permeates older settlements, will also have to be left aside. Some New Urbanist praxis, notably that concerned with the renovation of existing cities and suburbs, would at least seem to represent a step in the right direction. What can be asserted here, at any event, is that all such Neotraditional construction runs the risk of a superficial theming, for if the developers' commitment to New Urbanist principles is only skin-deep, the intended character of the town may appear gratuitous or artificially imposed. In the case of Kinkade's Village at Hiddenbrooke the token nature of the references to his paintings ensures that the theming is here manifested less at the level of built reality than in simple marketing strategy. Thus, one might more reasonably speak of branding, the assignment of a distinctive corporate image to a given (and often rather arbitrary) consumer product, a practice Kinkade has long carried out in licensing his name to some sixty lines of furniture, decorative objects, collectibles, and other merchandise.[28] The extension of branding to architecture was thus a predictable step within Kinkade's business strategy; it, in fact, finds some precedent in the careers of prominent architects like Michael Graves, Robert Stern, Richard Meier, or Arthur Erickson, whose very names are often enough to guarantee success for new condominium developments. At the same time, Kinkade's themed village irresistibly evokes Jean Baudrillard's notion of simulation ("the generation by models of a real without origin or reality"), in which any stable reference points in terms of actual history have been effaced by a reliance on the purely imaginary.[29] Architectural critics like Michael Sorkin have long decried "buildings that rely for their authority on images drawn from history, from a spuriously appropriated past that substitutes

for a more exigent and examined present."³⁰ The difference, in the case of Kinkade's Hiddenbrooke development, is that its inhabitants are not living in a simulation of some past or present reality (e.g., a Cotswolds village) but in the simulation of a mass-marketed fiction of a place that has never existed. The result, dangerously supplanting any sense of history as a lived and political reality, evinces a vertiginous condition of hyperreality found hitherto mainly in the media-inspired environments of theme parks.³¹

I would argue, however, that in spite of its palpable failure to live up to Kinkade's pictures, the tract housing of the Village remains faithful to his artistic procedure, though not in the sense of a literal transcription of his paintings. This parallel is most evident in the way that both painting and architecture manifest notions of exclusion—the escape from urban reality. Kinkade's escapism, often articulated as nostalgia or "the beauty of nature," is thus equivalent to the phenomenon of white flight from the American city and the apparently relentless march of the suburbs.³² In another direction we could even say that all of Kinkade's production attempts to validate standardized, mass-produced consumer products by the addition of token "highlights," whether these be in the form of bogus half-timbering applied to a conventional suburban house or dabs of "Romantic Impressionist" paint added by an assistant to a photomechanically reproduced image of a cottage. This is, in essence, modernist standardization, economic rationalization, and blank-slate development masquerading as postmodern diversity and historical embeddedness. The "Village" is a textbook example of suburban sprawl that, like many gated developments, introduces notions of tradition and community while providing none of the essential urban characteristics that might support them. As Mark Gottdiener has pointed out, the appearance of a benevolent, nurturing, and fulfilling agenda in relation to the consumer is inevitably the mask behind which such themed merchandising disguises itself.³³ But as in Kinkade's images of cottages in the wilderness, there is an implicit selfishness in demonstrating a manifest right to set up house anywhere in the American landscape, no matter how impractically remote from established settlements—essentially arrogating the landscape to oneself for private consumption while excluding or (more realistically) ignoring the presence of others. It comes as no surprise to learn that more recent plans for a second Kinkade-themed housing development placed even greater emphasis on luxury and exclusive location: the five lake-view homes that were to compose "The Gates of Coeur

d'Alene," a development estimated to cost between four and six million dollars, were to rise on a twenty-acre site by Lake Coeur d'Alene, Idaho.[34] The architect, Rann Haight, noted that Kinkade, whom he described as "a frustrated architect," would be closely involved in the design decisions to ensure the closest possible resemblance between the new houses and those in his paintings.

In spite of—or rather because of—their overabundant deployment of architectural motifs calculated to evoke visual and psychic pleasure in the viewer, one might be justified in concluding that Thomas Kinkade's paintings are fundamentally about fear, contemporary urban fears in particular. In effecting its exclusions, his art finds its necessary counterpart in the rise of gated housing developments and the decline of public space. Like the suburban tract, his paintings succeed in their market niche by an active suppression of difference in favor of repetition—the compulsive and mantra-like reiteration of soothing images of safety, familiarity, and control. In seeming to promise an escape to a healthier and more desirable world of tradition, community, and unmediated connection to nature—the same rhetoric used by developers to lure potential homebuyers into suburban housing tracts—Kinkade's architecture, both painted and realized, presents us with all-too-believable models of controlled social environments based on exclusion and exclusive possession. His cottages and small towns, consoling evocations of authenticity and history, serve as indices of the absence of such qualities in the reality of the commercially built environment. While evoking fictive notions of an idealized past and catering to American fantasies of escape and self-sufficiency, they ultimately work against any renewed sense of community. One can only hope that the New Urbanism, which at least in the field of urban reconstruction has shown a willingness to reengage directly with the problems of the American city, may have greater success in manifesting a more workable cultural ideal.

Notes

1. See Kinkade, *Thomas Kinkade*, 9–34, esp. 32. Despite Wendy J. Katz's closeness to her subject, her essay therein provides a useful, balanced, and insightful introduction to Kinkade's work.

2. See Duany, Plater-Zyberk, and Speck, *Suburban Nation*.

3. Katz, introduction to Kinkade, *Thomas Kinkade*, 23. (Kinkade repaid the favor to Disney by painting a commemorative image of Disneyland's Sleeping Beauty Castle for the theme park's fiftieth anniversary in 2005.) The Swedish artist Gustaf Tenggren is perhaps better known as an illustrator of children's books, notably Janette Sebring Lowrey's *The Poky Little Puppy* (New York: Simon and Schuster, 1942). A more thoroughgoing attempt to research the sources of Kinkade's visual style, which I am not attempting here, would need to take into account the influence of such commercial (rather than fine) artists: the fantasy paintings of Greg and Tim Hildebrandt, for example, which attained great popularity in the later 1970s, have much in common with those of Kinkade, especially in their depiction of imaginary cottages and similar buildings. The numerous background scenes that Kinkade created for Ralph Bakshi's animated sword-and-sorcery epic *Fire and Ice* (1983) might also repay some consideration in this respect, especially insofar as Kinkade has since expressed admiration for the film's coproducer and production designer, the veteran fantasy illustrator Frank Frazetta. (Given the abundant violence and sexuality characteristic of the latter's work, it has to be said that this admiration would seem to be significantly at odds with Kinkade's professed Christian values.) See Kinkade, *The Thomas Kinkade Story*, 24. Also collaborating on *Fire and Ice* was Kinkade's friend and onetime Berkeley roommate James Gurney, who again worked on some of the backgrounds; together they published *The Artist's Guide to Sketching*. Gurney has since established himself as a well-known creator of children's books, notably the Dinotopia series (Atlanta: Turner Publishing).

4. Somewhat puzzling is Kinkade's relative lack of popularity in Britain, where one might have expected the imagery to be more familiar to a buying public, if only at the level of chocolate boxes. His major retail outlet in England would seem to be the Thomas Kinkade gallery in the picturesque Cotswolds town of Broadway, Worcestershire, where the gallery is appropriately housed in an authentic stone cottage.

5. For critical reaction to Kinkade see especially Harvey, "Skipping Formalities"; Orlean, "Art for Everybody"; and Doherty, "Thomas Kinkade Shares His Light."

6. See Jos Sances, www.josart.net. Sances's painting *Holiday Home* (2002), for example, parodies Kinkade's *A Holiday Gathering* (1998) by contrasting a typically Kinkadian Victorian house aglow with cheerful light on a dark winter evening with a homeless man who wheels a loaded shopping cart along the snowy road in the foreground. While many other contemporary artists have dealt critically with Kinkade in their work, the recent imagery of New York–based Lisa Sanditz is remarkable in that it specifically addresses Kinkade's Village at Hiddenbrooke.

7. Interviews with Kinkade collectors are cited in Orlean, "Art for Everybody," 126; see also Wilson, "America's Most Wanted."

8. Kinkade, *Thomas Kinkade*, 28.

9. See, e.g., the large and representative survey in McAlester and McAlester, *A Field Guide to American Houses*.

10. For the classic exposition see Lynes, *The Tastemakers*, esp. chap. 14.

11. Duany, Plater-Zyberk, and Speck, *Suburban Nation*, 48.

12. Basic readings in the New Urbanism would include Calthorpe, *The Next American Metropolis*; Katz, *The New Urbanism*; Dutton, *New American Urbanism*; Calthorpe and Fulton, *The Regional City*; Duany, Plater-Zyberk, and Alminana, *The New Civic Art*; and Talen, *New Urbanism and American Planning*. The recent literature on suburbia, a related but much broader topic, would necessarily include Kunstler, *The Geography of Nowhere*; Baxandall and Ewen, *Picture Windows*; Duany, Plater-Zyberk, and Speck, *Suburban Nation*; Hayden, *Building Suburbia*; Bruegmann, *Sprawl*; and Kruse and Sugrue, *The New Suburban History*.

13. For more on Seaside, see Mohney and Easterling, *Seaside*; Brooke, *Seaside*; and Bressi, *The Seaside Debates*.

14. The initial point of reference would, of course, be Jacobs, *The Death and Life of Great American Cities*; Lewis Mumford's urbanistic perspective is summarized in his *The Highway and the City*.

15. The literature on European New Urbanism is extensive, but a few texts are canonical: Krier, *Urban Space*; Krier, *Rational Architecture*; Charles, Prince of Wales, *A Vision of Britain*; and Papadakis and Watson, *New Classicism Omnibus*.

16. See Leccese and McCormick, *The Charter of the New Urbanism*; the document is also reprinted in Duany, Plater-Zyberk, and Speck, *Suburban Nation*, 256–61. On Foster's two postmodernisms, see Foster, *The Anti-Aesthetic*, xii.

17. From "The Charter of the New Urbanism," in Duany, Plater-Zyberk, and Speck, *Suburban Nation*, 256–57.

18. Quoted in Campbell, "Land of the Twee." The approved narrative of Kinkade's childhood is most fully recounted in Kinkade, *The Thomas Kinkade Story*. See also Kinkade, "Holiday Inspirations," 16.

19. For gated communities, see McKenzie, *Privatopia*.

20. The Village is only a small but central part of the larger, contiguous Hiddenbrooke development. For official information on Hiddenbrooke, see the developers' website: www.visithiddenbrooke.com. Useful critique of the Village can be found in Brown, "Ticky-Tacky Houses from the 'Painter of Light'"; see also Campbell, "Land of the Twee."

21. Shattering my preconceptions, one of the satisfied residents I met in the Village had emigrated from Paris. She described herself as very pleased with the Kinkade development, noting that she loved the isolation and closeness to nature and that there was nothing comparable to it in France.

22. Cheryl O'Connor, a developer and vice-president of Taylor Woodrow, was quoted as describing the idea of bringing Kinkade branding to the Tay-

lor Woodrow development as "a marketing gimmick" in Katherine Conrad, "Builder Sells 'Picture-Perfect' Homes," *East Bay Business Times*, July 20, 2001, http://eastbay.bizjournals.com/eastbay/stories/2001/07/23/story3.html (accessed May 10, 2010).

23. Quoted in Campbell, "Land of the Twee."

24. In tracing a continuity between contemporary architectural theming and such earlier manifestations of the historicizing impulse, I differ with many critics of the New Urbanism, who would instead see theming as marking a categorical break with past practices.

25. For theming in contemporary American architecture, see especially Gottdiener, *The Theming of America*. While generally critical of theming, Gottdiener notes that this development at least marks a return to semiotic meaning after the impoverished "hyposignification" (i.e., abstraction) of modernist praxis.

26. On Celebration, see Ross, *The Celebration Chronicles*; Frantz and Collins, *Celebration, USA*; and Lassell, *Celebration*. More critical appraisals of Celebration are legion, but one useful starting point might be Anton, "Disney-Planned."

27. Huxtable, *The Unreal America*, 69. Huxtable reserves particular scorn for Duany and Plater-Zyberk: "By reducing the definition of community to a romantic social aesthetic emphasizing front porches, historic styles, and walking distance to stores and schools as an answer to suburban sprawl—that post–World War II domestic American dream that has fallen out of favor as suburban problems have multiplied—they have avoided the questions of urbanization to become part of the problem" (ibid., 42).

28. In 2005 Kinkade's company received official recognition for its success in "establishing Thomas Kinkade as a lifestyle brand" by being nominated in multiple categories of the Licensing Excellence Awards given annually by a group known as the International Licensing Industry Merchandisers' Association (LIMA).

29. See Baudrillard, "Simulacra and Simulations." Baudrillard, in fact, singled out Disneyland, and "Main Street USA" in particular, as exemplary of the phenomenon of hyperreality.

30. See Sorkin, *Variations on a Theme Park*, xiv.

31. One might well ask, for example, whether Disneyland's Sleeping Beauty Castle lives up to the one seen in the animated film.

32. It must be admitted that Hiddenbrooke seems increasingly behind the curve in terms of the projected future viability of such remote suburban developments. Christopher B. Leinberger has argued that changing social and economic conditions, notably the mortgage and oil crises, have now doomed many large American suburbs to decay and abandonment, while increasing demand for quality inner-city housing will revitalize and densify older neighborhoods. See Leinberger, "The Next Slum?" A similar theme had already been

taken up in *The End of Suburbia: Oil Depletion and the Collapse of the American Dream* (dir. Gregory Greene, 2004), which drew heavily on the ideas of James Howard Kunstler. Such pessimism has nevertheless been critiqued as speculative, factually misinformed, and unduly alarmist; see, e.g., Joel Kotkin, "Suburbia's Not Dead Yet," *Los Angeles Times*, July 6, 2008, http://articles.latimes.com/2008/jul/06/opinion/op-kotkin6 (accessed May 4, 2010). In the present discussion the related issues of the *viability* versus the perceived *desirability* of suburban living should nevertheless be kept separate; that is, many people may still yearn for the Kinkadian ideal of an isolated rural cottage, even in the bogus guise of a suburban tract house, despite the fact that this fantasy now appears to have become even more socially and economically unfeasible.

33. See Gottdiener, *The Theming of America*, esp. chap. 4.

34. As reported in Nicholas K. Geranios, "Want to Live in a Kinkade Painting? It's Possible," *Seattle Post-Intelligencer*, May 19, 2006, http://seattlepi.nwsource.com/lifestyle/270774_kinkadehomes19.html (accessed June 28, 2006), "The Gates of Coeur d'Alene" project appears to have foundered in the post-2006 slump, and nothing has yet been built on the site, according to Rann Haight (telephone conversation with the author, June 9, 2010).

"A Temple Next Door":
The Thomas Kinkade Museum and Cultural Center

JULIA ALDERSON

> My desire to leave a legacy is one of the reasons I've chosen to spend my
> life making art. Art is made to last. I am not saying my art will live forever.
> I have no control over earthquakes or oxidizing paint formulas or—even
> more fickle—artistic taste.
> —Thomas Kinkade, in Kinkade and Buchanan, *Simpler Times*

> The art snobs frown on any marketing or business, but the old masters
> weren't successful until they were dead. I don't want to wait that long.
> —Robert Wyland, in Dan Cray, "Art of Selling Kitsch," *Time* (August 30, 1999)

If Thomas Kinkade has his way, he will leave behind a lasting artistic legacy
not only through the millions of reproductions of his work that blanket
the globe but in the form of the Thomas Kinkade Museum and Cultural
Center. This institution, fully funded and designed by the artist and the
corporation he controls, will house Kinkade's original works, displaying
them for posterity and cementing, or at least institutionalizing, Kinkade's
memory and place in history. Like the marine artist Robert Wyland (whose
career and marketing strategies are similar to Kinkade's), the artist is not
content to wait for history to someday determine his importance; he wants
it to happen now and on his own terms.

It would be easy to argue that Kinkade's museum is yet another ex-
ample of the artist's well-recognized ability to self-promote. Yet it would
appear that he is not content to merely exist according to the whims of the
marketplace. He wants to dominate the fine-art world as well. This desire

is playfully seen in a small detail of Kinkade's painting *Paris: City of Lights* (1993; pl. 10). Visible in the Parisian street scene is a poster announcing an exhibition of his work at the Louvre; then plastered across the poster is a sign proclaiming the show "sold out." Kinkade's own museum can be seen as an attempt by the artist to legitimize his work in a way that the Louvre surely will not.

Kinkade's institutionalization of his own work is intimately tied to his broad artistic intentions. As he has claimed, "In more than twenty years as a professional painter, my consistent goal has been to create inviting worlds that draw people into their depths and encourage them to seek a better, brighter, more hopeful existence."[1] To Kinkade, his art strongly differs from the work produced by the elitist and insular contemporary art world. Unlike the artists celebrated in that sphere, Kinkade states that he wants to create an art that truly touches the viewer and that generates a positive social impact through that communication.

These goals are similarly attached to his designs for the museum. A closer look at the Museum and Cultural Center, its opening, operation, and current closure, as well as Kinkade's attitudes toward art generally, the function of his own art in particular, and museum and display theory, will show that his museum is a highly crafted and considered institution. It is intended to stand in sharp contrast to the contemporary art gallery and mainstream museum worlds that Kinkade so strongly opposes (and that, almost exclusively, reject him as well).

While this essay will illustrate the myriad ways that Kinkade seems determined to set himself up as an art-world outsider, it is through the museum institution that the impossibility of his position is most clearly demonstrated. His museum is not a mere marketing gimmick or simply a crass attempt at self-apotheosis, as the art world would have it. It is also not fundamentally separate from traditional or mainstream art institutions; Kinkade's museum deploys display techniques and visitor amenities that are actually unerringly similar to those seen today in major museums the world over. Studying the Thomas Kinkade Museum and Cultural Center illuminates a lack of meaningful distinction between these two realms, each of which seems determined to deny and disparage the other. The distinctions—highbrow/lowbrow, popular/elite, art/kitsch, insider/outsider—disappear, and as Kinkade's museum positions itself within this con-

versation, it becomes clear that the base economic motivations of our elite museum institutions are not terribly different from his own.

Building a Dream: The Unfolding History of the Kinkade Museum

Kinkade has long desired to develop a museum space to display the extensive collection he has amassed of his own original oil paintings. Prior to 1997 the artist sold the oils from which the myriad print reproductions of his work are taken. Eventually realizing the vast marketing potential of his imagery, not only through the prints but also by way of licensing agreements, Kinkade began to retain the works and thus the reproduction rights to them.[2] It is this group of works that forms the core of the Kinkade collection.

Kinkade's stated and obvious inspiration for his own institution is the museum of his artistic idol, Norman Rockwell. Kinkade noted on his visits to the Norman Rockwell Museum not only the work but also the crowds: "You go to the Norman Rockwell Museum in Stockbridge, Massachusetts, and there are hundreds of people there on any given day—far more than you'd find at your average museum."[3] According to Vu Myers, former curator and director of the Thomas Kinkade Museum and Cultural Center, Kinkade was determined to model his own museum after Rockwell's, particularly in that he wanted it to be housed in a historic building.[4]

Kinkade's original idea was to display the collection in his hometown of Placerville, California. He purchased an appropriate building there in 2001, with the intent to endow his collection to the town for display at that location.[5] These plans changed, however, once Kinkade's business operations moved to Monterey, California. He relocated his family there as well, and although his connection to Placerville continued to be strong, he no longer maintained a home in the area. Kinkade ultimately decided that it would be best to site the museum in Monterey. The museum's website explained that Monterey "has always been a special retreat for Thom and his family. Thom loved painting all the inspiration of the Monterey Peninsula: the Carmel Mission and other downtown city scenes, the rocky cliffs of Big Sur, the historic Colton Hall in Monterey, and Lover's Point of Pacific Grove."[6] It was there that the Thomas Kinkade Museum and Cultural Center finally took physical form.

Monterey, a beachside community situated on Monterey Bay, approximately one hundred miles south of San Francisco, was an excellent location to headquarter Kinkade's operations. Indeed, it was in Monterey in 1992 that the first gallery to sell his work exclusively was established. The city is home to dozens of art galleries, most of which emphasize plein air landscape works, and the local landscape views would have been fitting for the work Kinkade produces.[7]

In addition to the natural and artistic landscape, the economic scene in Monterey was also no doubt attractive to Kinkade. The city boasts a bustling tourist industry; in addition to the art galleries there are attractions such as the Monterey Bay Aquarium and Cannery Row.[8] Monterey's tourist trade generates thousands of visitors annually, many with the disposable income and desire to mark their visit by purchasing an artistic memento. Monterey is also a mere seven miles north of Carmel, an extremely wealthy community. The local and visiting populations would have been particularly attractive demographically as consumers of Kinkade's art, as well as potential visitors to the museum.

The museum opened on May 20, 2001, to surprisingly little fanfare. National press was nonexistent, and even local coverage was scant. While it is not clear if this inattention stemmed from a PR failing on the museum's part, or was due to an actual lack of interest in the opening, it is certainly unexpected, given Kinkade's typical promotional savvy and the great popularity of his work at the time. The only significant article covering the inauguration of the museum was a piece in the *Monterey County Weekly*, the title of which clearly indicates the tone it took toward the museum's debut: "Charge of the Light Brigade: Thomas Kinkade's Artsy Empire Stakes Claim to Historic Monterey Adobe." In addition to the museum, the article noted the recent appearance of several commercial Kinkade galleries in the area and the fact that, "while the opening of these new galleries merely evokes gasps, giggles, and gossip from the dyed-in-the-wine-and-cheese art cognoscenti, the proposed opening of the Thomas Kinkade Cultural Arts Center in the Casa Gutierrez Adobe really pisses 'em off."[9] Other quotes in the article included a statement by Richard Gadd, then director of the Monterey Museum of Art: "It's one thing in Carmel or Cannery Row, but to position themselves in the center of Monterey as a cultural arts museum? We have Colton Hall, the adobes and Larkin House all in a few blocks, and that sort of institution seems out of place." Mary

Buskirk, a local artist and board member of the Fort Ord Artists' Habitat Project, opined, "I find it difficult to reconcile it with the other things that are happening in the city. It certainly degrades the level of awareness of what art is here." An anonymous member of the city's Cultural Arts Commission added, "I just think the quality of his work is far beneath the historical quality of the adobe. It's totally out of place."[10] Obviously, not all of Kinkade's new neighbors were pleased with his latest venture.

As the critics noted, the museum was housed in a historic downtown building built in 1841 and unique in its simple Mexican style. The Casa Gutierrez was renovated for the museum's purposes, keeping its distinctive architectural details and intimate scale.[11] On beige walls Kinkade's works were hung in elaborate gold frames amid furniture historically appropriate for the adobe structure. The museum also incorporated a courtyard space with a fountain, flowers, and hummingbirds, all meant to create an area of rest and relaxation for visitors.

In addition to Kinkade's own original works, the museum also presented exhibitions of work by local artists, Norman Rockwell, and a show highlighting the work of disabled artists.[12] Myers explained the breadth of the museum's displays as expressing the fact that, while Kinkade paints what he loves, he supports a wide variety of art and artists, and he appreciates "art for art's sake."[13]

The museum had a limited amount of exhibition space, and only thirty to fifty Kinkade works were shown at a time. They rotated frequently to showcase the collection.[14] One advantage to the limited exhibition space in the gallery was that it allowed Kinkade's paintings to be used in other exhibition contexts. Many originals traveled to Kinkade galleries across the country, which enabled gallery owners to stage events for their local clientele. In addition, Kinkade developed a traveling exhibition, the "Share the Light Museum," which was housed in a thirty-eight-foot RV outfitted to display his paintings. The museum traveled widely, up to sixty thousand miles per year, again to Kinkade franchise shops.[15] While the Share the Light Museum was ultimately discontinued (its high insurance costs and security concerns made it difficult to maintain), it was yet another way to make Kinkade's original work accessible to a broader public and to create "events" and publicity for individual galleries.[16]

Considering the broad and active exhibition and sponsorship schedule, particularly through 2004, it is surprising that Kinkade decided in that year

to move all his company's operations north, to a single location in Morgan Hill, California. To make this move, the museum was closed to the public in January of 2005, with the installations completely removed by that July. After four years, approximately ten thousand visitors, and fundraising events totaling more than twenty-five thousand dollars in 2004 alone, the Monterey iteration of the Thomas Kinkade Museum was officially and unceremoniously closed.[17]

It is difficult to imagine that this decision would have been made had the museum been functioning as successfully as hoped. Certainly the physical consolidation of Kinkade's operations reflected the general contraction of his company at that time, as Signature Galleries were closing, sales were slowing, and the stock price continued to fall.[18] Not surprisingly, the Kinkade organization does not cite corporate financial concerns as the reason for the museum closure. According to Myers the museum was unable to gain accreditation at the Casa Gutierrez location because of the impossibility of making the necessary accommodations for security and air quality.[19] As a historic building, the adobe required certain structural and cosmetic protections that would have conflicted with the alterations necessary to maintain the art at museum-quality standards. According to Myers this impasse between the needs of the art and of the building ensured that the museum could not fulfill both its preservation and accreditation requirements.

Another concern was the fact that the Thomas Kinkade Galleries of Carmel and Monterey, located near the museum, similarly displayed but also actually sold original Kinkade paintings.[20] This establishment, the first exclusive Kinkade gallery and the only to sell original works, was thus in an odd state of competition with the museum. Visitors familiar with the gallery brought with them an expectation that works could be purchased at the Museum and Cultural Center. It was tricky for the public to distinguish between the commercial gallery and the nonprofit museum institution, and this confusion created some difficulties with museum visitors.[21]

According to the company the closure of the Monterey site is not the end of the Kinkade Museum. The newest concept for the Museum and Cultural Center involves opening yet another version of the institution at the company's corporate headquarters in Morgan Hill. It was originally hoped that the museum would open in the summer of 2006, but to date, it is not completed. The company is currently housed in two buildings at

the Morgan Hill site, and there is not yet enough space allocated for the museum. Until the various company functions can be rearranged in a more accommodating way, plans for the museum are on hold.[22]

When it is finally completed, the museum will incorporate space for Kinkade's work, galleries for temporary exhibitions of other artists' work, a theater, and a gift shop. It will clearly reflect Kinkade's "vision," incorporating a design aesthetic similar to that of the Signature Galleries and the Monterey museum. Though it will obviously no longer be housed in a historic building, an attempt will be made to replicate a similar effect.

The careful attention to detail evidenced throughout Kinkade's various museum plans clearly illustrates their significance for the artist; this Morgan Hill iteration will be the third site for the museum. All this activity raises the question, What does Kinkade need with and from a museum? To fully understand Kinkade's motivation for creating such a specific experience for his viewers, it is first necessary to understand his perceptions of his own work within larger cultural and artistic spheres. Only then will a clear picture emerge of how Kinkade came to evolve his display aesthetics, why they are so important to him, and the ways in which the museum is meant to stand as the most significant manifestation of those ideas.

He Paints for You: The Evolution of Kinkade's Artistic Mission

Kinkade's life story has taken on a mythological quality typical of numerous artistic self-fashionings. The heroic artist myth—which began with Giorgio Vasari's *Lives of the Most Excellent Painters, Sculptors, and Architects* (1550) of the Renaissance and has continued on to include Pablo Picasso's romantic entanglements and Joseph Beuys's adventures during the Second World War—has become a familiar component of artists' biographies.[23] Kinkade's story similarly includes a variety of references to formative art experiences and influences. He has described reading back issues of *American Artist* magazine as a child, and as a young man meeting the painters Charles Bell and Glen Wessels in his hometown of Placerville.[24]

By far the most influential figure, in terms of Kinkade's molding of a meaningful artistic model, was Norman Rockwell. Kinkade repeatedly compares his childhood to growing up in a Rockwell painting, and the illustrator and the work he would come to represent for Kinkade were present from the very beginning: "I was an artist since I was a baby. I re-

member my mom had a big collection of copies of [*Saturday Evening Post*] magazines, and that was really my introduction to those great illustrators. Not just Rockwell, but Stephan Dohanos, John Falter, John Clymer, and others."[25] Kinkade found this work much more meaningful than the other art he had been exposed to: "I had seen so much art in the museums— still-life paintings and landscapes and so forth—but that was very mannered compared to this. This was very compelling, very believable."[26]

The connection to Rockwell pervades discussions of Kinkade's work, for positive or negative, in both the popular and art press. Kinkade himself clearly feels a profound admiration and bond with the illustrator. In describing his experience visiting Rockwell's museum, Kinkade said, "I mean, you go to that Norman Rockwell museum and walk around all those paintings up there in Stockbridge and you know, this is a timeless part of our heritage. Those images have meaning long beyond the painter's lifetime. That's what gets me excited about art."[27] The heritage he sees there is a popular one, not the elite art milieu that he eventually trained to participate in. The disjunction between these two worlds would lead Kinkade to the most important artistic realization of his life. This moment is described in the widely repeated anecdote explaining Kinkade's epiphany at the University of California, Berkeley:

> I'll never forget the day when the lights came on in my life. I was sitting in an art class at the University of California at Berkeley, listening to yet another erudite professor ramble on about the nature and purpose of art. The gist of the lecture was that the artist is by definition on the fringes of society and is responsible only to the demands of a personal artistic vision. Art exists for itself alone. It is in essence a private language whose sole purpose is to allow the artist to express himself.
>
> "Your art is all about you," the professor droned. "It doesn't matter if anyone else appreciates it. It doesn't matter if anyone else enjoys it. It doesn't even matter if anyone else understands it. All that is important is you." And so on, and so forth. *If my art is only about me*, I wondered, *if it speaks only in an esoteric language that no one else can understand, what's the point?* Suddenly I realized that the self-centered, self-serving artistic approach I was being taught was just the opposite of what I wanted my life and my art to be about. And at that moment a differ-

ent philosophy began to form itself in my mind, one that has driven my life and career ever since. My art, I realized, is not about me; it's about you. I paint because the act of creation brings me pleasure, but I also paint to benefit and enrich the life experience of others.[28]

This memory is key to understanding Kinkade's art, as well as his general motivation in creating his galleries and museum displays, and the visual forms those displays take. Here we clearly see Kinkade's anti-elitist sensibility; he realizes that the "erudite" professor who "rambles on" is forcing on him a "self-centered, self-serving artistic approach." This realization continued to evolve after Kinkade left Berkeley for the Art Center College of Design in Pasadena. It was there that he "finally rejected the 'pseudo-sophistication' he had learned at college and decided that the modernist art he had become enamored with was not really for him. He wanted his art to appeal to everybody, not just art critics."[29] Kinkade fully liberated himself in order to create the work he truly wanted to make.

This liberation is described by the artist as an act of defiance. He admits, "I suppose I was a bit of a rebel at the Art Center. Most students were doing hard-edged photo-derived work, but I wanted to paint soft, romantic things with a heavy dose of imagination."[30] Kinkade's audience is led to understand that his seemingly traditional work is an act of mutiny against the disconnected art world. He defies the ultra-elite Berkeley scene and moves to what in comparison is a much more conservative, traditional training, yet even in that context Kinkade needs to fight for his personal artistic vision. Against all odds and in the face of art-world rejection, the heroic artist presents his own vision for the good of his eventual audience. As Kinkade himself states, "I'm really the most controversial artist in the world."[31]

While Kinkade may seem to revel in his role as a controversial contemporary artist, this position is somewhat undermined by his desire to present work that is eminently populist. Kinkade goes so far as to relate his accessibility to that of today's most famous golfer: "I'm sort of the Tiger Woods of art. Tiger Woods has raised the awareness and the popularity of the entire sport of golf, just because of his charisma, his energy for the game, and his excellence. In our culture, I've raised the awareness of art just because ten million people wake up every day and see one of my paintings. And most of those people have never bought a piece of art before. The work that I've

done has been to introduce people who may never have had an interest be-
fore to the joy of collecting art."[32] For Kinkade, what is most important is
to introduce his art as broadly as possible, to the widest possible audience.
Like Woods he brings a traditionally elitist practice to the common person
and (also like Woods) reaps the rich rewards of fame.

It would seem that through the focus on breadth of dissemination,
Kinkade's definition of artistic success relates to how pervasive an art-
ist's work is. This pervasiveness is also a hallmark of Rockwell's art. As
Kinkade notes, "How few people see paintings in a gallery, but as Rock-
well said, 'The *Saturday Evening Post* is a gallery that goes into millions of
people's homes.'"[33] While this omnipresence seems in direct opposition to
"museum art," the value of which is predicated on its preciousness, it does
reflect Kinkade's sense of posterity. His volume-equals-importance equa-
tion has served him well in the financial realm and in terms of his fame
with the general public. Kinkade's belief seems to be that, in time, this
general popularity will translate into lasting artistic recognition. (See Anna
Brzyski's essay in this collection for an alternative interpretation of Kin-
kade's future legacy.) Though the contemporary art world around him de-
nies his importance today, Kinkade believes that his true significance will
ultimately be revealed. He reminds us that "the popular, even plebian, arts
of one generation often become the valued heirlooms of future genera-
tions."[34] Indeed, Greek trash becomes our museum art, and even Rockwell,
with his 2001 exhibition at the Guggenheim, has apparently gained access
to the museum's inner sanctum.[35]

*Display Methodology: The Home Becomes
the Gallery Becomes the Museum*

It is Kinkade's concern for his art's place in history that has led him to
consider various methodologies for its display. He is clearly aware of the
significance such issues have for the meaning and effect of art, and his
awareness of such contextual considerations is reflected in the display
manifestations he has developed (for his commercial galleries, catalogue
publications, Internet presence, and his museum), and also in his explana-
tions of these displays as being purposefully different from standard tech-
niques of contemporary art presentation.[36]

Kinkade's desire to see his work displayed, and the techniques he has

chosen to do so, no doubt come from his own life experiences. His various biographies are rife with descriptions, both positive and negative, of such art encounters. He recounts a memory wherein his mother framed his childhood artistic endeavors and hung them with the other "art" in their home: "The two pieces of art in our house that I really remember were a Rembrandt print and a print by one of the Parisian street scene painters, a boulevard with lights aglow. . . . Seeing my drawings hanging on the wall next to reproductions of great masterpieces encouraged me to think that I might become an artist someday."[37] He also describes transformative museum visits that first exposed him to the landscapists he would come to love. In describing his first contact with the work of Thomas Hill, Kinkade admits, "I'll never forget the first time I saw one of his paintings of Yosemite. It was at the Oakland Museum, and that experience is one of the reasons why I paint landscapes."[38]

Equally important as these positive experiences with museum-quality art are Kinkade's negative art encounters. These are most clearly described in his discussions of exhibition methodologies at play in the presentation of contemporary art. In an interview with Kinkade that introduces a survey of his work, *Masterworks of Light*, Wendy Katz writes of his display techniques as embodying

> a system of values that differs from that operating in an art world and market which prefer artwork to challenge artistic conventions and social expectations. In an especially effective critique of the atmosphere of contemporary galleries and museums, Kinkade points out that most of these settings are even today intimidating, uncomfortable spaces, with white walls, bright, overhead lights, and hard edges, where work that is often difficult to understand or confrontational is displayed without much explanation. The result, he says, is an underlying message to most people that "You are not part of this experience. Modern art does not include you."[39]

Kinkade's desire to present an alternative viewing experience is no doubt a reaction to what he sees as this aggressive, cold display method. In his own installations Kinkade seeks to argue against this space of intimidation and sterility; he notes, "We upset the paradigm and turned it on its ear."[40]

The paradigm that has been upended is the one famously identified by Brian O'Doherty as the "white, ideal space that, more than any single pic-

ture, may be the archetypal image of twentieth century art."[41] To O'Do-
herty's mind, "a gallery is constructed along laws as rigorous as those for
building a medieval church. The outside world must not come in, so win-
dows are usually sealed off. Walls are painted white. The ceiling becomes
the source of light. The wooden floor is polished so that you click along
clinically, or carpeted so that you pad soundlessly."[42] Clearly, Kinkade's
perception is accurate and acknowledged as a trope even within the main-
stream art world. Such display spaces have been calculatingly constructed
to ensure little distraction from the work on exhibit. This may indeed be
entirely appropriate for highly self-referential modern and contemporary
art, but Kinkade rightly identifies this stripped-down aesthetic as poten-
tially alienating to his audience. At the very least, it is not a terribly appeal-
ing or realistic model for the display of art in the average home.

Indeed, the home is the true model for Kinkade in his thinking about
the display of his art. Memories of art in his childhood home, of his own
work displayed with print reproductions of "real" art, and the inspirational
effect of such display are taken beyond Kinkade's own life and into the
lives of those who purchase his work. He wants his patrons to enjoy a simi-
lar experience, here with his own work as the "real" art on view.[43] In this
spirit Kinkade styled the first display spaces for his art, the Signature Gal-
leries that sell his work exclusively, on domestic interiors. His thoughts on
the development of the galleries' décor are discussed in his book *The Art of
Creative Living: Making Every Day a Radiant Masterpiece* (2005). In this text,
which is basically a self-help book through which Kinkade gives tips (and
home-decorating suggestions) for living a fulfilling life, the artist notes:

> I wasn't sure what interior would be the most appealing. Should the
> galleries be white and hard-edged, like most contemporary art spaces,
> or should they be designed in some radical new way?
>
> In the back of my mind, I had an offbeat idea to turn the tables on
> the usual gallery experience and make the Kinkade galleries warm
> and homey. I envisioned hunter-green walls, fireplaces, and comfy
> chairs. I pictured a mood-filled atmosphere, where the lighting shone
> primarily on the paintings, making them focal points of light and in-
> spiration against the subtle walls. And I imagined friendly staff mem-
> bers, who weren't necessarily art "experts," but rather were everyday
> people, who loved sharing the joy of art with others.[44]

Again we see the populist thread in Kinkade's artistic conception, playing out here in relation to his display techniques. He wants to create a "comfy," "mood-filled atmosphere" where future patrons are lovingly introduced to his work by people just like themselves.[45]

In terms of their commercial purposes the gallery installations are obviously calculated to help potential buyers imagine the work hanging in their own home—a point Monica Kjellman-Chapin considers in her essay in this collection. What makes this imagining possible is the fact that the works are presented in an identifiable, approachable way to the general public. This comfort would not be possible without all the domestic trappings, which contrast starkly with high modernist commercial display details, such as white walls, sharp light, and neutral flooring. Kinkade's commercial display techniques, which are theoretically similar to his patrons' domestic interiors, are a far cry from the typical gallery, and ultimately museum, aesthetic.

As these presentation techniques have served to successfully present Kinkade's work to an art-buying public (witness his phenomenal financial successes), it is not at all surprising that the artist chose to transfer such qualities into his museum space. His audience, drawn to the anti-contemporary gallery commercial spaces, could be expected to be similarly attracted to an institutional space designed to be more welcoming and intimate than the cathedral-like environment of a typical museum. Thus, the Monterey museum, which was physically installed within authentic domestic architecture, incorporated the same warmly colored walls, soft lighting effects, and tastefully placed furnishings as the Signature Galleries. Once it is completed, the Morgan Hill manifestation of the museum will also echo this design. The museum will recreate the antimuseum space familiar to anyone exposed to Kinkade's work in a commercial venue or at the earlier museum in Monterey—again, and as in all things related to his position vis-à-vis the art-world establishment, setting Kinkade up as a true contemporary art alternative.

Yet while Kinkade styles himself a "rebel" in terms of his display techniques, the reality is that the museum environment he loathes is being changed and shaped by many of the same conversations about space, audience, and reception with which he is himself concerned. The transformation of the museum as an institution has historically reflected social and political changes. What seems to differentiate its evolution today is a focus

on economics and commercialism. Such concerns, which are inevitably raised in any discussion of Kinkade's art, are where the true connection between Kinkade and the mainstream art world lie.

While museums began as seventeenth-century ultra-elite cabinets of curiosities, accessible only to the extremely wealthy, the museum concept was transformed into a public institution under the influence of the ideals of the Enlightenment and in light of revolutionary movements from the second half of the eighteenth century on. In this upheaval royal collections became public collections.[46] American museums have always been somewhat more "democratic" than their European counterparts. Rather than springing from royal collections, they were generally amassed by wealthy American industrialists. These patrons ultimately donated their treasures to public institutions or often established such institutions themselves.[47]

Regardless of their source, one consistency in these formal museum collections seems to be the architecture created to house them. As J. Randolph Coolidge Jr., a trustee of the Museum of Fine Arts in Boston, wrote regarding an early renovation of that institution's building: "A museum of fine art should convey the positive assurance that that which is to be seen within shall be of the best that men have imagined and wrought. For such a conception the architectural style at once suggested is the classical."[48] Classical- and Renaissance-inspired architecture became the standard for museum structures and can be seen in museums as various as the Louvre, the Metropolitan Museum of Art, the State Museum in Berlin, and the Uffizi in Florence.

The Museum of Modern Art in New York City was the most important break with this tradition, and it is to Alfred Barr's model that we owe the white-cube tradition. The 1939 MOMA construction that Barr supervised included a new type of gallery space, with twelve- and fourteen-foot ceilings "that imposed a relatively small and quasi-private module on the galleries," which Barr intended to be neutral contexts for the art displayed by the museum.[49] Compared to the grand, pre-1930s museum buildings, Barr's commissioning of these smaller scale, simple gallery spaces was actually, according to William Rubin, "far more radical than neutral—and it set an appropriate MOMA style."[50]

While the now classic white box was intended as a completely cool receptacle for the objects it held, current practice focuses on architecture that speaks strongly, perhaps sometimes too strongly, on its own. As Rubin

mused in discussing such dramatic museum structures, "Is it only coincidence that those most breathtaking masterpieces of museum architecture, Frank Lloyd Wright's 1959 Guggenheim and Mies van der Rohe's 1968 New National Gallery in Berlin, should be among the museums *least* suited to showing the art for which they were created?"[51] As Rubin noted, the Guggenheim's curved walls are notoriously unaccommodating for large-scale two-dimensional work, and Mies's glass pavilion physically and visually overwhelms most art exhibited within it. Perhaps the most interesting contemporary example of museum architecture overwhelming its art is Daniel Libeskind's Jewish Museum in Berlin. The building opened in February of 1999 without anything on display at all. No art was exhibited until the museum officially opened on February 9, 2001. In the meantime thousands visited to simply look at the building.[52]

Although Kinkade's museum is clearly not meant to express such dramatic architectural forms, he, too, is concerned with moving beyond the typical minimalist gallery aesthetic. In fact, he may be seen as reflecting the postmodern trend that appropriates traditional architectural and interior design components over International Style simplicity. Like Philip Johnson's AT&T Building in New York or Michael Graves's Portland Building in Oregon, Kinkade's design brings coloration, texture, and historical references to his exhibition spaces. The goal, as with similar postmodern architectural projects, is to bring a sense of humanity to the often machine-dominated aesthetic of mid-twentieth-century architecture. This form of postmodern architecture may not be as sexy as the deconstructivist strain seen in buildings by Frank Gehry, Zaha Hadid, and Libeskind, which more literally attempt to destroy the traditional modernist glass tower by physically breaking up the architectural forms and creating structures that seem to be undulating or fragmenting, but it is certainly related.[53]

Even Kinkade's use of domestic architecture as a display model is not as radical as he claims. Many other artists, both historical and contemporary, have valued such a context for the display of their work. This was the case with the impressionist artists, who, as Victoria Newhouse has noted in describing their independent exhibitions, "modeled rooms on their studios and residences and embellished display spaces with draperies like those in private galleries. . . . Rocking chairs and settees were added in an attempt to re-create the domestic environment for which this work was intended."[54] The contemporary artist Dorothea Rockburne likewise argues for display

in a domestic interior: "Although paintings might have to fight for their life, they look better in a home than in a museum because they're alive, you feel them; they haven't been intellectualized and categorized historically."[55]

Many museums have relied on the amenable environment a domestic interior can provide for art. The Frick Collection is housed in the former mansion of the nineteenth-century industrialist Henry Clay Frick. As the museum itself notes, "The special ambience provided by this setting—that of an art connoisseur's home—has been preserved."[56] This is also the case at perhaps the most famous "home museum," the Isabella Stewart Gardner Museum in Boston. To house her art collection, Gardner constructed a building echoing the architecture of a fifteenth-century Venetian palace. Here the architecture is central, as "the Museum itself provides an atmospheric setting for Isabella Stewart Gardner's inventive creation."[57] Of course, both the Gardner and the Frick museums utilize actual homes; art owned by individual collectors is displayed as it was experienced and enjoyed by those collectors. In contrast, Kinkade's galleries construct a mere facsimile of a home environment. While echoing the general concept of the home museum, his is instead an architectural fantasy of the ideal domestic backdrop for his art.

It is not only architecturally that Kinkade can be related to current museum practice, however. He also is intimately tied to the current debate about the "commodification" of the museum experience. Major museums the world over are being forced, as a result of financial concerns, shifting demographics, and changing notions of high and low culture, to change their promotional strategies. As a result many are renovating their current structures and expanding their facilities to include elaborate spaces for eating, shopping, and social interaction. The museum is becoming a destination site, expected to demonstrate positive economic impacts on its host city and to provide for the enjoyment of a variety of experiences beyond mere artistic ones.[58] These commercial components are intended to strengthen the institutions' bottom lines and have transformed the museum into a space many would argue is more concerned with entertainment than education or aesthetic edification.[59]

Museums are increasingly dependent on the staging of blockbuster shows to bring in the largest crowds possible. Often those shows themselves generate criticism, for pandering to the general public and denying

the museum's more exalted mission. Of course, the emphasis on impressionist exhibitions is the most common example; thus, as the journalist Mark Stevens notes, "As a rule, shows of Impressionist painting deserve suspicion. Only gold, I would venture, does better at the box office, which means that museums often crank out shows of Impressionism as a form of fancy art sausage for the masses."[60]

This commodification finds perhaps its most obvious form in the increasing emphasis on retail spaces in museums today. These shops are typically set in high-traffic areas of a museum, generally near the main entrance and accessible even to visitors who do not purchase tickets to enter the main exhibition spaces. It is possible to shop without seeing a piece of original artwork on display at all. Such shops may also be installed in temporary locations at the end of specific special exhibitions. Visitors are funneled directly into a retail space upon leaving the exhibit, through which they must pass in order to move on to other galleries or the museum exit.[61] Ubiquitous in these stores are reproductions of the museum's best-known works in poster, postcard, and notecard formats, as well as on T-shirts, coffee mugs, calendars, mouse pads, and so forth.[62] Perhaps the most extreme manifestations of this retail phenomenon are the "Museum Shop" mall stores, eMuseumStore.com, and museumstorecompany.com. Such retail establishments and website stores are the ultimate in commodity museum shops—one does not even need to actually visit a bricks-and-mortar museum to acquire and enjoy the art commodities offered there. This is all very much like Kinkade's licensing items, and it serves the exact same function in each instance—to produce revenue.[63]

This collapsing of the commercial with the sanctified art space is where today's museums become in many ways like shopping malls, with their ubiquitous Kinkade Signature Galleries. Current theory analyzing mall space is strikingly similar to the issues and questions raised in contemporary museum analysis. Marianne Conroy has noted that "recent work in cultural studies posits the shopping mall as a premier site for the making of postmodern subjectivity—where boundaries between high and low culture are effaced, where commodities and consumer desire determine the organization of public space and the forms of social exchange, and above all, where simulated experiences attenuate historical and temporal consciousness."[64] The melding of high and low, the emphasis on commercial-

ism in the organization of space, and the crafting of simulated experience are all seen in the high-art museum world. The fact that Kinkade's mall galleries and museum plans also emphasize these qualities heightens the sense that his various display venues function at the nexus of these worlds and thus illustrate current trends in the modern urban sphere. It would seem that through Kinkade's museum and galleries we see contemporary public space, whatever its intended function, evolving into a highly controlled, commodity-driven arena.

Issues of control are pertinent in the high-art museum as well. As Carol Duncan has noted in her discussion of the museum and ritual, "Art museums are neither neutral sheltering spaces for objects nor simple architectural products; rather, they are complex totalities that include everything from the building to the selection and ordering of collections and the details of their installation and lighting." Duncan identifies this totality "as a ritual setting, a ceremonial monument in its own right and not just a container for monuments."[65] This control allows the institution to give a precisely rendered vision of its collection. Duncan states that "to control a museum means precisely to control the representation of a community's highest values and most authoritative truths" and that "what we see and do not see in art museums—and on what terms and by whose authority we do or do not see it—is closely linked to larger questions about who constitutes the community and who defines the identity."[66] Traditionally, it has been the art and museum establishment that has held this authority and established these rules. With Kinkade the "outsider" artist conceives and presents an overall experience of his work through his particular display methodologies and assumes his own manner of control over a precisely rendered vision of his art.

It is clear that the Thomas Kinkade Museum and Cultural Center can be seen as a reflection of current museum practices and organizational structures. To survive financially, most museums today are as concerned as Kinkade is with creating accessible, inviting displays and a multitude of experiences and products to provide the means to support themselves financially. The museum truly can no longer survive in economic isolation, dependent only on the good graces of a few patrons or the government. What this illustrates more than anything else is the paucity of support for the arts in the United States. Were American art museums not driven by

a desperate need to generate the funding necessary to simply open their doors, they might not employ the same strategies that Kinkade does in his pursuit of vast personal wealth.

This struggle to engage with the general public may appear to some as an unfortunate pandering that debases the museum function. The "mallification" of our greatest cultural institutions, and their movement toward the Kinkade model, is indeed painful to those who desire a world of art removed from the hurly-burly of everyday life. It remains to be seen if the American museum's shift toward a more capitalist mode will succeed or if this is indeed the beginning of the end. Perhaps the naysayers are right, and museum culture in America is sliding toward its demise. But for now, as our museums increasingly move toward an engagement with the general public, and as they strive for our disposable income, the visitor becomes an increasingly powerful actor in the world of art. Our consumerism drives the art world to care increasingly about our needs and interests, and museums must work creatively to take us into account, in parallel with their educational and scholarly missions. While our failure to adequately support our art institutions necessitates their shift toward the Kinkade model, perhaps through this process we will get the museums we ultimately deserve.

But those who hope for a different result may take heart in the fact that Kinkade's museum model does not actually seem to work. While the artist and his company continue to insist that plans for the museum are merely on hold, the length of the institution's dormancy and the general decline of the company's fortunes call this into question. In the end it appears that Kinkade's museum plans have failed. He may have mastered the commercial gallery format, but he does not seem able to build a museum on that design. Something is missing. Perhaps that something is where the future of our museums truly lies.

Notes

1. Kinkade and Buchanan, *Lightposts for Living*, vii.

2. That Kinkade himself has an extensive collection of the paintings was obvious in the citations for the exhibition of the artist's work Thomas Kinkade: Heaven on Earth, curated by Jeffrey Vallance. Most works in the catalogue were shown and reproduced "courtesy of the Thomas Kinkade Museum and Cultural Center." The other works were all owned by Rick and Terri Polm.

3. Kinkade and Reed, *Thomas Kinkade*, 11. It is not clear what Kinkade bases his attendance estimates on or what sort of "average" museum he is speaking of here.

4. Phone interview with Vu Myers, May 11, 2006. All information here on the Museum and Cultural Center, as well as Kinkade's general museum ideas, comes from this interview unless otherwise noted. Myers, who has a master's degree in history, was hired to organize and run the museum particularly because of this requirement. She had worked previously at a historic home and had much experience dealing with preservation organizations and the myriad details necessary for working in such an environment. On the closing of the museum Myers moved into the company's licensing department. She is no longer employed by the Thomas Kinkade Company, and it seems that no one has replaced her as curator and director.

The Norman Rockwell Museum was originally housed in the historic Old Corner House on Main Street in Stockbridge. The museum was moved in 1993 to its present site outside of town, with Rockwell's studio relocated nearby. The main collection is now displayed in galleries designed by Robert A. M. Stern.

5. "I have probably 200 paintings in my collection. My goal is to endow this collection to my hometown community someday so there could be beautiful art for people there" (quoted in Ted Kreiter, "Thomas Kinkade's American Dream," *Saturday Evening Post*, 41).

6. The museum website is no longer active, but various iterations of it from 2002 to 2005 can be viewed at the Internet Archive site www.archive.org. For this particular quote, see http://web.archive.org/web/20020202140745/kinkade museum.org/History (accessed July 27, 2006).

7. This point was brought to my attention by E. Michael Wittington, the current director of the Monterey Museum of Art. Wittington noted that plein air work is a very strong element of the local artistic tradition (telephone interview, July 19, 2006).

8. According to the Monterey County Convention and Visitors Bureau, the California Travel and Tourism Commission report of 2005 assessed the Monterey tourist industry figure at $1.978 billion. See the Monterey County Convention and Visitors Bureau website, http://media.montereyinfo.org/?p=8464 (accessed Aug. 3, 2006).

9. Chuck Thurman, "Charge of the Light Brigade: Thomas Kinkade's Artsy Empire Stakes Claim to Historic Monterey Adobe," *Monterey County Weekly*, Sept. 16, 1999, 12.

10. Ibid.

11. According to various news accounts and the museum's website, the Thomas Kinkade Foundation remodeled the adobe at a cost of approximately $150,000 (see archives URL in note 6).

12. A brief chronological overview of the museum's exhibition program demonstrates this variety of offerings: in December 2001 the museum presented the Holiday Expo show, in conjunction with Monterey's "Christmas at the Adobes." In March of 2002 the museum hosted a Very Special Arts of California exhibition. VSA California, the Santa Ana–based affiliate of the international VSA nonprofit organization, promotes art exhibition and education programs for children and adults with all classifications of disability. In the fall of 2002 the museum presented a thematic display of Kinkade's own work, The Artist in Nature: Original Plein Air Works by Thomas Kinkade. In the winter of 2003 the museum hosted an exhibition of original works by the Venture Gallery, a local artist-owned collective featuring thirty Monterey artists working in a variety of media. Kinkade paintings featured concurrently with the Venture Gallery show similarly highlighted the Monterey Peninsula landscape. The year 2004 was especially busy; the museum exhibited oil and pastel works by the local artist Joel Smith, a show entitled Norman Rockwell: The American Family Drawings, and an exhibition of digital photography by Michael Steelman Jr. Information on the exhibition program was gathered from art listings in the Monterey County Weekly newspaper, as well as from the archived Kinkade Museum's website.

13. Vu Myers, telephone interview, May 11, 2006.

14. See www.artofthesouth.com/thomas_kinkade.htm (accessed May 12, 2006).

15. The sixty-thousand-mile-per-year figure was given by Leon Mendez, a sales manager for Media Arts Group, in Kip Keller, "Painter of Lite," Austin American Statesman, Feb. 8, 2001. Many short press announcements were published announcing the museum's touring. A typical example reads, "Mary's Collectibles Gifts and Home Furnishings will host the Thomas Kinkade 'Share the Light' Touring Museum from 4 to 8 p.m. Friday at 1880 Washington Road in Washington. The touring museum is a 38-foot-long bus, retrofitted to display Kinkade's original oil paintings and sketches." See "Share the Light Museum Visits Washington," Pantagraph, July 18, 2002.

16. It also reflected general museum practice. Museums frequently lend out works to other museums or generate traveling exhibitions when their own storage and exhibition facilities prove inadequate for their own collections.

17. These attendance and fundraising numbers were provided by Vu Myers to the Monterey County Herald. See Victoria Manley, "Thomas Kinkade Museum to Move from Monterey, California, to Morgan Hill," Monterey County Herald, Jan. 11, 2005.

18. For general information on the company's financial difficulties, see Christopher Byron, "Kitsch Me, Kinkade! When Bad Paintings Make Lots of Money," New York Observer, Oct. 22, 2001, http://newyorkobserver.com (ac-

cessed Oct. 12, 2006); John Leland, "Subdivided and Licensed, There's No Place like Art," *New York Times*, Oct. 4, 2001; and Kim Christensen, "Painter Said to Be Focus of FBI Probe," *Los Angeles Times*, Aug. 29, 2006.

19. It is impossible to access any information on the museum's accreditation application through the American Association of Museums, the national body that certifies such institutions. According to the AAM website, "AAM does not disclose information regarding the details of the listed museums' accreditation. Any information about a museum's application, status in the accreditation review process, accreditation history, or accreditation dates can only be disclosed by the museum itself, at its discretion." See www.aam-us.org/museumresources/accred/list.cfm (accessed July 24, 2006).

20. Myers noted this issue in discussing the museum's closing. The Thomas Kinkade Galleries of Monterey and Carmel sells original oils released by Kinkade himself, as well as work acquired through other channels. Like the traditional Signature Galleries it also sells limited-edition prints. In addition to the retail components, this site houses some corporate offices, as well as the Thomas Kinkade National Archives, a trove of documentation and resources utilized by collectors interested in determining the valuation of the works they own.

21. It is certainly important to note that such confusion clearly indicates the degree to which the museum display echoed those techniques used in the commercial gallery context, to which Kinkade customers had clearly become accustomed. For more on the issues of display, both in the galleries and the museum, see below.

22. Myers indicated that the company's computer team and server have recently relocated to Morgan Hill, so space is even tighter than originally anticipated.

23. Linda Nochlin famously broke down the heroic artist myth in her essay "Why Have There Been No Great Women Artists?" She describes details of this myth-making, including the artist's (pointedly "his" in Nochlin's essay) "mysterious inner call in early youth," and "the fairy tale of the discovery by an older artist or discerning patron of the Boy Wonder." She also describes how the artist "struggles against the most determined parental and social opposition, suffering the slings and arrows of social opprobrium like any Christian martyr, and ultimately succeeds against all odds—generally, alas, after his death—because from deep within himself radiates that mysterious, holy effulgence: Genius" (Nochlin, "Why Have There Been No Great Women Artists?" 153–55).

For Kinkade such details are described in almost every telling of his life story. Typical examples are found on the Kinkade Museum's website, in a narrative entitled "The Thomas Kinkade Story" as told by Kinkade's brother: "Thom laughs now when he talks of the month he lived off a couple sacks of potatoes, baking them and then eating them as apples for breakfast, lunch and dinner," and "Stories

of the starving artists tend to center on Greenwich Village in New York or Soho in London but I believe any trial experienced by those living in these areas would pale to the gantlet Thom ran in Los Angeles for love of his work. He lived in a one-person Bohemia but never faltered in his belief of his ultimate destiny. Thom was an artist." For Kinkade's life story as told by his brother, Patrick Kinkade, see http://web.archive.org/web/20050307074317/www.kinkademuseum .org/tkinkade/tkbio_1_24.html (accessed Aug. 31, 2006).

24. Kinkade and Reed, *Thomas Kinkade*, 9. Bell was a Los Angeles sign painter who moved to Placerville when Kinkade was eleven years old. Wessels had taught at the California College of Arts and Crafts and then at the University of California, Berkeley. He retired to Placerville when Kinkade was a sophomore in high school.

25. Kreiter, "Thomas Kinkade's American Dream," 41. Rockwell is invoked throughout Kinkade's life narrative. He is most consistently evoked when Kinkade expresses nostalgic memory and longing for the simplicity of his idyllic, rural California childhood. For more on the issue of nostalgia in Kinkade's work, see Andrea Wolk Rager's essay in this volume.

26. Kreiter, "Thomas Kinkade's American Dream," 41.

27. Ibid., 86.

28. Kinkade and Buchanan, *Lightposts for Living*, 133–34. Kreiter's interview with Kinkade in the *Saturday Evening Post* has yet another retelling of the Berkeley anecdote: "My college professor at the University of California pontificated one afternoon about the artist being an icon, an island, who had to be detached from the culture. He would say 'Your art is all about you. It doesn't matter if they understand it. It doesn't matter if they have any interest in it. It's all about you.' That just grated on my sensibilities" (Kreiter, "Thomas Kinkade's American Dream," 94).

29. Kreiter, "Thomas Kinkade's American Dream," 94.

30. Kinkade and Reed, *Thomas Kinkade*, 13.

31. In Vallance, *Thomas Kinkade*, 11. This statement allies Kinkade with radical contemporary artists who inspire controversy for their unorthodox materials, methods, and subject matters. It is wonderfully ironic that Kinkade equates his own work with such controversy, yet it again serves his purposes well. In hindsight some of the most controversial artists in history (artists such as Caravaggio, Manet, and Picasso) have eventually become recognized as the most important.

32. Ibid., 66. One issue to ponder in this quote and many others throughout this essay is the description of what consumers buy as "paintings." That this language is used and accepted indicates the degree to which Kinkade appears to have been successful in manipulating perceptions of what it is that he actually sells to the public.

33. Kinkade and Reed, *Thomas Kinkade*, 17.

34. Kinkade, "Reflections," 19.

35. Norman Rockwell: Pictures for the American People traveled from 1999 through 2001 to major museums in various cities, including San Diego, Chicago, Washington, and New York.

36. For a discussion of issues related to the effect display has on art, see Newhouse, *Art and the Power of Placement*.

37. Kinkade and Reed, *Thomas Kinkade*, 9.

38. Ibid., 11–12.

39. Kinkade, *Thomas Kinkade*, 9. Kinkade's quite accurate description of the infamous modernist "white cube" is the main focus of contrast for his own display. This convention, and Kinkade's alternative response, is discussed below.

40. Kreiter, "Thomas Kinkade's American Dream," 66.

41. O'Doherty, *Inside the White Cube*, 14.

42. Ibid., 15.

43. Again, it must be noted that this is all greatly complicated by the issues of original vs. reproduction that are intimately connected to Kinkade's production. He may be seen as a "real" artist by the people who display his work, but what they hang in their homes is not original art.

44. Kinkade and Procter, *The Art of Creative Living*, 146. Randall Balmer's description of a visit to a Signature Gallery to view Kinkade's work illustrates this effect in action. His article "The Kinkade Crusade" begins, "'Make yourself at home.' The pleasant young woman points to a loveseat in a small room. 'This is the best way to appreciate Thomas Kinkade's genius as an artist.'" Balmer goes on to describe viewing the work in a "tiny, carpeted cubicle" with controlled lighting that is dimmed to bring out the luminosity of Kinkade's work. See Balmer, "The Kinkade Crusade," 49.

45. These "homey" display characteristics show themselves in the other commercial presentations of Kinkade's art, including the brochure and catalogue imagery, as well as the online gallery components at thomaskinkade.com. These publications typically illustrate Kinkade's works, hung in ornate gold frames or displayed on tables or easels, against warmly colored walls and amidst domestic furnishings and inkwells, candles, and festive floral decorations.

46. Essays such as Andrew McClellan's "The Musée du Louvre as Revolutionary Metaphor during the Terror" and Annie Coombes's "Museums and the Formation of National and Cultural Identities" illustrate the ways in which the museum has come to reflect larger issues of education, politics, class, and race within Western societies as these societies moved to more democratic systems of government.

47. In many ways Kinkade's museum impulse echoes that of these men. He, too, is a product of American ingenuity and hard work, and he, too, wants to share the art he has collected with the general public.

48. J. Randolph Coolidge Jr., "The Architectural Scheme," *Museum of Fine Arts Bulletin* (June 5, 1907): 41.

49. William Rubin, "When Museums Overpower Their Art," *New York Times*, April 12, 1987.

50. Ibid. It is somewhat ironic that the foundation of the white cube, which Kinkade so clearly rejects, was similarly concerned with issues of intimacy.

51. Ibid.

52. Rubin argued that such architectural extravaganzas were liable to somehow injure the art they housed: "The problems arise primarily when the architect's personal vision overflows into the galleries reserved for the art itself, inflecting, abutting or overwhelming the visions of painters and sculptors" (ibid.). More recent structures that might be seen as "endangering" art collections in this way are Frank Gehry's Guggenheim Museum in Bilbao, Zaha Hadid's Contemporary Art Center in Cincinnati, and Daniel Libeskind's extension of the Victoria and Albert Museum in London. These architectural wonders look extreme and unusual from the outside, but it should be noted that their interior gallery spaces tend to follow, though often on a larger scale, the white-cube model.

53. See Christopher Pearson's article in this collection for a different view of the relationship between postmodern architecture and Kinkade.

54. Newhouse, *Art and the Power of Placement*, 22. Newhouse notes that for the impressionists the goal was to contrast with the incredible visual bombardment of contemporary salon display but that the impressionist method was quickly rejected by the neoimpressionists "on the ground that it relegated art once again to the status of decoration."

55. Ibid., 13. The Rockburne quote is noted as having been taken from a conversation between the artist and Newhouse, May 20, 2003.

56. Quoted from the "Director's Greeting" on the museum's website. See www.frickmuseum.org (accessed Oct. 13, 2008).

57. See www.gardnermuseum.org/collection/overview.asp (accessed Oct. 13, 2008).

58. It is interesting in this context to see the ways in which art displays are similarly used to enhance other commercial venues. The phenomenon of museum-quality exhibitions in Las Vegas casinos is perhaps the most significant recent manifestation of this. The developer and art collector Steve Wynn successfully enhanced the prestige of the Bellagio Hotel and Casino by filling it with artwork, displayed in conspicuous locations such as the Bellagio Gallery of Fine Art and Picasso, one of the hotel's fine-dining restaurants.

59. For more information on the issues of the transformation of the museum's function, see McClellan, *Art and Its Publics*. For more on the melding of elite and popular culture, see Collins, *High-Pop*.

60. See Stevens, "Critic's Pick," 54.

61. The newest and most notorious entrant into the museum shop debate must be the fully functioning Louis Vuitton shop positioned directly within the recent Takashi Murakami retrospective exhibit. Displayed at the Los Angeles Museum of Contemporary Art (Oct. 29, 2007–Feb. 11, 2008) and then the Brooklyn Museum of Art (April 5–July 13, 2008), the Murakami exhibition incorporated a boutique selling limited-edition handbags designed through a collaboration between Murakami and the luxury goods company. See Roberta Smith, "Art with Baggage in Tow," *New York Times*, April 4, 2008.

62. At the Metropolitan Museum of Art shop one can purchase a "Tiffany Iris Umbrella," decorated with a design taken from the museum's *Magnolias and Irises* window by Louis Comfort Tiffany; at MOMA one can buy a set of "Coonley Tumblers," decorated to echo Frank Lloyd Wright's Avery Coonley Playhouse window in Riverside, Illinois; and at the Smithsonian store one can pick up a "Castle Mosaic Tie," embellished with the patterning of various nineteenth-century floor tiles from the Smithsonian's Castle.

63. "According to a 1999 survey of 1,800 museums by the American Association of Museums, revenue from gift shops and publications accounted on average for 25.5 percent of earned income" (Celestine Bohlen, "When the Going Gets Tough, Some Go Shopping at Museums," *New York Times*, Jan. 10, 2002). For more information on the importance of shops to the financial health of museums, see Rosen, "New Look at Art Museum Stores," 35–36; and Kramer, "Met Museum Looks to Restore the Retail Picture," 4, 59.

64. Conroy, "Discount Dreams," 63; see also Monica Kjellman-Chapin's essay in this collection.

65. Duncan, "The Art Museum as Ritual," 10. This idea is similarly explored by Victoria Newhouse, who states that "museums increasingly divorced art from a lived experience and elevated it to the status of a secular religion in what I refer to as the *Museum as Sacred Space*" (Newhouse, *Towards a New Museum*, 9). Considering the religious thrust of Kinkade's artistic project, it is especially apt to think of his museum in relationship to ritual, ceremony, and the sacred.

66. Duncan, "The Art Museum as Ritual," 11.

Thomas Kinkade's Heaven on Earth

JEFFREY VALLANCE

The Show

Let me begin by stating that I am writing this from my handsome Kinkade La-Z-Boy recliner. In 2004 I was asked to curate the first-ever contemporary art world exhibition of the works of Thomas Kinkade, held simultaneously at the California State University, Fullerton, Main Gallery and the nearby Grand Central Art Center in Santa Ana, California (fig. 1).

In the Chapel

I first met with Thomas Kinkade in the serenity of Kinkade Chapel, constructed for the exhibit, in Santa Ana (fig. 2). The chapel had a rough-hewn wood altar, cruciform pulpit, pews, and gothic stained-glass windows. Similar to cathedrals of old that held masterworks of art and precious relics, in the Kinkade Chapel were Kinkade's Christian paintings, including *The Good Shepherd's Cottage* (2001; Boylan fig. 1, p. 20), *Sunrise* (1999), and *The Prince of Peace* (1990; Morgan fig. 7, p. 44). This was the first time *The Prince of Peace* was exhibited in public, and the painting was on loan directly from Kinkade's mother, Mary Anne Kinkade. The chapel also had a selection of Kinkade's Christian products, such as chapel-shaped night-lights, Christian teddy bears and mugs, and an inspirational three-dimensional manger scene. It was in the tranquility of this holy place that Kinkade poured out his vision to me. What was said was witnessed only by Kinkade, myself, and the all-seeing electronic eye—a high-tech surveillance system installed for insurance reasons. What Kinkade revealed to me in the quietude of the chapel was conveyed in a solemn manner like a pastor speak-

Figure 1. Thomas Kinkade and Jeffrey Vallance at the opening of Thomas Kinkade: Heaven on Earth (2004), Santa Ana, Calif. COURTESY OF MICHAEL MCGEE.

Figure 2. Kinkade Chapel at Thomas Kinkade: Heaven on Earth (2004), installation view, dimensions variable, California State University, Fullerton, Main Gallery and CSUF Grand Central Art Center, Santa Ana, Calif. COURTESY OF MICHAEL MCGEE.

ing to a member of his congregation. The only way I can describe the scene is that it reminded me of the legendary account of Richard Nixon and Henry Kissinger kneeling together in the Oval Office. As we sat facing the altar from the first pew, a Nixonian glow emanated from Thom's countenance as he divulged his divinely inspired design for the Kinkade Empire.

The Mythology

In the chapel I received a revelation into the mythology of Thomas Kinkade. Kinkade's is a classic myth of transformation; the hero experiences a momentous event and is wholly changed. Every superhero experiences a transmutation in which his superpowers are revealed. For Thomas Kinkade this metamorphosis occurred when he was a student at Art Center College of Design in Pasadena. In art school Kinkade made typical student artwork—his drawings and paintings were of fantasy/sci-fi themes like gargoyles, ogres, trolls, and the like. He also tried his hand at pop art, for example painting an Andy Warhol–like banana. But one day Thomas became bored with painting the nude model in his art class. He went into a kind of trance. When he came out of the altered state, there in front of him stood an image of Jesus, painted as if by the hand of God. In the chapel Thom told me that he has no memory of painting the portrait. Through this altered state the humble student was transformed into the Painter of Light. Kinkade's first Jesus painting, *The Prince of Peace*, is similar to other religious-icon paintings called *acheropita*, a Latinization of the Greek term *acheiropoietos*, meaning "not made by hands." A much-celebrated acheropita icon resides in the chapel of the Sancta Sanctorum in Rome. Kinkade's portrait of Jesus is visually comparable to *acheiropoietos* images in a number of ways. The image features a frontal view of the head of Christ hovering on a sanguine, stainlike background; Christ has a two-pronged beard and long hair, and his nose and cheeks are prominent. He also wears the Crown of Thorns, and his eyes are weary and closed. Christ's face expresses deep sorrow, like that which he experienced on the road to Golgotha. Finally, the face seems to radiate a spiritual light or halo—the first glimmer of the Painter of Light's trademark. The Lord revealed himself to Thom that fateful day: "I am the light of the world" (John 8:12).

In the still of the Kinkade Chapel I was able to closely examine *The Prince of Peace*. It is different from every other painting done by Kinkade

in at least two respects. First, it seems to be spontaneously produced. It is painted on what appears to be the cardboard back of a standard drawing pad, the cheap, nonarchival, gray-brown board that backs large drawing tablets. This would be consistent with the alacrity in which it was painted, in the transcendental state. Second, it is the only portrait known to exist by Kinkade, the first and last of its kind. Its function seems to be only one of transformation, the visual expression of a born-again experience. Both these factors attest to the spontaneity of the painting. I believe Thom when he claims that he does not remember creating the painting. I would argue that possibly other *acheiropoietos* paintings were made in a similar trancelike, shamanistic, or euphoric state, in which the artist wakes up seeing an image of a deity *not painted by human hands*. Related is a belief that Kinkade shares with other painters—that the hand of God directs their paintbrushes.

The Vision

When I first proposed my plan for the Kinkade exhibition to the Kinkade organization, they were cautious, hesitant, and even suspicious. I think they expected some kind of mockery. My exhibition proposal sounded quite eccentric, and it seemed as if they would not accept it. Then slowly, they cautiously agreed, but with all kinds of constraining stipulations, rules, and regulations. "We can't do this," or "we couldn't have that." Then Kinkade must have had one of his visions. I can picture Kinkade having a fitful night, tossing and turning. Then he sits up. A light goes on in his head. He understands that no matter how outrageous I would be with the show, it could only benefit him. Actually, the nuttier I am, the better, and the more hip he would look for allowing me to do it. He could not lose. As if from on high comes the proclamation from Kinkade: "Let Vallance do whatever he wants. Let him have whatever he needs." The door was flung wide open, and nothing was held back from me. Kinkade is one smart businessman! Somehow he knew that the more unconventional I was with the installation, the better, and he was right. For perhaps the first time, he was taken seriously by the art world.

The Grand Exhibition

The genesis of the Thomas Kinkade: Heaven on Earth exhibition came into being as a wager. In a 2001 article in the *New Yorker* Kinkade bet the author Susan Orlean a million dollars that a major museum would hold a Thomas Kinkade retrospective in his lifetime (shades of Satan making the wager with Jehovah in the Book of Job). After reading the article, the board of directors of the Grand Central Art Forum for Grand Central Art Center voted to mount the show that seemingly nobody else would touch, with one board member, Stuart Spence, stipulating that "it could only be pulled off if Vallance curated the show." Another board member, Greg Escalante, called me and asked if I would do the show. I was already thinking about Kinkade and had recently ordered Kinkade-style address labels. So I excitedly said yes to the show that no one dared to do. I was selected to curate the show on account of my record of curating exhibitions dealing with pop culture and problematic themes. I have done exhibitions dealing with the Richard Nixon Museum, the King of Tonga, the Shroud of Turin, and Christian relics. In Las Vegas, where I lived for five years, I curated shows in the fabulous museums on the Strip: the Liberace Museum, the Clown Museum, the Magic Museum, the Debbie Reynolds Museum, Cathedral Canyon (an abandoned Christian sculpture park), and the Cranberry Museum.

I took my job as curator of the Thomas Kinkade exhibition very seriously. First and foremost I wanted only original paintings—no prints. The public had rarely seen Kinkade's actual paintings. Second, I wanted one example of everything Kinkade mass-produced, which amounted to thousands of items, a real Noah's Arkload of Kinkades. Samples of Kinkade's products had to be obtained from all of Kinkade's different manufacturers, including ceramics, lamps, fabrics, books, Bibles, videos, audio CDs, furniture, toys, miniature villages, mantel clocks, grandfather clocks, watches, blankets, figurines, snow globes, Christmas ornaments, Santa Claus figurines, Christian kitsch, greeting cards, dolls, teddy bears, quilts, calendars, nightlights, spice racks, umbrellas, coffee, model train sets, model cars and trucks, and promotional material on his log cabins and housing tracts (fig. 3; pl. 11).

I organized all these objects into a series of themed installations. Kin-

Figure 3. *Bridge of Faith* and Kinkade miniature ceramic villages (*Nighttime Winter* and *Daytime Summer*) at Thomas Kinkade: Heaven on Earth (2004), installation view, dimensions variable, California State University, Fullerton, Main Gallery and CSUF Grand Central Art Center, Santa Ana, Calif. COURTESY OF MICHAEL MCGEE.

kade's original paintings hung on walls that had been painted his trademark hunter green (the same color as his mall gallery walls). There were then two Kinkade libraries displaying hundreds of his publications and a theater playing Kinkade's promotional videos. His innumerable products were arranged into cozy installations, including a living room, dining room, bedroom, and a Christmas scene with a twelve-foot Christmas tree glistening with Kinkade ornaments. There were cases upon cases of Kinkade collectibles, a home décor area featuring Kinkade wallpaper and fabrics, and two fireplace scenes. There was also a three-dimensional recreation of "The Bridge of Faith" (based on Kinkade's painting *The Bridge of Faith*), consisting of a life-size functional wooden bridge over an artificial babbling brook surrounded by attractive plastic flower arrangements. Then the aforementioned Kinkade Chapel, which featured his Christian works. In the chapel the Reverend Ethan Acres, a performance artist and preacher, delivered a rousing sermon based on Kinkade's paintings. At the opening the reverend also performed a legal wedding for two Cal State Fullerton art students.

There were two miniature light-up Kinkade collectable villages, with ceramic replicas of houses and scenes (one a daytime summer scene and one an evening winter scene) from his paintings. A room was dedicated to Kinkade's architectural drawings and photos of his life-sized log cabins, and of the entire Kinkade-themed housing tracts. The exhibition also contained a relic from the 9/11 Twin Towers disaster—a charred Kinkade daily calendar that somehow survived the inferno. There were even a few objects in the show that Kinkade himself had never seen before. My favorite artifact was the Kinkade La-Z-Boy recliner. As the centerpiece, a Kinkade MBNA Visa credit card was displayed in a vitrine resting on a velvet pillow.[1]

I designed the show to work on three levels. For faithful Kinkade fans it was like a pilgrimage to the ultimate Kinkade Shrine. I observed Kinkade's collectors pointing out which objects they had in their collections, which pieces they would like to have, and which ones they were seeing for the first time. For them the show was truly heaven on earth. For the jaded contemporary art viewer it was over the top yet organized into what appeared to be contemporary art installations so that even if they hated Kinkade, they liked the show. Then there was the third group, who saw it working on both levels at once. The only problem was when someone got trapped on the wrong level of perception. For example, if a contemporary-art person became trapped on the Kinkade-collector level and could not transcend the kitsch, it was excruciatingly painful for him or her. More rarely, if a Kinkade collector somehow got a glimmer that contemporary art was afoot, it unsettled him or her. (I saw some raised eyebrows when the Reverend Acres tore off his preacher's robe to reveal that he was dressed as Dorothy from *The Wizard of Oz*, wearing a dress sewn in Kinkade fabric.) I would say that viewers trapped on the wrong level of perception represented probably less than 1 percent of the viewing audience. Most people entered and exited the exhibition at the same level as their belief or value system.

When people began to hear that I was curating the Thomas Kinkade exhibition, many erroneously thought that I would do the show in an ironic way. For me irony is far too simplistic and expected. To do the show seriously was the challenge. As I often say, "The only irony is there is no irony." In this manner I could infiltrate both sides. Kinkade is contaminated by the

art world, and the art world is contaminated by Kinkade. It is a wickedly sharp double-edged sword.

A Cognitive Dissident

As a child I was raised in the Lutheran Church, and as an adult I work in the contemporary art world. I see no disparity in honoring both traditions (though I am also a heretic). Like Hermann Hesse's Steppenwolf character I have a dual and divided nature. When I curate, I deliberately walk the razor's edge between extremes. Because I am dyslexic, I can hold two contradictory beliefs at the same time while seeing the absurdity of my position *and relishing it*. Dyslexics appear to be able to provisionally affirm simultaneously several incompatible assertions owing to the excess connections and pathways wired into their brains. (This may account for the three-tiered levels of perception built into the Kinkade exhibition.) I find my rapture in the seemingly impossible unity of opposites. The closest terms I can find in relation to my curating method are *multivalence, antinomy*, and *cognitive dissonance*. The term *multivalence* means the quality of having various subtle meanings or values, as in a multivalent allegory. According to Carl Jung, *antinomy* is "a totality of inner opposites." *Antinomy* is a contradiction between two statements, both apparently obtained by correct reasoning. According to the cognitive dissonance theory developed by Leon Festinger in 1957, there is a tendency for people to seek consistency among their beliefs and cognitions. When there is an inconsistency between beliefs, it is dissonance. Dissonance occurs most often in situations where an individual must choose between two incompatible beliefs or actions. The greatest dissonance is created when the two alternatives are equally attractive. A person who has intense dissonant cognitions is said to be in a state of *dissonance arousal*. In this euphoric state of dissonance arousal I can look people in the eye and explain my cockamamie plans, and they recognize I am being candid with them. I may have my own perverted agenda, but I clearly explain that to them as well. For some reason this convoluted method seems to achieve the desired results. This specialized art and curating technique I call *infiltration*. It is like getting away with murder and having the public love you for it.

The Controversy

The show was diabolically wicked and subversive yet warm and cozy. Some people will never forgive me. The controversy was felt most by art-world people who see Kinkade as an anathema. They fear his existence. He threatens everything they stand for, and he makes them nauseous. Kinkade's association with fundamental Christianity is particularly mortifying to the contemporary art world. The local Orange County art community was especially horrified. For them, seeing the Kinkade exhibit at Grand Central Art Center, known as a cutting-edge art space, represented the end of everything as they knew it, doom and gloom. They thought Grand Central Art Center had sold out. There were protests from local artists, and students carried picket signs and wore black armbands. Diatribes against Kinkade were written, and derogatory pamphlets were distributed. An artist named Jeff Gillette, calling himself the Painter of Blight, had a booth outside the gallery where he sold paintings of appalling slums done in the candy colors of Kinkade. Scores of threats were made against Kinkade and his paintings. An anonymous caller threatened to stone Mr. Kinkade, and another threatened to slash his paintings. An armed guard had to be posted at the exhibition at all times. I saw the guard looking at Kinkade's paintings. He liked them very much. He looked at me quite puzzled and asked why anyone would want to destroy them.

Before the show I had read many critiques of Kinkade, and to say that they were unkind would be putting it mildly. Many critics seemed to take great glee in putting down Kinkade, but things were different when critics wrote about the Heaven on Earth show at Grand Central Art Center. Many reviewers of the show followed a similar pattern. Most writers pretty much admitted that they loathed Kinkade and came expecting to hate the show—like gawkers at a train wreck. But then something happened. When they came to see the actual show, the kitsch was laid on so thick that something snapped in their brains. They experienced transcendence and ended up liking the show. This was precisely what I had planned. This sudden change in the critics, from loathing to approval, was not lost on Kinkade. When I talked to him about it, he looked ecstatic. So the word is *transcendence*—just as the student Kinkade had had his moment of transcendence in his trancelike state, viewers of the exhibition, even some against their will, transcended into another realm of perception.

The Urination Ritual

In 2006 Kinkade's image took a tumble. There were lawsuits, accusations were flying, and many unsavory exposés were published, the most damning a series in the *Los Angeles Times*. When I read the *Times* article, some of Kinkade's actions smelled more like performance art than vandalism to me. For example, no one would think it odd if the contemporary artist Paul McCarthy pulled off such wild antics. So I wrote a letter to the paper defending Kinkade's artistic endeavor. It was never published, but I have reprinted it here:

> In Defense of Thomas Kinkade Urinating
> on Winnie the Pooh at Disneyland
>
> On March 5, 2006, an article in the *Los Angeles Times*, "Dark Portrait of a 'Painter of Light,'" by Kim Christensen, mentions artist Thomas Kinkade allegedly pissing on a statue of Winnie the Pooh at Disneyland. Kinkade called his act "ritual territory marking." I am a personal friend of Thomas Kinkade, and I worked with him closely in 2004 on an exhibition of his work, Thomas Kinkade: Heaven on Earth, at California State University Fullerton's Grand Central Art Center in Santa Ana. On April 4, 2004, the show received a favorable feature article in the *Los Angeles Times*, "Painted Into a Corner?" by Hunter Drohojowska-Philp. From my experience, I would label Kinkade's act of urinating on Winnie the Pooh as performance art. On more than one occasion, Thom has said to me half-seriously that he would like to become a performance artist. He also muses that he would like to out-Koons Jeff Koons and become the next Salvador Dalí or Andy Warhol. Kinkade sees his immense printing facility in Morgan Hill, California, as comparable to Warhol's Factory. It is fascinating to note that Kinkade used the word "ritual" when talking of his urinating episode. A ritual is the performance of ceremonial acts or rites prescribed by tradition or by sacred decree. The use of ritual is prominent among performance artists today. Often the goal of ritual performance art is personal transformation and attempts to reclaim the spiritual.
>
> I see Kinkade's Pooh-pissing as the next step in the grand legacy of piss art. The granddaddy of all piss art is, of course, Marcel Duchamp's

Fountain (1917). It has been the subject of a series of incidents by guerrilla performance artists who have urinated in the porcelain readymade urinal. Andy Warhol, the Pop artist who Kinkade links himself most closely to, from 1977 to 1978 made a series of elegant abstract works entitled *Oxidation Paintings* in which Warhol and his friends urinated on canvases prepared with copper pigment that oxidized to an aesthetic patina. The process of applying uric acid to create a patina on metals is an ancient art technique. Picasso was also said to have done the same and would encourage his children to urinate on his sculptures. Warhol was inspired by Abstract Expressionist painter Jackson Pollock's drip paintings. In a famous incident, Pollock urinated in collector Peggy Guggenheim's fireplace. In 1982, Mike Bidlo recreated the mythic Pollock urination in a performance entitled *Jack the Dripper at Peg's Place*. David Hammons, in a performance called *Pissed Off* (1981), urinated on a Richard Serra steel sculpture in Lower Manhattan and was arrested for public urination. Also in 1981, I urinated on a bronze sculpture of Spiro Agnew to form a green patina on it for inclusion in my *Richard Nixon Museum*. In 1989, porn star and performance artist Annie Sprinkle urinated on stage in her performance *Post-porn Modernist*. In 2001, Rubén Ortiz-Torres created a life-size wax sculpture/fountain of rock star Ozzy Osbourne that continually urinates against a wall to commemorate the infamous 1992 incident when Osbourne was arrested for pissing on the Alamo in San Antonio, Texas. The piss list goes on and on.

Urination can be used as a device to mark out territory, as utilized by various mammals. Painting has been viewed as a metaphor for pissing. Kinkade supposedly chose to urinate on the character Pooh (pronounced the same as "poo," another form of human excrement). However, Thomas Kinkade has told me he has a high regard for Walt Disney, wishing that he could accomplish a fraction of what Walt did in his lifetime. Therefore, Kinkade's performance of pissing on Winnie the Pooh at Disneyland would be no sacrilege to Disney, but an aspiration to be on the same level as his hero. Kinkade's urination piece is just one more gesture in the annals of piss art. He has certainly made his mark in art history! I salute Kinkade and welcome him to the world of performance art.

In the letter to the editor I endeavored to point out that many people are pissed-off at Kinkade because they perceive that his actions are inconsistent with his revered myth and his seemingly *holier than thou* persona. When figures such as Thomas Kinkade or Mel Gibson present themselves as "righteous," others look for character flaws to bring them down. If one appreciates that Kinkade is, in fact, acting the same way many contemporary artists operate, then the situation could possibly be defused. (I have participated in enough late-night drunken-brawling-artist parties myself to know the routine very well.) I feel the *Times* is dead-set on toppling Kinkade from his lofty throne.

The Ivy Gate Cottage

After the exhibition I was invited to Thomas Kinkade's secluded studio, dubbed "Ivy Gate," at a location I vowed not to disclose. It was quite an honor, as only a few chosen people have been invited into his *sancta sanctorum*. Kinkade's studio, nestled among the trees, is larger than a luxury house. It is decorated with taxidermied deer heads, various antlers, gothic Christian icons, and rustic carvings of saints. It is designed to resemble Yosemite Lodge and features a huge stone fireplace. It truly seems like a haven from the modern world. On the walls hang paintings by Kinkade's favorite painters, including an original by his hero, Norman Rockwell. There were also paintings by Kinkade, and I inspected his palette and brushes close up. There were those blobs of candy-color paints he is so famous for, and on his easel was a study of the Disneyland Sleeping Beauty Castle for the Magic Kingdom's fiftieth anniversary (pl. 12). I brought with me two Bibles from the Kinkade Chapel that I had Kinkade sign and solemnly bless. Then we talked man-to-man about the intricacies of Heaven on Earth.

Some people surmise that I am not straightforward with the subjects I deal with, that I am somehow trying to pull the wool over their eyes. But I am always forthright in dealing with people, and Thomas Kinkade was no exception. I spoke with him bluntly and to the point, leaving nothing out. I told him exactly what I was doing, why I was doing it, and the different levels I expected the show to be viewed on. Thomas and I related to each other well, like twins separated at birth (though I have been called the anti-Kinkade). In his studio Thom mused about the possibility of be-

coming a performance artist. He got so excited that he half-jokingly said that he would like to start wearing all black to his art openings. I advised him against it. I told him that he was already as outrageous as he could be, the way he normally is. He is so *out* that he is *in*.

Before I curated the show, I had a suspicion that Thom was a kind of repressed trickster who would now have to live up to his own mythology. I feel that it is the prankster in him that is somehow delighted with my approach. Through me he can pursue some directions closer to the edge, while he himself can appear immune and unchanged. It is like "good cop, bad cop."

The Future Projects

In the seclusion of Ivy Gate Kinkade revealed his desire to pursue several new projects; I subsequently proposed several ideas. The first is a collaborative print. A limited series of prints will be produced by Thomas Kinkade and myself and marketed as a collaboration. I will be working over existing Kinkade images (a reference to the Warhol/Basquiat collaboration) and will use the same factory and printing process that Kinkade normally uses for these limited editions.

I also proposed a one-hundred-thousand-dollar art competition. This competition will be the largest art contest and award ever offered in the world. The exhibition will feature the many spoofs, takeoffs, and mockeries of Kinkade's trademark style (for example, a typical Kinkade cottage with a mushroom cloud in the background). The content of the art will not be censored in any way. In addition to the money, the winner will receive a solo exhibition at a major venue, with the individual's artwork featured in an exhibition catalogue. Second prize will be five thousand dollars; third prize will be three thousand dollars. Additionally, a major group exhibition for the top fifty entries (including first-, second-, and third-place winners) will be mounted.

There are also two more exhibitions I asked him to consider. The first would highlight Kinkade's early work, including his early pre-Christian, underground comic–inspired, fantasy/sci-fi– and pop art–influenced work, plus additional sketchbooks and artwork. Images of artistic work that inspired Kinkade would also be featured, as well as influential comics, writings, music, and films. The second exhibition would be a major showing

of original Kinkade paintings with a life-size Kinkade cottage installation exhibited in a prominent New York art museum. A selection of Thomas Kinkade's most important paintings would be featured. The installation concept is that one walks into the museum, enters a room, and sees a life-size Kinkade cozy cottage. Everyone has seen Kinkade's paintings of light-filled cottages and has wondered what is going on inside. Now, for the first time, they will be able to enter a Kinkade house. Warm glowing light will emanate from the cottage windows, beckoning. The cottage will be filled with Kinkade trademark products—cups, pillows, comforters, furniture, clocks, and knickknacks. (The only features not made by Kinkade will be some taxidermied trophy heads—deer and moose—and mounted antlers.) When visitors walk inside, a "grandmother" will greet them and offer freshly baked cookies. (She will be a museum docent or actor dressed as a Norman Rockwell–style grandmother.) This is contemporary art, installation art, and performance art. This is family values—mom and apple pie—perfect for this polarized country. The museum walls surrounding the cottage will be painted hunter green with original Kinkade paintings hanging on them. Around the cabin will be full-size, living pine trees—with their wonderful, natural aroma. Circling the cottage will be an abundance of fresh living flowers, changed often to stay fresh throughout the show. Out in front of the cabin will be a life-size wax figure of Thomas Kinkade himself, standing at an easel in the act of making a painting of the cottage.

I am pleased to report that, so far, I know of at least one repercussion that came out of my project proposal for the life-size cottage installation. Kinkade is now using language very similar to that of the proposal. He is working with an architect to construct full-size, four-million-dollar to six-million-dollar luxury homes that look exactly like the cottages found in his paintings. Concerning his architectural project, Kinkade recently said, "People tell me they often wish they could enter into one of my paintings. Now you can." The consummate businessman!

Art in Every Home

At home I enjoy drinking my coffee out of a Kinkade mug while relaxing in my Kinkade La-Z-Boy. I have to admit that one of the main reasons I am attracted to Kinkade's process is that I see it as an extension of what

Warhol started with his factory and multiples. In the early 1990s I wrote several manifestoes in which I wanted to produce every kind of product possible with my images on them so they could infiltrate the homes and lives of average people everywhere. Well, Kinkade has done that, and I applaud him for the grand scale of his incredible vision and accomplishment.

Notes

1. Organizing Heaven on Earth was a complex endeavor. A delicate rapport had to be established among the various parties through a slowly unfolding process until full trust was gained. There were extensive discussions and negotiations over every minute detail. An incredibly sharp team developed every aspect of the exhibit. Vu Meyers, former director of the now-defunct Kinkade Museum in Monterey, rallied behind the exhibition and was a major factor in getting much of the artwork for the show. Andrea Harris, director of the CSUF Grand Central Art Center, did the lion's share of the work, including interceding with Kinkade's people, communicating with the various manufacturers, and scouring the Internet and local galleries for elusive Kinkade artifacts. Along with her skilled staff, Andrea directed the installation of the show and the publication of the accompanying book. The stunning full-color catalogue of the show was copublished by Last Gasp and Grand Central Press. Deborah Brown (known for her inspired graphic work for the legendary Crystal Cathedral) designed the book, giving it that "heavenly" look that Kinkade and his organization value so much. The catalogue was enhanced by insightful essays written by the Reverend Ethan Acres, Doug Harvey, Mike McGee, and Ralph Rugoff. Rick and Terri Polm, two notable Kinkade collectors, graciously loaned five major original paintings for the show. Kinkade's right-hand man, Bob Davis, acted as a supportive intermediary between the Painter of Light and our group. Finally, Mr. Kinkade and his family generously loaned works from their private collections, making the exhibition especially distinctive and first-rate.

Manufacturing "Masterpieces" for the Market: Thomas Kinkade and the Rhetoric of High Art

MONICA KJELLMAN-CHAPIN

OIL PAINTING. Thomas Kinkade ltd edition *Eiffel Towers, City of Lights II*. 18×27" in beautiful gold frame. #176 of 275 A/P canvas, hand signed & numbered by Thomas Kinkade. Has been completely sold out for quite a few yrs. One of the few that came to the Boston area I was told. Also additionally hand highlighted by Thomas Kinkade Master Highlighter on Nov. 21, 1998. Painting never displayed. I have been told due to the age and rarity of this painting it will continue to go up in value quickly. Asking only $4295; Have documents.

—*Want Advertiser*, July 2003

To say that Thomas Kinkade paints for the market is to acknowledge that art making is largely a commercial endeavor and, in Kinkade's case, to point out something that seems too obvious to warrant scrutiny. Aside from selling prints of his original oil paintings through a variety of venues, Kinkade's images adorn a dizzying array of consumer goods. It is in part Kinkade's aggressive and comprehensive marketing strategies that have caused the art world to dismiss him; he seems the paragon of a for-profit mentality spun to epic proportions.[1]

Kinkade's relationship to contemporary artistic practice warrants attention, however, because of the art world's resistance to his inclusion within its borders. This rejection signals something important about a covert continuation of modernist beliefs and value systems subtending the ostensible openness and "anything goes" attitude of postmodernism. Kinkade's "outsider" status, an identity the artist plays up, bespeaks an "us versus them"

ideology redolent of an older structure, one largely codified in the writings of the modernist art critic Clement Greenberg. Greenberg's strongest condemnations were reserved for those whom he perceived as catering to majority tastes, preferences, expectations, and visual knowledge. Kinkade has been accused of doing precisely such pandering, offering the public nostalgic landscapes awash in his trademark glowing light.[2]

If the sales figures are considered evidentiary, Kinkade offers the American public precisely what it wants, and he has made it easy to consume.[3] Kinkade's pictorial empire is based on a carefully structured system of reproductions and licensing agreements; he makes his work available in tiers of scrupulously hierarchically ranked multiples sold in independently owned and operated "Signature Galleries," thus circumventing the usual procedures for having one's art exhibited. In addition to the Signature Galleries, Kinkade showcased his original oils in rotating thematic exhibition at the now closed Thomas Kinkade Museum and Cultural Center, and he also sent his paintings across the United States in a "Touring Museum."[4]

The creation of venues of display outside of those offered by the art world has triggered parallels to postmodernism. The art critic Doug Harvey, for instance, argues that Kinkade has built "an entirely new parallel art world, one that defies high and lowbrow distinctions and teleological models of art as a formalist polemic awaiting completion, subverts the established hierarchy of the gallery and museum system, and cuts a swath through the tangled elitism of the academic paradigm. These are, of course, the declared ideals of all good Postmodernists."[5] Following a similar logic, Wendy Katz has suggested that Kinkade may be a postmodernist in spite of himself, in that his work compels a reevaluation of the ways in which pictorial efforts can be shaped by its consumers, as well as contributing to an ongoing assessment of the relationship between art and popular culture.[6] It has also been suggested that if there is such a thing as "naïve postmodernism," then Kinkade's enterprise is it, because his "tactics could be seen as a hilariously effective critique of the traditional art world's market-driven deification of the art object."[7]

I suggest a different reading of Kinkade, one that makes him neither naive nor particularly postmodern. Instead, I propose that part of Kinkade's project involves an especially shrewd marketing apparatus that leans heavily on a binary opposition between kitsch and "high art." Part of Kinkade's phenomenal appeal is located somewhat to one side of his imagery;

it resides in the careful orchestration of a rhetoric and praxis that targets a populist understanding of what art is, what features art is supposed to have, what an artist does, and what the requisite signs of artistic worthiness are. Kinkade wraps himself in the mantle of "high" art and, by extension, wraps the names and styles and qualities associated with a canonical art history around his productions. Specifically, he mobilizes a populist understanding of major artists and movements in the history of Western art, as well as what constitutes Art-with-a-capital-A, in order to increase the marketability (and subsequent market value) of his work and to rescue it from such debased categorizations as "commercial" art or kitsch.

Kinkade relies on an associative linkage between himself and his work and the artists and art located within the fold of the Western canon as a mechanism of legitimization. Repeated references to canonical art history help Kinkade secure his status and justify the high prices for some of the works he sells. He clearly understands the career-enhancing potential of relentless self-promotion, but the incessant marshalling of certain key concepts and "isms" has additional value as well. This tactic elevates the status of his work. He is not (merely) a commercial artist; the rhetoric strives to remove qualifiers from the appellation "artist." Kinkade depends on nearness to the undisputed and popularly known "masters" and "masterpieces" of Western art, but it must also be understood that his reliance on the ideas, traits, artists, and artworks considered canonical means that he is not only using an a priori canon but is simultaneously producing, perpetuating, and concretizing that canon. Kinkade, in fact, is currently one of the most compelling and effective agents of canon building and policing of the boundaries of art, as he not only reinforces the canonical parameters set forth textually by survey books and popular introductions to art history, as well as institutionally by blockbuster shows, but also actively constructs a narrative of canonical objects and producers that has its beginnings in the Italian Renaissance and its climax with the French impressionists at the end of the nineteenth century.[8]

The Production of Art in the Age of Populism

Once the exclusive purview of an educated, usually male, elite, the aesthetic domain is now increasingly accessible to a much broader audience. Publications like *The Annotated Mona Lisa*, *Instant Art History*, and *Art for*

Dummies suggest that a general public is interested in learning something about art and its histories.[9] These texts imply that knowledge about art and art history is not only attainable but also advantageous. Popularly oriented books also increasingly instruct readers on how to become connoisseurs and collectors and promote the idea that art is for everybody. Certainly such sentiments are laudable, but we should attend carefully to the language in which these pronouncements are couched.

The art world, in both its institutional and individual forms, is typically vilified in these introductory texts, portrayed as an alienating agent that strives to make art unavailable, inaccessible, intimidating, esoteric, and intended only for a select few. In a how-to manual on art collecting aimed at a general readership, Glen Helfand writes, "Chances are, you really do know what you like, but the critical language that often circulates around the fine arts may give you cause for wonder. Don't worry—those impenetrable reviews are most likely the art world equivalent of a trade magazine, filled with technical terms that you don't necessarily need to know."[10] Thomas Hoving, a former director of the Metropolitan Museum of Art and author of *Art for Dummies*, casts similar aspersions, calling the art world "a bit precious and uppity":

> Art experts seem to be snobbish, impeccably dressed sorts who speak with at least a trace of an English accent. Their attitude is that art is for the highly educated and socially acceptable, not the common man. When asked for an opinion about some work of art, they either don't bother to answer because you're one of the masses, or if they do, what they tell you sounds like a cross between the contents of a Dead Sea scroll, a medieval manuscript, and a Hollywood contract. . . . Critics write in jargon that is little understood even by other critics. They invariably either ignore or try to destroy the true genius of the day whose talent will be discovered only after the artist has died—in abject poverty.[11]

Both Helfand and Hoving claim to invoke such stereotypes in order to debunk them, but in not only repeating them but elaborating on them, their descriptions serve to cement the image of the art expert and the art world as unfriendly, pompous, remote, and incomprehensible to the majority.

Books aimed at introducing or explaining art to a general readership reassure their constituency that art can be understood and even acquired

by anyone. This is not quite the same thing as a vernacularization of art; rather, such books promote a consistent and canonical set of works, artists, and styles.[12] This repetition not only results in the perception that these select artists, artworks, and characteristics are "better" or "best" but also helps generate a preference for them. What is at stake is less a matter of quality than how often an audience is exposed to a particular cluster of images, ideas, and names.[13]

The readers of popular introductions to art are not only told who and what is best but are also informed what visual qualities are critical to an identification of Art-with-a-capital-A, as well as the effect of Art upon the viewer. Hoving's *Art for Dummies* instructs its readers on "How to Recognize Good Art" by means of a checklist of questions:

√ Does it express successfully what it's intending to express?
√ Does it amaze you in a different way each time you look at it?
√ Does it grow in stature?
√ Does it continually mature?
√ Does its visual impact of mysterious, pure power increase every day?
√ Is it unforgettable?[14]

Instant Art History informs its readers that art "is defined as a special thing with unique qualities, like beauty or craftsmanship."[15] Certain attributes are put forth repeatedly as connoting the "value" of art—uniqueness, originality, invention, and the artist's authoritative "hand"—and certain movements, practitioners, and individual artworks are incessantly highlighted as the best representatives of truly noteworthy art. No longer insular to the art world, they are qualities, names, and styles that are regularly promoted and widely disseminated as bespeaking "greatness."

Kinkade's work intersects and interacts with these ideas in various ways. He produces paintings, and from those parental images issue a variety of reproductions. Such a praxis opens up onto the dissentious and often confusing terrain of the relationships between original, copy, and authenticity, especially as the last might be secured by a visible authorial authority in the form of the artist's touch. Kinkade does not sell the paintings he makes, and although he superintends the reproduction process, that alone is insufficient to secure the singularity expected of "high" art.[16] As a compensating strategy he promotes a remarkably expansive and elastic notion of "original" and "copy," afforded by a replicative technology that is capable

of mimicking the appearance of brushstrokes and even the texture and weave of canvas. Printed on a variety of surfaces, from canvas and paper to Masonite, the reproductions are issued in limited-edition collections, a process that asserts their "specialness." The prints are organized into an elaborate "Editions Pyramid," which also helps to determine the price and perceived value of each.[17] Each print that is sold also comes with a certificate attesting to its legitimacy, and each is stamped with Kinkade's signature in DNA-coded ink as a testament to its authenticity.[18] Kinkade is thus served by a complex replication strategy, in which limiting the reproductions and providing each one with a kind of provenance allows something of the quality of uniqueness to shade his multiples.

The claim of singularity is further enhanced by the hand-painted glints and dabs of paint put on by Kinkade-trained "Master Highlighters" or by the "Painter of Light" himself. Certainly the most coveted and most expensive reproductions are those that are personally (re)touched by Kinkade, signaling the qualitative and monetary divisions written into the hierarchy of reproductions. These "Master Editions" not only come with the certificate of authenticity and the DNA-coded signature but also bear Kinkade's thumbprint in a piling up of the authorial markers; moreover, the "extensive hand-lighting by Kinkade himself over the foundation of apprentice highlighting" enhances the exclusivity of the Masters Edition print and makes it, according to the literature, "the ultimate expression of detail, artist involvement, and collectibility."[19]

The direct involvement of the artist in the form of his "touch"—brushstroke and fingerprint in collusion—is thus linked explicitly to the value (collectibility) of the work. The reality that this is a copy is all but erased both by the proliferating signs of authorship and by the accompanying literature. To a lesser extent this is true of all the variants and editions and proofs in the elaborate hierarchy of prints; each is given the appearance of being hand-painted, either because it has a layer of paint over the lithographic print or because of the technology that faithfully mimics canvas weave and brushstrokes. Because the reproductions are individually highlighted by Master Highlighters, each one is, in a sense, unique.

Kinkade has thus not only revived the atelier system of master artist and pupils, but he has guaranteed that each image has the appearance of being a "unique original." He understands that "unique" and "hand-painted," like "master," are highly resonant signifiers for "Art," and he absolutely and

resolutely capitalizes on those associations by producing what might be considered multiple originals. Only "master" artists have followers, and only "great" artists' works are worthy of copying; the nature of the system works to confer "greatness" on him, while deflecting awareness that the work being copied is itself the result of duplication. To adopt the identity of "Artist," Kinkade must produce something that appears to be singular and that bears all the requisite signs of "fine art." Prints on their own are inadequate signifiers of a present-day equivalent of an Old Master. Prints that closely approximate paintings, however, with the expected attributes present in abundance, created by someone so influential as to have legions of followers in the form of his own "school" or atelier, effectively distance their maker from "commercial" art, which is often burdened by the suspicion that it is produced by an anonymous agent.[20]

Kinkade's audience knows that "real" art—Art-with-a-capital-A—is only made by artists. In this regard Arthur Danto has observed that "it is analytically true that artworks can only be *by* artists, so that an object, however much (or exactly) it may resemble an artwork is not *by* whoever is responsible for its existence, unless he is an artist." He continues, however, proposing that the label *artist* "is as ascriptive a term as 'artwork,' and in fact 'by' is as ascriptive as either."[21] This may be, but the arbitrariness of such labels goes largely unremarked except in specialized discourses. By Danto's equation, Kinkade's prints, highlighted by nameless Master Highlighters, cannot be works of art because they are not made by someone bearing the attribution "artist." The assuaging rhetoric set into play is that these unnamed mark-makers are trained by the artist himself, are handpicked for his atelier, and therefore function as extensions of the master in the studio—in Kinkade's case, the studio is an assembly-line production operation in the Morgan Hill facility—and as his sanctioned surrogates at highlighting events in the public arena of malls across America. They are not, in other words, anonymous daubers but critical participants in the ascriptive process. Increased esteem for Kinkade also translates into higher profits; the more assuredly he can occupy the position "Artist," the higher the prices he can command for his near-paintings, as they can more easily be marketed as investments.

Consuming the Aesthetic and Banking on the Myth of Genius

Another device by which Kinkade aligns his project with "high" art is the carefully choreographed meeting between the target audience and his pictures. Much of this occurs in the crucial discursive space of the showrooms dedicated to the selling of Kinkade's products—these are "galleries" rather than "stores." Usually located in shopping malls, they might best be considered "malleries," where the works are framed and carefully hung in "rooms" created through movable partitions. The walls are painted in a rich, sober tone, and the lighting is subdued. The showroom is the antithesis both of its mall neighbors and the gleaming Spartan white cube associated with contemporary art galleries, an image that Kinkade deliberately invokes, which helps to convey the impression that what is displayed in this somber space is endowed with the gravity of "masterpiece."[22]

Certainly Kinkade is not the only artist to step outside the traditional "artist with gallery representation" model, especially in recent practice. In the past two decades important investigations have examined the ideologies underpinning and motivating collections, the impulse to acquire collections of things, artwork and otherwise, the narratives constructed by their methods of display, and the ways in which spectatorship is perforce performed in these spaces by the exhibitionary tactics in use.[23] At the same time, artists have paid increasing attention to similar concerns, especially to the way apparatuses of display operate within, through, and potentially against capitalism; these concerns have led some artists to radically rethink their approach to the siting of their work and its relationship with the spatiality of the museum, and especially the gallery, which has traditionally been a commercial enterprise.[24]

The contrast between the Kinkade Signature Gallery and the stereotyped paradigmatic contemporary art gallery is both important and specifically engineered. Kinkade claims most exhibition venues are too brightly lit, architecturally harsh, and intimidating. This sentiment is similarly found in the "pop art history" books: "Some contemporary art galleries can resemble the setting for a Woody Allen satire of urban intellectuals, where people discuss elaborate video installations in a language that doesn't sound like English."[25] The rhetoric about art history's exclusionary and unnecessarily arcane language sends the powerful message that art is being kept from the public by an elite few who jealously guard it; a similar

point is broadcast about museums. Hoving expands the list of uninviting structures from modern or contemporary art galleries to the full range of museums:

> The image of the art world is frightening to most people, and for good reasons. Museums can be forbidding structures. Some look like something built for a Roman emperor. Others are modernistic, in-your-face buildings surrounded by weird sculptures that make no sense. After you enter the museum, no one seems to want to help— and the galleries go on for miles without places to sit, carpets to soothe aching feet, or toilets. The walls are loaded with what seems like a million works of art with explanatory labels as long and comprehensible as logarithm tables. If you let it be known above a whisper that you like something, you are warned by one of the guards. If you ask that guard where to go to find whatever, you get a disdainful glance.[26]

The Kinkadian mallery stands in stark contrast to such an environment; it offers an inviting, cozy atmosphere with diffuse lighting and is staffed with helpful and knowledgeable personnel. Its small size means that the visitor gets the experience of touring through different rooms without having to spend a lot of time or having to walk very far; there is little chance of his or her being bored or becoming tired.

The difference between the Kinkadian mallery and the museum or gallery invoked by such descriptions as Hoving's is as engineered as the contrast between the Signature Gallery and its mall neighbors.[27] The commercial reality of the Signature Gallery is carefully and consistently submersed except in specific pockets within the space, setting it apart from the other stores that occupy the mall. Conversely, the Signature Galleries also share with the larger mall environment the concern for structuring a highly controlled space, which moves its consumers through it with a minimum awareness of how they are made to perform the rituals of shopping by the overall design, including spatial layout, coloration, lighting, arrangement of elements, and traffic flow. The increasing centrality of the shopping mall within the American financial and cultural economy has been the focus of numerous scholars. By 2000 there were more than forty-five thousand shopping malls in the United States, an increase of more than eight thousand over the preceding decade; the number of shopping malls quadrupled

between 1970 and 2000.[28] Although architectural differences inform various retail built environments, all shopping malls are designed to maximize the amount of time the visitor spends in the space and minimize the awareness of the temporal and monetary expenditures; thus, the mall visitor's navigation of the mall is stringently choreographed. It is essential that the retail built environment enable "a fantasized dissociation from the act of shopping . . . [by] manufactur[ing] the illusion that something else is going on, while also mediating the materialist relations of mass consumption and disguising the identity and rootedness of the shopping center in the contemporary capitalist order."[29] This dissociation begins at the entrance, which offers a crucial point of transition from the exterior world to the enclosed world of the mall, pulled not only out of space and time, as William Kowinski has noted, but rendered "its own special world with its own rules and reality."[30]

Within this hermetic world every feature is carefully planned and planted to convince the shopper that she or he is partaking of a social activity in a primarily civic rather than commercial space. Although multiple models exist, the most prevalent enclosed retail space design in the United States has been the concept of a transposed "Main Street," anchored by large department stores.[31] Along this main corridor are fountains, restful refuges with plants and benches, street signs, and streetlights but none of the troubling aspects of the external world, such as crime, variable weather conditions, poor lighting, and lack of amenities such as restrooms and resting places.[32] The mall thus reproduces an idealized Main Street that not only allows the visitor the pretense that she or he is engaged in a social pursuit but actively promotes that notion. It is essentially "a *pseudoplace* which works through spatial strategies of dissemblance and duplicity."[33] Similarly, the Kinkadian Signature Gallery housed within this pseudoplace denies its commercial nature behind a museal veneer that comfortably connotes the respectability and respite of the decommodified art space—and therefore also of art object—precisely through its appropriation of the logic of the controlled space of the mall. The mallery, then, is coded according to the dictates of the larger space in which it is housed, even as it differentiates itself from other stores within the mall, just as it appropriates the positive, "high" culture attributes of the museum, with none of its potentially negative or off-putting aspects. It pulls what it requires from the larger cultural institutions of the shopping mall and the museum in order to capitalize on

shared attributes and associations, while positioning itself as distinct from both. Just as malls may be seen as enclosed, sanitized, miniaturized, and controlled versions of a mythical Main Street, USA, so the Kinkadian mallery is a smaller, cozier, more welcoming, and more accessible version of a museum.

Many of the malleries are equipped with an area near the entrance where visitors can purchase souvenirs; all manner of collectibles, from the expected mugs and calendars, puzzles, and nightlights to the more unusual wallpaper, needlepoints, and teddy bears are available. While the identity of the reproductions as reproductions in the exhibition space is carefully concealed, those for sale at the entrance are packaged and marketed as just that—reproductions—rather than as art. This strategy helps promote the idea that the reproductions hanging in the exhibition portion of the mallery are a different order of being.[34] Beyond the gift shop the viewer confronts framed paintings hung on the wall at eye level with identifying placards beneath them, exactly as one would see artwork displayed in a museum. By comparison with its often more raucous neighbors, the mallery is a relatively hushed place, with all focus directed toward the paintings on the walls, effected through the mode of display, the color scheme, lighting, and the elimination of prices. The reality that this is a store in a shopping mall has been largely erased.

The design of the malleries, the revival of an atelier system stocked with Master Highlighters, the building of a dedicated museum, and the ample presence of expected markers of "high" art contribute to an understanding of Kinkade as "fine artist"; so do the various publications devoted to him and his pictorial project. Kinkade has collaborated with a number of authors to produce glossy, lavishly illustrated monographs and catalogue raisonnés.[35] Books of that genre speak loudly of elevation and worthiness; as Elizabeth Prettejohn has pointed out, one of the functions of such texts, "so closely associated with Old Master scholarship, is to confer canonical status on the artist."[36] Like the Thomas Kinkade Museum and Cultural Center and the Signature Galleries, these books are instances of self-consecration, but awareness of that fact is mitigated. While information that Kinkade is involved in the books project is not hidden—he is often listed as the author—the major essays are written by people other than the painter. Kinkade's specific involvement is less important, ultimately, than the ability of the texts to exalt him.

Within the texts the reader finds biographical tidbits that further cement Kinkade's identity as Artist-with-a-capital-A. One of the most prevalent myths about artists since the publication in the middle of the sixteenth century of Giorgio Vasari's *Lives of the Most Excellent Painters, Sculptors, and Architects* is that of the precocious genius.[37] Vasari instigated the belief that quality in a work of art is an irrefutable expression of individual genius, so the most direct access to the work is through recourse to the artist's biography. Within his biographies Vasari produced a story fated to be repeated, reified, and subsequently used as a fundamental indication of genius—the tale of the young Giotto, whose tremendous innate talent was discovered by the older painter Cimabue when he came across the boy drawing some sheep on a rock. Duly impressed, Vasari recounts, Cimabue invited Giotto to his studio to become his apprentice, and in short order the younger artist surpassed his teacher.[38] With minor variations this tale is repeated in the artistic biographies of numerous artists; as Linda Nochlin points out, a host of other artists were "all discovered in similar pastoral circumstances. Even when the young Great Artist was not fortunate enough to come equipped with a flock of sheep, his talent always seems to have manifested itself very early, and independent of any external encouragement."[39] Gifted precocity became a fundamental component in the paradigm of artistic genius and an expected element in the identity of the Artist-with-a-capital-A.[40]

The myth of the precocious genius is repeated in virtually every text devoted to Kinkade; moreover, the biographical sketches replicate the general contours of the Giotto story. Thus, we read that, having demonstrated an astonishing skill at an early age, Kinkade was apprenticed to an older, more experienced artist, who presumably—and by the dictates of this particular narrative trope—he eventually surpassed in talent.[41] According to the literature devoted to him, Kinkade's interest and facility in handling color, an ability on which he largely staked his artistic identity and enterprise, came at an early age, prior to formal artistic training.[42] Kinkade, the reader is told, is also tremendously inventive and aesthetically restless, two more critical components in the formulation of artistic genius; by the time he had reached his teens, he had experimented with a variety of styles, including impressionism, expressionism, and cubism, and as a fully matured artist he continues to "experiment with other mediums: water color, airbrush, charcoal, pencil, and acrylics."[43]

Kinkade is a full participant in such mythologizing; he relates a story,

repeated in more than one text, of how, at the age of three or four, he intuitively understood how linear perspective works and was capable of rendering it skillfully.[44] This sounds suspiciously like a Vasarian vignette, and it is without a doubt a deliberate echo. While many of the customers who flock to the Signature Galleries to purchase Kinkadiana may never have heard of Giorgio Vasari, they would and do understand the notion that "great" artists have some inherent ability that reveals itself early in life. The books devoted to Kinkade are yet another means to put powerfully into circulation the idea that he is an incontrovertible genius of immense and innate talent, a living Old Master.

Mechanical Multiplication: Authenticity and the Many

Part of the seductive appeal of Kinkade has to do with a kind of intensive catering to firmly established notions of where artistic quality, value, and worth reside. His marketing rhetoric relentlessly and effectively declares an unbroken continuum between his images and "high" art. If differences exist, the Kinkadian machine suggests, they are to be located in the fervent popularity of his production versus that of much modern art, art to which Kinkade asserts his opposition.[45] Kinkade claims, in fact, that part of his drive to become an artist was "in competition" with Picasso, whom he castigates for his relentless pursuit of the dollar. Kinkade claims, "[Picasso] is a man of great talent who, to me, used it to create three Picassos before breakfast because he could get $10,000 for each of them."[46] The implication is not subtle: Picasso commands high prices for work produced quickly, effortlessly, without much thought except for the financial gain. Kinkade sets himself in opposition to that; in contrast to Picasso or other modern artists, Kinkade invests his work with sincerity, validating once again its authenticity as art.

Kinkade's oppositional stance to much of modern art is a position that the art-historical references on which he relies appear to validate. He profits both literally and figuratively from a consumptive audience that has been repeatedly told through a variety of vehicles, including "blockbuster" shows, reproduction in commercial advertising and licensed objects, and publications like Art for Dummies, that certain styles, such as impressionism or the Italian Renaissance, constitute apexes of artistic quality.[47] Contrary to Walter Benjamin's thesis about the progressive loss of aura in the wake

of mechanical reproduction, popular styles such as impressionism or Italian Renaissance find their paintings, sculptures, and practitioners not diminished by their wide dissemination and reproduction in every possible context but, paradoxically, by Benjamin's standpoint, notably amplified.

In his oft-cited essay "The Work of Art in the Age of Mechanical Reproduction" Benjamin argued that the advent of mechanical processes of reproduction had invariable consequences for the original work of art. Mechanical processes such as photography were notably different from previous means of replication in their effects on the objects and images subject to reproduction. "In principle," Benjamin acknowledges, "a work of art has always been reproducible."[48] But prior to the introduction of mechanical processes such reproduction was done by hand, and while Benjamin does not suggest it, there existed at that time the possibility that the copy would bear enough unique features to qualify as an original itself rather than a (mere) replica. After all, copying by hand will inevitably result in differing indexical traces, regardless of how proximate the scrivener manages to be.

Reproduction by hand, however, differed notably from the mechanically produced copies with which Benjamin was concerned.[49] For one thing, replication by hand will necessarily introduce dissimilarities discernible between the original and its copy. Moreover, as Benjamin notes in his seminal article, copying by hand limits the number of replicas that can exist. Mechanical forms of reproduction radically changed that: "For the first time in the process of pictorial reproduction, photography freed the hand of the most important artistic functions which henceforth devolved only upon the eye looking into a lens."[50] Once the manual was replaced by the machine, not only was the pace at which reproductions could be made rapidly increased, so was the volume of copies producible. "Since the eye perceives more swiftly than the hand can draw," Benjamin wrote, "the process of pictorial reproduction was accelerated so enormously that it could keep pace with speech."[51] The possibility that the reproduction would bear enough unique features to qualify as an original in its own right was also eradicated, since mechanical processes result in identical copies that literally ape the parental image without admitting even the remotest possibility of the potential idiosyncrasies of manual replication.[52]

One of the most profound consequences of this accelerated copying, at least for some commentators, was the ever-expanding audience for works

of art; those who might never have access to the original, whatever the reason, could now take visual and actual possession of an artwork in reproductive form. For André Malraux this was precisely the beauty of reproductions and led to his theorizing of the enormous advantages of the *musée imaginaire*: "Nowadays an art student can consult colour reproductions of most of the world's greatest pictures. . . . The modern connoisseur has far more great works accessible to his eyes than those contained in even the greatest of museums. For an Imaginary Museum without precedent has come into being, and it will carry infinitely further that process of 'intellectualization' which began with the comparison, partial and precarious though it had to be, of the originals and museums of the western world."[53] Malraux suggested that image reproduction would allow for greater "intellectualization," as he put it, about art, because not only could vast numbers of people access a particular artwork, but it was now possible to make direct comparisons between works of art, irrespective of geographic, temporal, cultural, or media differences. Photographic reproduction also granted unprecedented access to details, allowing for analyses that may have been unlikely or even impossible in their absence.

Long before Malraux made famous the notion of a "museum without walls," the positive potential of such photographic reproduction had been touted. As early as 1880, the critic H. Wilson noted that "by multiplying excellent copies of the highest works of human genius with a cheapness which brings them within the reach of thousands who can rarely see, and never possess, originals of the highest merit," art education and appreciation would be exponentially increased, since "the possession of a few first-rate copies of first-rate originals . . . is likely to do more to engender and foster a real love of Art than any amount of wearing and tiring 'doing' of Art galleries is likely to accomplish."[54] While Malraux in the mid-twentieth century and Wilson in the late nineteenth agreed that the wide circulation of objects and images through mechanically produced replicas was beneficial to both art and audience, it was that very diffusion that caused Benjamin concern.

The work of art multiplied infinite times would progressively displace the authority of the original, he cautioned, and could potentially render it obsolete. Whereas Malraux celebrates the artwork's insertion, through its mechanically reproduced twin, into situations and spaces inconceivable for the original, for Benjamin this same quality could only do harm to the

original. "Technical reproduction," Benjamin wrote, "can put the copy of the original into situations which would be out of reach for the original itself. Above all, it enables the original to meet the beholder halfway."[55] While this may not seem like a negative consequence of reproduction, Benjamin goes on to state that although "the situations into which the product of mechanical reproduction can be brought may not touch the actual work of art . . . the quality of its presence is always depreciated."[56] This is because much of the original's authority and authenticity—what Benjamin refers to as its aura—is bound up in its unique presence in a particular time and place. The percipient experience, in other words, is limited for both participants. Not so in a culture of copies, which cleaves the work of art from the realm of tradition. Herein lies the crux of Benjamin's ambivalence about mechanical reproduction. Unlike replication by human hands, which allowed the original to retain its aura, copying of this sort results in progressive, inevitable, and irrevocable devaluation:

> In the case of the art object, a most sensitive nucleus—namely, its authenticity—is interfered with whereas no natural object is vulnerable on that score. The authenticity of a thing is the essence of all that is transmissible from its beginning, ranging from its substantive duration to its testimony to the history which it has experienced. Since the historical testimony rests on the authenticity, the former, too, is jeopardized by reproduction when substantive duration ceases to matter. And what is really jeopardized when the historical testimony is affected is the authority of the object. One might subsume the eliminated element in the term "aura" and go on to say: that which withers in the age of mechanical reproduction is the aura of the work of art.[57]

One might argue, however, that rather than a progressive loss of the auratic, canonical "masterpieces" find their auras very much intact and indeed energized and augmented, reinvested via multiple and constantly multiplying reproductions, facsimiles, approximations, and reinterpretations.[58] The multiplying reproductions do not thus discredit the original, although its aura might be understood as residing in something other than singularity—perhaps even in its ability to proliferate. As Hillel Schwartz has noted, "Practical distinctions between the unique and the multiple have historically been entrusted to theologians, notaries, connoisseurs, and curators. None of these now seems to be able to keep the One apart from

the Many. Can we still uphold—or is it time to abandon—any distinction between original and replica?"[59] The interdependence of the One and the Many further complicates such a distinction. The process vibrates with the smooth tautological pendulousness of a reciprocity firmly embedded in capitalism and consumer culture, as the public demands proliferating replicas of one-of-a-kind masterpieces that attain that status precisely because they are one of a kind but see their stature augmented and elevated because of their wide circulation through reproduction.

Certainly the issue is slightly different in the case of Kinkade, who now makes work always predestined to be reproduced. Although he could not have foreseen the changes in reproduction wrought by digital means, Benjamin noted in 1936 that already with inventions such as photography, and particularly film, the time had come when "to an ever greater degree the work of art reproduced becomes the work of art designed for reproducibility."[60] But aura was still very much a necessary aspect of the work for Benjamin, because without its connection to authenticity, art "begins to be based on another practice—politics."[61] The fact that Kinkade paints deliberately—and some would say mercenarily—in order that the work be distributed in multiples not only foregrounds the assembly-line aspect of his art making but also severs the work's umbilical ties to tradition and anything resembling Benjamin's auratic realm. Instead, it comes to stand as "an externalised manifestation of the work of industrial capitalism itself."[62] For the image purchased at the local mallery to justify the relatively high cost for what is essentially a digitally manufactured poster, however, that reality must be concealed. It must therefore be attended, as I have argued, by ever-escalating rhetoric and proofs of its worthiness, its value, its claim to "Art." And here is where those signifiers of canonicity play a critical role. The current culture of copies has produced a paradoxical situation, as Schwartz remarks, because "the more adept the West has become at the making of copies, the more we have exalted uniqueness. It is within an exuberant world of copies that we arrive at our experience of originality. . . . What are we about, who take so easily to ditto marks yet look so hard for signs of 'individual touch'?"[63] The indexical trace, the visible sign of a work's coming into being, and a key testimonial to its singularity, even if simulacral, may be one of the contributing factors in Kinkade's choice of canonical citation.

Out-Moneting Monet: Capitalizing on the Aura of Impressionism

Of the many art-historical references Kinkade makes, the one deployed most prevalently and persistently is to impressionism.[64] In 2003 Kinkade fans were treated to a new body of work, which mobilized an especially trenchant chain of signifiers—the recently "discovered" work of Robert Girrard. The production of a pseudonymous body of work offers the possibility of later disavowal should the pictures not be well received, but the Girrard collection seemed specifically designed to augment Kinkade's stature. A previously "unknown" group of paintings, produced "under a brush name to secure artistic anonymity,"[65] the Robert Girrard collection represents an excessive instantiation of Kinkade's strategies to invest a sense of uniqueness in multiplicity and to establish an artistic identity with a secure claim to canonical status. Kinkade chose the pseudonym *Girrard* because it was a "French-sounding name [which] would be helpful if he were to paint impressionistic works."[66]

Working as his Francophone alter ego, Kinkade was able to master yet another style of painting, as "Girrard's career solidified him as an American Impressionist master."[67] The Girrard literature moves freely between French impressionism and American impressionism without identifying distinctions between the two. The easy slippage between French and American functions much like the repetitive alternation between "impressionist" and "impressionistic." The Girrard collection both partakes of a known historical style — *-ist* — and approximates but is not that style — *-istic*. The semantic shift that occurs with the addition of *-ic* signals the degree to which specific meaning has been evacuated from the former term, which thus enables it to be pressed into service as a more fluid and more potent signifier of artistic merit and worth.

The Robert Girrard Collection is only one of many references to impressionism; Kinkade's reliance on this style has undoubtedly to do with its position within the canon of Western art history. French impressionism, as Richard Brettell has argued, enjoys a unique prestige in American and British museums; it is given a privileged position in the organization of most major institutions because it attracts more patrons than other holdings in the permanent collections. Its popularity thus makes it a very attractive candidate for blockbuster shows, which in turn helps further its appeal and its hegemonic status.[68]

Impressionism's bankability places a burden on museum curators; the necessity of generating revenue through ticket sales means that innovative and experimental exhibitions or shows of interesting and high quality but unfamiliar paintings are less likely to be mounted than yet another variation on the moneymaking impressionist exhibition.[69] Origins of Impressionism, held at the Metropolitan Museum of Art in 1994, brought in more visitors, just shy of eight hundred thousand, than any previous exhibition of paintings.[70] Those figures are on par with the attendance records for the 1998–99 Monet in the Twentieth Century, which was attended by more than five hundred thousand people at the Museum of Fine Arts, Boston, and more than eight hundred thousand when it traveled to the Royal Academy of Arts in London.[71] The intentions of curators and the quality of the show and the paintings in it are far less relevant than the inclusion of the term *impressionism* or one of its better-known sons in the title of the exhibition, the presence of which is a key ingredient in the securing of worthiness.[72] It is through such repetition that impressionism has been effectively and emphatically canonized; it is presented as the very culmination of Western art, with the concomitant result that it has also been widely and popularly disseminated as the foremost "brand" of art.[73] As Anthea Callen pithily puns, "Monet makes the world go around."[74]

These assertions find validation in Kinkadia and in turn validate Kinkade. As Girrard, Kinkade claims that he set out to "reinvent academic styles."[75] Impressionism is thus understood not as the inception of a critical modernist aesthetic imperative but as a "classic" mode of painting, replete with the authority of tradition, of the academy. The institutional packaging of impressionism encourages the collapse of Monet into the moneymaking and makes possible Kinkade's use of impressionism/impressionist/impressionistic as a highly malleable sign that lacks not only historical but also stylistic specificity.

Impressionism is pressed into service for two other Kinkadian ventures: the "French Impressionist Collection" and the "*Plein Air* Collection." The "French Impressionist" paintings were, according to official Kinkade literature, "created by Thomas Kinkade during the Robert Girrard era and later reworked by Thomas Kinkade,"[76] in a piling up of authorship; the doubling is literalized by the fact that the works are signed by both Thomas Kinkade and Robert Girrard.[77] The "*Plein Air*" paintings are treated as a separate group from either the "French Impressionist" or the Robert Gir-

rard pictures, although they rely on the same semantically shifting signifiers, allowing Kinkade to again draw authority from nineteenth-century impressionism.[78] Furthermore, the "*Plein Air* Collection" paintings are accompanied by a choice of "Michelangelo" or "Rembrandt" frames, thus amplifying their (nearness to) greatness (see fig. 1 and pl. 13).[79] Kinkade takes so much from "high" art, presses into service so many references, signs, codes, and experiences, that the public cannot help but feel assured that what it is consuming, both visually and financially, is in fact "Art." Any anxiety the consumer may have had at plunking down a considerable sum of money is alleviated as the Kinkadian machine smoothly transforms print into painting, reproduction into original, multiplicity into singularity, and customer into collector.[80]

Kinkade, Kitsch, and Willful Art

There is clearly a reciprocity between "high" art and consumer culture that rotates on such well-worn isms as impressionism, and Kinkade exploits that reciprocity, using it to ratchet up the stature of his (re)productions. While the sentimentality of his images is undeniably a contributing factor, his proximity to but perpetual distance from that which he references so emphatically has caused the charge of kitsch to be leveled against him.[81]

Part of what constitutes kitsch is bound up in the idea of the commercial. For most commentators on the subject, kitsch is not only founded on but revels in its broad-based, consumerist appeal. Kitsch does not lay claim to the more edifying goals generally associated with fine art. There is always presumed to be some extant difference between kitsch and art, even when the distinction is ambiguous or difficult to discern. In Greenberg's oft-cited essay "Avant-Garde and Kitsch" Greenberg defines kitsch specifically as "ersatz culture." This idea of kitsch as marked by a quality of artifice or (cheap) substitution is at the core of most subsequent explications and applications of the term; *kitsch* is used to denote that which is illegitimate, insincere, or inauthentic.[82] Greenberg also emphasizes kitsch's sycophantic nature—it requires for its sustentation, indeed for its very existence, nonkitsch forms to emulate, reflect, or subrogate. As Greenberg writes, "The precondition for kitsch, a condition without which kitsch would be impossible, is the availability close at hand of a fully matured cultural tradition, whose discoveries, acquisitions, and perfected self-consciousness

Figure 1. Thomas Kinkade, *Bloomsbury Café*. © 1995 THOMAS KINKADE.

kitsch can take advantage of for its own ends. It borrows from it devices, tricks, stratagems, rules of thumb, themes, converts them into a system, and discards the rest."[83]

Certainly, the ways in which I have argued that Kinkade draws on "high" art references might be taken as the perfect example of the circumstances and process Greenberg describes. Kitsch, however, seems almost too facile a label for the Kinkadian painted print, in part because his recourse to this rhetoric is specifically designed to enact and maintain some critical distance from that taxon. It is also an inadequate tag, however, because it is too often meant dismissively, signaling aesthetic paucity, wanness, tastelessness, or talentlessness. Kinkade's products are not inadequate in the way kitsch is usually perceived; they present themselves as more, as better. His impressionist/ic scenes, reproductions that are hand-painted, bearing not one but two signatures, are wrapped in the Renaissance arms of Michelangelo or the Old Master ones of Rembrandt.[84]

Greenberg's caution about the insidiousness of kitsch might be taken into consideration here: "Kitsch," he writes, "is deceptive. It has many different levels, and some of them are high enough to be dangerous."[85] The peril of kitsch is that it erases any "distinction made between those values only to be found in art and the values which can be found elsewhere."[86] Kinkade's appropriation of the apparatuses and attributes of "fine art," particularly as they have been popularized through a variety of means, has a double outcome. His easy assimilation of "high" art's values and markers serves simultaneously to obviate any distinction *and* to concretize the division between elite and ersatz, while appearing to confirm his own pictorial efforts as legitimate Art-with-a-capital-A. Kinkade depends on a calcified, formulaic, static, even stale division between "high art" and low forms of culture, since even as he enters the fray at the latter level, he relies on the value embedded in and conveyed by a strict and stringently preserved notion of the former to imbue his own productions with value/prestige/ aura/authenticity. In other words Kinkade needs kitsch in order to partake of and try to participate in its elevated Other.

I claimed at the beginning of this essay that Kinkade was not particularly postmodern; perhaps what I should have said was that he is not *exactly* postmodern. To be sure, he does partake of many of those characteristics and devices associated with postmodern artistic practice, but he does so without the apparent and often scrupulously self-aware irony, cyni-

cism, drollery, or apathy that attends much postmodern production.[87] The entirety of his marketing apparatus, in fact, seems to depend on popular understandings of major "high art" movements, moments, and names, while at the same time it works tirelessly to preserve the binaries that are often the target of postmodernist praxis. Kinkade needs the distinctions of "high" versus "low," of art versus kitsch, of elevated and worthy versus debased and denigrated, because only through that separation can certain codes, references, associations, and qualities be pressed into service as legitimating devices in a cultural arena that, despite its participation in and activation of its processes, ultimately derides commercialism and pandering to the public unless it is tongue-in-cheek, ironic, or its crassness and gaucherie can be harnessed to some claim of discursive criticality.

If the art world is opposed to calling the fantastical world proffered by Kinkade's imagery "art," perhaps it has less to do, then, with its proximity to kitsch and more to do with his unapologetic pictorial promiscuity. The rhetoric operates as a palliative device, a protective mantle that shields him from suggestions that he is not a "true" artist, while working furiously to confer near-canonicity on him. Anyone who doubts his ambition for high rather than low has only to look again at a painting like *Paris: City of Lights* (1993; pl. 10), which not only contains a self-portrait of Kinkade being stared at adoringly while painting *en plein air* but also informs us that his one-man show at the Louvre has sold out. While Julia Alderson argues elsewhere in this collection that this painterly gesture is merely wishful thinking, I would argue that Kinkade's persistent recourse to "high" cultural references seems to be a way to locate ever more securely his pictorial efforts on the "right" side of the dividing line between art and kitsch. As a purveyor of Kinkadia at a Massachusetts mallery said about works at the middle level of the reproductive pyramid: "We don't say they're on Masonite; we call them Classics."[88]

Notes

The epigraph was sent to me by Timothy Shary; I thank him for supporting my ongoing interest in all things Kinkadian. I have deleted the telephone number; otherwise the advertisement is reprinted verbatim. This essay is an elaboration of arguments first presented at the College Art Association conference in February 2004. Its arguments have benefited enormously from the close reading and

insightful comments and suggestions of Alexis Boylan and several anonymous reviewers. I also owe many thanks to my fellow conference panelists for their contributions to a stimulating and thought-provoking consideration of Kinkade, his work, and its position within the landscape of art history. I would also like to thank Anna Brzyski, Ellen Longsworth, David Raymond, Jack Amariglio, and Benjamin Kjellman-Chapin for their encouragement of my Kinkadomania.

1. By "art world" I mean to indicate a discursive space defined primarily by art institutional, academic, and textual forces.

2. Kinkade's response to such accusations is to insist that his financial success has liberated him from the demands of the market; he is free to paint whatever he wishes. See Kinkade, *Thomas Kinkade*, 9.

3. In the mid-1990s Vitaly Komar and Alexander Melamid conducted a survey to discover what the American public's preferences were for painting, which resulted in the 1994 *America's Most Wanted*. An overwhelming majority of those polled (88 percent) preferred landscapes of the "realistic-looking" variety. See Wypijewski, *Painting by Numbers*.

4. The Kinkade Museum opened in May 2001 and closed in May 2005. The Touring Museum is no longer operational owing to security concerns, according to Vu Myers, the licensing marketing manager for the Thomas Kinkade Company, in conversation with the author, June 2005. Original oils by Kinkade can still occasionally be seen at the Thomas Kinkade National Archives in Monterey, California.

5. Harvey, "Skipping Formalities," 18.

6. See Kinkade, *Thomas Kinkade*, 32–33.

7. This suggestion was made by Kenneth Baker of the *San Francisco Chronicle*, quoted in Tessa DeCarlo, "Landscapes by the Carload: Art or Kitsch?" *New York Times*, Nov. 7, 1999.

8. I have considered further Kinkade's relationship to the Western art historical canon in Kjellman-Chapin, "Kinkade and the Canon."

9. See Strickland, *The Annotated Mona Lisa*; Robinson, *Instant Art History*; and Hoving, *Art for Dummies*. To this list might be added Wilder, *Art History for Dummies*. Museum attendance has been on the rise since at least the middle of the 1990s; for specific figures, see Ebony, "Museum Attendance on the Rise."

10. Helfand, *Collecting Art*, vi.

11. Hoving, *Art for Dummies*, 2:

12. The canon such texts promote is a distillation of the canon produced by and within the discipline of art history; see my "Kinkade and the Canon."

13. In psychology the process of generating a preference through repetition has been identified as *mere exposure*. See also Cutting, "Mere Exposure, Reproduction, and the Impressionist Canon."

14. Hoving, *Art for Dummies*, 12. This list is also printed at the front of the book on a "Cheat Sheet."

15. Robinson, *Instant Art History*, xiv.

16. Artists like Marcel Duchamp and Andy Warhol, just to name two, staged reconsiderations of artistic practice through their work, Duchamp by "producing" the Readymades and Warhol by generating work through assistants at the Factory. Nevertheless, the notion persists, particularly outside of the art world, that the artist must be involved in some direct way with his or her work, and preferably that involvement will be registered in a palpable and reassuringly apparent manner. On the subject of originality, reproduction, and value see Krauss, "The Originality of the Avant-Garde"; and Benjamin, "The Work of Art in the Age of Mechanical Reproduction."

17. See Breslau, "Paint by Numbers," 48; and *Thomas Kinkade, Painter of Light: 2003 Limited Edition Comprehensive Catalog*, 132, which explains the particular specifications for each subdivision within the "Editions Pyramid."

18. See Kinkade, *The Thomas Kinkade Story*, 147; this practice was apparently begun in 1997. See also Weintraub, *In the Making*, 23; Weintraub briefly discusses Kinkade's strategies for making copies function akin to originals. For a consideration of the ways in which copies function in relation to originals and to the art market, see Benhamou and Ginsburgh, "Is There a Market for Copies?"

19. *Thomas Kinkade, Painter of Light: 2003 Limited Edition Comprehensive Catalog*, 132.

20. This is beginning to change, given the expanding market for "fine art" prints marketed by companies like Brushstrokes, which emphasizes the individual maker with brief biographical sketches and photographs of the featured artists. This differs from the tradition of "sofa art," which is, for all intents and purposes, anonymous even though there is almost always a name attached. See Reed, "Off the Wall and onto the Couch!" On the relationship between contemporary art and Brushstrokes and similar companies' offerings, see Kjellman-Chapin, "Landscapes of Exclusion."

21. Danto, "Artworks and Real Things," 14.

22. The analysis of the Kinkade Signature Gallery is based on my visits to Signature Galleries in the Natick Mall and the Burlington Mall, both in Massachusetts, in addition to a freestanding Signature Gallery in Shrewsbury, Massachusetts, in November 2003 and January 2004. Kinkade's relationship to contemporary exhibition spaces and installation practices is the subject of my article in progress titled "Presenting the Artist: Performing Exhibitionary Codes in the Kinkadian Signature Gallery."

23. There are too many studies to provide an adequate inventory here, but by way of beginning see Pearce, *Interpreting Objects and Collections*; Anderson, *Reinventing the Museum*; Elsner and Cardinal, *The Cultures of Collecting*; and Preziosi

and Farago, *Grasping the World*, which contains reprints of key texts by Hayden White, Mieke Bal, Shelly Errington, and Carol Duncan, among many others.

24. See, e.g., Ann Hamilton's recent works, such as the 2004 corpus, an installation piece for Mass MoCA's Building 5 gallery, which constantly transforms the space and the viewer's experience by sound, light, and continually falling paper. Artists such as Fred Wilson and Andrea Fraser use existing museum holdings as part of their reconceptualizing of the spaces and objects of display, as well as being attentive to the role of language in such constructions. Wilson's installations often involve using the material provided by the museum itself but interrogating its assumptions and messages through juxtaposition, rearranging the objects, and rewriting the wall texts and labels. Like Wilson, Fraser understands her function as artist to be interlocutor of the extant museum structure. In Fraser's work *Museum Highlights*, for instance, the artist performs as a docent, giving a tour of both the galleries and the toilet facilities with equal gravity and with the same attention to and language of their respective aesthetics.

25. Helfand, *Collecting Art*, vi.

26. Hoving, *Art for Dummies*, 1.

27. The Kinkadian Signature Gallery is not the only example of the intersection of museums and malls. In addition to the fairly standard museum store housed in commercial spaces, museums themselves are relocating increasingly to malls to vie for the attention of a public more culturally omnivorous than ever before. In 1990 the Trowbridge Museum in Wiltshire, England, dedicated to the area's wool industry, relocated to the Shires Shopping Centre, becoming the first museum to open in a shopping mall. The New Brunswick Museum followed suit in 1996, opening inside the Market Square shopping center. One of the more controversial such pairings was unveiled when the Louvre reopened in 1993 with a large underground shopping mall, the Carrousel du Louvre, which allows visitors to access the museum directly from the commercial space. For a thorough discussion of these examples, see McTavish, "Shopping in the Museum?"; and McTavish, "Edifying Amusement at the New Brunswick Museum." For an introduction to the class implications of the cultural omnivore, see Peterson and Kern, "Changing Highbrow Taste." Museums have long partnered with corporate America as part of an "outreach" project, and the Rouse Company, a real estate investment firm, received an NEA grant for its "Art in the Marketplace" program. See Hoffman, "Law for Art's Sake in the Public Realm," 572n82; and Lewis, "Grafting a 'Branch' Museum onto a Mall or Office Is Delicate Work." The difference between the Kinkade model and these other examples is that the Signature Gallery is simultaneously an exhibitionary and commercial space devoted to the same artifacts.

28. See Farrell, *One Nation under Goods*, xi–xii. See also Goss, "The 'Magic of the Mall,'" 18.

29. Goss, "The 'Magic of the Mall,'" 19.

30. Kowinski, *The Malling of America*, 60. See also Farrell, *One Nation under Goods*, 25; Farrell also calls attention to the importance of the entry points as transitional nodes between the external world and the insular one of the retail world. Of course, as Carol Duncan and Alan Wallach remind us, the passage from outside to inside is a crucial one in the museum as well; see Duncan and Wallach, "The Museum of Modern Art as Late Capitalist Ritual," 485–86.

31. See Farrell, *One Nation under Goods*, 26–27; Kowinski, *The Malling of America*, 64–73; Goss, "The 'Magic of the Mall,'" 22–24.

32. See Farrell, *One Nation under Goods*, 150–55, for a discussion of the way in which malls produce and reinscribe racial divisions; see also Goss, "The 'Magic of the Mall,'" 26–27; and Jackson, "All the World's a Mall."

33. Goss, "The 'Magic of the Mall,'" 19.

34. Passing through the gift shop a second time in order to exit the mallery, visitors are reminded once again of the difference in the Kinkades on view. The presence of the gift shop is absolutely critical to Kinkade's enterprise. Certainly there is the financial benefit of making the visitor pass through the "commercial" space twice. There is also an equally (if not more so) associative value—the gift shop is in the same location, and the items sold in it are just like those in virtually every museum, so the layout and experience of a Kinkade Signature Gallery replicates that of any repository of fine art, helping to obscure the distinction between the two. All aspects of the mallery collude to convince viewers that they are not simply consumers but potential collectors. These (almost) paintings are not commodities but investments, and, perhaps most important, they are not mechanically produced duplicates but individually and indisputably hand-crafted works of art. It is worth mentioning in this regard that Hoving, in *Art for Dummies*, expressly suggests visiting the museum shop first to purchase a postcard or two before entering the galleries because "virtually every museum in the world publishes a color postcard of the hottest material," and thus "in an instant, you can assess the strengths of the place without getting embroiled in what can be frustratingly uninformative conversations." Museums are increasingly dependent on their museum shops for revenue, bringing them into an interesting alignment with Kinkade's practices. Under the directorship of Hoving, the Metropolitan Museum of Art greatly expanded its retail efforts, moving the gift shop into a larger space and introducing "satellite" shops in various galleries throughout the museum. This has become a common feature of major museums across the world. For the 1996 Paul Cézanne retrospective, for instance, the Philadelphia Museum of Art collaborated with QVC, giving a virtual tour of the show and offering various items for sale. Other museums, including the MFA, Boston, the Winterthur Museum, the Metropolitan, and the Smithsonian, have also contracted with the home shopping channel to sell products based on

works in their permanent collections. This makes it all the more ironic that some in the art world have castigated Kinkade for what has been seen as his mercenary marketing, particularly as an art-world institution preceded him in using the television shopping network to publicize works of art and generate sales of licensed objects. See Hoving, *Art for Dummies*, 17; see also Gregg, "From *Bathers to Beach Towels*"; and Julia Alderson's essay in this collection.

35. See, e.g., Kinkade and Reed, *Thomas Kinkade*; Kinkade, *The Thomas Kinkade Story*; and Doherty, *The Artist in Nature*, which has an introduction and commentary by Kinkade. See also Kinkade, *Thomas Kinkade*. Kinkade is listed as the author, but part of Wendy J. Katz's introductory essay is based on interviews with Kinkade, and he wrote the dedication to the book, indicating his close involvement with it.

36. Prettejohn, "Locked in the Myth," 301.

37. See Vasari, *The Lives of the Most Excellent Painters, Sculptors, and Architects*. Vasari is often credited with producing the first art-historical texts, although he relied on the model provided by ancient authors; see also Rubin, "What Men Saw."

38. See Vasari, *The Lives of the Most Excellent Painters, Sculptors, and Architects*, 57–58. The most comprehensive analysis of the construction of artistic mythologies remains Kris and Kurz, *Legend, Myth, and Magic in the Image of the Artist*. See also Pollock, "Artists' Mythologies and Media Genius, Madness and Art History."

39. Nochlin, "Why Have There Been No Great Women Artists?" 154; see also Kris and Kurz, *Legend, Myth, and Magic in the Image of the Artist*, 13–60.

40. Johanna Drucker points out that the legacy of this narrative is so firmly entrenched that it has been difficult to dislodge and resist, even for those who are aware of it as a myth-making fabrication (see Drucker, *Theorizing Modernism*, 114).

41. Kinkade, *Thomas Kinkade*, 9–10. On the prevalence of the father-son dynamic in art-historical narratives, see Salomon, "The Art Historical Canon."

42. Kinkade and Reed, *Thomas Kinkade*, 19.

43. Kinkade, *Thomas Kinkade*, 21.

44. Kinkade and Reed, *Thomas Kinkade*, 8; Kinkade, *Thomas Kinkade*, 20, repeats the story.

45. Katz, *Thomas Kinkade*, 21.

46. *60 Minutes*, July 2004, www.CBSNews.com (accessed Oct. 24, 2004). Although Kinkade does not make direct reference to it, there is also the lingering suspicion that Picasso was one of a number of artists who would essentially sell his signature. See volume 2 of Merryman and Elsen, *Law, Ethics, and the Visual Arts*: "What are we to say of the major artists (several are known to have done this) who sign blank sheets of paper that are then wholesaled with permission to print a reproduction of a painting or drawing that is then numbered and issued

as an original print? It was at one time said of Picasso that [he] would sign anything for a price" (527).

47. On the "blockbuster" show, including those held at art-expo arenas, see Rosenbaum, "Blockbusters, Inc."; Gibson, "Blockbuster Art Shows," 28; Lehrer, "Is Bigger Always Better?" 37; and Stevens, "The Shock of the Old," 29–33.

48. Benjamin, "The Work of Art in the Age of Mechanical Reproduction," 220. Especially since 1992, the centenary of Benjamin's birth, there has been a tremendous outpouring of scholarship devoted to Benjamin, including a reappraising session at the most recent conference of the Association of Art Historians, held in April 2006. For a useful analysis of the place of some of the more recent publications in Benjamin studies, see Isenberg, "The Work of Walter Benjamin in the Age of Information"; this volume is a special issue devoted to Walter Benjamin. See also Gaines, "Research on Walter Benjamin."

49. It is outside the scope of this essay to critique Benjamin's formulation of aura or to parse his categories of reproductions and reproducibilities; on these concerns, see, among others, Baas, "Reconsidering Walter Benjamin"; Krauss, "Reinventing the Medium"; Buck-Morss, "Aesthetics and Anaesthetics"; Mattick, "Mechanical Reproduction in the Age of Art"; and Kaufman, "Aura, Still."

50. Benjamin, "The Work of Art in the Age of Mechanical Reproduction," 221.

51. Ibid. Benjamin's statement about photography keeping pace with speech is a bit disingenuous, since, especially at its inception, photography was a relatively slow and inefficient reproductive medium. On this point see Baas, who notes that "as with lithography, Benjamin here confounds speed of composition with speed of transmission" ("Reconsidering Walter Benjamin," 343).

52. Kinkade's process complicates this binary, since many of the reproductions are hand-highlighted, either by a "master highlighter" or the artist himself, which means that there will be subtle differences within each ostensibly identical reproduction. I expand on these arguments, moving beyond Kinkade to consider a broad range of digital reproductive practices and practitioners in the paper "Aura in the Era of the Virtual," presented at the 2006 annual conference of the Mid-Atlantic Popular Culture/American Culture Association.

53. Malraux, *Museum without Walls*, 17.

54. Quoted in Schwartz, *The Culture of the Copy*, 252.

55. Benjamin, "The Work of Art in the Age of Mechanical Reproduction," 222.

56. Ibid., 223.

57. Ibid.

58. For a discussion of Benjamin's argument about aura in these terms, see Baas, who writes, "Contrary to Benjamin's expectations, increasingly refined (and increasingly expensive) art reproductions offered by museums, collectors,

even artists themselves, have not lessened the public's interest in the perpetually and mysteriously distant 'original' work of art. The aura or perceived potency of presence of the art object is seemingly enhanced, not diminished, in 'the age of mechanical reproduction'" ("Reconsidering Walter Benjamin," 347).

59. Schwartz, *The Culture of the Copy*, 212.

60. Benjamin, "The Work of Art in the Age of Mechanical Reproduction," 226. Indeed, Rosalind Krauss has remarked that by the 1980s digital imaging began to "replace photography altogether as a mass social practice. Photography has, then, suddenly become one of those industrial discards, a newly established curio, like the jukebox or the trolley car" (Krauss, "Reinventing the Medium," 296).

61. Benjamin, "The Work of Art in the Age of Mechanical Reproduction," 226.

62. Nichols, "The Work of Culture in the Age of Cybernetic Systems," 23.

63. Schwartz, *The Culture of the Copy*, 212. As Derek Conrad Murray and Soraya Murray have written in a different context, "Under the rubric of art history, the relationship between the art object as a conductor of aura and the individual agency (or autonomous genius) is key. Aura is therefore about agency, but also about who is deemed fit to wield aura" (Murray and Murray, "Uneasy Bedfellows," 35). I would argue that Kinkade very much understands how vital it is to be judged suitably worthy to wield aura.

64. Ken Raasch, with whom Kinkade founded Media Arts Group, Inc., proclaimed in 2001 that Kinkade "really is an accomplished painter. He can out-Monet Monet." Quoted in Christina Waters, "Selling the Painter of Light," *AlterNet*, Oct. 16, 2001, www.alternet.org/story/11730 (accessed Nov. 2003).

65. *Thomas Kinkade, Painter of Light: 2003 Limited Edition Comprehensive Catalog*, 130.

66. Ibid., 128. Kinkade also found the name appealing because it has the same number of syllables as his own.

67. Ibid. On the same page Girrard/Kinkade is also referred to as a "romantic impressionist."

68. See Brettell, "Modern French Painting and the Art Museum."

69. As Patricia Mainardi has recently pointed out, this is true even if the impressionist show is mediocre; she cites the Brooklyn Museum's In the Light of Italy, an exhibition of pre-impressionist plein air painting in Italy, and Monet and the Mediterranean, held in 1996 and 1997 respectively. The Italian show was critically acclaimed, whereas the Monet show was rightfully pointed out as lacking; nevertheless, the Brooklyn Museum held another impressionist exhibition in short order, as Impressionists in Winter opened in 1999. See Mainardi, "Repetition and Novelty."

70. See Tinterow, "The Blockbuster, Art History, and the Public," 144.

71. House, "Possibilities for a Revisionist Blockbuster," 154.

72. I use the term *sons* here because it is almost always the male practitioners of impressionism that are given dominant billing.

73. Brettell, "Modern French Painting and the Art Museum."

74. See Callen, "'Monet Makes the World Go Around.'"

75. *Thomas Kinkade, Painter of Light: 2003 Limited Edition Comprehensive Catalog*, 128.

76. Ibid., 130.

77. Girrard's signature is an adaptation of Kinkade's own. Kinkade based his signature on that of Norman Rockwell, whose signature was a variation on that of Albrecht Dürer; see Christina Waters, "Selling the Painter of Light," *AlterNet*, Oct. 16, 2001, www.alternet.org/story/11730 (accessed Nov. 2003).

78. This authority is further enhanced by the publication of Doherty's book *The Artist in Nature*, which firmly places Kinkade in a tradition of plein air painting; its layout even seems to draw from texts like Bomford, Kirby, Leighton, and Roy's *Art in the Making*.

79. All of the prints Kinkade sells are offered with what are advertised as "museum quality" frames.

80. There is, of course, a sense in which every produced good might eventually accrue enough value to make it worth collecting—this seems to be operative behind the impulse to collect corporation-related artifacts, such as Coca-Cola bottles or Pez dispensers—so that even if Kinkade's prints did not attain or sustain their "art" association, they might still be viewed as worthwhile collectibles. On the other hand, one reason to offer merchandise with a clear identity as a collectible, which Kinkade does in abundance, would be to distance the highlighted (hand-painted and so close to unique) prints from that realm. The traffic in collectibles is only one of the many phenomena that seem simultaneously to create and perpetuate the need to make consumption something significant and to transform shopping and possessing into "high" cultural experiences. Leah Dilworth writes that not only does the market for mass-produced collectibles continue to grow, but the realities of "eBay, Pokémon, and *Antiques Roadshow* confirm that cultural authority resides squarely in the marketplace" (Dilworth, *Acts of Possession*, 3).

81. Many commentators link Kinkade with kitsch on the basis of his marketing tactics as well.

82. See, e.g., Dorfles, *Kitsch*; Calinescu, *Five Faces of Modernity*; and Kulka, *Kitsch and Art*. See also Alexis Boylan's careful consideration herein of Greenberg's framing of the term, which subtends the discussions of most other authors.

83. Greenberg, "Avant-Garde and Kitsch," 12.

84. In some respects, and especially in light of the Vallejo, California, housing

development called the Village at Hiddenbrooke, inspired by Kinkade's paintings, this might be related to the "furious hyperreality" identified by Umberto Eco (see Eco, "Travels in Hyperreality").

85. Greenberg, "Avant-Garde and Kitsch," 13.

86. Ibid., 15.

87. One might profitably contrast Kinkade with an artist like Jeff Koons on this point; Koons taps into popular tastes, making work that speaks directly of an American public whose aesthetic tastes are rooted in "fine" collectibles like Baccarat crystal, Hummel figurines, and objects put out by companies like the Franklin Mint. Koons's objects do not appeal to the majority of the public, however, nor are they meant to; his work instigates a sense of superiority in his appropriation and re-presentation of the less-elevated tastes of the bourgeoisie. There is clearly a market for "art collectibles" or "artibles," as they might be called, as the success of a company like the Design Toscano company indicates; Kinkade circulates in that discourse, but he is careful to declare his difference from those people producing objects for Design Toscano.

88. Thomas Kinkade Signature Gallery, Natick Mall, Natick, Mass., Nov. 2003.

Art Ethics:
Thomas Kinkade and Contemporary Art

ANNA BRZYSKI

If one looks at the history of Western discourse on visual and material culture, that history divides rather neatly into two separate but unequal fields of knowledge: (1) the knowledge about the fine arts, until fairly recently the exclusive domain of art history, and (2) the knowledge about those aspects of the visual and material culture not covered by that designation, which until the advent of cultural and visual studies had fallen under the purview of ethnography and anthropology.[1] Whereas the latter fields have concerned themselves primarily with the broadly defined cultural processes and therefore with the evidence (visual or other) that a culture produced, art history has traditionally focused on a very narrow register of cultural production occupied by artistically or aesthetically (rather than just culturally) "significant" statements.[2] Those statements identified as "artworks" have been treated ever since the mid-eighteenth century as if they were fundamentally distinct from and superior to all other forms of visual production.

That fine arts were accorded special status during the Enlightenment is a historic given.[3] While we may wonder why art achieved such an elevated rank at this particular moment in European history, or question what motivated this radical cultural promotion of a particular type of luxury goods, we cannot ignore the fact that since the Enlightenment, our Western culture has treated "art" in a fundamentally different way from everything else. Moreover, the special status of fine arts has not diminished, even though it has fallen out of fashion to speak about genius, masters, or masterpieces. If anything, the West has been extremely successful in exporting its cultural values and hierarchies. Today, art occupies a privileged

position not only within our culture but globally. And everywhere the system of art has been adopted, the same rules apply. While some objects and images designated as artworks are showcased in museums, other objects (including some paintings and sculpted figures) remain confined to the visual environment of daily life, of little or no interest to those concerned with the history of art or contemporary art practice.

The advent of the academic interest in Western popular culture and visual aspects of the cultural environment has done little to change this situation. While art historians have certainly begun to venture into subject areas that until recently lay beyond the discipline's borders, and the scholarship in cultural and visual culture studies has provided important insights into the visual material not classified under the rubric of fine arts, those studies have had virtually no impact on the general perception of what is and what is not perceived as "art." The fine-arts system continues to occupy the "top niche" within our cultural hierarchy and remains the main concern of the museum-based, as well as academic, art history, not withstanding the growing interest in design or the current fascination with certain aspects of popular culture.[4] This system encompasses the entirety of the discourse (both verbal and visual, art-historic and critical) on art, as well as institutional, educational, museological, professional, and market structures that together form what Arthur Danto has identified as the "artworld." Danto's original definition acknowledged that the artworld is not just a sum total of those discourses, participants, agents, institutions, and organizations; it is an environment of shared beliefs and knowledge. "To see something as art requires something the eye cannot decry [sic]," he wrote in 1964, "an atmosphere of artistic theory, *a knowledge of the history of art*: an artworld."[5] I would add that the artworld and, by extension, the art system are bound by something else—an ethics that regulates behavior of those claiming membership within the system.

It is the existence of the art system and its code of ethics that poses the greatest challenge for anyone interested in doing research on Thomas Kinkade. While Kinkade may be a painter, he is not recognized as a "contemporary artist" within today's global artworld. Because he is not considered a significant art figure, he is not available as a "proper" subject for art-historic consideration. In other words, his works can be examined as cultural evidence but not as legitimate art statements. Although they certainly provide ample opportunity for analysis, as this collection of essays

demonstrates, they play no role in shaping the perception of contemporary American art. Even this anthology, ostensibly dedicated to Kinkade, neither celebrates him as an important contemporary artist nor functions as a traditional monograph. Instead, it treats Kinkade, his business empire, and visual production as a fascinating and telling phenomenon of contemporary American culture. As such, it belongs much more securely on the shelf labeled visual and cultural studies than on the one labeled art history.

Kinkade provides a convenient focus for my discussion, but the argument I wish to make does not concern him alone. Rather, it deals with the internal logic of the system of art. With this in mind it is important to acknowledge that even though Kinkade may have become uniquely visible, he is by no means unique. He is only the most commercially successful member of an enormous segment of the U.S. art market, which so far has failed to register on art history's disciplinary radar or, for that matter, that of visual and material culture studies. Kinkade is in company with professional artists whose work is shown by the second- and third-tier commercial art galleries (especially those outside of the main art centers) and encompasses the entire output of the so-called fine-art print industry that commands today a lion's share of the U.S. art-market revenues.[6] All individuals whose art practice is similar to Kinkade's fall beyond the boundaries of the mainstream art system, which defines and validates works as *contemporary art* and participates in the conversion of the contemporary into the historic. What interests me is the logic that underpins the ethical codes that drive the sorting of works within that system into art and not-art or kitsch, valid and invalid statements, and historically significant and historically irrelevant, and the mechanisms that ultimately determine the market value of "art" objects, as well as their relation to the production of art-historic knowledge.

Contemporary Art and Commercial Art

At the heart of this system is a very particular and narrow definition of contemporary art, one that (1) distinguishes between artworks and cultural artifacts and (2) presumes continuity between the past and the present. When art historians turn their attention to the distant past or to cultures that do not belong to the Western tradition, they routinely disregard boundaries between art and artifact, often treating with equal regard ob-

jects that were accorded special status and things that belonged to the material culture of a particular time and place. Although they acknowledge and make qualitative distinctions between major and minor forms, pieces, and figures, this does not prevent them from considering both exceptional achievements and examples of routine studio practice. In fact, as a matter of ingrained disciplinary habit, art history embraces the typical in order to map general tendencies and period styles and to establish the baseline that renders significant departures from the norm visible.[7]

The same, however, cannot be said with regard to the most recent past and the present. The closer one gets to the here and now, the narrower the definition of art becomes and the tighter the controls over the content of the category. For the last fifty years or so, a period belonging to living artists, the field of art has contracted to such an extent that the typical relationship between the normative and the exceptional is in effect reversed. When contemporary art becomes the subject of discussion and study in art history, a very narrow and elite register of current art practice becomes the norm that defines the entire field.[8] It functions in that context both as a designation and a value judgment. The act of designating or recognizing something as art automatically takes it out of the sphere of the ordinary and places it in a special sphere of culturally significant, and therefore potentially valuable, things. At the same time, the distinction between *art* and *contemporary art* collapses. The types of current visual practice that for some reason fall short of the threshold set up for the category *contemporary art* or that seem to violate its code of ethics become available for art historic consideration only as examples of cultural evidence, a second order of not-quite-art production. Serious scholarly work on that material is generally not produced within art history but rather within cultural, visual, and material culture studies.[9]

The anticipation that the important art of today will become the historically significant art of tomorrow requires that distinctions be made between the really good, the mediocre, and the downright bad. Art historians in the guise of authors, critics, curators, and exhibition and conference organizers play a key role in that sorting process. Though they are by no means alone in identifying important works and artists, the weight of their consensus and judgments nevertheless has a tremendous impact. Contemporary art and what I will refer to as commercial art, though at times virtually indistinguishable for the uninitiated, occupy within the logic of this

system opposite sides of the cultural divide. The term *contemporary art* designates art production that belongs exclusively within the sphere of high-art economy. It consists of works that are perceived to have a potential for historic significance from the perspective of the present or some future narration of the history of art. How exactly that narration is eventually constructed and how those works will fit into it is not as important as the fact or the speculation that they will. The more central a work (or an artist or a location) is for the evolving historic narrative, the more significant, desirable, and therefore valuable it becomes. From this perspective, the so-called blue-chip artists are not just artists represented by the most prestigious venues; they are individuals who have earned a secure place in the current historic narrative. Their works have the highest current value, the greatest potential for appreciation, and the lowest risk as investments. In other words, although they have premium pricing, they are also the closest one can get within the art economy to a safe investment.

In contrast, commercial art is assumed to lack the fundamental potential for any such art-historic significance. The term *commercial art* is used here to designate works produced in traditional fine-art media, such as painting, drawing, printmaking, and sculpture, for alternative art markets, such as the market for Western art or the market for inexpensive decorative prints, which exist outside the mainstream artworld. It does not refer to various forms of "art for hire," such as illustration, comics, graphic novels, graphic design, advertising, and the like. Because commercial art production is not supposed to play a formative role in the history of art, its value is determined entirely by forces governing purely economic transactions. In other words, the prices in this market sector react to fluctuations of supply and demand in the same way as they would in any other luxury commodities market. Conversely, they are not supposed to follow the rules operating within cultural markets dealing with symbolic capital. This conviction underlies the view, shared widely within the mainstream artworld, that commercial art is not art but a pernicious form of pseudo-art or kitsch that imitates art's effects without pursuing its aims.[10] Viewed from this perspective, commercial art does not inhabit the legitimate art economy but a parallel and inherently parasitic kitsch economy, a circuit of transactions and markets that belongs to the sphere of *dominant culture*, a designation that obscures the reality of the artworld's monopoly hold on recognition and validation of works as art.

The economic value and cultural prestige of contemporary art is contingent on the existence and maintenance of the gap between the domain of art and the domain of kitsch, or more broadly between art and the so-called popular or mass culture. This artworld understanding of the concept of kitsch, which makes it the polar opposite of art, turns kitsch into what E. H. Gombrich has called a term of exclusion.[11] More than identifying and describing a particular cultural phenomenon, the designation that something is *kitsch* provides an illustration of the ethical injunction "thou shall not . . . ," which defines the boundaries of normative art practice. Kitsch and, by extension, commercial art function, therefore, as the Other of "serious" or contemporary art, a negative point of reference that allows production of codes of professional behavior, identities, meanings, and ultimately hierarchies of value.[12]

The narrowing of this gap and blurring (though never breaching) of boundaries in contemporary art practice and cultural criticism accounts for the seemingly uncertain status of someone like Thomas Kinkade, though I would argue that suggestion of such ambiguity of location is to a large extent disingenuous. When pressed, the majority of those inhabiting the artworld would place Kinkade well beyond the pale of serious and therefore legitimate art practice. Kinkade may produce paintings, may have been educated as an artist, and may well be the only living artist familiar to the general American public, but for the minority whose opinions count within the confines of the artworld, he is not and, I would argue, will never be, an important *contemporary artist*.

The response to Jeffrey Vallance's installation of Kinkade's products in the form of a curated show, Thomas Kinkade: Heaven on Earth at the Grand Central Art Center and the California State University, Fullerton, in 2004 was clearly predicated on this understanding of Kinkade. No matter how it was characterized in the accompanying text and publicity materials, the location of the show in the project galleries of the GCAC and Vallance's well-known fondness for culturally subversive statements predetermined how the installation would be read by the majority of artworld insiders. Regardless of what Vallance may have intended (see Vallance's essay in this collection for his explanation of his intention), the logic of the art system and the precedent of other works using similar strategy made it virtually impossible to see the arrangement of Kinkade's original paintings, lithographs, and licensed products as anything other than cultural evidence,

and therefore raw material, for an art installation by the show's true artist, namely Vallance.[13] Within the ethics of the art system Vallance, an established artist with gallery representation and critical approval, could not fail to make contemporary art (no matter what material he may have been using), while Kinkade could not produce anything recognized as contemporary art by the artworld no matter how hard he tried.

Art as Representation

One of the reasons for this binary system is that the artworld identifies works as contemporary art in reference to their function as representations. In this context the term *representation* does not refer to a mimetic relationship of the work to the world but rather to its function as a sign, text, image, aesthetic semblance, or embodied meaning.[14] This view of art, which can be traced to Neoplatonic and German idealist philosophy, in particular G. W. F. Hegel, bases art's special status on its role as a vehicle for achieving self-awareness and knowledge.[15] This function of art is predicated on a particular understanding of reality, which comprises three discrete realms: the domain of abstract concepts, principles, and ideas; the world of phenomena and things; and the sphere of representations. The special status of art as representation is based on its ability to function as a mediating agent and therefore as a point of synthesis in a dialectic understanding of the production of knowledge. By engaging and representing for the consciousness the domain of concepts, of phenomena, and of other representations, artworks are supposed to function as a conscious (often hyper-self-conscious) commentary on the world. In other words, art is believed to give those who encounter it in a thoughtful and reflective manner an opportunity to arrive at self-knowledge and critical comprehension of the internal world of ideas, as well as the external world of natural, social, and cultural phenomena.

Unlike works of art, which according to this view always have a potential for being read as critical representations, the works of the popular and material culture are treated as if they belonged to the realm of things-in-themselves, which is always symptomatic and evidentiary. Although works of popular culture may function as representations of particular ideas, views, or ideologies, they do not have the same status as art repre-

sentations because they are not recognized as critical utterances. Only art representations are granted the ability to unmask "the real" by allowing audiences to peer beneath the veneer of dominant ideologies. The works of popular culture, in contrast, are always assumed to merely reflect and reproduce those ideologies.

Although this understanding of representation can be traced to Enlightenment-era valorization of fine art as a unique source of insight and knowledge, the dialectic and oppositional characterization of the relationship between art and mass culture has more recent origins. It can be traced to the nineteenth-century cultural theories, which were used to establish legitimacy of avant-garde cultural practices, and, in the twentieth century, to the work of the Frankfurt Institute and the legacy of critical theory. Theodor Adorno, a key member of the institute and a major contributor to the discourse on mass culture, made the following observation in "The Schema of Mass Culture": "The commercial character of culture causes the difference between culture and practical life to disappear. Aesthetic semblance (*Schein*) turns into the sheen which commercial advertising lends to the commodities which absorb it in turn. But that moment of independence which philosophy specifically grasped under the idea of aesthetic semblance is lost in the process. On all sides the borderline between culture and empirical reality become[s] more and more indistinct." For Adorno and other critics associated with critical theory, the collapse of distance between culture and ordinary life in mass culture threatens not only the presumed autonomy of art but also the possibility of criticality. Therefore, what is ultimately at stake is not just the privileged status of art but its function as representation, a mirror held up to the world, which reveals to those who care to look that the emperor has no clothes.[16]

Those views concerning the character and function of art are as current today as they were under the discursive regime of modernism. The emphasis and language may have changed, but the message remains the same. Criticality, or rather the potential for critical reading and therefore critical awareness, is still regarded as a fundamental precondition that guarantees art's and, in particular, contemporary art's special status and is therefore the basis for determining its symbolic and economic value. Ironically, art's function as representation, which grants it autonomous existence outside the order of things, means that irrespective of actual content or intention

art is *always and necessarily* viewed as critical because it is perceived to *always* create a potential for critical reception. In the wake of Roland Barthes's announcement of the death of the author and the resulting democratization of the production of meaning, the burden of criticality has been simply shifted from the artist, who is no longer required to produce formally, socially, or politically critical statements, to the viewer, whose recognition of the work as representation and therefore commentary confers and confirms its status as art.[17]

This is the foundation, for instance, of Johanna Drucker's recent effort to examine and ultimately redeem what she refers to as contemporary art's complicity with mass culture:

> The reflective self-consciousness by which art performs the task of insight, and then of memory, provides a crucial means by which the apparently seamless, "natural" condition of our existence is called to attention. See this? Look at that! Take a note and rethink what you think you know—again. And again. By such basic rhetorical principles fine art objects provide the cracks in the surface of appearance. Without these insights, we have no capacity at all to think critically— by which I mean, to think imaginatively—about our condition as specifically cultural beings enmeshed in highly particular historic circumstances. Through an aesthetic appeal to the eye and senses, fine art achieves its effect. Through its artifice, it shows the constructed-ness of its condition—and ours.[18]

In this context the difference between the subject and the object of commentary, that which merely appears and that which renders visible the reality hidden under the surface of things, determines not only meaning of particular statements but also their relative value. The representation's fundamental importance is based on its potential to produce new insight and knowledge; the object's significance is based on its status as primary evidence, that which enables representation and interpretation. The representation needs the object to be understood as a commentary, but it must be always recognizable as representation. It must continually underscore the difference, lest it risk being mistaken for the thing itself.

Art vs. Commodity

The function and status of contemporary art as representation elevates it above the order of mere things to the order of discourse. This conceptual upgrade sanctions in equal measure the production of aesthetic artifacts unmistakable for anything other than art and institutional and market critiques, which often simulate practices they critique to such a degree that they all but dissolve the boundaries between representation and its referent. In works by artists such as Jeff Koons, Keith Haring, Barbara Kruger, Slop Art, Damien Hirst, Vallance, and many others, which have taken the form of critical provocations targeting the artworld's own system of prohibitions, fundamental assumptions, and values, the actual (rather than the presumed) function of the project is not always clear. Was Haring critiquing, endorsing, or merely using the market system when he opened his PoP Shop (considered by the artist an extension of his work) in downtown Manhattan in 1986? What exactly is the status of artist-licensed products, such as Koon's limited-edition porcelain puppy flower vase, formerly available through the Museum of Modern Art (MOMA) store, or Kruger's signature mugs, which seem to be available at most museum stores in the country? How should we understand Slop Art's website, exhibitions, and sales fliers filled with art at bargain-basement prices? What are we to make of Hirst's diamond-encrusted skull or his most recent effort to sell his art though an art auction?

The realities of art practice, the evolving strategies of contemporary artists, and the ethical ideals of the art system coexist in an uneasy relationship. The art system and the art economy are based on a paradox. Because art functions as representation, and therefore does not belong to the order of things, it is never considered a mere commodity. Art may be commodified, or treated as a commodity by the market system, but its function as critical representation always keeps it in a presumed state of grace.[19] That is why we believe that the market value of an artwork can never account fully for its *true value* (however that may be defined). And yet, under the current system, the market or exchange value of art depends *entirely* on the belief in existence of *true value*, which is assumed to always exceed the actual price tag.

The concept of commodity depends here on an ethical (and not necessarily sound from an economic perspective) perception of how value

is established. Economic theory assumes that market exchanges involving ordinary commodities leave nothing unaccounted for in the transaction and that the price of the commodity accurately reflects its actual present value. In other words, the commodities are traded evenly for their cash equivalent. Because the prices are subject to pressures of supply and demand, the value of commodities always depends on the market conditions. This means that it is always contingent; value can rise sharply as a result of speculation or sudden demand, but it can also collapse, rendering a commodity essentially worthless.

commodity value = exchange value

Within the ethically based art economy, however, the value of art is never determined or exhausted by its exchange value.[20] In addition to its market price, which can fluctuate according to supply and demand, art is also always assumed to have intrinsic symbolic or cultural value, which prevents it from ever becoming truly worthless, even if its exchange value in the marketplace happens to collapse. Art's symbolic value is predicated on its status as representation and its function in production of knowledge and self-awareness. This function is not viewed as a service that can be bought and sold. Rather, it is conceived of as a "gift" participating in what Jean Baudrillard has referred to as a symbolic (rather than economic) exchange. It is regarded as being "priceless"—without and beyond monetary value—and therefore as escaping the logic of commodity exchange.[21]

art value = exchange value + symbolic value

This equation, of course, does not describe the reality of how prices are determined within the art market; it represents an effort to visualize the belief system that underpins the art economy as such. In the marketplace contemporary art's exchange value is linked to its potential for appreciation, which in turn depends on the perception of its symbolic value. Since symbolic value—defined here as perception of cultural importance, rather than intrinsic "gift" function—is a function of the works' and artists' perceived historic significance, one could say that art's exchange value and future potential for appreciation are also a function of that perception. This is one reason why Kinkade (who has been accused of producing commodities rather than artworks) may be able to achieve unprecedented current profits through mass production, sales volume, vertical integration, fran-

chising, and licensing agreements, yet he is unlikely to ever realize prices on the secondary art market commanded today by significant contemporary artists, such as Koons or Hirst, or the canonical modern masters, such as van Gogh or Picasso. Moreover, Kinkade's violation of the ethical injunction against crass, unmediated commerce means that he will never be commissioned to produce pieces for artworld consumption, invited to participate in shows such as the Whitney Biennial, Venice Biennale, or Documenta, or collected by serious individual or institutional contemporary art collectors. In short, he will never be identified as a significant contemporary artist within the art system. As a result, though by no means insignificant, the value and potential appreciation of his work will always be restricted by its circulation within the collectibles and eventually antiques markets and its categorical exclusion from the art economy.

Performance of Disinterest

When one considers the market savvy of the contemporary artist and much bemoaned commercialization of contemporary art, the distance between Kinkade and the contemporary artist appears more than ever a matter of degrees rather than of fundamental distinctions. In the end it is the difference in presentation and reception, rather than the work itself or the actual intentions of artists, that determines the location and status of each. Quite simply, Kinkade cannot be recognized as an artist within the discourse on contemporary art because he refuses to veil the purely commercial character of his work behind the claims of criticality. He is, therefore, viewed within the artworld as a producer and peddler of pseudo-art commodities or kitsch, which cannot be redeemed as critical representations.

Kinkade's cardinal sin is a fundamental breach of the art decorum, a failure to perform disinterest that allows a mere painter to be recognized as an artist, a mere image to function as a critical representation, and a mere commodity to be redeemed as a work of art. In the *Critique of Judgment* Kant identified disinterest as a fundamental condition of a genuine aesthetic experience.[22] Disinterest is an ideal attitude that combines cool detachment with passionate absorption. Through the concept of disinterest the work of art is taken out of normal life experience predicated on embodied desires and material needs and placed within an autonomous sphere of purely mental contemplation. What the concept of disinterest

assumes is that the aesthetic experience by its very nature escapes the logic of commodity exchange. It creates a dimension of experience that has no price and therefore no value or, perhaps more accurately, that has value that cannot be calculated in economic terms. As such, aesthetic experience and, by implication, disinterest participate in the production of symbolic value.

Although the concept of disinterest as articulated by Kant dealt primarily with the viewer's perception and hence his or her ability to form judgments, it has evolved to affect not only our views concerning proper attitude for art viewing but also proper attitudes for art making. When considered from the perspective of production rather than reception, disinterest becomes synonymous with an ideal critical position outside the order of things; it creates a vantage point from which representation and therefore critical commentary become possible. If disinterest on the side of reception allows for detached contemplation, disinterest on the side of production allows for detached and therefore potentially critical representation. It is important to keep in mind that disinterest conceived this way is not synonymous with disengagement from the world but rather with an attitude that allows for critical engagement and that posits artworks first and foremost as statements and only secondarily as objects that can be bought and sold.

If we define disinterest as an attitude of detachment and critical distance, then its opposite must be identified with the inability or unwillingness to establish such distance and consequently with failure to rise above the order of mere things that result in the production of commodities. It is here that the terms developed by Walter Benjamin to describe the function of art in the age of photomechanical reproduction come in handy. For Benjamin the postphotographic work of art is a work stripped of the aura, a demystified work that cannot be mistaken for anything other than representation. It always functions with a Brechtian self-awareness of its own status as representation and creates a potential for distracted—that is, potentially critical—viewing. For Benjamin the work of art in the age of photomechanical reproduction always has a potential to perform the work of revealing and unmasking auratic presentations, irrespective of their status or cultural location, as forms of ideology.[23] The return of the real in contemporary art, to borrow Hal Foster's phrase, is by this logic always its return as representation, or as a code, sign, text, picture, image, or simulation, inscribed as an embodied meaning through appropriation,

installation, staging, or framing. The real is never the thing itself, or rather it is never presented as an unmediated reality. All these instances of presentation are merely different modes of the same strategy. They rely on irony, camp, and contextual annotation to establish disengagement and disinterest and thereby to suggest the potential for subversive or critical reading.[24]

For example, the contemporary painter Lisa Yuskavage's sexualized depictions of female nudes will never be mistaken for the kitschy images they seem to emulate. They will always function for the artworld insiders such as Cornelia Butler, the chief curator of drawings at MOMA, as "confrontational representations" that use the pinup as "a rich source of material."[25] Even for the artist's critics the relevant questions are whether Yuskavage's works are interesting or successful, not whether they are artworks. They will always be read and readable as artworks commenting on popular or commercial culture, sentimentality, conventions of depiction, pornography, and so forth. No matter how close in appearance a work of contemporary art may be to a work of commercial art, no matter whether the artwork appropriates images or forms from popular culture, it will never be mistaken for those images and forms by the members of the artworld who "know" the difference between the real thing and its representation or presentation or appropriation.

As Arthur Danto has observed, it is the framework of reception that ultimately determines that difference. And it is here that the distinction between the intentional criticality of a work and the potential for a work to be read critically becomes all important. The burden of proof falls, in the end, not on the artist who produced the work but on the members of the art audience. That said, the artist must give sufficient indications to allow for reasonable doubt; in other words, he or she must perform disinterest.[26] Disinterest in this context is a matter of emphasis and perception rather than of intention or actual attitude. The performance of disinterest creates the possibility of detachment and criticality without necessarily confirming either's existence. To be clear, disinterest understood as critical detachment is not synonymous with active criticism, nor is it tantamount to an artist's lack of interest in commercial success.[27] Instead, it makes such interest palatable and excusable by creating a potential for viewing the work in a space that takes it out of the context of purely commercial, market considerations and situates it within the context of critical discourse as meaningful commentary on culture.

Disinterest on the part of the artist is, therefore, always performative in character. It shifts the burden of criticality onto reception and ultimately perception of the work by the beholder, here generalized to the artworld as such. It does not matter from the point of perception whether the artist is in fact authentically disinterested, as long as he or she maintains the appearance of disinterest and therefore propriety. There appears to be only one steadfast rule: to be able to claim disinterest, an artist must not engage in the production of commodities. This means very simply that artists must be perceived as being primarily interested in their work's function as representation and only secondarily in its sale. The only exception to this rule is the case in which the production and sale of the works is understood as a form of critique, as with Andy Warhol's Factory, Claus Oldenburg's Store, Haring's PoP Shop, and Slop Art.

The division of labor within the artworld identifies the artist as perpetual commentator, a producer of representations and therefore of art, leaving the business of commerce and legitimization to others. It is the dealer, or in some cases an art collective, that acts as the artist's agent, and who ultimately absorbs the stigma of the trade. The dealer-agent and the market system he serves are identified as the parties responsible for commodification of art. This creates the perception that serious artists, no matter what they may do to further their careers, are essentially unsullied. They maintain deniability, which allows the audience to suspend disbelief when considering their performance of disinterest. Similarly, an artist may participate in art discourse and make assertions or pronouncements, yet his or her statements are always perceived as primary sources. The discursive inscription of the work begins with second-order interpretation—interpretation by others, be it other artists, critics, art historians, museum professionals, or cultural critics. In this context the escalation of demand and therefore of prices, driven by actions of the dealers and by discursive inscription of the work, is understood and explained as a mark of recognition of the work's symbolic value and the evidence of others' desire rather than of the artist's descent into commercial commodity production.

The failure to perform disinterest and to maintain detachment in a convincing way (as far as the artworld is concerned) takes the work out of the order of representations and submerges it in the order of commodities. When viewed as a commodity, the work's value collapses to its exchange value. The symbolic value is withheld with dire consequences, since it is

the symbolic value of the work alone that guarantees its status as art. Without symbolic value a work cannot be recognized as contemporary art in art discourse or in art history. It can only be represented as an example of popular or visual culture, or entirely evaded as an example of kitsch.

Kinkade's perception by the artworld falls into either of those two categories. He is either studied as a phenomenon of American mass culture or entirely excluded from consideration as a maker of kitsch. Curiously, he is often excluded from discussions of contemporary visual culture, since those tend to be predicated on a particular understanding of visual culture as an authentic, if ideologically grounded, cultural form. Here the concept of visual culture tends to focus on visual representations produced in the context of mass media, entertainment, the Internet, advertising, illustration, or lived environment rather than the liminal zone of commercial art.

Kinkade's efforts to build a commercial empire by marketing his work as art are seen as further proof of his inauthenticity and duplicity. From the perspective of the artworld the kitsch economy, a system of transactions and exchanges that confers value on commercial art and therefore on Kinkade's work, turns the idea of symbolic value on its head. Instead of liberating the work from commodity exchange, through the claim that a work has symbolic value and is thus not merely a commodity, the kitsch economy allows a commercial exchange to take place. By presenting the kitsch object as a work of art, the kitsch economy guarantees its exchange value. The artworld perceives this guarantee, however, to be fundamentally fraudulent, since it misrepresents what art is by focusing on superficial formal resemblance between art and kitsch, while ignoring their essential functional dissimilarity. In doing so, it engages in what Matei Calinescu has referred to as the "aesthetics of deception and self-deception" for no other purpose than to sell stuff.[28] According to this logic, a work of kitsch, for instance one of Kinkade's original paintings, can sell for thousands of dollars because it mimics the appearance of art to such an extent that those who are not art insiders are simply incapable of distinguishing the difference. It participates in a con game made possible by the cultural ignorance of the American public. What that view does not acknowledge is that the ability to distinguish between the genuine thing and the simulation is strictly determined by location. It is not just a matter of knowledge of a particular belief and value system but of participation in it. Kinkade's collectors cannot—or, perhaps more accurately, are unwilling to—distinguish be-

tween contemporary art and contemporary kitsch because the difference between the two is not visible to them. It is only visible from within the art system. Their location outside that system precludes them from knowing and noticing and acknowledging as valid the presumed dissimilarity.

For those inside the system, however, Kinkade's operation is a direct affront to the taboo on self-marketing, which has been in effect in the artworld ever since the French academy put an end to the practice of artists running their workshops as businesses. Kinkade's commercial success is correctly seen by the artworld to be not a result of external recognition but of Kinkade's own direct involvement in and control over production, distribution, marketing, and even legitimization of his work. Kinkade's art empire is a perfect example of vertical integration, a business concept developed to capture and maximize upstream and downstream profits. Within vertically integrated business, a company may own and therefore control the entire or almost entire supply chain, from extraction of the raw materials and production of parts to assembly of products, their distribution, and marketing. This model of business practice, which is based on an economy of scale, with returns and profits depending on mass production, low cost, and large scale of distribution, is fundamentally opposed to the artworld's economy of scarcity, based on low production volume, restricted distribution, and high prices.

Kinkade's self-incorporation as a business, and, in particular, the vertical integration of his enterprise, which places under his control not only production, reproduction, and licensing of his works but also their distribution and marketing, constitutes a fundamental breech of artworld ethics. His obvious interest in commercial success is read by the artworld as the primary motivation for his work. Seen in this context, Kinkade's failure to perform disinterest is to a large extent linked to his failure to respect the implicit division of labor. In negating the distance between the producer and the network of distribution and validation, Kinkade acts more like a guild master than an academic painter. In his approach the links between production and commercial exchange are all too direct and simply too crass. Moreover, they are unmediated by external agency, since galleries selling Kinkade's work operate on a franchise model. In effect, they are extensions of the Kinkade corporation rather than independent agents. Similarly, virtually all publicity materials, including catalogues of Kinkade's work, are published by the artist's own company. The marketing function

of the legitimizing discourse is here not only undisguised but explicitly self-produced.

If Kinkade winked, if he gave us an indication of ironic detachment, criticality (on however minimal a level), or even campy complicity, which would create a possibility that his practice functioned as representation and not the thing itself, and that he was, in fact, one of *us*, instead of one of *them*, he could be celebrated as one of the most significant artists working today. However, it does not appear likely that he will ever do so. Unless the structure of the art system changes, Kinkade and other artists like him will remain for the foreseeable future confined to the sphere of strictly anthropological interests. A fundamental change in the ethics of the art system is unlikely since it would spell disaster for the art economy, which includes not only the primary and secondary art markets but also the art-publishing industry, the global network of exhibition venues, and an academic and curatorial job market for artists, critics, museum professionals, and art historians—in short, the entire artworld. There is simply too much at stake for far too many to allow the current configuration to disintegrate. Ultimately the question raised here is not whether Kinkade can be redeemed but whether the privileged status of contemporary art and of the ideological system that supports it can be maintained. If, as a result of this examination of Kinkade, the artworld itself, its ethics, and values become a subject of serious critical investigation, it is possible that the categories such as art and kitsch (which we now accept as unproblematic) may be revealed to be not only ideologically invested, but also culturally contingent and therefore relative.

Notes

1. Although non-Western art began to attract the attention of Western art historians in the early twentieth century, it has never been fully integrated into the classical narrative of art's history (cave paintings to contemporary art), which has focused on the idea of "development" and has been mainly concerned with the Western European tradition. For a critique of the Eurocentrism of art history see Preziosi, *Rethinking Art History*; Nelson, "The Map of Art History"; Pinder, *Race-ing Art History*; and Brzyski, *Partisan Canons*.

2. An exception to this trend is Schneider and Wright, *Contemporary Art and Anthropology*.

3. For discussion of the development of the Western system of fine arts and

the modern concept of art, see parts 1 and 2 of Kristeller, "The Modern System of the Arts"; Shiner, *The Invention of Art*; and Belting, *Likeness and Presence.*

4. The development of the new category of design, which dates to the end of the nineteenth century, did not have an adverse effect on the status of artworks, but it did elevate the status of certain types of functional and decorative objects designed and displayed now within the context of fine-art exhibitions. By emphasizing design (as opposed to actual making), those exhibitions and related developments extended the range of legitimate art practice into illustration, graphic design, decorative and applied arts, photography, and stage and architectural design (in particular in the context of Bauhaus and constructivism). With this broadening and diversification of the top cultural category, the imperative to police the borders of the art and to censure and guard against "bad" art, as well as "bad" design, assumed new and critical importance. I have argued elsewhere that it is not a coincidence that the German term *kitsch*, initially used to designate quickly produced cheap paintings and drawings, entered the critical vocabulary of modernism in the 1920s as a designation for all forms of popular and elite cultural production (from paintings to knickknacks) that did not fit the modernist formal and conceptual criteria of excellence. See Brzyski, "Policing the Borders between Art and Kitsch." On the definition of the artist as a designer and designer as an artist see vast bibliography on Bauhaus, East Central European avant-gardes, and constructivism, in particular Margolin, *The Struggle for Utopia*; and Gough, *The Artist as Producer.* On recent developments in the relationship between art and design, see Coles, *Design and Art.*

5. Danto, "The Artworld," 580 (my emphasis).

6. Ian Robertson refers to this segment of the art market as Gamma Galleries, though his analysis, based on a European perspective and progression from local to international, fails to consider its uniquely American character. See Robertson, *Understanding International Art Markets and Management*, 13–36, esp. figure 2.6 (29).

7. This approach was the guiding principle behind Heinrich Wölfflin's *Kunstgeschichtliche Grundbegriffe* (*Principles of Art History*).

8. This radical narrowing of the definition of contemporary art can be traced to the work of early-twentieth-century modernist critics, art commentators, and art historians, in particular Julius Meier-Graefe and Clive Bell, who made modern art synonymous with art as such and excluded from the category of modern art all works that did not fit their criteria of formal and conceptual excellence. See Bell, *Art*; and Meier-Graefe, *Modern Art.* In the United States Clement Greenberg's 1939 essay "Avant-Garde and Kitsch" extended those ideas by presenting avant-garde practice as a synonym with art as such. In Greenberg's essay contemporary works that were not avant-garde in character not

only ceased to be of interest, they ceased to be considered art. The formerly qualitative distinction between good art and bad art became an ethical one of art versus kitsch. See Greenberg, "Avant-Garde and Kitsch."

9. See, e.g., Morgan and Promey, *The Visual Culture of American Religions*; Bogart, *Artists, Advertising, and the Borders of Art*; Lee, *Picturing Chinatown*; Coombes, *History after Apartheid*; and Michaels, *Bad Aboriginal Art*.

10. Greenberg, "Avant-Garde and Kitsch," 15.

11. Gombrich, *Norm and Form*, 88.

12. See Brzyski, "Policing the Borders between Art and Kitsch."

13. Vallance, *Thomas Kinkade*. In many ways Vallance's installation is similar in spirit, if not necessarily in intention or content, to the work of other artists embarking on institutional critique projects, such as Fred Wilson or Andrea Fraser. For an example of a normative art reading of Vallance's installation, see Kjellman-Chapin, "Kinkade and the Canon."

14. See Adorno, "The Schema of Mass Culture"; Danto, *After the End of Art*; and Danto, *The Transfiguration of the Commonplace*. This understanding of the status and function of art does not contradict Danto's analysis of the nineteenth-century shift from the Imitation Theory (IT), i.e., mimesis, to what he referred to as the Reality Theory (RT), which based evaluation of artistic quality on creation of new forms instead of imitation of existing ones (see Danto, "The Artworld"). The reality principle of art, which accounts for such diverse practices as abstract and pop art, always operates with an understanding that the work under consideration as art is distinct from the realm of ordinary object because it functions as a meaningful statement, even if its specific meaning is never explicitly disclosed. It is this potential for meaning that identifies the work as representation.

15. Brzyski-Long, "Retracing the Modernist Origins," 99–100.

16. Adorno, "The Schema of Mass Culture," 61; see Benjamin, "The Work of Art in the Age of Mechanical Reproduction."

17. See Barthes, "The Death of the Author."

18. Drucker, *Sweet Dreams*, xiii.

19. For distinction between economic and symbolic exchange, see Baudrillard, *Passwords*.

20. See Calinescu, *Five Faces of Modernity*, 240; see also Baudrillard, *Passwords*, 9–11.

21. See Baudrillard, *Passwords*, 15–18.

22. Kant, *Critique of Judgment*, 38–39.

23. Benjamin, "The Work of Art in the Age of Mechanical Reproduction," 232–37.

24. See Foster, *The Return of the Real*.

25. Cathryn Keller [interview with Cornelia Butler], "Lisa Yuskavage: Critiquing Prurient Sexuality, or Disingenuously Peddling a Soft-Porn Aesthetic?" *Washington Post*, April 22, 2007.

26. The idea of the performance of disinterest is based on T. J. Clark's discussion of the distinction between the courtesan and the prostitute in the representations of sexuality in nineteenth-century French art. See Clark, *The Painting of Modern Life*, 79–146.

27. See Benjamin's discussion of distracted viewing in "The Work of Art in the Age of Mechanical Reproduction," 237–39.

28. For a definition of kitsch, see Greenberg, "Avant-Garde and Kitsch"; see also Calinescu, *Five Faces of Modernity*, 229, 235.

Bibliography

Adorno, Theodor W. "The Schema of Mass Culture." In *The Culture Industry: Selected Essays on Mass Culture*, edited by J. M. Bernstein, 61–97. London: Routledge, 2001.

Alphen, Ernst van. "'What History, Whose History, History to What Purpose?': Notions of History in Art History and Visual Culture Studies." *Journal of Visual Culture* 4, no. 2 (Aug. 2005): 191–202.

Anderson, Benedict. *Imagined Communities: Reflections on the Origin and Spread of Nationalism*. Rev. ed. London: Verso, 1991.

Anderson, Gail, ed. *Reinventing the Museum: Historical and Contemporary Perspectives on the Paradigm Shift*. Lanham, Md.: AltaMira, 2004.

Anton, Saul. "Disney-Planned." *Salon*, Sept. 9, 1999, www.salon.com/books/feature/1999/09/09/celebration/index.html (accessed April 28, 2003).

Baas, Jacquelynn. "Reconsidering Walter Benjamin: 'The Age of Mechanical Reproduction' in Retrospect." In *The Documented Image: Visions in Art History*, edited by Gabriel P. Weisberg and Laurinda S. Dixon, 337–47. Syracuse: Syracuse University Press, 1987.

Bal, Mieke. "Visual Essentialism and the Object of Visual Culture." *Journal of Visual Culture* 2 (April 2003): 5–32.

Balmer, Randall. "The Kinkade Crusade." *Christianity Today*, Dec. 4, 2000.

———. *Mine Eyes Have Seen the Glory: A Journey into the Evangelical Subculture in America*. 4th ed. Oxford: Oxford University Press, 2006.

Barthes, Roland. "The Death of the Author." In *Image-Music-Text*. Translated by Stephen Heath, 142–48. New York: Hill and Wang, 1977.

Bassin, Donna. "Maternal Subjectivity in the Culture of Nostalgia: Mourning and Memory." In *Representations of Motherhood*, edited by Donna Bassin, Margaret Honey, and Meryle Mahrer Kaplan, 162–73. New Haven: Yale University Press, 1994.

Baudrillard, Jean. *The Consumer Society: Myths and Structures*. London: Sage, 1998.

———. *Passwords*. London: Verso, 2003.

————. "Simulacra and Simulations." In *Jean Baudrillard: Selected Writings*, edited by Mark Poster, 166–84. Palo Alto: Stanford University Press, 1988.

————. *Simulations*. Translated by Paul Foss, Paul Patton, and Philip Beitchman. New York: Semiotext(e), 1983.

Baxandall, Rosalyn, and Elizabeth Ewen. *Picture Windows: How the Suburbs Happened*. New York: Basic Books, 2000.

Beecher, Catherine E., and Harriet Beecher Stowe. *The American Woman's Home; or, Principles of Domestic Science*. New York: J. B. Ford, 1869.

Bell, Clive. *Art*. New York: Frederick A. Stokes, 1910.

Belting, Hans. *Likeness and Presence: A History of the Image before the Era of Art*. Translated by Edmund Jephcott. Chicago: University of Chicago Press, 1994.

Benhamou, Françoise, and Victor Ginsburgh. "Is There a Market for Copies?" *Journal of Arts Management, Law, and Society* 32 (spring 2002): 37–56.

Benjamin, Walter. "The Work of Art in the Age of Mechanical Reproduction." In *Illuminations: Essays and Reflections*, translated by Harry Zahn, 219–53. London: Jonathan Cape, 1970.

Berger, John. *Ways of Seeing*. London: BBC, 1972.

Binkley, Sam. "Kitsch as a Repetitive System: A Problem for the Theory of Taste Hierarchy." *Journal of Material Culture* 5, no. 2 (July 2000): 131–52.

Bogart, Michele H. *Artists, Advertising, and the Borders of Art*. Chicago: University of Chicago Press, 1997.

Bomford, David, Jo Kirby, John Leighton, and Ashok Roy. *Art in the Making: Impressionism*. London: National Gallery Publications, 1990.

Bonami, Francesco. "Paintings of Painting for Paintings: The *Kairology* and *Kronology* of Rudolf Stingel." In *Rudolf Stingel*, edited by Francesco Bonami, 13–20. Chicago: Museum of Contemporary Art, in association with Yale University Press, 2007.

Bourdieu, Pierre. "The Aesthetic Sense as the Sense of Distinction." In *The Consumer Society Reader*, edited by Juliet B. Schor and Douglas B. Holt, 205–11. New York: New Press, 2000.

————. *Distinction: A Social Critique of the Judgment of Taste*. Translated by Richard Nice. Cambridge: Harvard University Press, 1984.

Bourriaud, Nicolas. *Relational Aesthetics*. Translated by Simon Pleasance and Fronza Woods. Paris: Les Presses du Réel, 2002.

Boylan, Alexis L. "Stop Using Kitsch as a Weapon: Kitsch and Racism." *Rethinking Marxism* 22, no. 1 (Jan. 2010): 42–55.

Breslau, Karen. "Paint by Numbers: Thomas Kinkade's Dreamy Paintings Remain Wildly Popular, but His Business Plan Needs Touching Up." *Newsweek*, May 13, 2002.

Bressi, Todd W. *The Seaside Debates: A Critique of the New Urbanism*. New York: Rizzoli, 2002.

Brettell, Richard R. "Modern French Painting and the Art Museum: The Problematics of Collecting and Display, Part 2." *Art Bulletin* 77, no. 2 (June 1995): 166–70.

Brooke, Steven. *Seaside*. Gretna, La.: Pelican, 1995.

Brown, Frank Burch. *Good Taste, Bad Taste, and Christian Taste: Aesthetics in Religious Life*. Oxford: Oxford University Press, 2000.

Brown, Janelle. "Ticky-Tacky Houses from the 'Painter of Light.'" *Salon*, March 18, 2002, www.salon.com/mwt/style/2002/03/18/kinkade_village (accessed April 28, 2003).

Bruegmann, Robert. *Sprawl: A Compact History*. Chicago: University of Chicago Press, 2005.

Bruyn, Joshua. "Toward a Scriptural Reading of Seventeenth-Century Dutch Landscape Paintings." In *Masters of Seventeenth-Century Dutch Landscape Painting*, edited by Peter Sutton, 84–103. Boston: Museum of Fine Arts, 1987.

Brzyski, Anna, ed. *Partisan Canons*. Durham: Duke University Press, 2007.

———. "Policing the Borders between Art and Kitsch." In *Kitsch*, edited by Monica Kjellman-Chapin. New Castle: Cambridge Scholars, 2012.

Brzyski-Long, Anna. "Retracing the Modernist Origins: Conceptual Parallels in the Aesthetic Thought of Charles Baudelaire and G. W. F. Hegel." *Art Criticism* 12, no. 1 (1997): 95–111.

Buck-Morss, Susan. "Aesthetics and Anaesthetics: Walter Benjamin's Artwork Essay Reconsidered." *October* 62 (autumn 1992): 3–41.

Burlein, Ann. "Focusing on the Family: Family Pictures and the Politics of the Religious Right." In *The Familial Gaze*, edited by Marianne Hirsch, 311–24. Hanover, N.H.: University Press of New England, 1999.

Burns, Sarah. *Pastoral Inventions: Rural Life in Nineteenth-Century American Art and Culture*. Philadelphia: Temple University Press, 1989.

Calinescu, Matei. *Five Faces of Modernity: Modernity, Avant-Garde, Decadence, Kitsch, Postmodernism*. Durham: Duke University Press, 1987.

Callen, Anthea. "'Monet Makes the World Go Around': Art History and 'The Triumph of Impressionism.'" *Art History* 22, no. 5 (Dec. 1999): 756–77.

Calthorpe, Peter. *The Next American Metropolis: Ecology, Community, and the American Dream*. New York: Princeton Architectural Press, 1993.

Calthorpe, Peter, and William Fulton. *The Regional City: Planning for the End of Sprawl*. Washington: Island, 2001.

Campbell, Duncan. "Land of the Twee." *Guardian*, July 8, 2002, www.guardian.co.uk/culture/2002/jul/08/artsfeatures1 (accessed May 4, 2010).

Caputi, Mary. *A Kinder, Gentler America: Melancholia and the Mythical 1950s*. Minneapolis: University of Minnesota Press, 2005.

Cava, Marco R. della. "Thomas Kinkade: Profit of Light." *USA Today*, March 12, 2002.

Charles, Prince of Wales. *A Vision of Britain: A Personal View of Architecture*. London: Doubleday, 1989.

Chase, Malcolm, and Christopher Shaw. "The Dimensions of Nostalgia." In Shaw and Chase, *The Imagined Past*, 1–17.

Clapper, Michael. "Thomas Kinkade's Romantic Landscape." *American Art* 20, no. 2 (2006): 76–99.

Clark, T. J. "Painter Said To Be Focus of FBI Probe." *Los Angeles Times*, Aug. 29, 2006.

———. *The Painting of Modern Life: Paris in the Art of Manet and His Followers*. Princeton: Princeton University Press, 1984.

Coles, Alex, ed. *Design and Art*. Cambridge: MIT Press, 2007.

Collins, Jim. *High-Pop: Making Culture into Popular Entertainment*. Oxford: Blackwell, 2002.

Conroy, Marianne. "Discount Dreams: Factory Outlet Malls, Consumption, and the Performance of Middle-Class Identity." *Social Text* 54 (spring 1998): 63–83.

Coombes, Annie. *History after Apartheid: Visual Culture and Public Memory in a Democratic South Africa*. Durham: Duke University Press, 2003.

———. "Museums and the Formation of National and Cultural Identities." In *Museum Studies: An Anthology of Contexts*, edited by Bettina Messias Carbonell, 231–46. Oxford: Blackwell, 2004.

Corbet, David Peters. "Visual Culture and the History of Art." In *Dealing with the Visual: Art History, Aesthetics, and Visual Culture*, edited by Caroline van Eck and Edward Winters, 17–36. Aldershot: Ashgate, 2005.

Cray, Dan. "Art of Selling Kitsch." *Time*, Aug. 30, 1999.

Cutting, James. "Mere Exposure, Reproduction, and the Impressionist Canon." In Brzyski, *Partisan Canons*, 79–94.

Danto, Arthur. *After the End of Art: Contemporary Art and the Pale of History*. Princeton: Princeton University Press, 1997.

———. "Artworks and Real Things." *Theoria* 39 (1973): 1–17.

———. "The Artworld." *Journal of Philosophy* 61, no. 19 (1964): 571–84.

———. *The Transfiguration of the Commonplace*. Cambridge: Harvard University Press, 1981.

Davis, Fred. *Yearning for Yesterday: A Sociology of Nostalgia*. New York: Free Press, 1979.

Demerath, N. J., III. "Cultural Victory and Organizational Defeat in the Paradoxical Decline of Liberal Protestantism." *Journal for the Scientific Study of Religion* 34, no. 4 (1995): 458–69.

Derdak, Thomas, ed. "Media Arts Group, Inc." In *The International Directory of Company Histories*. Vol. 42, 254–57. Chicago: St. James, 2002.

Diamond, Sara. *Not by Politics Alone: The Enduring Influence of the Christian Right.* New York: Guilford, 1998.

Didion, Joan. *Where I Was From.* New York: Knopf, 2003.

Dika, Vera. *Recycled Culture in Contemporary Art and Film: The Uses of Nostalgia.* Cambridge: Cambridge University Press, 2003.

Dilworth, Leah, ed. *Acts of Possession: Collecting in America.* New Brunswick: Rutgers University Press, 2003.

Doherty, M. Stephen. *The Artist in Nature: Thomas Kinkade and the Plein Air Tradition.* New York: Watson-Guptill, 2002.

———. "Thomas Kinkade Shares His Light." *American Artist* 65, no. 711 (2001): 20–27.

Dorfles, Gillo, ed. *Kitsch: The World of Bad Taste.* New York: Bell, 1969.

Drucker, Johanna. *Sweet Dreams: Contemporary Art and Complicity.* Chicago: University of Chicago Press, 2005.

———. *Theorizing Modernism: Visual Art and the Critical Tradition.* New York: Columbia University Press, 1994.

Duany, Andres, Elizabeth Plater-Zyberk, and Robert Alminana. *The New Civic Art: Elements of Town Planning.* New York: Rizzoli, 2003.

Duany, Andres, Elizabeth Plater-Zyberk, and Jeff Speck. *Suburban Nation: The Rise of Sprawl and the Decline of the American Dream.* New York: North Point, 2000.

Duncan, Carol. "The Art Museum as Ritual." *Art Bulletin* 77 (March 1995): 10–13.

Duncan, Carol, and Alan Wallach. "The Museum of Modern Art as Late Capitalist Ritual: An Iconographic Analysis." In Preziosi and Farago, *Grasping the World*, 483–500.

Dutton, John A. *New American Urbanism: Re-forming the Suburban Metropolis.* Milan: Skira, 2001.

Ebony, David. "Museum Attendance on the Rise." *Art in America* 87, no. 3 (March 1999): 27.

Eco, Umberto. "Travels in Hyperreality." In *Travels in Hyperreality,* translated by William Weaver, 3–58. San Diego: Harcourt Brace, 1986.

Edwards, Owen. "The Basilica Chip: Gilder Likens the Microchip to a Medieval Cathedral." *Forbes,* Oct. 7, 1996.

Elger, Dietmar. *Felix Gonzalez-Torres.* 2 vols. New York: DAP, 1997.

Elkins, James. *On the Strange Place of Religion in Contemporary Art.* New York: Routledge, 2004.

Elsner, John, and Roger Cardinal, eds. *The Cultures of Collecting.* Cambridge: Harvard University Press, 1994.

Everts, William Wallace. "The Social Position and Influence of Cities." In *Words in Earnest: Comprising the Social Position and Influence of Cities,* edited by William Wallace Everts, 1–36. New York: Edward H. Fletcher, 1851.

Farrell, James J. *One Nation under Goods: Malls and the Seductions of American Shopping*. Washington: Smithsonian Books, 2003.

Finke, Roger, and Rodney Stark. *The Churching of America, 1776–1990: Winners and Losers in Our Religious Economy*. New Brunswick: Rutgers University Press, 1993.

Foner, Eric. *The Story of American Freedom*. New York: Norton, 1999.

Forbes, Bruce, and Jeffrey Mahan, eds. *Religion and Popular Culture in America*. Berkeley: University of California Press, 2000.

Foster, Hal, ed. *The Anti-Aesthetic: Essays on Postmodern Culture*. Seattle: Bay, 1983.

———. *The Return of the Real: The Avant-Garde and the End of the Century*. Cambridge: MIT Press, 1997.

Frank, Thomas. *One Market Under God: Extreme Capitalism, Market Populism, and the End of Economic Democracy*. New York: Anchor, 2000.

Frantz, Douglas, and Catherine Collins. *Celebration, USA: Living in Disney's Brave New Town*. New York: Owl, 2000.

Fraser, Andrea. "A 'Sensation' Chronicle." *Social Text* 67 (summer 2001): 127–56.

Free Expression Policy Project. *Free Expression in Arts Funding: A Public Policy Report*. New York: Free Expression Policy Project, 2003.

Frykholm, Amy. *Rapture Culture: Left Behind in Evangelical America*. Oxford: Oxford University Press, 2004.

Gaines, Jeremy. "Research on Walter Benjamin." *Theory, Culture, and Society* 10, no. 2 (1993): 149–67.

Gaustad, Edwin Scott, and Philip L. Barlow. *New Historical Atlas of Religion in America*. Oxford: Oxford University Press, 2001.

Gibson, Eric. "Blockbuster Art Shows." *Insight on the News*, March 26, 2001.

Giggie, John M., and Diane Winston, eds. *Faith in the Market: Religion and the Rise of Urban Commercial Culture*. New Brunswick: Rutgers University Press, 2002.

Gilder, George. *The Spirit of Enterprise*. New York: Simon and Schuster, 1984.

Gombrich, E. H. *Norm and Form: Studies in the Art of the Renaissance*. London: Phaidon, 1966.

Goss, Jon. "The 'Magic of the Mall': An Analysis of Form, Function, and Meaning in the Contemporary Retail Built Environment." *Annals of the Association of American Geographers* 83, no. 1 (March 1993): 18–47.

Gottdiener, Mark. *The Theming of America: Dreams, Visions, and Commercial Spaces*. Boulder: Westview, 1997.

Gough, Maria. *The Artist as Producer: Russian Constructivism in Revolution*. Berkeley: University of California Press, 2005.

Grainge, Paul. "Nostalgia and Style in Retro America: Moods, Modes, and Media Recycling." *Journal of American and Comparative Culture* 23, no. 1 (spring 2000): 27–34.

Greenberg, Clement. "Avant-Garde and Kitsch." In *Clement Greenberg: The Col-*

lected Essays and Criticism. Vol. 1, edited by John O'Brian, 5–22. Chicago: University of Chicago Press, 1986.

Greenfell, Michael, and Cheryl Hardy. *Art Rules: Pierre Bourdieu and the Visual Arts*. Oxford: Berg, 2007.

Gregg, Gail. "From *Bathers* to Beach Towels." *ArtNews* 96, no. 4 (April 1997): 120–23.

Grewe, Cordula. *Painting the Sacred in the Age of Romanticism*. London: Ashgate, 2010.

Gurney, James, and Thomas Kinkade. *The Artist's Guide to Sketching*. New York: Watson-Guptill, 1982.

Gutterman, David. *Prophetic Politics: Christian Social Movements and American Democracy*. Ithaca: Cornell University Press, 2005.

Guttmann, Monika. "Thomas Kinkade's Artistic Values." *USA Weekend Magazine*, Feb. 6, 2000.

Harvey, Doug. "Skipping Formalities: Thomas Kinkade, Painter of Light." *Art Issues* 59 (Sept. 1999): 16–19.

Haxthausen, Charles W., ed. *The Two Art Histories: The Museum and the University*. Williamstown, Mass.: Sterling and Francine Clark Institute, 2002.

Hayden, Dolores. *Building Suburbia: Green Fields and Urban Growth, 1920-2000*. New York: Pantheon, 2003.

Hebdige, Dick. "In Poor Taste: Notes on Pop." In *Modern Dreams: The Rise and Fall and Rise of Pop*, 77–86. Cambridge: MIT Press, 1988.

Helfand, Glen. *Collecting Art*. San Francisco: Chronicle, 2002.

Hennessey, Maureen Hart, and Anne Knutson, eds. *Norman Rockwell: Pictures for the American People*. New York: Harry N. Abrams, 1999.

Hoffman, Barbara. "Law for Art's Sake in the Public Realm." *Critical Inquiry* 17, no. 3 (1991): 540–73.

Homer, Karen. "Thomas Kinkade: Catching the Light in Guatemala." *World Vision's "Today" Magazine*, Sept. 1999.

House, John. "Possibilities for a Revisionist Blockbuster: *Landscapes/Impressions of France*." In Haxthausen, *The Two Art Histories*, 154–61.

Hoving, Thomas. *Art for Dummies*. Foster City, Calif.: IDG, 1999.

Hughes, Holly, and Richard Elovich. "Homophobia at the NEA." In Wallis, Weems, and Yenawine, *Art Matters*, 232–34.

Huxtable, Ada Louise. *The Unreal America: Architecture and Illusion*. New York: New Press, 1997.

Hyde, Lewis. "The Children of John Adams: A Historical View of the Fight over Arts Funding." In Wallis, Weems, and Yenawine, *Art Matters*, 252–75.

"Interview with Herbert D. Montgomery." *Wall Street Transcript*, Aug. 22, 2002, www.twst.com/notes/articles/rad610.html (accessed May 11, 2010).

Isenberg, Noah. "The Work of Walter Benjamin in the Age of Information." *New German Critique* 83 (spring–summer 2001): 119–50.

Jackson, Kenneth T. "All the World's a Mall: Reflections on the Social and Economic Consequences of the American Shopping Center." *American Historical Review* 101, no. 4 (Oct. 1996): 1111–21.

Jacobs, Jane. *The Death and Life of Great American Cities*. New York: Vintage, 1961.

Jacoby, Mario. *Longing for Paradise: Psychological Perspectives on an Archetype*. Translated by Myron B. Gubitz. Boston: Sigo, 1985.

Jameson, Fredric. *The Cultural Turn: Selected Writings on the Postmodern, 1983-1998*. London: Verso, 1998.

Jasper, William F. "A Beacon in the Night." *New American*, Dec. 17, 2001.

Kant, Immanuel. *Critique of Judgment*. Translated by J. H. Bernard. New York: Hafner, 1951.

———. *Observations on the Feeling of the Beautiful and the Sublime*. Translated by John T. Goldthwait. Berkeley: University of California Press, 1960.

Katz, Peter. *The New Urbanism: Toward an Architecture of Community*. New York: McGraw-Hill, 1994.

Kaufman, Robert. "Aura, Still." *October* 99 (winter 2002): 45–80.

Kelly, Kevin. *Out of Control: The New Biology of Machines, Social Systems, and the Natural World*. Reading, Mass.: Addison-Wesley, 1995.

King, John. "Suburban Legend: The Faded Promise of a Subdivision Inspired by Thomas Kinkade, Painter of Light, Proves That Licensing Madness (Thankfully) Has Its Limits." *Metropolis*, July 2003.

Kinkade, Thomas. "Holiday Inspirations." *American Artist*, Dec. 2001.

———. *I'll Be Home for Christmas*. Compiled by Anne Christian Buchanan. Eugene: Harvest House, 1997.

———. "Maximalism." *American Artist*, Nov. 2001.

———. "Putting God into Words." *Saturday Evening Post*, July 2003.

———. "Reflections." In Vallance, *Thomas Kinkade*, 19–20.

———. *Simpler Times*. Eugene, Ore.: Harvest House, 1996.

———. *Thomas Kinkade: Masterworks of Light*. Essays by Wendy J. Katz. Boston: Bulfinch, 2000.

———. *The Thomas Kinkade Story: A Twenty-Year Chronology of the Artist*. Text by Rick Barnett. Boston: Bulfinch and AOL Time Warner, 2003.

Kinkade, Thomas, with Anne Christian Buchanan. *Lightposts for Living: The Art of Choosing a Joyful Life*. New York: Warner, 1999.

Kinkade, Thomas, and Pam Procter. *The Art of Creative Living: Making Every Day a Radiant Masterpiece*. New York: Warner Faith, 2005.

Kinkade, Thomas, and Philippa Reed. *Thomas Kinkade: Paintings of Radiant Light*. New York: Abbeville, 1995.

Kinkade, Thomas, and Katherine Spencer. *Cape Light*. New York: Berkley, 2002.

"Kinkade Print to Benefit Charity, New Kinkade Credit Card Released." *Art Business News*, Oct. 2002.

Kintz, Linda. *Between Jesus and the Market: The Emotions That Matter in Right-Wing America*. Durham: Duke University Press, 1997.

Kjellman-Chapin, Monica. "Kinkade and the Canon: Art History's (Ir)Relevance." In Brzyski, *Partisan Canons*, 267–88.

———. "Landscapes of Exclusion: Contemporary Painting's Neglected Vistas." Paper presented at the 94th annual conference of the College Art Association, Boston, Feb. 2006.

Klein, Herbert S. *A Population History of the United States*. Cambridge: Cambridge University Press, 2004.

Kowinski, William Severini. *The Malling of America: An Inside Look at the Great Consumer Paradise*. New York: William Morrow, 1985.

Kramer, Louise. "Met Museum Looks to Restore the Retail Picture." *Crain's New York Business*, April 24, 2000.

Krause, Martin, and Linda Witkowski. *Walt Disney's "Snow White and the Seven Dwarfs": An Art in Its Making*. New York: Hyperion, 1994.

Krauss, Rosalind. "The Originality of the Avant-Garde: A Postmodernist Repetition." *October* 13 (fall 1981): 47–66.

———. "Reinventing the Medium." *Critical Inquiry* 25, no. 2 (winter 1999): 289–305.

Kreiter, Ted. "Thomas Kinkade's American Dream: Every Kid Deserves to Draw." *Saturday Evening Post*, March/April 2003.

Krier, Leon. *Rational Architecture: The Reconstruction of the European City*. Brussels: Éditions des Archives d'architecture moderne, 1978.

Krier, Rob. *Urban Space*. New York: Rizzoli, 1979.

Kris, Ernst, and Otto Kurz. *Legend, Myth, and Magic in the Image of the Artist: A Historical Experiment*. New Haven: Yale University Press, 1979.

Kristeller, Paul Oskar. "The Modern System of the Arts: A Study in the History of Aesthetics, Part 1." *Journal of the History of Ideas* 12, no. 4 (1951): 496–527.

———. "The Modern System of the Arts: A Study in the History of Aesthetics, Part 2." *Journal of the History of Ideas* 13, no. 1 (1952): 17–46.

Kristeva, Julia. *Black Sun: Depression and Melancholia*. Translated by Leon S. Roudiez. New York: Columbia University Press, 1989.

Kruse, Kevin M., and Thomas J. Sugrue, eds. *The New Suburban History*. Chicago: University of Chicago Press, 2006.

Kulka, Tomas. *Kitsch and Art*. University Park: Pennsylvania State University Press, 1996.

Kundera, Milan. *The Unbearable Lightness of Being*. New York: Harper and Row, 1984.

Kunstler, James Howard. *The Geography of Nowhere: The Rise and Decline of America's Man-Made Landscape*. New York: Simon and Schuster, 1994.

Lassell, Michael. *Celebration: The Story of a Town*. New York: Disney, 2004.

Lazarus, David. "Dark Days for 'Painter of Light.'" *San Francisco Chronicle*, March 3, 2002.

Lears, T. J. Jackson. "From Salvation to Self-Realization: Advertising and the Therapeutic Roots of the Consumer Culture, 1880–1930." In *The Culture of Consumption: Critical Essays in American History, 1880-1980*, edited by T. J. Jackson Lears and Richard Wightman Fox, 1–38. New York: Pantheon, 1983.

Le Beau, Bryan F. *Currier and Ives: America Imagined*. Washington: Smithsonian Institution Press, 2001.

Leccese, Michael, and Kathleen McCormick, eds. *The Charter of the New Urbanism*. New York: McGraw Hill, 2000.

Lee, Anthony. *Picturing Chinatown: Art and Orientalism in San Francisco*. Berkeley: University of California Press, 2001.

Lehrer, Eli. "Is Bigger Always Better?" *Insight on the News*, Nov. 16, 1998.

Leinberger, Christopher B. "The Next Slum?" *Atlantic*, March 2008, www.theatlantic.com/doc/200803/subprime (accessed Sept. 25, 2008).

Lewis, Roger K. "Grafting a 'Branch' Museum onto a Mall or Office Is Delicate Work." *Museum News* 70, no. 2 (March–April 1991): 21–23.

Lippman, Laura. *Every Secret Thing*. New York: Avon, 2004.

Lowenthal, David. "Nostalgia Tells It like It Wasn't." In Shaw and Chase, *The Imagined Past*, 18–32.

―――. "Past Time, Present Place: Landscape and Memory." *Geographical Review* 65, no. 1 (Jan. 1975): 1–36.

Lynes, Russell. *The Tastemakers*. New York: Harper and Brothers, 1955.

Maharaj, Sarat. "Pop Art's Pharmacies: Kitsch, Consumerist Objects and Signs, the 'Unmentionable.'" *Art History* 15, no. 3 (Sept. 1992): 335–50.

Mainardi, Patricia. "Repetition and Novelty: Exhibitions Tell Tales." In Haxthausen, *The Two Art Histories*, 79–86.

Malraux, André. *Museum without Walls*. Translated by Stuart Gilbert. New York: Pantheon, 1949.

Marcus, Daniel. *Happy Days and Wonder Years: The Fifties and Sixties in Contemporary Cultural Politics*. New Brunswick: Rutgers University Press, 2004.

Margolin, Victor. *The Struggle for Utopia: Rodchenko, Lissitzky, Moholy-Nagy, 1917-1946*. Chicago: University of Chicago Press, 1998.

Marling, Karal Ann. *Designing Disney's Theme Parks: The Architecture of Reassurance*. Paris: Flammarion, 1997.

―――. "Escapism?" In *Architourism: Authentic, Escapist, Exotic, Spectacular*, edited by Joan Ockman and Salomon Frausto, 122–25. Munich: Prestel, 2005.

————. *Graceland: Going Home with Elvis*. Cambridge: Harvard University Press, 1996.

————. *Looking North: Royal Canadian Mounted Police Illustrations: The Potlatch Collection*. Afton, Minn.: Afton Historical Society Press, 2003.

————. *Merry Christmas: Celebrating America's Greatest Holiday*. Cambridge: Harvard University Press, 2000.

Martin, William. *With God on Our Side: The Rise of the Religious Right in America*. New York: Broadway, 1996.

Mattick, Paul, Jr. "Mechanical Reproduction in the Age of Art." *Theory, Culture, and Society* 10, no. 2 (1993): 127–47.

May, Elaine Tyler. "Echoes of the Cold War: The Aftermath of September 11 at Home." In *September 11 in History: A Watershed Moment?*, edited by Mary L. Dudziak, 35–54. Durham: Duke University Press, 2003.

McAlester, Virginia, and Lee McAlester. *A Field Guide to American Houses*. New York: Knopf, 1984.

McClellan, Andrew. *Art and Its Publics: Museum Studies at the Millennium*. Oxford: Blackwell, 2003.

————. "The Musée du Louvre as Revolutionary Metaphor during the Terror." In *Readings in Nineteenth-Century Art*, edited by Janis Tomlinson, 1–24. Upper Saddle River, N.J.: Prentice Hall, 1996.

McCormack, Scott. "Making People Feel Good about Themselves." *Forbes*, Nov. 2, 1998.

McDannell, Colleen. *The Christian Home in Victorian America, 1840–1900*. Bloomington: Indiana University Press, 1986.

————. "Marketing Jesus: Warner Press and the Art of Warner Sallman." In *Icons of American Protestantism: The Art of Warner Sallman*, edited by David Morgan, 95–122. New Haven: Yale University Press, 1996.

————. *Material Christianity: Religion and Popular Culture in America*. New Haven: Yale University Press, 1995.

McGirr, Lisa. *Suburban Warriors: The Origins of the New American Right*. Princeton: Princeton University Press, 2001.

McKenzie, Evan. *Privatopia: Homeowner Associations and the Rise of Residential Private Government*. New Haven: Yale University Press, 1994.

McTavish, Lianne. "Edifying Amusement at the New Brunswick Museum." Paper presented at the Atlantic Canada Studies conference, University of New Brunswick, Fredericton, May 12, 2005.

————. "Shopping in the Museum? Consumer Spaces and the Redefinition of the Louvre." *Cultural Studies* 12, no. 2 (1998): 168–92.

Meier-Graefe, Julius. *Modern Art: Being a Contribution to a New System of Aesthetics*. 2 vols. London: William Heinemann, 1908.

Mercer, Kobena. "Introduction." In *Pop Art and Vernacular Culture*, edited by Kobena Mercer, 6–35. Cambridge: MIT Press, 2007.

Merryman, John Henry, and Albert E. Elsen. *Law, Ethics, and the Visual Arts*. Vol. 2. Philadelphia: University of Pennsylvania Press, 1987.

Michaels, Eric. *Bad Aboriginal Art: Tradition, Media, and Technological Horizons*. Minneapolis: University of Minnesota Press, 1994.

Midgley, Mary. "Brutality and Sentimentality." *Philosophy* (1979): 385–89.

Miller, Angela. *The Empire of the Eye: Landscape Representation and American Cultural Politics, 1825–1875*. Ithaca: Cornell University Press, 1993.

Miller, David, ed. *American Iconology: New Approaches to Nineteenth-Century American Art and Literature*. New Haven: Yale University Press, 1993.

Miller, Donald E. *Reinventing American Protestantism: Christianity in the New Millennium*. Berkeley: University of California Press, 1997.

Mitchell, W. J. T. "Showing Seeing: A Critique of Visual Culture." In *The Visual Culture Reader*, edited by Nicholas Miroeff, 86–101. London: Routledge, 1998.

———. *What Do Pictures Want? The Lives and Loves of Images*. Chicago: University of Chicago Press, 2005.

Mohney, David, and Keller Easterling. *Seaside: Making a Town in America*. New York: Princeton Architectural Press, 1991.

Molaro, Regina. "Light Ideas: Thomas Kinkade Refines His Licensing Strategy, Moving from an Image Based Focus to a Lifestyle Focus in Multiple Tiers of Distribution." *License!* (winter 2004): 4.

Moore, R. Laurence. *Selling God: American Religion in the Marketplace of Culture*. Oxford: Oxford University Press, 1995.

Morgan, David. *Protestants and Pictures: Religion, Visual Culture, and the Age of American Mass Production*. New York: Oxford University Press, 1999.

———. *The Sacred Gaze: Religious Visual Culture in Theory and Practice*. Berkeley: University of California Press, 2005.

Morgan, David, and Sally M. Promey, eds. *The Visual Culture of American Religions*. Berkeley: University of California Press, 2001.

Mumford, Lewis. *The Highway and the City*. New York: Harcourt, Brace and World, 1963.

Murray, Derek Conrad, and Soraya Murray. "Uneasy Bedfellows: Canonical Art Theory and the Politics of Identity." *Art Journal* 65, no. 1 (spring 2006): 22–39.

Nelson, Robert. "The Map of Art History." *Art Bulletin* 79, no. 1 (1997): 28–40.

Newhouse, Victoria. *Art and the Power of Placement*. New York: Monacelli, 2005.

———. *Towards a New Museum*. New York: Monacelli, 1998.

Newman, William M., and Peter L. Halvorson. *Atlas of American Religion: The Denominational Era, 1776–1990*. Walnut Creek, Calif.: AltaMira, 2000.

Nichols, Bill. "The Work of Culture in the Age of Cybernetic Systems." *Screen* 29 (winter 1988): 22–46.

Nochlin, Linda. "Why Have There Been No Great Women Artists?" In *Women, Art, and Power, and Other Essays*, 145–78. New York: Harper and Row, 1988.

O'Doherty, Brian. *Inside the White Cube: The Ideology of the Gallery Space*. Berkeley: University of California Press, 1999.

Olalquiaga, Celeste. *The Artificial Kingdom: A Treasury of the Kitsch Experience*. New York: Pantheon, 1998.

Orlean, Susan. "Art for Everybody." *New Yorker*, Oct. 15, 2001.

Papadakis, Andreas, and Harriet Watson, eds. *New Classicism Omnibus*. London: Academy Editions, 1990.

Pearce, Susan M., ed. *Interpreting Objects and Collections*. London: Routledge, 1994.

Peters, Harry T. *Currier and Ives, Printmakers to the American People*. Garden City, N.Y.: Doubleday, Doran, 1942.

Peterson, Richard A., and Roger M. Kern. "Changing Highbrow Taste: From Snob to Omnivore." *American Sociological Review* 61, no. 5 (Oct. 1996): 900–907.

Peterson, Sylvia E. *The Ministry of Christian Art: A Story of Artist Warner Sallman and His Famous Religious Pictures*. Indianapolis: Kriebel and Bates, 1947.

Pinder, Kymberly N., ed. *Race-ing Art History: Critical Readings in Race and Art History*. New York: Routledge, 2002.

Pollock, Griselda. "Artists' Mythologies and Media Genius, Madness and Art History." *Screen* 21, no. 3 (spring 1980): 57–95.

Prettejohn, Elizabeth. "Locked in the Myth." *Art History* 19, no. 2 (June 1996): 301–7.

Preziosi, Donald. *Rethinking Art History: Meditations on a Coy Science*. New Haven: Yale University Press, 1991.

Preziosi, Donald, and Claire Farago, eds. *Grasping the World: The Idea of the Museum*. London: Ashgate, 2004.

Raffety, Michael. "Thomas Kinkade." *Southwest Art* 19 (Oct. 1989): 112–16.

Reed, Christopher. "Off the Wall and onto the Couch! Sofa Art and the Avant-Garde Analyzed." *Smithsonian Studies in American Art* 2, no. 1 (winter 1988): 32–43.

"Responses to Mieke Bal's 'Visual Essentialism and the Object of Visual Culture.'" *Journal of Visual Culture* 2 (Aug. 2003): 229–68.

Rice, Mark. *Through the Lens of the City: NEA Photography Surveys of the 1970s*. Jackson: University Press of Mississippi, 2005.

Ritivoi, Andrea Deciu. *Yesterday's Self: Nostalgia and the Immigrant Identity*. Lanham, Md.: Rowman and Littlefield, 2002.

Ritzer, George. *Enchanting a Disenchanted World: Revolutionizing the Means of Consumption*. Thousand Oaks, Calif.: Pine Forge, 1999.

Robertson, Ian, ed. *Understanding International Art Markets and Management*. London: Routledge, 2005.

Robinson, Walter. *Instant Art History: From Cave Art to Pop Art*. New York: Byron Preiss Visual Publications, 1995.

Rogoff, Irit. "Studying Visual Culture." In *The Visual Culture Reader*, edited by Nicholas Miroeff, 24–36. London: Routledge, 1998.

Rosen, Judith. "New Look at Art Museum Stores." *Publishers Weekly*, May 8, 2006.

Rosenbaum, Lee. "Blockbusters, Inc." *Art in America* 85 (June 1997): 45–50.

Ross, Andrew. *The Celebration Chronicles: Life, Liberty, and the Pursuit of Property Values in Disney's New Town*. New York: Ballantine, 2000.

Rubin, Patricia. "What Men Saw: Vasari's Life of Leonardo da Vinci and the Image of the Renaissance Artist." *Art History* 13, no. 1 (March 1990): 34–46.

Salomon, Nanette. "The Art Historical Canon: Sins of Omission." In *The Art of Art History: A Critical Anthology*, edited by Donald Preziosi, 344–55. Oxford: Oxford University Press, 1998.

Schmidt, Leigh Eric. *Consumer Rites: The Buying and Selling of American Holidays*. Princeton: Princeton University Press, 1997.

Schneider, Arndt, and Christopher Wright, eds. *Contemporary Art and Anthropology*. Oxford: Berg, 2005.

Schwartz, Hillel. *The Culture of the Copy: Striking Likenesses, Unreasonable Facsimiles*. New York: Zone, 1996.

Shaw, Christopher, and Malcolm Chase, eds. *The Imagined Past: History and Nostalgia*. Manchester: Manchester University Press, 1989.

Shiner, Larry. *The Invention of Art: A Cultural History*. Chicago: University of Chicago Press, 2001.

Shumway, David. "Cultural Studies and Questions of Pleasure and Value." In *The Aesthetics of Cultural Studies*, edited by Michael Bérubé, 103–16. Malden, Mass.: Blackwell, 2005.

Silberman, Vanessa. "A Changing Light." *Art Business News*, Aug. 2002.

Smith, Russell Scott, and Ken Baker. "Sunny Side Up: Thomas Kinkade's Pretty Pictures Make Critics Cringe as They're Making Him Rich." *People Weekly*, April 10, 2000.

Sorkin, Michael, ed. *Variations on a Theme Park: The New American City and the End of Public Space*. New York: Hill and Wang, 1992.

Spackman, Betty. *A Profound Weakness: Christians and Kitsch*. Carlisle: Piquant Editions, 2005.

Stafford, T. A. "A Consecrated Artist." *Expositor and Homiletic Review* 43, no. 3 (March 1941): 142–43.

Stevens, Mark. "Critic's Pick." *New York Magazine*, Sept. 12, 1994.

———. "The Shock of the Old." *New Republic*, Nov. 16, 1992.

Stolz, Donald, and Marshall Stolz. *Norman Rockwell and the "Saturday Evening Post."* Vol. 2. New York: MJF, 1994.

Strickland, Carol. *The Annotated Mona Lisa: A Crash Course in Art History from Prehistoric to Post-Modern*. Kansas City: Andrews and McMeel, 1992.

Talen, Emily. *New Urbanism and American Planning: The Conflict of Cultures*. New York: Routledge, 2005.

Tannock, Stuart. "Nostalgia Critique." *Cultural Studies* 9, no. 3 (Oct. 1995): 453–64.

Thomaselli, Rich. "Kinkade to Light Up More Than a Canvas." *Advertising Age*, June 30, 2003.

Thomas Kinkade, Painter of Light: 2003 Limited Edition Comprehensive Catalog. Morgan Hill, Calif.: Media Arts Group, 2003.

Tinterow, Gary. "The Blockbuster, Art History, and the Public: The Case of *Origins of Impressionism*." In Haxthausen, *The Two Art Histories*, 142–53.

Troy, Gil. *Morning in America: How Ronald Reagan Invented the 1980s*. Princeton: Princeton University Press, 2005.

Truettner, William H., and Roger B. Stein. *Picturing Old New England: Image and Memory*. Washington: National Museum of American Art, Smithsonian Institution, 1999.

Truettner, William H., and Alan Wallach, eds. *Thomas Cole: Landscape into History*. New Haven: Yale University Press, 1994.

Tuan, Yi-Fu. *Escapism*. Baltimore: Johns Hopkins University Press, 1998.

Vallance, Jeffrey, ed. *Thomas Kinkade: Heaven on Earth*. Santa Ana, Calif.: Grand Central, 2004.

Vance, Carole. "The War on Culture." In Wallis, Weems, and Yenawine, *Art Matters*, 220–31.

Vasari, Giorgio. *The Lives of the Most Excellent Painters, Sculptors, and Architects*. Vol. 1, edited by George Bull. London: Penguin, 1965.

"Visual Culture Questionnaire." *October* 77 (summer 1996): 25–70.

Wakefield, Mary. "Saving Souls through Painting." *Spectator*, July 27, 2002.

Wallach, Alan. "The Norman Rockwell Museum and the Representation of Social Conflict." In *Seeing High and Low: Representing Social Conflict in American Visual Culture*, edited by Patricia Johnston, 280–90. Berkeley: University of California Press, 2006.

———. "The *Voyage of Life* as Popular Art." *Art Bulletin* 59, no. 2 (June 1977): 234–41.

Wallis, Brian, Marianne Weems, and Philip Yenawine, eds. *Art Matters: How the Culture Wars Changed America*. New York: New York University Press, 1999.

Watson, Justin. *The Christian Coalition: Dreams of Restoration Demands for Recognition*. New York: St. Martin's, 1997.

Weintraub, Linda. *In the Making: Creative Options for Contemporary Art*. New York: Distributed Art Publishers, 2003.

"Westinghouse Lighting Corp." *Do-It-Yourself Retailing*, May 2004.

Wilder, Jesse Bryant. *Art History for Dummies*. Foster City, Calif.: IDG, 2007.

Wilson, Andrew. "America's Most Wanted." *Modern Painters* (July–August 2006): 94–97.

Wilson, Janelle L. *Nostalgia: Sanctuary of Meaning*. Lewisburg, Pa.: Bucknell University Press, 2005.

Wolfe, Gregory. *Intruding Upon the Timeless: Meditations on Art, Faith, and Mystery*. Baltimore: Square Halo, 2003.

Wölfflin, Heinrich. *Kunstgeschichtliche Grundbegriffe: Das Problem der Stilentwicklung in der neueren Kunst*. Munich: F. Bruchmann, 1915. Translated by M. D. Hottinger as *Principles of Art History: The Problem of the Development of Style in Later Art* (New York: Dover, 1932).

Wooding, Dan. "'Simpler Times' with 'The Painter of Light.'" *Assist News* (Aid to Special Saints in Strategic Times), Jan. 1, 2001, www.assistnews.net/strategic/s0000030.htm (accessed May 11, 2010).

Wriston, Walter. *The Twilight of Sovereignty: How the Information Revolution Is Transforming Our World*. New York: Scribner, 1992.

Wypijewski, JoAnn, ed. *Painting by Numbers: Komar and Melamid's Scientific Guide to Art*. Berkeley: University of California Press, 1999.

Contributors

JULIA ALDERSON is an assistant professor of art history at Humboldt State University in Arcata, California. Her research interests include topics in modern sculpture, public art, contemporary architecture, and museum studies.

ALEXIS L. BOYLAN is an assistant professor in residence of women's studies and art history at the University of Connecticut. She is currently completing a book titled *Man on the Street: Masculinity, Urbanism, and the Art of the Ashcan Circle.*

ANNA BRZYSKI is the editor of the anthology *Partisan Canons* (2007). Her work on Polish and more broadly Eastern European art and historiography has appeared in *Art Criticism, Centropa, 19th Century Art Worldwide, Res, Third Text,* and a number of anthologies. She teaches art history at the University of Kentucky, Lexington. Her current research explores the problem of value and status of different types of artistic production within culture, art economy, and art history.

SETH FEMAN is a PhD candidate in American Studies at the College of William and Mary. His interest in Kinkade's reception has stimulated the methodology he has used in his dissertation, which focuses on art encounters and the experience of vision in mid-twentieth-century art institutions.

MONICA KJELLMAN-CHAPIN is an associate professor of art history at Emporia State University. She is interested in the dialogue between canonical and popular forms of the visual, as well as the implications of digital reproduction. Her essays on a range of topics, including Whistler, kitsch, Thomas Kinkade, and autofictionalization, have appeared in *Art History, Konsthistorisk Tidskrift, Specs, Rethinking Marxism,* and *Partisan Canons.* She is currently editing a collection of essays on kitsch to be published by Cambridge Scholars Press.

KARAL ANN MARLING is a professor emerita of art history and American studies at the University of Minnesota. Author of more than thirty books on American art and cultural studies, she is currently creating a collection of Kinkade collectibles.

MICKI McELYA is an assistant professor of history at the University of Connecticut. She is the author of *Clinging to Mammy: The Faithful Slave in Twentieth-Century America* (Harvard University Press, 2007).

DAVID MORGAN is professor of religion at Duke University. Author of several books, including *Visual Piety* (University of California Press, 1998) and *The Lure of Images* (Routledge, 2007), Morgan is coeditor of the journal *Material Religion*.

CHRISTOPHER E. M. PEARSON is a historian of art, architecture, and urbanism who focuses on the visual culture of the twentieth century. He has taught both graduate and undergraduate courses in the history of art and architecture at the University of California at Davis, Santa Clara University, Arizona State University, the University of Oregon, Trinity University (San Antonio), and the University of British Columbia. In 2006 he was a founding faculty member of the nascent Quest University Canada.

JEFFREY VALLANCE is an artist whose work blurs the lines between object making, installation, performance, curating, and writing. He is represented by Bernier/Eliades in Athens, Galerie Nathalie Obadia in Paris, Margo Leavin Gallery in Los Angeles, and Tanya Bonakdar in New York. In 2004 Vallance received the prestigious John Simon Guggenheim Memorial Foundation award for installation art. In addition, he has written for many publications, including *Art Issues*, *Artforum*, *L.A. Weekly*, *Juxtapoz*, *Frieze*, and *Fortean Times*; he has published nine books and curated the first art-world exhibition of the Painter of Light™, entitled Thomas Kinkade: Heaven on Earth. He currently teaches New Genres in the Department of Art at the University of California, Los Angeles.

ANDREA WOLK RAGER is a postdoctoral research associate at the Yale Center for British Art. She has been the recipient of an Andrew W. Mellon Fellowship in Humanistic Studies, a Paul Mellon Centre Junior Fellowship, and a Robert W. Wark Fellowship at the Huntington Library. She is currently working on a book manuscript adapted from her doctoral dissertation, "'Art and Revolt': The Work of Edward Burne-Jones." Her essay on Burne-Jones's Briar Rose series can be found in the spring 2009 issue of *Victorian Studies*.

Index

ALEXIS L. BOYLAN is assistant professor in residence
of women's studies and art history at the University
of Connecticut.

Library of Congress Cataloging-in-Publication Data
Thomas Kinkade : the artist in the mall / edited by
Alexis L. Boylan.
p. cm.
Includes bibliographical references and index.
ISBN 978-0-8223-4839-9 (cloth : alk. paper)
ISBN 978-0-8223-4852-8 (pbk. : alk. paper)
1. Kinkade, Thomas, 1958– 2. Christian art and
symbolism—United States. I. Boylan, Alexis L.
ND237.K535T46 2011
759.13—dc22 2010035881

DATE DUE

GAYLORD #3522PI Printed in USA